Developments in Timber Engineering

Anton Steurer

Developments in Timber Engineering

The Swiss Contribution

Birkhäuser – Publishers for Architecture
Basel · Boston · Berlin

Bibliographic information published by Die Deutsche Bibliothek
Die Deutsche Bibliothek lists this publication in the Deutsche National-
bibliographie; detailed bibliographic data is available in the internet at
http://dnb.ddb.de.

© 2006 Birkhäuser – Publishers for Architecture,
P.O. Box 133, CH-4010 Basel, Switzerland
Part of Springer Science+Business Media

A publication by the Society for the Art of Civil Engineering
(ETH Hönggerberg, CH-8093 Zurich)

This book is also in a German language edition available
(ISBN-10: 3-7643-7164-1, ISBN-13: 978-3-7643-7164-7)

Printed on acid-free paper produced from chlorine-free pulp. TCF ∞
Layout and Cover: Werner Handschin, Basel; Emil Honegger, Zurich
Printed in Germany

ISBN-10: 3-7643-7163-3
ISBN-13: 978-3-7643-7163-0

www.birkhauser.ch

9 8 7 6 5 4 3 2 1

Content

Foreword

No other material has played as large a role in the history of human development as wood. No other material has influenced us as much, and no other material has been as extensively shaped and transformed by us. Wood does not have a rarefied, exclusive air. The ideas with which it is associated have evolved slowly over millennia. It not only boasts great strength, but can be worked, shaped and altered in a multitude of ways – properties from which dedicated master carpenters, engineers and architects have profited since time immemorial.

"Developments in Timber Engineering. The Swiss Contribution" reports on the work of these masters, placing particular emphasis on the contribution made by Swiss wood builders and architects. The book charts out the development of wood as a building material in Switzerland and depicts the influence of Swiss experts.

Wood was indispensable in many areas of life well into the nineteenth century, but its role was gradually usurped by the new technical materials steel and concrete in the early twentieth century. In recent years, the development of new wooden materials with large dimensions and great strength, as well as improvements in connection technology, have given wood a unique new position in the field of engineered applications. Over the last few decades, daring builders have designed and constructed numerous structures in Switzerland that have not only blazed new trails, but set the tone for further developments. These structures are distinguished by originality, high-

quality design and breathtaking dimensions. Vivid architectural examples reveal the extraordinary interplay between inventive talent, research and the trust designers place in material strength. Now and in the past, the studies conducted by Swiss universities and research facilities have been instrumental in establishing and advancing the technical credibility and reliability of engineered timber construction.

Through their support, the Institute of Structural Engineering at the ETH Zurich, the Society for the Art of Civil Engineering, the "Gerold und Niklaus Schnitter-Fonds für Technikgeschichte" at the ETH Zurich, as well as the Swiss Agency for the Environment (with its Holz 2000 program) have contributed to this special documentation of the history and development of timber engineering. I owe them my heartfelt thanks. I would also like to express my gratitude to the many engineers, builders and architects who made photographs and project documentation available to me. Personal thanks goes to Emil Honegger (ETH Zurich) for his dedicated supervision of text processing and graphic design, and to Charles von Büren (Bern) for his sound technical editorial work.

Anton Steurer

Wood

For millennia, wood was a fundamental material, the very substance of existence. It still is today, even if it sometimes remains hidden from view.

Wood is not one of the four elements – air, water, earth and fire – but if we could add a fifth, wood would be the inevitable choice. Many new products seem to suggest that wood has finally become replaceable. Buildings, furniture and utilitarian objects of wood – such as pepper grinders, umbrella handles and violins – are often seen with a touch of nostalgia. But to view them in this way is to overlook wood's great importance and the influence it exerts on our lives.

There is virtually no quotidian object that does not contain wood or elements of wood. Cellulose – the structural material found in wood cell walls – is by far the most common organic compound in nature. It is also considered the most important raw material for industry. Yet cellulose not only provides a basis for paper and cardboard production. It is also used to make fabrics with a shiny finish, or to manufacture articles of clothing like summer dresses and blouses that have a light, airy feel. In these textiles, it is in the form of chemically or physically extracted cellulose threads (artificial silk) or viscose fibers (cell wool). Cleanroom garments, wound dressings, cellophane, velvet box lining – all are ultimately wooden products.

Wood can also be found in food and pharmaceutical products: the cellulose in canned orange juice ensures a homogeneous mixture of water and fruit. It gives toothpaste its consistency and makes ice cream melt on our tongues. Practically all medicinal and body care products contain wood ingredients. A good example is aescultetin, a horse chestnut extract that absorbs ultraviolet rays in sun block.

"Communities that sell their forests and squander the proceeds are like savages who chop down fruit trees to pick the fruit." This judgement, which comes from an 1848 educational pamphlet from Graubünden Canton, reveals the great value people attached to wood during this age. Though it remains an indispensable part of our lives today, wood generally seems replaceable and is only truly appreciated in the forests we visit for recreation. Yet two factors are certain to enhance the status of wood in the twenty-first century: its highly diverse applications, and its importance as the most plentiful renewable resource.

Everyday Life 100 Years Ago

Well into the nineteenth century, wood remained an important material in practically all areas of life, whether the household, agriculture, the skilled trades, architecture, shipbuilding or mechanical engineering … the list is endless. Life was inextricably bound up with wood and wooden objects.

With the transition from pre-industrial to industrial society, materials such as coal and iron usurped the role of wood. There were radical changes in many fields of application that had been dominated by wood for centuries, and man's relationship with wood went through a dramatic transition, too. The technological upheaval was impressively reflected in mammoth steel structures, railways, great feats of engineering and new production methods. Even so, wood continued to exert a strong practical and emotional influence on people's lives.

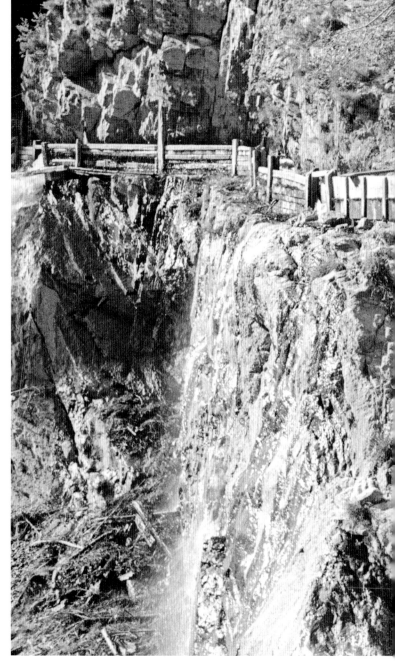

Wooden structures known as *Wasserfuhren,* or water conduits, were once used to guide water down from the mountains. These daredevil constructions ran along steep mountain cliffs and were used to irrigate more than a third of the agricultural land in Wallis Canton around 1900.

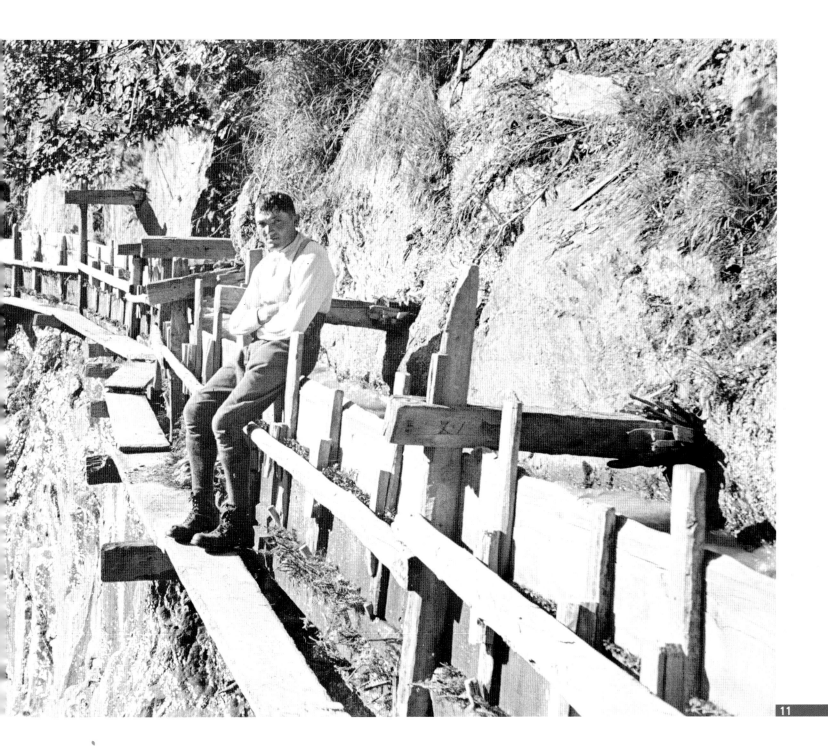

Industrialization irrevocably transformed the technological and social landscape. Even so, one hundred years ago, wood continued to play a major role in people's lives. Though brown coal, hard coal and peat had been burnt for years, charcoal and wood continued to be the primary source of energy – not only for cooking and heating, but for all branches of industry, including glass and ink production, salt extraction and brick-firing. About half of the timber felled was burnt. In view of these diverse applications, it is hardly surprising that, when designing the Swiss fifty franc bill, the Swiss painter Ferdinand Hodler (1853–1918) selected the forest as a symbol of "work in Switzerland", the theme prescribed by the Swiss National Bank. His famous painting is entitled *The Lumberjack*.

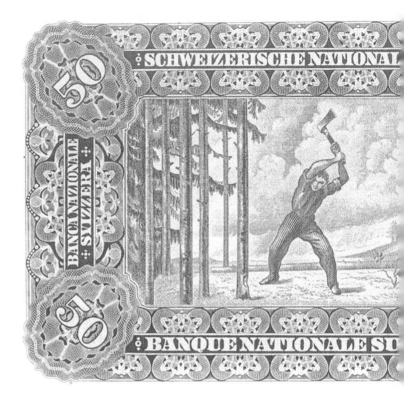

The back of this fifty franc bill, in circulation between 1911 and 1958, is imprinted with the picture of a lumberjack. Ferdinand Hodler's original 1910 painting explores the theme of work in Switzerland, illustrating the close bond between man and wood.

The Lumberjack, painting by Ferdinand Hodler

«The rough, work-worn hands grasp the axe with a confidence and strength that will soon cost the thin tree trunk its life.
But the strength that flows into the tool not only originates in these hands but courses through the entire body in a great rhythmic motion … It is the intensity of work that is shown here. The treatment is one-sided and uncritical … The link between man and nature is severed.»

From a description of the painting by Hanna and Ilse Jursch

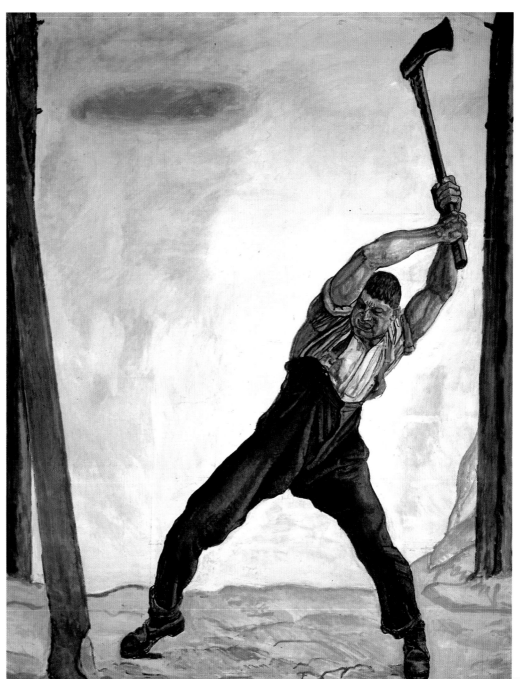

Concerns about daily water supplies around 1900 illustrate how closely nature and mankind, wood and human life, were intertwined despite the rapid pace of industrialization. Until the late nineteenth century, sections of the water supply system in Switzerland were built of wooden pipes called *Deuchel.* These pipes, which were roughly five meters long and had an inside diameter of five to nine centimeters, were fitted together or connected with iron rings.

During this period, supplies of basic foods in Wallis Canton were dependent on the artificial irrigation of agricultural land and vineyards. Without the man-made conduits called *Suonen* in the German-speaking part of Wallis, no agriculture would have been possible in the hottest and driest part of Switzerland. The water was guided down from the mountains, where it often originated in glaciers, and ran for hours in wooden conduits along steep mountain cliffs. The construction and maintenance of these structures was a taxing, bold and risky business. Around 1900, over 300 of these *Heilige Wasser* (sacred waterways) were in operation, and the entire network measured some 2,000 kilometers. There were also about 25,000 kilometers of shorter channels.

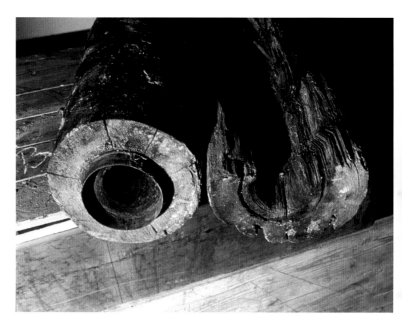

This wooden pipe from the beginning of the twentieth century, found in Zurich, was part of the city's old water supply system. Because of their high resin content, pine and silver fir were the preferred woods for these pipes, called *Deuchel.* Holes were drilled just after trees were chopped down to keep the wood from split-ting. The pipe was buried at a depth of about one meter.

Less than 100 years ago, wooden pressure mains were used to deliver fresh water. The Zurich company Locher & Cie manufactured a "modern" wooden pipe using a traditional keg construction method. The individual staves consisted of 5-mm-thick boards with radially planed soffits and tongue-and-groove edges. Pieces of sheet metal were inserted into their ends and pressed into adjacent layers to ensure that the pipes were adequately sealed. Iron rings held the pipe sections together.

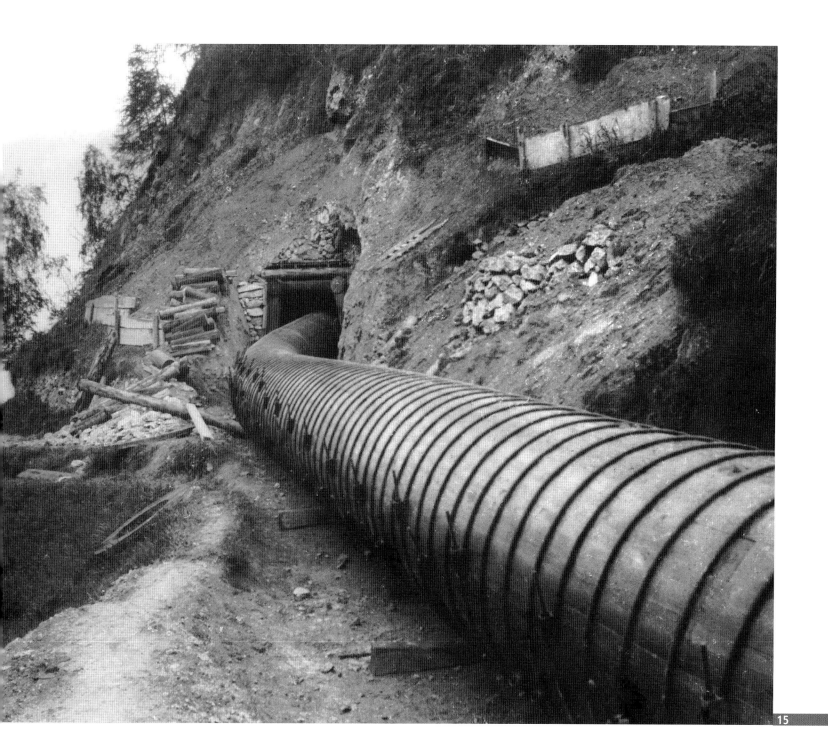

There are many instances of masterly wood craftsmanship from the period around 1900, and it is likely they are a response to the increased uniformity of machine production. Intricately designed accordions are one impressive example: their over 1,000 parts were pieced together with the greatest of precision. The *Schwyzerörgeli*, or Swiss organ, is a testimony not only to a high level of craftsmanship and profound knowledge of wood, but also to the intimate relationship between man and material.

Concealed in the treble and bass sections under the bellows is a veritable work of art that has been fashioned with the precision of a clock. Tiny handmade wooden components, bonded together with a homemade bone-based glue, form the base for the reeds in this delicate wooden structure. The quality is reflected in the careful selection of wood, its storage before and after cutting, as well as in the accurate workmanship and precise production.

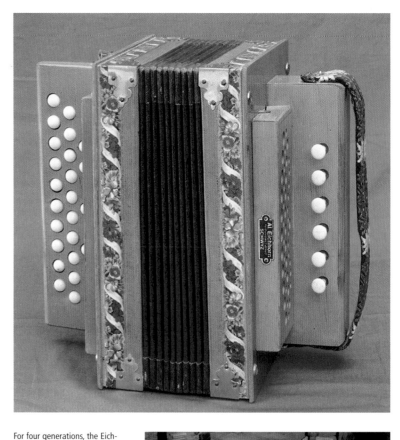

Alois Eichhorn from Schwyz (Schwyz Canton) is one of the first great Swiss organ makers. He began production in 1886. This organ, completed in 1896, has six bass and four half-tone keys. Even today, it has excellent sound quality and can be used for virtuoso performances – a testimony to the extraordinary woodworking skills of its maker.

For four generations, the Eichhorn organ has been built using the original construction technique. The wood is seasoned in the open air for several years and then cut to the approximate dimensions. After being stored for another ten to fifteen years in the attic above the workshop, it is ready for the next phase of production.

The exposed treble section of this Swiss organ, built by Alois Eichhorn in 1896, reveals the delicate structure of the glued components. The high standards of precision can be distinguished in the method used to attach the reed plates. They are mechanically mounted to the reed beds via threaded components. To ensure a proper seal, this construction technique requires precisely manufactured wooden components that are perfectly coplanar with the pieces they are placed on. The level of precision sets this technique apart from those that use wax as a sealant.

The sound of the organ matures over a period of ten to fifteen years, during which time it is ideally played two to three hours a day. It is only the sustained exposure to sound waves that brings out the desired sound properties. This also shows the great importance of wood selection and craftsmanship.

Everyday Life Today

Although wood might seem largely nonessential today, it continues to be used in a wide variety of objects. Many we take for granted, others remain hidden from view. Wood has undergone a technological transition, and our emotional relationship with it has changed as well. Today wood accounts for much more than sawn lumber, and it is no longer only the stuff of romantic dreams.

Wood is carving out additional careers for itself, and in many of its new forms it is barely recognizable. It has emerged as a chemical product – as cell wool, cellophane or cellulose acetate (used to make artificial silk). Even celluloid, produced in an elaborate chemical decomposition process, is made of wood. Wood continues to surround us, and we often use it without noticing: eyeglass frames, clear plastic folders, screwdriver handles, the plastic windows in envelopes, cigarette filters … ultimately all these objects are made of or contain wood.

This sculpture in a public space shows free and daring use of wood. The two Thun-based artists Reto Leibundgut and Daniel Zimmermann left their mark on the train station in Thun (Bern Canton), creating the installation *Buffer Stop as Wooden Art/Bistro* (1993–1994). It consists of boards that are 70 meters long, 7 meters wide and 7 meters high. While the station restaurant was being remodeled, travelers temporarily ate in a dining car, which the artists embellished and transformed into an eye-catching landmark.

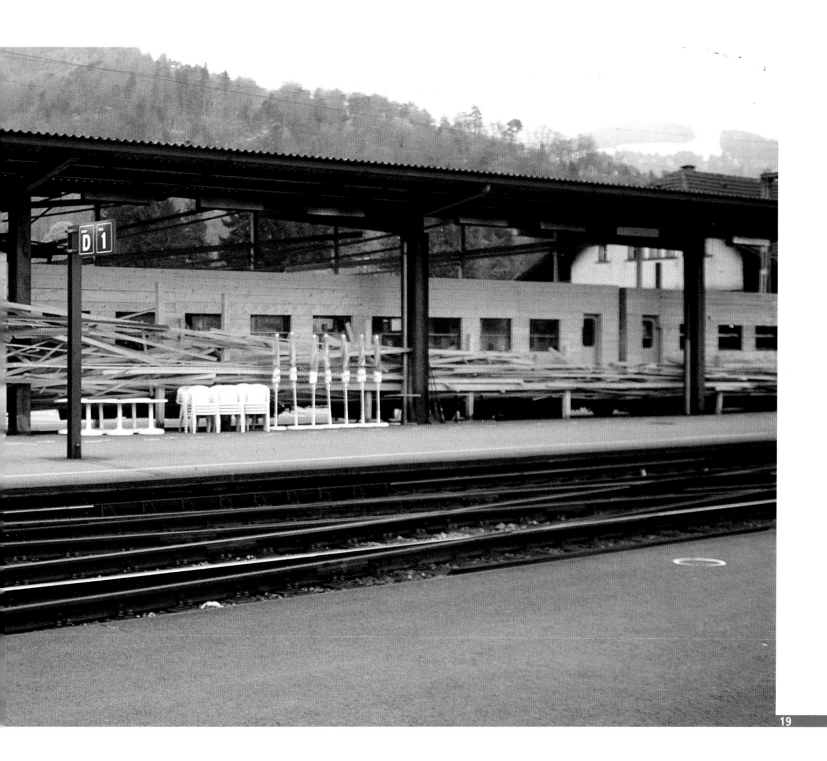

Wood is the source of many modern materials. Technicians, physicists and chemists have long been able to convert wood into materials suitable for modern technologies, and they have created new wooden products by homogenizing its properties and by transcending the dimensions of trees. Paradigms in our everyday lives are clearly changing. For instance, the idea of combining wood and plastic has given rise to a new generation of composites based on these two very different materials.

Wood-plastic composites combine natural and synthetic polymers. Wood particles or fibers measuring between 0.1 and 2.1 millimeters are first mixed with a matrix material – normally a thermoplastic such as polypropylene or polyethylene. The mixture consists of 20 to 90 percent wood depending on the desired properties. Pigments, light stabilizers, lubricants, fungicides and fire retardants are also added in order to optimize the desired properties. This mixture of wood particles, plastics and additives is either extruded in a single or multistage process to form a continuous semi-finished product, or it is fashioned into formed components in a die-casting process. The flexural strength and stiffness of the composite can be up to threefold as high as the original plastic, depending on the percentage of wood. This gives the composite a set of striking new properties.

For several decades now, the automotive industry has used interior door panels and crash pads made exclusively of wood fiber composites. These interior panels, whose surfaces can be easily concealed, are able to absorb a great deal of energy in crashes without splintering. Once consisting solely of natural fiber materials, the panels now incorporate plastics, which improve the formability and component properties of the three-dimensional parts.

Wood chips are washed, heated under pressure, ground, glued and finally dried until they have a fiber moisture content of 15 percent. The wood fibers are then sprinkled on a web of polyester fibers and bond mechanically to form a non-woven material. In a compression mold, this fiber mat is deep-drawn into its final shape using a negative mold heated to 230 degrees Celsius. It is then compressed for about sixty seconds.

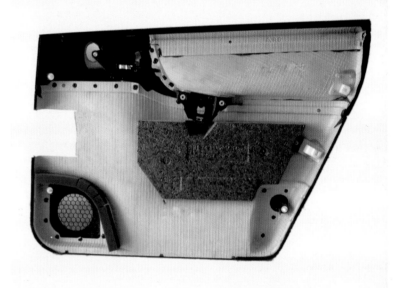

There are diverse applications and a wide range of potential future uses for wood-plastic composites. Aside from easily definable product properties, their important advantages include a high level of quality assurance, fully automatic production, and the ability to design complex geometric shapes. The best-known of such formed component today is the extruded section for weatherproof flooring, but a number of other high-quality products are on offer, including window sections, toys, sporting goods and semi-finished furniture.

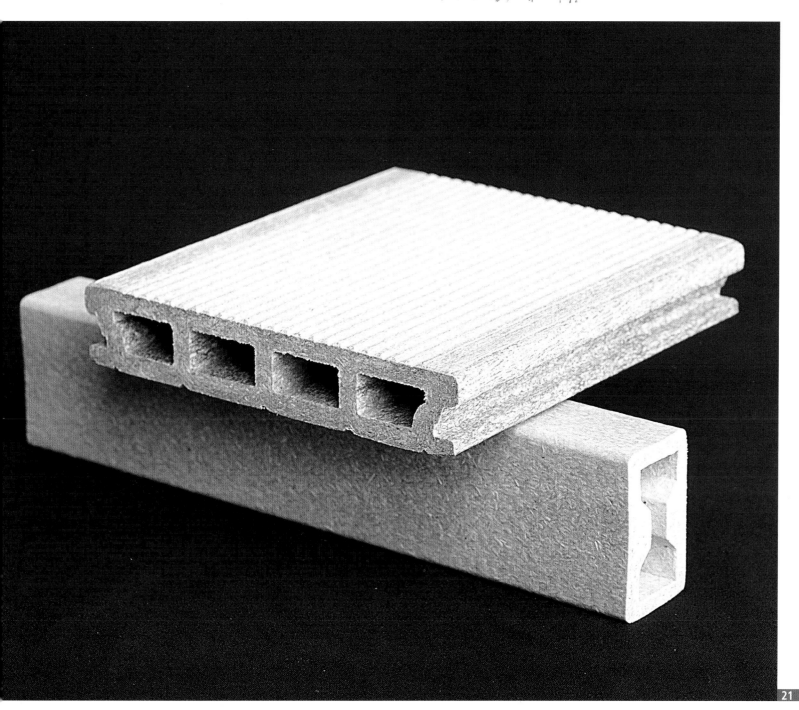

Wood is the most important renewable resource in the world. It is the only resource that does not require primary energy in its formative phase. The lifecycle of wood as a resource and building material begins in the forest – it has its "roots" in the tree.

An estimated 500 million trees grow in the Swiss forest, which covers about a third of the total land area of the country. About nine million cubic meters of wood grow annually, and of this, only five million cubic meters are harvested. The forest is a natural ecosystem that uses its nutrient capital in an extremely economical way and is not dependent on "exports" from beyond its borders. The forest is self-sufficient, powered solely by solar energy.

Forests store substantial amounts of carbon, and timber performs an important function in protecting the climate. Through photosynthesis, a tree takes in the greenhouse gas carbon dioxide, converts the carbon it contains to biomass and releases oxygen. Forests also maintain and renew the soil and water, forming a natural habitat for innumerable animal and plant species as well as offering us a place for recreation and solitude. If wood is left untreated, it is easier to put it to another use. It is also easier to break it down into its component parts after several uses or to burn it to produce heat. If recycled in this way, wood only releases the carbon (as CO_2) that was earlier locked up in the tree. Nature's cycle is complete.

Some tree species can live for 5,000 years, and it is not uncommon to see conifers in the Swiss forests that are 400 years old. Each of these trees is an individual creation with its own special appearance. When we observe these trees, our eyes are in constant motion. We attempt to take in every detail but cannot possibly grasp the whole. An incomprehensible amount of life has taken form in trees.

The ongoing use of wood is an essential part of prudent, natural forest management. The carbon that a growing tree takes in decreases with age as it becomes fully mature. If the old tree is replaced by a young one, this young tree once again stores carbon. If we use the old tree's wood to make buildings, furniture or other products, the carbon it stores will be locked up for decades or even centuries.

So every wooden structure can be seen as a kind of storehouse for carbon dioxide. For example, a total of 165 cubic meters of dry wood was needed to construct the single-lane, 30-meter-long Selgis road bridge over the Muotha (Schwyz Canton). Roughly 132 tons of CO_2 from the atmosphere are locked up in the structure. By contrast, the average Swiss family releases about eleven tons of CO_2 each year through energy consumption.

Research

In all likelihood, timber construction has been more heavily influenced than any other construction method by its close relationship with the skilled trades. Knowledge of both the properties of wood and the behavior of buildings did not come from scientific studies. Rather, builders continued craft traditions and erected structures on the basis of passed-down knowledge, accumulated experience and an intimate relationship with the material. The most prominent of these, including the Grubenmanns, a family of master builders from Appenzell, Switzerland, had the rare ability to refine their intuitive grasp of the interplay of forces in their day-to-day work as well as by examining existing structures. They were all researchers in their own right, and the construction site was their laboratory.

The seventeenth century saw the formulation of the first theoretical methods for the stress analysis of load-bearing structures. However, it took a long time before they were understood by those who did the actual building. With the onset of the Industrial Revolution, technical colleges such as the Zurich Polytechnikum (the predecessor of today's Swiss Federal Institute of Technology, or ETH) spread at an accelerated pace, which in turn led to a consolidation of the natural sciences. This period is associated with many milestones and important names, including Carl Culmann, the father of truss theory and the first professor of engineering in Zurich; and Ludwig von Tetmayer, the developer of the theory of buckling in compact members and the first director of the Eidgenössische Materialprüfanstalt (forerunner to the Swiss Federal Laboratories for Materials Testing and Research, or EMPA).

The shift from conventional to engineered timber construction took place in the early twentieth century and was essentially rooted in fundamental systematic research that helped verify the design and engineering rules elaborated at the time and translated these into the first reliable standards. Both then as now, the studies conducted at Swiss colleges and research institutes have helped establish and advance the technical credibility and reliability of engineered timber construction.

Research into wood now includes the macro-, micro- and nanospheres. Research into the smallest possible areas provides insights into the innermost structures of the material, improves scientists' grasp of the material-technological connections and, finally, makes it possible to manipulate and change materials at the nano-level, atom for atom. This illustration of dyed wood fibers of spruce (picea abies), which have already been isolated from the tissue, shows how analysis of the micro-sphere can reveal the structure of sub-elements and make it possible to draw conclusions about the various mechanisms and behavior of the material concerned.

From Master Carpenter to Engineer

Right into the nineteenth century, carpenters and master builders often built wooden trusses without any knowledge of either the theoretical principles or the structural physics involved. Often, they did not have precise architects' plans either. The most impressive examples of their bold structures with long spans demonstrate an extraordinary intuitive grasp of structural loads and forces and exceptional skill in exploiting wood's properties to the full. The most outstanding master builders also displayed that rare gift of being able to train their intuitive grasp of the interplay of forces in their day-to-day work as well as by examining existing structures.

For a long time, the mathematical models developed by the two Swiss theoreticians Leonhard Euler (1707–1783) and (later) Daniel Bernoulli (1700–1782) in the eighteenth century were neither understood nor applied to construction. The transformation from master carpenter to engineer was a drawn-out process.

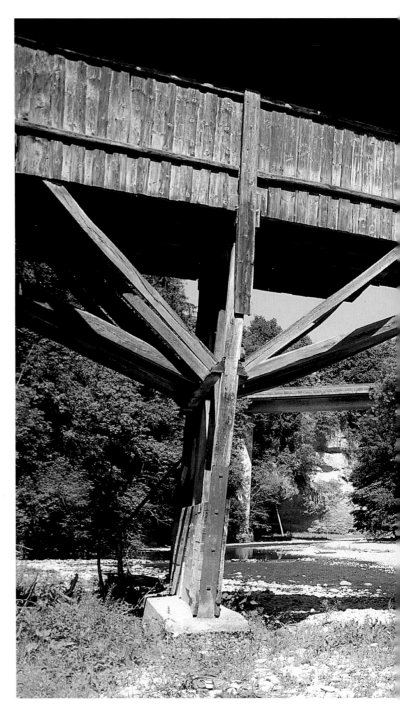

The multiple supports and bracing of Letzi bridge, which was built in 1853 near Ganterswil (St. Gallen Canton), impressively illustrate the builders' pragmatic grasp of structural physics.

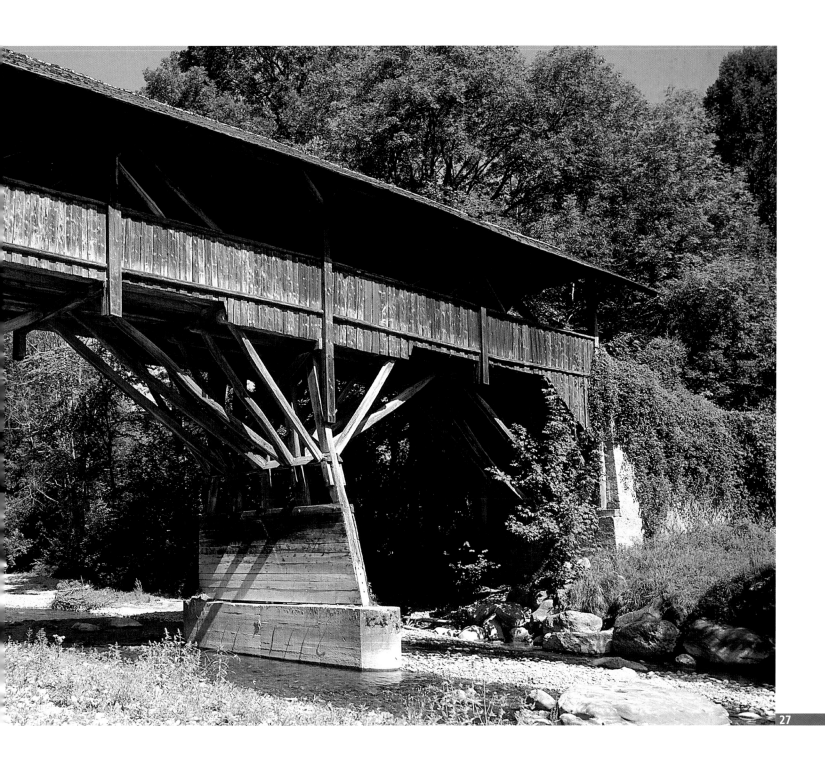

In view of the undeniable risks involved, one can assume that experienced master builders were commissioned to construct bridges who had already proved their skill in roof construction. Indeed, a close relationship between roof and bridge construction is evident in the work of all master builders. The outstanding masters of wood construction at this time were the Grubenmann brothers from Teufen (Appenzell Ausserrhoden Canton). The structural changes they made to their roof trusses over the course of time provide a visual lesson in structural physics. One can clearly see how the experience they gained from one project flowed into optimizing the structure of the next.

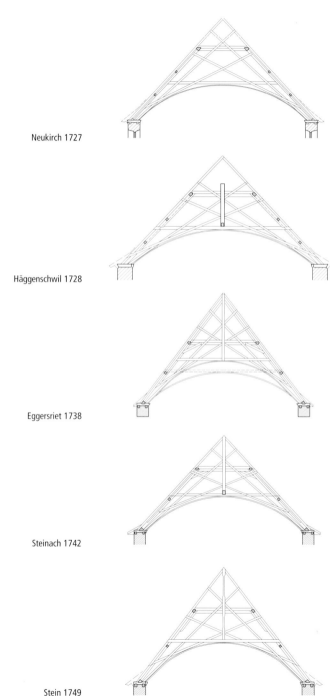

Neukirch 1727

Häggenschwil 1728

Eggersriet 1738

Steinach 1742

Stein 1749

The structural concept underlying the trusses designed by the Grubenmanns was a product of intuition, knowledge, skill and, above all, experience. It also came from the meticulous observation of the behavior of existing structures. A chronological comparison of their roof trusses shows how their knowledge and skill developed over the years.

The subsidence that Jakob Grubenmann (1694–1758) apparently noticed in the roof truss of the church built in Neukirch (Thurgau Canton) was due to the way the bracing structure had been built and the yielding of the walls. Only one year later, Grubenmann fitted a mullion in the roof truss for the church in Häggenschwil (St. Gallen Canton), thus significantly enhancing the structure. In the roof trusses he made for the churches in Eggersriet and Steinach (both in St. Gallen Canton) in 1738 and 1742, the posts reach as far as the roof ridge. Using this approach he was able to create additional triangular voids and achieve a noticeable increase in stiffness. As a result, the load-bearing capacity was less dependent on the lateral stiffness of the walls.

The first church that Hans Ulrich Grubenmann (1709–1783) built together with his brother Jakob shows another very effective improvement. In the roof truss of the church erected in 1749 in Stein (Appenzell Ausserrhoden Canton), the reinforcing posts are no longer arranged in single truss levels but at all rafter levels. This considerably improved the truss's load-bearing behavior and stiffness with very little additional effort or expense.

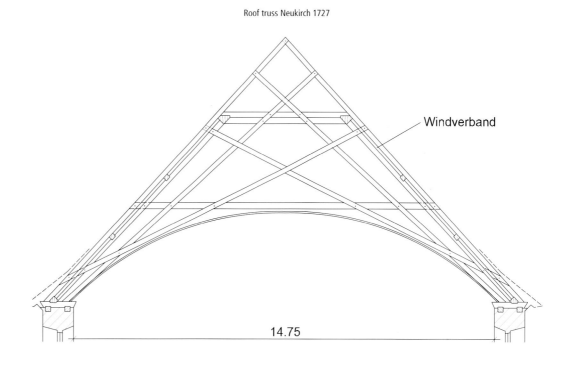

Roof truss Neukirch 1727

Windverband

14.75

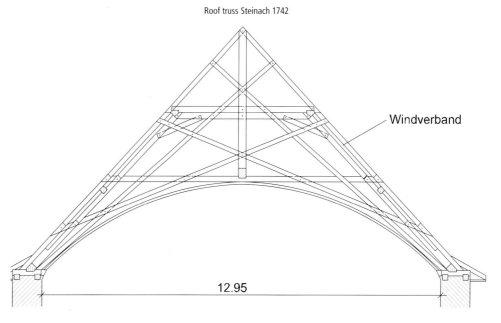

Roof truss Steinach 1742

Windverband

12.95

The great building boom stimulated by the construction of the railways from the mid-nineteenth century on made it necessary to find more reliable methods than personal judgment for erecting structures. This called for the introduction of an impersonal, objective instrument, namely, structural physics. The École des Ponts et Chaussées in Paris, founded in 1747, made a vital contribution in this regard. The École's first director was the Swiss-born Jean-Rodolphe Perronet (1708–1794). From this time on, engineering schools served an increasingly important function. Carl Culmann (1821–1881), the first professor of engineering at the Eidgenössisches Polytechnikum, founded in 1855, played a significant role in new developments within engineering.

Culmann, who had originally served the Bavarian state as a mathematician and engineer, acquired his knowledge of construction on study trips to North America and England. His accounts of his journeys became famous. The first one deals with the design and construction of wooden bridges in the United States.

Just as wooden bridge construction in Europe had an influence on wooden bridge building in the United States in the eighteenth and early nineteenth centuries, the frames used by the Americans had a stimulating impact on developments in Europe from the mid-nineteenth century on. Carl Culmann's travel accounts, published in the *Allgemeine Bauzeitung* in 1851 and 1852 by L. Förster, made a great contribution in this respect. The first part focuses on the design and construction of wooden bridges in North America; the second part describes iron bridges in England and North America.
Culmann also provides detailed descriptions of the most remarkable bridges he saw on his journey. He measured both the trusses and specific details and supplemented his commentaries with illustrations of the plans. The present example shows the single-track railroad bridge constructed by the Connecticut Railway Company on the basis of Howe's principles. The bridge has a span of fifty-four meters.

In his travel account, Culmann not only discusses existing buildings and planned projects but also documents new developments. For instance, he presents one of Remington's ideas for a structure, 'which certainly deviates from all familiar wooden structures; and although this one has neither been fully tested nor developed, it nonetheless deserves mention in this chronological outline of the development of bridge building in America as one of the simplest, most beautiful and ingenious conceptions, which holds the promise of extraordinary developments …'

Remington had planned a stress ribbon timber bridge with a span exceeding 130 meters. His project was based on a design in which wooden fibers are bundled like cables and subject to an equal tension and load. In cases where a slight sag is subject to vertical loads, no bending loads arise (according to tests performed by Remington on small samples) … This increases 'fourfold the absolute load-bearing capacity of the wood …'
The planned bridge had a 3-meter-wide and 30-centimeter-thick tieback composed of ten rows of parallel boards glued together and fixed at the ends with halved joints. A supported deck was then fixed to the bridge and a closely meshed latticework firmly attached to the sides for protection. Although Culmann was able to demonstrate mathematically the feasibility of Remington's idea, he nevertheless failed to see that he lacked the connections required to construct the bridge.

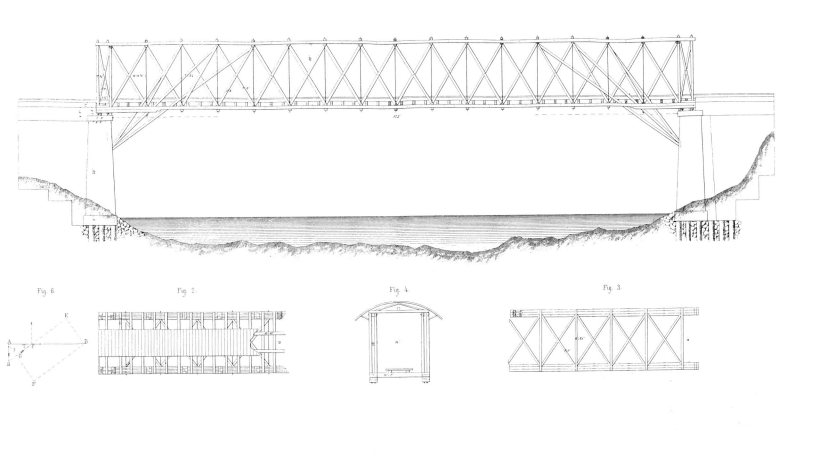

Fig. 6. Fig. 2. Fig. 4. Fig. 3.

The two mathematicians from Basel, Jakob Bernoulli (1654–1705) and Leonhard Euler (1707–1783), developed mathematical methods for computing the behavior of building elements. Nevertheless, builders at the time found their calculations incomprehensible. Louis Navier (1785–1836) was the first to take into account builders' practical concerns in his theoretical considerations, thus laying the foundations for modern structural physics.

Even though there already existed a number of different theoretical approaches to computing load-bearing behavior, the transformation from master carpenter to engineer proceeded very slowly in the practical world of construction. In his capacity as professor at the ETH Zurich, Carl Culmann published *Die graphische Statik* (graphic structural analysis) in 1866, which illustrated this problem simply and graphically and helped to create a greater understanding of engineering. He performed his first calculations on a parallel-chord truss and defined the term 'truss' for the first time. During the course of his teaching activities, he developed the more vivid and easily understandable graphic method for calculating these types of load-bearing structures.

In addition to documenting American timber bridges, the second part of Culmann's travel account also contains some basic theoretical considerations on the subject. Under the heading "Theorie der Fachwerk-, Latten- und Bogenbrücken", he presented some mathematical rules and formulae for calculating the forces in the new bridge systems.

Now, for the very first time, it was possible to assess the safety of these trusses mathematically. Culmann thus established the basis for modern truss theory. He used these rules to analyze and critically evaluate the bridges that he had seen and described. This, in turn, formed the basis of his famous work *Die graphische Statik,* published in 1866. This 'simple presentation' of structural analysis gave engineers an objective tool which soon became widely used. Culmann's pupil Maurice Köchlin, for example, applied his

teacher's graphic methods of structural analysis to the design and calculations for the Eiffel Tower in Paris.

Culmann also concentrated his efforts on developing the funicular polygon and, related to this, the closing line. Using the polygon of forces, engineers were now able to determine the reactions and derive the moment area directly from the extended funicular polygon.

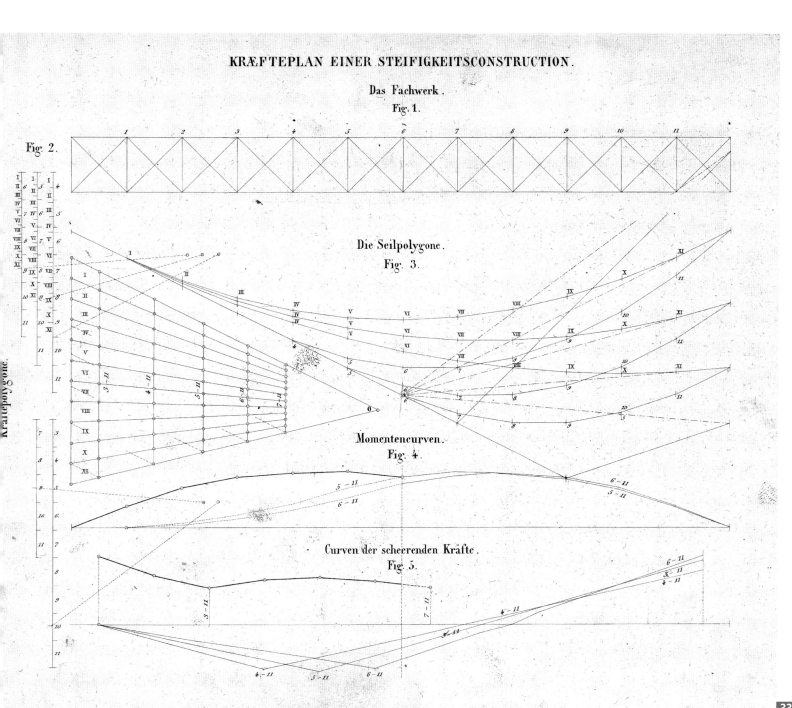

KRÆFTEPLAN EINER STEIFIGKEITSCONSTRUCTION.

Das Fachwerk.
Fig. 1.

Fig. 2.

Die Seilpolygone.
Fig. 3.

Momentencurven.
Fig. 4.

Curven der scheerenden Kräfte.
Fig. 5.

Although both analytical tools for determining internal forces and simple calculating methods already existed, uncertainty still prevailed on how to evaluate existing trusses. Builders constructing the latter had insufficient knowledge of the load-bearing and deformation behavior of 'new' connections. Nor were they aware of the experience gained in the meantime which showed that local deformation at the points of connection determined a structure's behavior. Hence, tests were frequently performed to determine experimentally the load-bearing behavior of a truss and to identify evident weak points.

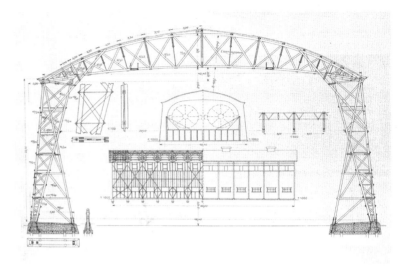

One century ago it was still not possible to establish beyond the shadow of a doubt the safety of a structure by mathematical means. Master carpenters had great difficulty in determining the actual interplay of forces in the load-bearing structure of the airship harbor in Lucerne. As a result, its behavior and anti-sag properties were tested by performing load tests on a 1:20 scale model. The total load of 560 kilograms on the model corresponds to a real load of 300 kg/m[2] on the hall roof and includes the dead weight, the snow load and the vertical components of the wind load. The experiments on the models were often also conducted with the aim – not to be scorned – of convincing clients of the safety of the structure.

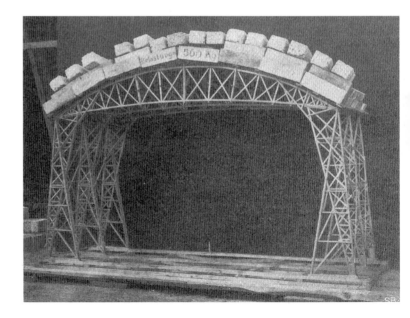

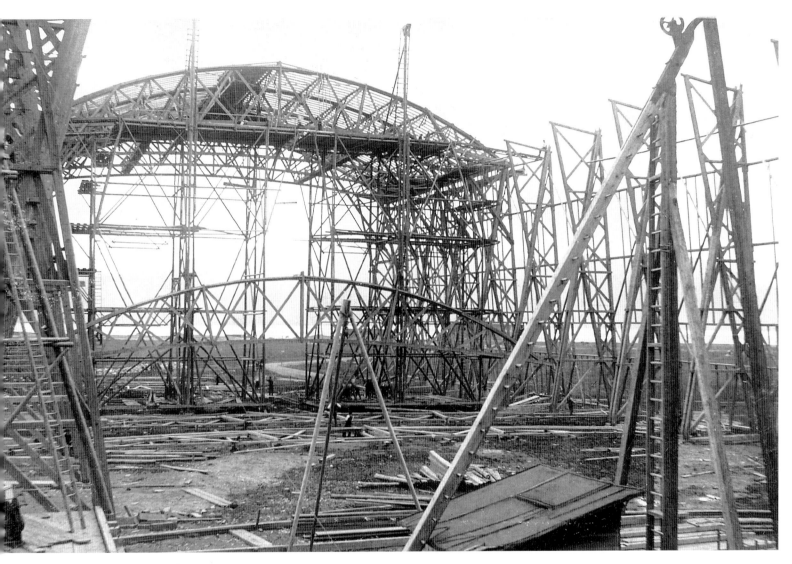

Fascinated by the arrival of the Zeppelin airship in Switzerland, Lucerne hotel owners seized the initiative and decided to erect an airship port in 1913. They founded the Genossenschaft Aero Luzern, the first commercial air-flight company in Switzerland. With a span of 46 meters and a height of 24 meters, the dimensions of the truss were truly impressive. Precisely 1,150 cubic meters of construction timber were nailed together with 8,000 kilograms of nails on site to create the structure for the 96-meter-long building in Tribschenmoos in Lucerne. The hall was large enough to hold two airships. One side of the building contained a restaurant where passengers 'could enjoy a selection of various fine wines, and some drank to give themselves the much-needed courage to sail up into the higher regions before they disappeared – sneering at the spectators below – in the clouds …' The First World War put an end to these flights.

The Problem of Buckling

Even though theoretical developments in the nineteenth century made it possible to ascertain both rod forces and loads, uncertainty still remained concerning the behavior of rods in compression. By 1744, the Swiss mathematician Leonhard Euler (1707–1783) had already dealt theoretically with buckling in what came to be known as Euler's buckling formula, with which all engineers are familiar even today. For quite some time, however, fundamental questions remained unanswered.

When Louis Navier (1785–1836) formulated his bending theory and closed the gaps in Euler's theory, the latter's formula came to be used more frequently. Later, however, damage and tests revealed that its application was problematic with compact rods. Ludwig von Tetmayer (1850–1905), professor at the ETH Zurich and the first director of the Eidgenössische Materialprüfanstalt (now the EMPA: a Swiss materials science and technology research institute), was able to remedy these shortcomings by conducting extensive tests using the well-known Tetmayer lines.

The bending tests, carried out more recently at the ETH Zurich in connection with the development of multishear dowel connections, clearly showed the complex interaction between pure theory and structural design. The results graphically demonstrate the influence of the rod design on the load-bearing behavior of rods in compression.

A typical problem related to the design of compression rods for trusses is failure caused by instability due to bending fracture before wood reaches its actual compression strength. When developing multiple-shear connections for wooden spaceframes, the ETH Zurich analyzed the load-bearing and deformation behavior of these structures on a 1:1 scale model of a truss section.

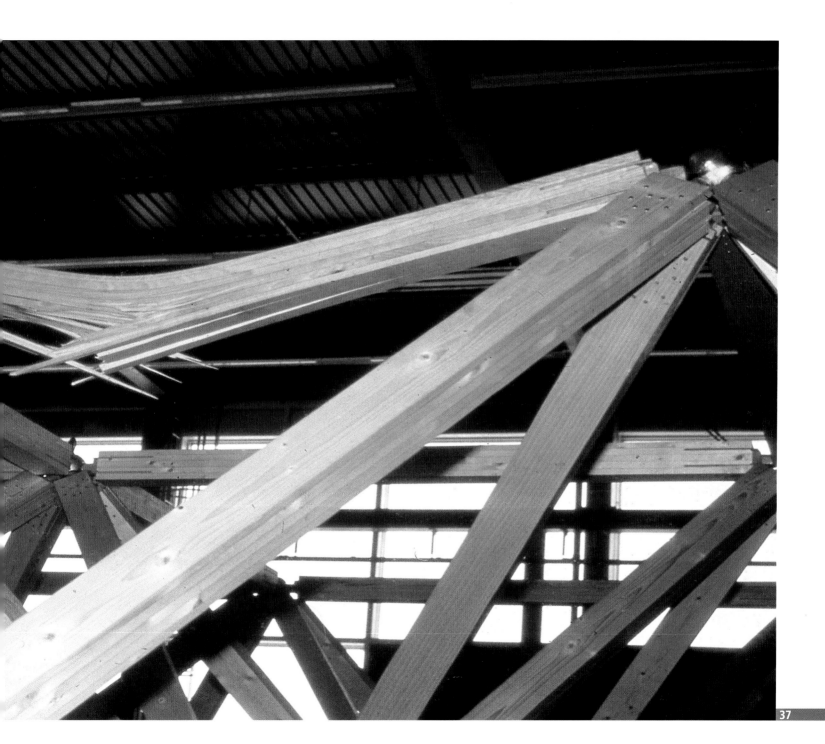

In 1744, the Basel mathematician Leonhard Euler first published the buckling formula that bore his name. The formula appeared in the appendix (on elastic curves) to his important work on isoperimeter problems. The derivation of the formula was but a minor episode in Euler's long and highly successful career. It was extremely important, however, for the development of structural physics and structural design.

Euler was not an engineer, but a mathematician and geometrician. Even so, he showed that his formula could be used to determine the load-bearing capacity of supports. He also gave instructions on how to determine the flexural resistance needed for this calculation by gauging deflection. However, it took a long time before Euler's epoch-making developments and mathematical models had any influence on building construction. Presumably his mathematical formulae were too complicated for design engineers at the time and could not be transferred to the drawing board.

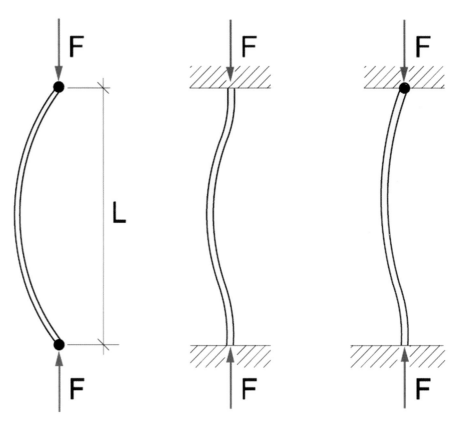

The introduction of the concept of the buckling length provided a standard formula for the buckling load under all load-bearing conditions. It also served as the starting point for Euler's well-known basic cases. Euler's so-phisticated methodology, which strives to grasp the essential elements in overcoming mathematical problems, is still valuable and instructive. It is characterized by exemplary clarity and is very elegant in form.

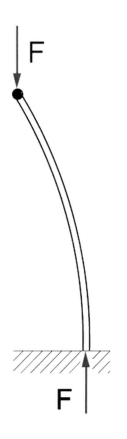

$$F_{kr} = \pi^2 \cdot \frac{EJ}{\ell^2_k}$$

It was not so much a technical as a theoretical interest that led Euler to analyze the buckling load of long rods. He had just developed the calculus of variations and was looking for problems to test it on. He examined the height a vertical rod can assume before it buckles under its own weight. It was hardly surprising, then, that the first theoretical analyses were based on the principle of the minimum of deformation work. The 'vis potentialis' (potential force) that Euler derived from this is actually (excluding factor 1/2) identical with deformation work. Daniel Bernoulli established that this deformation work must be reduced to a minimum; Euler had already demonstrated the applicability of the principle.

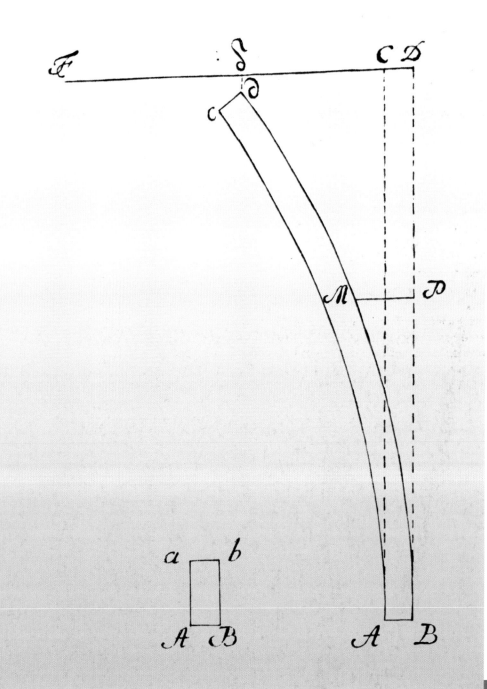

After Navier's almost visionary insights, nearly 150 years were to pass before Ludwig von Tetmayer, would perform experiments and investigate structures, enabling him to Euler's buckling formula to include the inelastic domain. Tetmayer tests, which included making measurements on both round and squared timber, were unique in terms of both procedure and the interpretation of the results. In his 1888 report on "Die Knickfestigkeit der Bauhölzer" (the buckling resistance of structural timber) he initially demonstrated that the critical value for low degrees of slenderness is not infinite, thus contradicting Euler's hyperbola. From the test results, Tetmayer derived a regression line, the so-called Tetmayer line, which still serves as a basis for ascertaining buckling today.

In the second half of the twentieth century, the EMPA – and in particular Ros, Brunner and Kühne – systematically continued Tetmayer's tests on buckling.

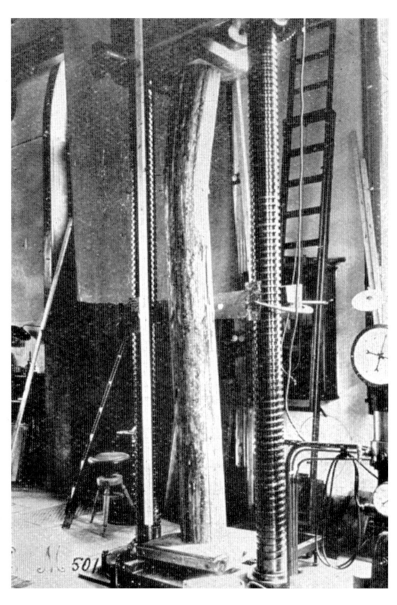

Tetmayer's approach was unprecedented: he conducted tests to determine the buckling load using full scale supports, which enabled him to take into account structural disturbances occurring in situ. The results were directly applicable in practice, unlike those obtained in small-scale tests free from interference, which led to an overestimation of load-bearing resistance and to erroneous interpretation. In the case of compact bodies, the dominant influence of naturally occurring differences in materials can thus be read immediately in the corresponding dispersion in the diagrammatic survey of the test values.

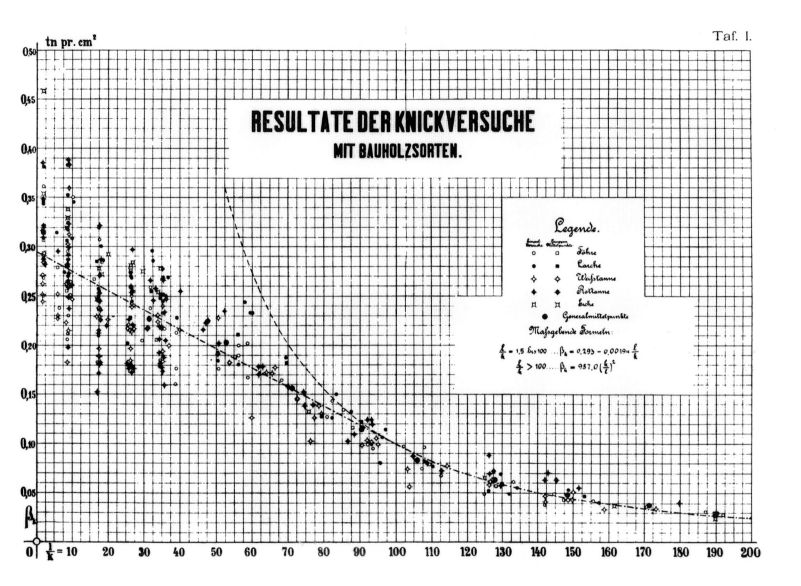

Even if they are not of such universal applicability, the results of more recent surveys undertaken by the ETH Zurich on columns in compression with deflection-resistant ends are also of interest. In connection engineering that uses multiple-shear dowels and gusset plates, the slits in the column ends reduce deflection resistance in the area of the connection. Depending on the geometric dimensions, the buckling load can be lowered quite considerably in relation to the column with a gross cross section.

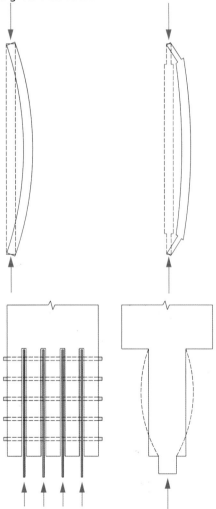

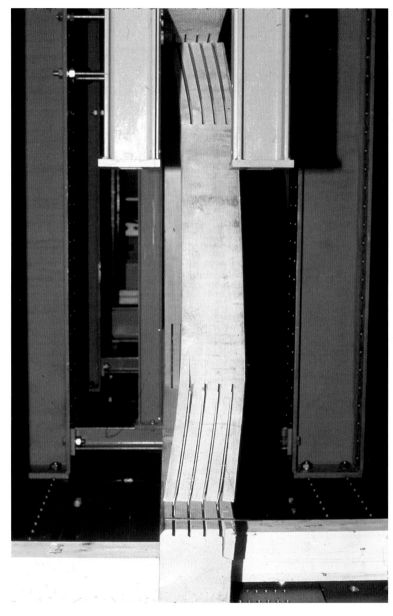

The slits at the column ends, which are needed to hold the gusset plates for multiple-shear dowel connections, weaken the material locally, which can, in turn, considerably diminish deflection resistance. A number of tests and mathematical analyses confirm the ensueing unfavorable impact on buckling strength. The effective column fails at a far lower load level than anticipated in the theoretical assumption of uniform deflection resistance.

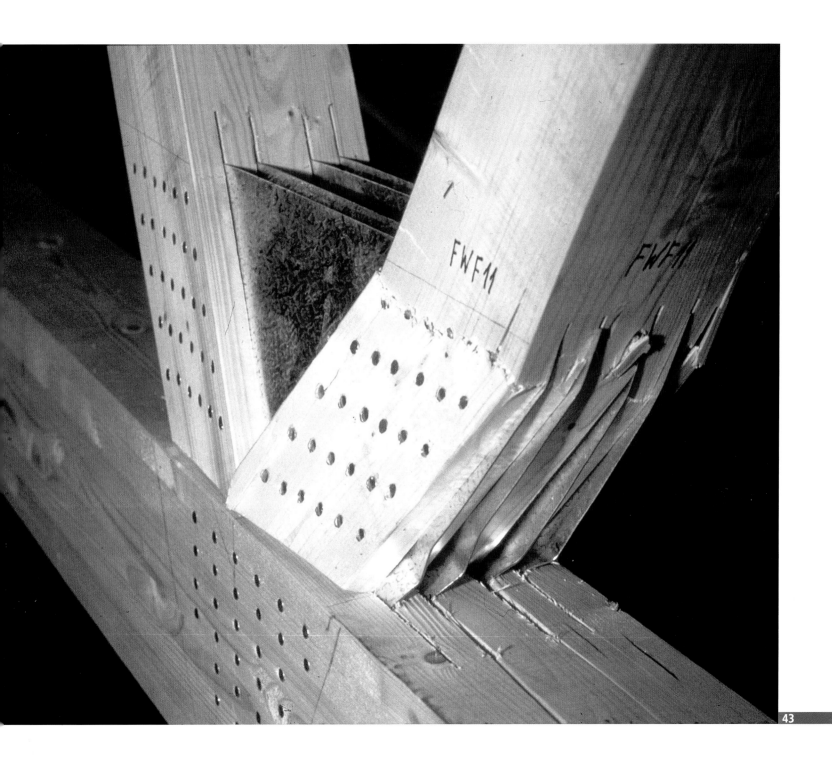

Research Developments

Developments in timber construction have probably been more heavily influenced by builders drawing on their practical experience than has been the case with any other building material. The marked proximity and intimate relationship that builders of timber structures have with their works and the material itself are presumably the reasons for the striking amount of practical research and development in this field. Innovations have often been tested and used in new buildings before any fundamental theoretical evaluations have been carried out. The insight acquired from these projects ultimately spurred the research and development activities required for broader application.
The following four disciplines have been especially important for developments in timber construction:

– Material properties
– Connections
– Glued laminated timber
– Structural components

With their studies in these individual disciplines, Swiss universities and research institutions have made an important contribution to advancing the field of engineered timber construction. Systematic fundamental research has not only helped to verify the design and engineering rules formulated in the early twentieth century, but also to translate these into reliable bodies of standards. Focused studies and further developments have continued to produce new, optimized applications.

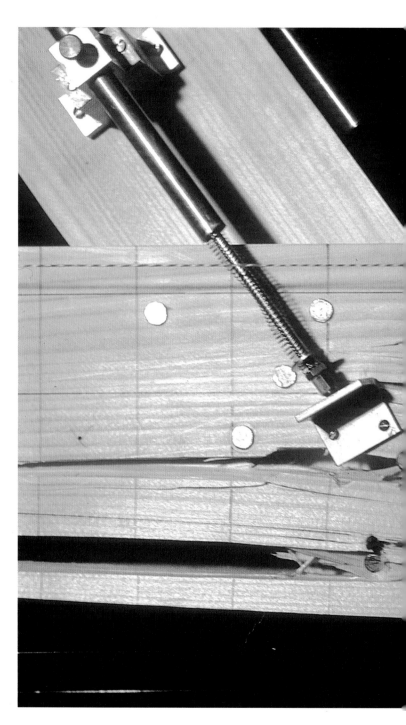

Progress in engineered timber construction is inextricably linked to the development of connectors and optimized joint forms. The comprehensive studies of different joint forms performed by Mario Fontana between 1981 and 1984 at the ETH Zurich expanded the basic knowledge of connection technology in trusses. This work provided a more thorough understanding of the complex conditions of load transfers and spurred further developments in the field.

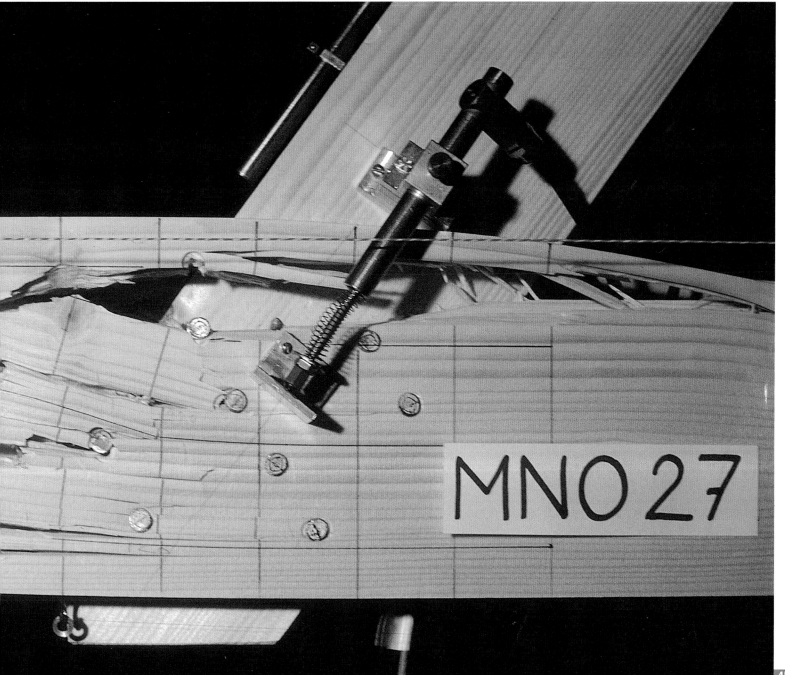

MNO 27

Material Properties

Louis Navier laid the foundation for calculating stresses and strains on a theoretical level, but his work was of little practical value without an understanding of material properties. Safe designs were first made possible by a comparison of existing and permissible loads. The Eidgenössische Materialprüfanstalt, forerunner to the Swiss Federal Laboratories for Materials Testing and Research (EMPA), was the first institute in Switzerland to conduct research into the behavior of indigenous wood types, laying the groundwork for bodies of standards on the design of timber structures.

Ludwig von Tetmayer determined mechanical strengths using small samples, and his successor, Mirko Ros (1879–1962), supplemented this data with extensive tests on square timber with the dimensions of real structural components. These tests provided a foundation for the SIA Standard for Timber Structures, first published in 1925. Even so, there were no corresponding sorting criteria at the time. This gap was eventually filled by Emil Staudacher (1898–1977) and later by Hellmut Kühne (1911–1989), whose systematic studies at the EMPA provided a reliable basis for the visual classification of lumber as regards physical properties.

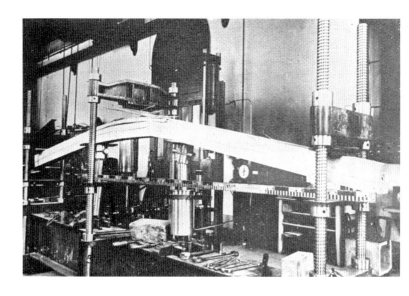

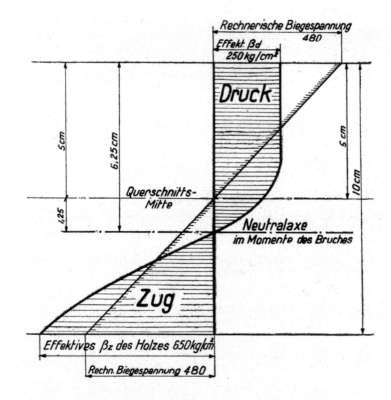

The specified permissible bending strengths of 100 kg/cm² (10 N/mm²) and 80 kg/cm² (8 N/mm²) are based on a series of tests on elastic beams that had the dimensions of real structural components. An average ultimate stress of 450 kg/cm² (45 N/mm²) was achieved in a total of 54 tests. Extensive elasticity measurements provided insight into the actual stress distribution.

The first SIA Standard for Timber Structures, approved after heated debate on 9 December 1925, specified the following permissible maximum values for compressive stress parallel to the grain: 75 kg/cm² (7,5 N/mm²) for "covered buildings under a static load" and 60 kg/cm² (6 N/mm²) for "covered and uncovered bridges of a provisional character." These values were based on 185 tests on cubes with edge lengths of 24 cm or 10 cm.

In addition, in order to investigate the problem of compressive splices from end grain to end grain, tests were performed on compact members with aligned and offset annual growth rings. Whereas there was no difference to cube strength in the first instance, there were losses of up to 30 percent in the latter, normal case.

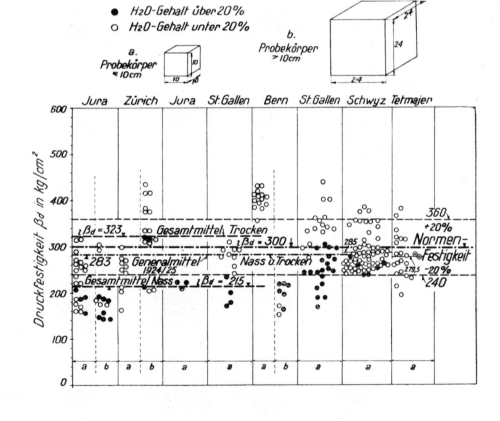

In their work with wood, researchers have always confronted the same dilemma: its mechanical properties vary enormously due to natural irregularities. To keep variance as low as possible, researchers are often tempted to use small samples without structural flaws. They can in fact verify individual influencing factors on such small samples, yet the acquired knowledge is generally not applicable to the construction lumber normally in use.

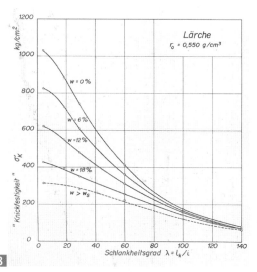

In the first half of the twentieth century, the EMPA continued Tetmayer's tests with its own systematic buckling studies, supervised by such researchers as Ros, Brunner and Kühne. The results show the complications associated with sample size. The buckling strengths measured on small samples with practically no flaws or defects and a uniform cross section of 50 x 50 mm demonstrate the characteristic dependence on water content, yet Tetmayer's values do not show any evidence of this influence at all. The inevitable structural flaws in samples the size of real structural elements dominate and obfuscate additional parameters, including moisture content.

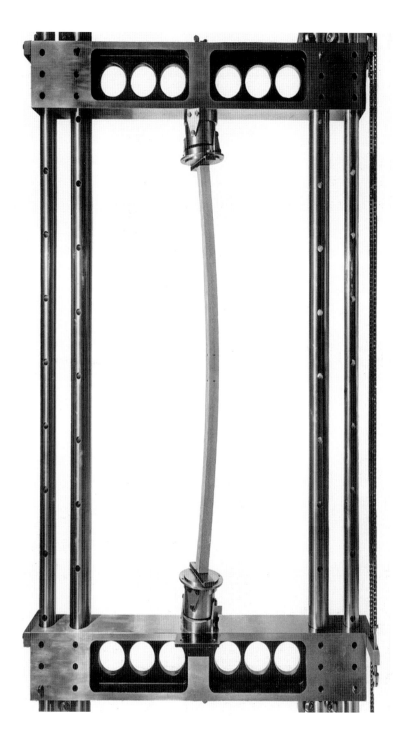

Whereas experimental compression tests are relatively easy to perform, the application of force is difficult in tensile tests. The samples used by Ros in 1924 and by Staudacher between 1937 and 1942 in compression tests at the EMPA show how difficult it is to determine tensile strength. It is entirely understandable that researchers preferred working with small samples.

Ros's results show the large influence exerted by the size of the sample, particularly when under tension. With cross section dimensions of 15 mm x 15 mm, Ros achieved a median tensile strength of 511 kg/cm² (51 N/mm²) in a series of 61 tests. With cross sections of 50 mm x 100 mm this value decreased to 255 kg/cm² (25 N/mm²).

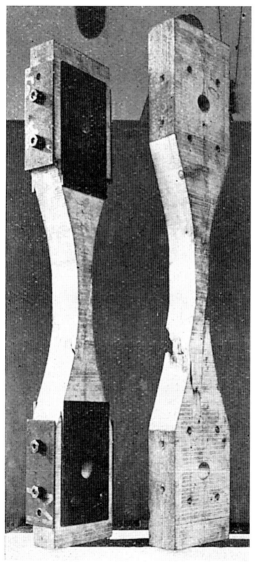

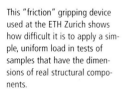

This "friction" gripping device used at the ETH Zurich shows how difficult it is to apply a simple, uniform load in tests of samples that have the dimensions of real structural components.

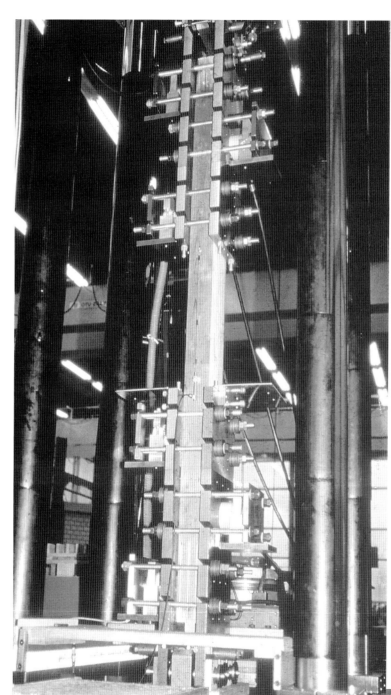

The biological and bio-mechanical studies at the EMPA demonstrate the broad range of research projects focusing on the material properties of wood. These projects do not use sam-ples with the size of real structural components. Instead, they analyze the nanostructure of wood under high-resolution electron microscopes. Researchers today are aware that the size, shape and arrangement of wood fibers and cells have a decisive effect on its special mechanical properties. Of particular importance are its molecular components, including cellulose and hemicellulose (aliphatic polymers made of sugar molecules), as well as the lignin matrix in the cell wall.

The wood cell wall is highly differentiated. With its sandwich-like design, it can be seen as a form of lightweight construction with extremely strong mechanical properties, a porous structure that uses material economically, and a highly robust frame. One can only marvel at the properties of naturally grown wood, particularly considering that this "construction method," in addition to its mechanical functions, optimally fulfills diverse physiological tasks. The intelligent construction principles and functionality of wood can serve as a model for process and materials technology – offering a promising new field of activity for timber research.

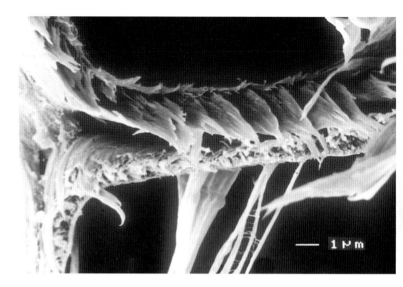

Studies of the fractured surfaces of spruce wood have shown that the wood cell wall is a load-bearing, sandwich-like composite in which all the structural elements perform important functions in ensuring stiffness and strength. The walls between the adjacent cells are double sandwich elements that increase the cell tissue's buckling resistance and longitudinal compressive strength.

The cellulose fibrils embedded in the lignin matrix of the wood cell wall are responsible for the extraordinarily high tensile strength of flawless timber. Using cellulose produced industrially in large quantities, the EMPA succeeded in isolating fibrils and fibril clusters with diameters of less than 100 nanometers (1 nanometer = 1 millionth of a millimeter) and lengths of several micrometers. It used these to reinforce polymers. With a fibril portion of 20 percent, the tensile strength and the stiffness of hydroxypropyl cellulose (HPC) was increased three- to fivefold. Possible application areas for (bio)polymers reinforced by cellulose fibrils are the pharmaceutical and food sectors, particularly when requirements include biological biodegradability linked with high mechanical strength.

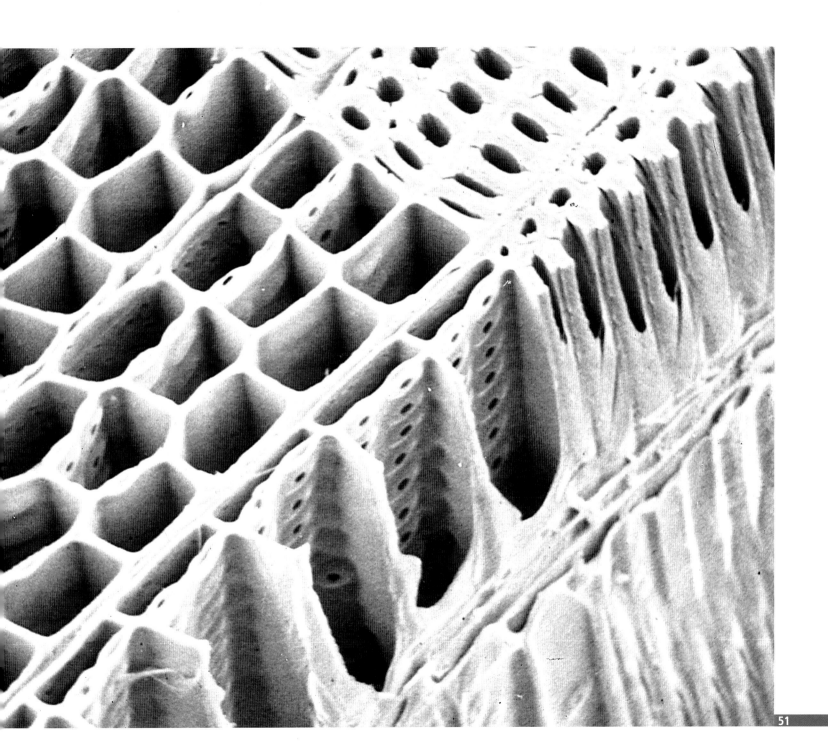

Connections

When wooden load-bearing structures are built, their design is primarily determined by the choice and type of connections. In other words, progress in engineered timber construction is dependent on the development of connections. Against this background, it should come as no surprise that connection techniques have been of special interest to scientists ever since research started in this area.

The studies performed in the first half of the twentieth century by the Eidgenössische Materialprüf- und Versuchsanstalt in Zurich – today's EMPA – demonstrate the characteristic interplay between research and practice. In his work, Emil Staudacher (1898–1977) endeavored to formulate general mathematical methods for analyzing connections, yet he also took an application-oriented approach, verifying general relationships with the help of comparative tests on truss joints with the dimensions of real structural components. Staudacher methodically compared traditional joint types (oblique dado, mortise-and-tenon, and dovetail) with new connectors (split ring, toothed-plate).

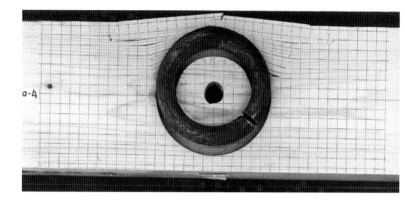

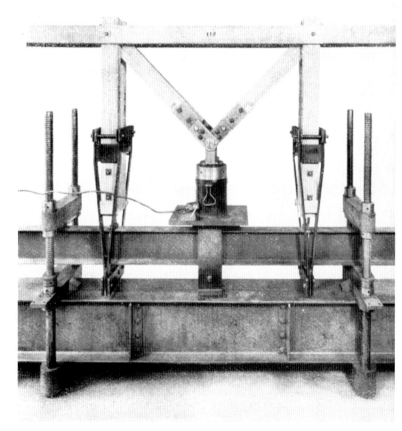

The systematic tests that Emil Staudacher conducted on truss joints at the EMPA (1934–1936) quantified the differences between traditional wood joints and "new" connectors such as the round iron split rings produced by Hoch- und Tiefbau AG in Interlaken.

In addition to theoretical studies and the insights acquired in experiments on individual joints, the load tests performed on 1:1 scale models of truss girders yield important knowledge. The EMPA studied the influence of joint type on the behavior of the entire load-bearing structure. In these experiments, researchers evaluated connection concepts such as the oblique dado used in combination with steel (tension boom and post). In a load test on the new building of the Solothurn Canton School, they also examined the load-bearing behavior of two nailed trusses in the roof structure.

The tests that the ETH Zurich performed on truss joints with centric and eccentric diagonal connections constituted a later stage in the development of connection technology and contributed to the specific, systematic study of joint forms. These tests primarily spurred the development of the multiple-shear dowel joint, which was based not only on theoretical work but also on extensive experimental studies on tensile connections and on application in trusses. This research has given today's engineers reliable connections with high bearing capacity.

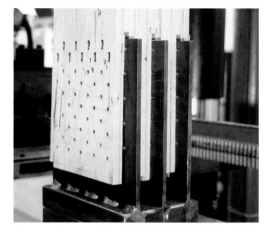

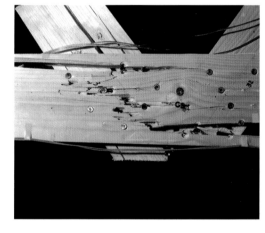

The progress achieved with multiple-shear dowels in the 1980s and 1990s was largely the result of the extensive, detailed studies at the ETH Zurich, which theoretically and experimentally evaluated the effects of different geometric parameters, such as connection design, edge distances and dowel thickness. This led to a more profound understanding of the function of these joint forms and provided a basis for more advanced developments. The research work dealt intensively with the influence of both the strength and the load-bearing/deformation behavior of the steel pins. It ultimately showed the advantages of high-strength drift pins and the importance of connection ductility.

In addition, tests in which the joint surfaces were covered with plywood demonstrated how load-bearing capacity could be effectively enhanced by simple measures. Gluing on relatively thin plywood boards prevented splitting and considerably increased the load-bearing capacity of the individual connectors. Equally interesting is the development of connection forms that do not incorporate steel parts and are intended for use in protective structures in sensitive antenna and radar facilities. They use the same design concept as conventional multiple-shear steel-to-wood connections, except that the plates are not executed in steel, but in beech plywood, with hardwood dowels. The load-bearing capacity of these types of connections is about two-thirds that of the corresponding steel solution.

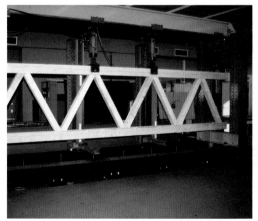

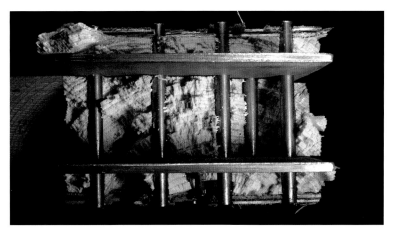
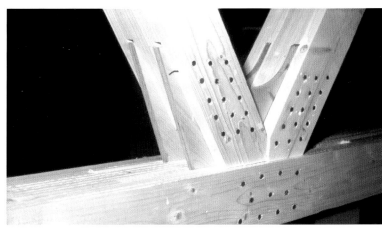
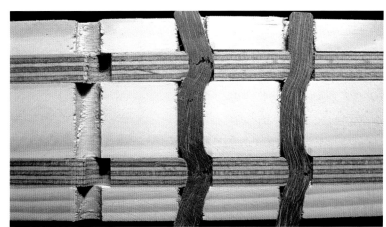

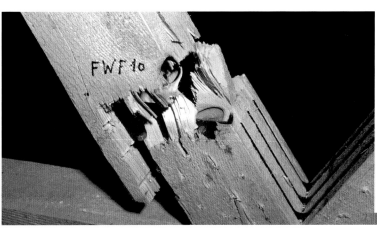

The continued optimization of nailed connections at the EPF Lausanne is interesting and revealing. The intrinsically simple combination of steel plates and nails ultimately produces an efficient connection for larger loads. The plate distributes the loads equally over the many individual nails, which leads to optimal, uniform stresses in the wood.

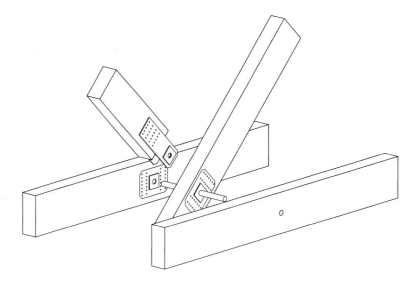

Structural implementation of this knowledge resulted in the hinge-pin connection, which exploits the excellent strength of the nails in the face joint of wide-span truss structures. As the central element, the hinge pin flexibly connects the individual members in the form of a fish joint. The steel fish plates are nailed to the outside of the timber cross section that is connected. The construction principle is based on two-part chording. Whereas the compression members and the chording are connected directly to the hinge pin, the steel fish plates on the sides of the tension members project over the end of the wooden piece and connect to the hinge pin in a fork-like form.

Previous tests on nailed connections have generally been restricted to small joints. These tests, mostly performed on select, structurally flawless timber, have resulted in deceptively high ultimate loads. The systematic studies which the EPF Lausanne carried out on joints with a large number of nails have provided insight into real conditions and have shown the link between structural defects, density and connection configurations.

In both large connections with the usual spacing between nails and in joints with denser nail arrangements (roughly half the connection surface), connection failure is mostly caused by the shearing off of the connection area. Compared with the usual nail arrangements, V-shaped, staggered layouts improve the distribution of forces, achieving a connection strength that corresponds to the tensile strength of the "unweakened" timber cross section.

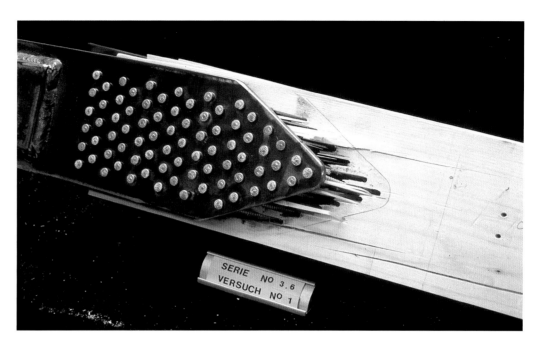

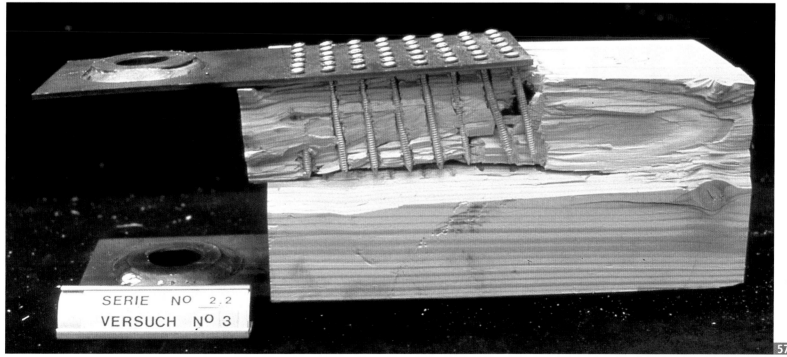

Glued Laminated Timber

Lamination technology proved to be one of the major, ground-breaking innovations in timber construction in the last century. Glued laminated timber has opened up new dimensions for engineered timber construction. The potential of this new technology was recognized early on in Switzerland, leading to diversified and extensive research and development activities in laminated construction.

The EMPA initially carried out fundamental studies on lamination and processing technology, thereby providing a scientific foundation for glulam construction in Switzerland. The early period of laminated timber construction in Switzerland saw the development of bold, dynamic architecture. Initially, experience acquired in the individual projects, partially supported by load tests on models, exerted a practical influence on continued developments. The methodical studies at the EMPA finally placed this method of construction on a secure footing, thus laying the basis for subsequent processing and design guidelines.

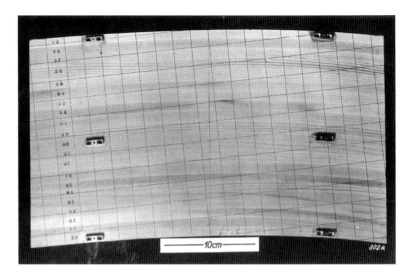

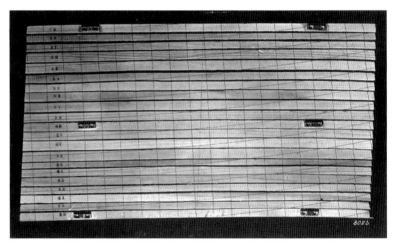

The tests conducted on residual stresses in bent glulam beams in 1944/45 show the broad range of research projects. After being stored for five years, existing beams were sawn open along the glued connections and taken apart to release the original laminations. After being removed from the curved composite beams – which were restrained by glue – the laminations exhibited a bending deformation of twenty percent, with eighty percent springing back.

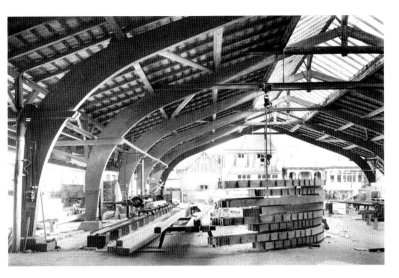

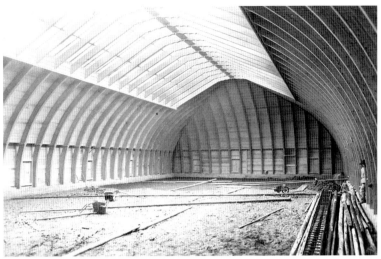

Parallel to ongoing studies and research work, load-bearing structures with the new glulam materials continued to emerge. These included the production hall for Nielsen-Bohny & Co., a carpentry company, built in Basel City in 1914 (upper left); the St. Gallen tennis hall, constructed in 1928 (upper right); and the storage hall of the Eternit works in Niederurnen (built in 1911, see below), with a span of 18 meters and a live load on the suspended ceiling of 1,000 kg/m².

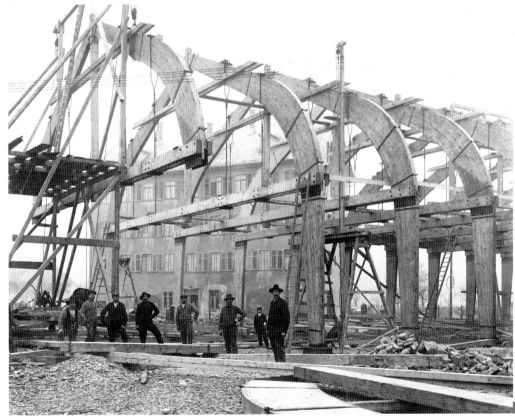

Over the years, research projects have brought quantitative and qualitative improvements to laminated timber construction. The work at the ETH Zurich and the EPF Lausanne has focused on optimizing glulam structural components and their connections.

The use of hardwood vividly illustrates the research and development activities pursued at both institutes in the area of glulam. The research project "Laminated Beech Wood Structures," initiated by Ernst Gehri at the ETH Zurich, was motivated by the poor commercial status of beech, which is Switzerland's most important hardwood. It proceeded from the principle in materials technology that higher density translates into higher strength. The project participants adapted production technologies (drying, sorting, laminating, moisture protection) and conducted short- and long-term tests on different structural members, paving the way for the use of beech in construction.

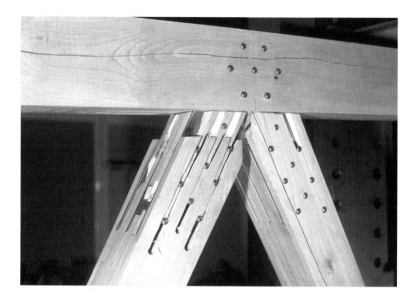

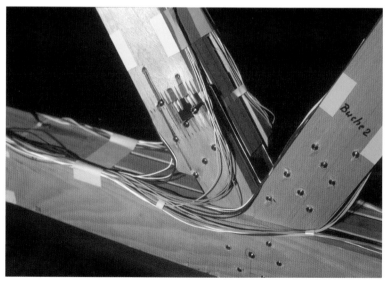

The superior properties of beech wood over softwood made possible smaller and more compact connections, which have proved especially advantageous for trusses. The use of multiple-shear dowel joints in combination with beech glulam has led to strong load-bearing structures, as is impressively demonstrated by the tests performed on truss girders with the dimensions of real structural components.

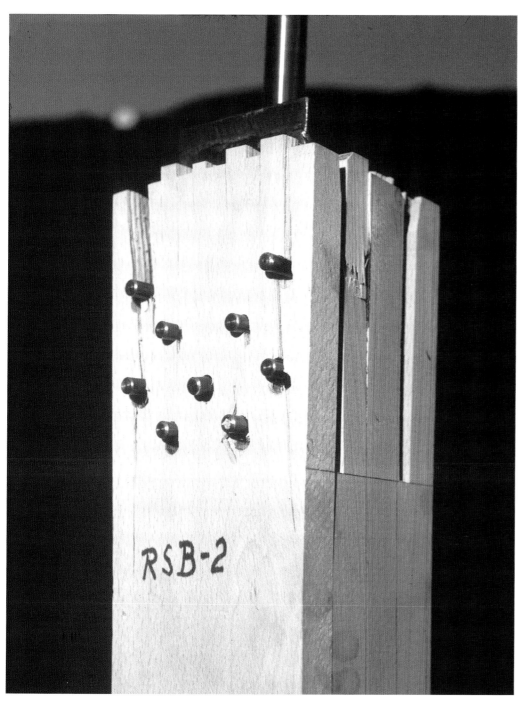

Even if the tensile strength of beech is on average only 20 to 30 percent higher than spruce, it has shear and lateral tension strengths that are almost twice as high (with small variances). Since both these key values determine load capacity in all joints with mechanical connectors, it is easy to understand the extraordinary importance of beech for engineered timber construction, where joints play a key role. For instance, tests on dowels showed visible hole deformations of a kind that are never observed in softwood due to its low tensile strength perpendicular to the grain. In the multiple-shear dowel connection, this results in a carrying capacity that is twice as strong in beech laminated timber as in spruce and fir glulam.

To date, beech wood has rarely been used to build load-bearing structures, which can mainly be attributed to its tendency to bend. The results of the research and development projects at the ETH Zurich devoted to the use of beech in glulam products have provided a foundation for tests on real buildings. Due to its greater strength than normal spruce lumber, beech wood is making possible commercially interesting applications in the construction industry. Pilot projects with beech glulam demonstrate the great potential of this new building material.

As a rule, eight members connect at the joints of space frames. The limited space in the joints makes compact members necessary, and these, in turn, play an important role in determining the construction method, particularly in frames with large spans and large forces acting on the connections. This is where previous timber designs have failed. The crucial point is the tension member, in which the joint determines cross-sectional dimensions. The Seeparksaal building, a pilot project executed in 1984 in Arbon (Thurgau Canton), was made possible by the use of glulam beech and by the development of a joint customized for this material. A total of 264 of the 1,284 members were executed in beech glulam for the space frame of the load-bearing structure, which has a span of 27 by 45 meters. For these members, which are subject to extreme stresses (up to 350 kN under live loads), both an extremely strong wood and a compact connection technique was needed to keep cross-sections down to a minimum (180 mm x 180 mm). This was the only way to cope with the tight geometry of the joint.

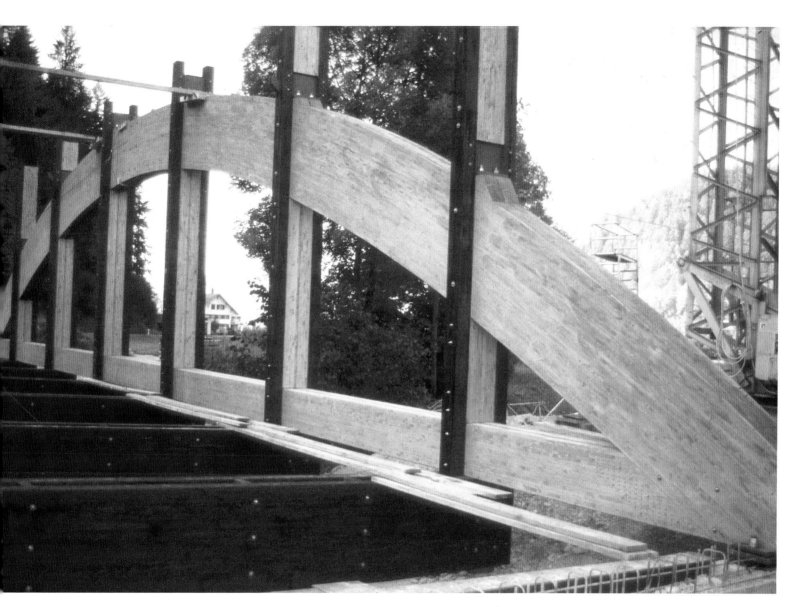

Newly developed beech glulam elements were first used in the two-laned road bridge built in 1984 in Eggiwil (Bern Canton). The relatively slender beech king posts facilitated compact connection types suitable to directing the high live loads of rough-ly 500 kN (50 tons) to the arches or transversal girders with as little secondary stress as possible. Similar conditions exist in the transversal girders. If glulam spruce had been used, the typically large loads on road bridges, coupled with the span width of 8.3 meters (a result of the two-laned roadway) and the limited height of the structure, would have resulted in dimensions that could not have been built. Beech glulam made this bridge possible.

Structural Components

Structural components and elements demonstrate the dynamic interaction between research and practice. This is especially true in the field of composite construction. The basic strategy of combining timber with other materials has become increasingly important in R&D and applications. The objective is to exploit the advantages of each material, to compensate for disadvantages, and to improve mechanical and application-specific properties.

Around 1940, the Timber Department at the Eidgenössische Materialprüf- und Forschungsanstalt (EMPA) studied combinations of steel and timber and later looked into combinations of wood with high-tensile synthetic fibers. Its long- and short-term studies of the load-bearing behavior of timber-concrete composites were accompanied by systems developments that advanced this particular construction method. The advantages were first seen in the refurbishment of old buildings. The fundamental studies and tests that were conducted in the field of wood-concrete composites at the ETH Zurich not only led to various new connection systems for buildings and bridges, but also provided an urgently needed basis for evaluating the behavior of wood-concrete composite slabs in long-duration fires in multistoried buildings.

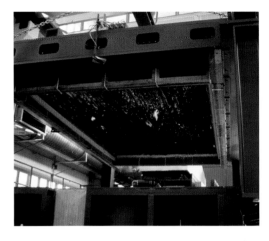

The timber-concrete ceiling system improves sound and fire protection. Extensive fire tests at the ETH Zurich have shown that, with the right design, this system can meet the fire protection requirements of multistory buildings.

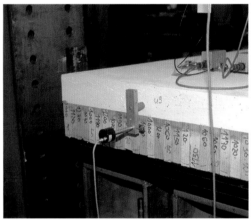

The scientific work, practical application and comprehensive experimental studies at the EPFL, EMPA and ETH Zurich have made a significant contribution to the development of timber and timber-concrete composite ceiling systems.

Connections are a possible application field for composites of wood and high-tensile synthetic fibers. Tests conducted on truss joints at the EMPA have provided insight into the behavior of fiber-reinforced plastic boards, which were inserted into grooves and friction-locked with pourable epoxy resin. The widening of the glued joint (1:15) in the middle makes for a "softer" transition and reduces stress peaks and secondary lateral loads. Shearing strengths up to 25 percent higher were achieved with this design.

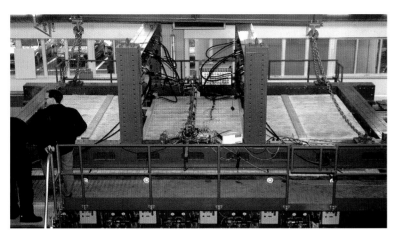
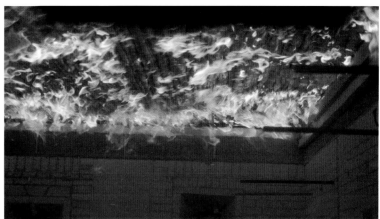
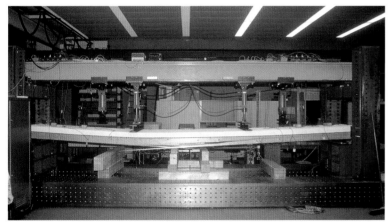

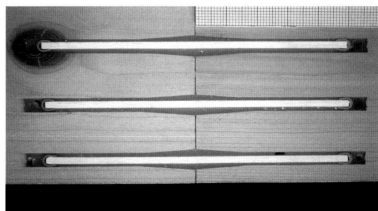

A special type of structural component is the STEKO wood block developed at the ETH Zurich in cooperation with industry. Guided by the idea of using small-dimensioned wood whose thin layers are cross-laminated to form the individual module, developers created a "building block" for walls that fulfills two important conditions: it is inexpensive and part of a sustainable system. Builders can easily stack the blocks via a mechanical joint, building a wall in a very short time without any additional processing of the material.

An extensive research program under the supervision of the ETH Zurich yielded fundamental scientific data on building physics, fire behavior, adapted building services and production guidelines – all necessary for safe practical use.

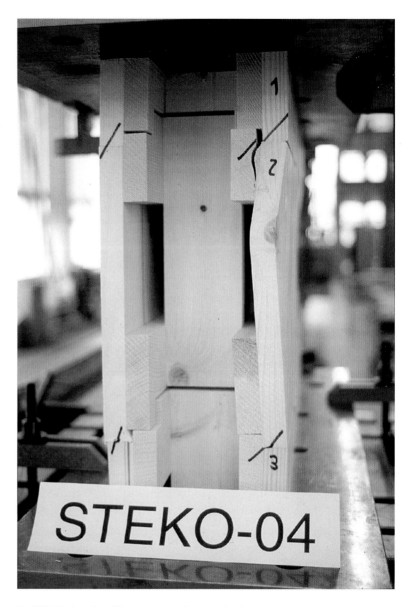

The STEKO block consists of five solid wood layers that are cross-laminated to ensure a high degree of dimensional stability. When subject to centric axial force, the load-bearing behavior of the individual block is determined by the resistance of the two outer layers carrying the load. In load-bearing tests, the block with standard dimensions of 160 mm x 320 mm x 640 mm achieved failure values significantly higher than 1,000 kN (100 tons).

The key question for engineers is how the "loose" mechanical plug connection behaves when subjected to axial force and, in particular, when subjected to axial force with simultaneous bending (which occurs when outer walls are buffeted by winds). This behavior is largely determined by the geometry of the module and, above all, by the place where forces are transmitted from block to block. This is clearly shown by a simple comparison of the force transmission principle of the STEKO block with that of a brick of the same width that is laid evenly on top of the one below. Since its two outer layers carry the axial stress, the STEKO block has a considerably larger capacity to accommodate bending stress either from effects of the second order or from outer horizontal effects. Furthermore, as a result of the smaller contact area, the stress resulting from axial force is substantially higher in the STEKO block. The compressive preload that counters the tensile force is thus considerably higher than in the solid module, which means that the joints only split open under a much higher load level.

The direct effects are vividly shown by the deformation curves derived from compressive tests on two different module types: whereas in the wall of bricks (left) the deflection is clearly visible at a load level of 250 kN, practically no deformations can be seen even at 430 kN in the STEKO blocks.

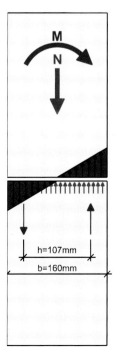

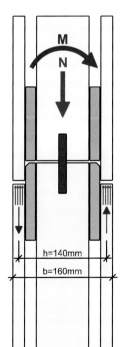

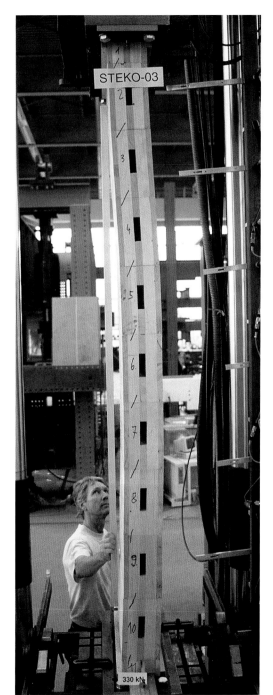

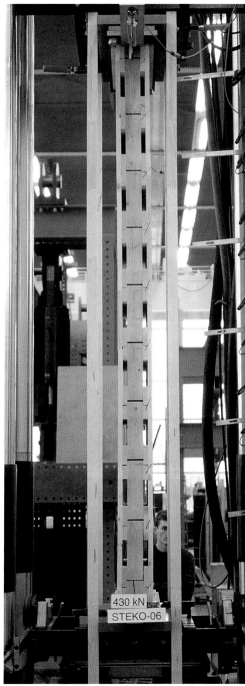

Optimizing Shell Structures

Timber shell structures vividly demonstrate the interplay between creativity, research, and the trust designers place in material strength. They represent an ideal adaptation of load-bearing structure to the characteristic properties of the material. This structural form is based on exploiting longitudinal strength and has much in common with membrane structures such as cable-net forms and even the soap bubble.

The work of two engineers has strongly influenced and advanced the timber shell construction method in Switzerland. Hans-Heini Gasser developed shell geometry and fine-tuned computer models that have paved the way for a variety of appealing skin-stressed structures of wood. With his ribbed shells with edge-glued panels, Julius Natterer has demonstrated both the diverse design possibilities and the elegant, delicate formal vocabulary of this construction method.

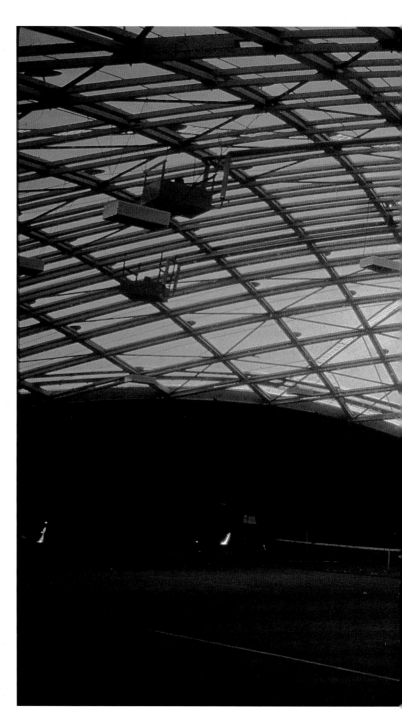

The roof over the tennis hall in Teufenthal (Aargau Canton) is designed as a double curved lattice shell and spans a floor plan of 35.5 x 28.2 meters. The lattice shell was pre-assembled in 1982 on level ground and subsequently brought into position by cranes. Both the frictional connections and the diagonal bracing ensure that it maintains its shape.

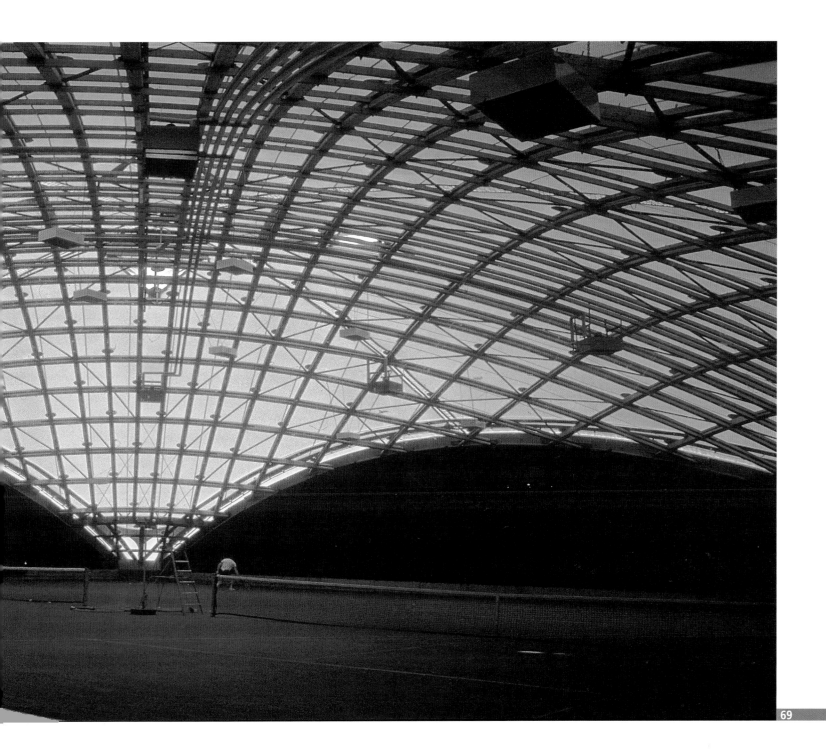

A large number of shell structures are built of crisscrossing layers of boards. Boards lend themselves particularly well to this approach: they can be easily bent around their weak axis and simultaneously twisted around their longitudinal axis. These features, coupled with the shortage of building materials at the end of the Second World War, induced the Schweizerische Bundesbahnen (Swiss Federal Railways, or SBB) to test and build shed arches in the form of circular cylindrical timber shells. The arches were modeled on nailed plate girders that, though designed as trusses, largely behave like stressed-skin structures.

In the structures designed by Hans-Heini Gasser, the shell is also built of crisscrossing layers of boards. However, their frictional connection is made with joint-filling glue. Nails or screws are only used to apply adequate compressive force.

Most of the stressed-skin structures designed by Julius Natterer, though built of boards, feature a mixture of open and solid-web sections. They essentially consist of crisscrossing timber ribs made of four to six layers of boards in a kind of lattice design. They are braced by one or two layers of boards with a diagonal orientation, which simultaneously serve as roof sheathing.

The cylindrical shells developed for the SBB's shed arches are made of four nailed layers of boards. Their behavior was established in 1945 in a test with granite blocks, which applied a distributed load of roughly 200 kg/m². These shells were designed as full-fledged arches that were supposed to serve as sheathing for the ferro-concrete roof under more favorable economic conditions.

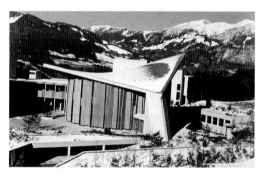

The roof of the Bethanienheim Church in St. Niklausen (Obwalden Canton) is another one of H. H. Gasser's designs (1971). The hyperbolic paraboloidal shell covers a floor plan of 22.5 x 22.5 meters, with the actual structure formed by two crisscrossing 30-millimeter-thick laminations.

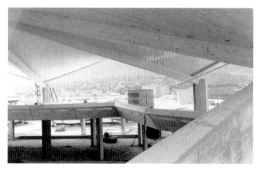

In 1985 H. H. Gasser designed a wooden shell roof – which consists of six identical hyperbolic paraboloidal elements – to cover the hexagonal floor plan of the multipurpose hall in the Children's Village in Leuk (Wallis Canton). The shell is formed by two crisscrossing 24-millimeter-thick layers of laminated boards.

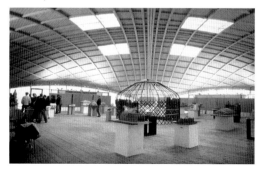

In 1991, J. Natterer designed a ribbed shell with edge-glued boards and stiffening sheathing to span the 24 x 24 meter floor plan of the Polydôme multipurpose hall in Ecublens (Waadt Canton).

The roof over the Hagenbuch Sports Arena in Arlesheim (Basel-land Canton), which J. Natterer designed in 2000, resembles a section of a cylinder and is borne by two rib structures positioned on top of each other. The ribs consist of four layers of boards that run through each other alternately at their intersection points. The compression arches brace and give shape to the roof.

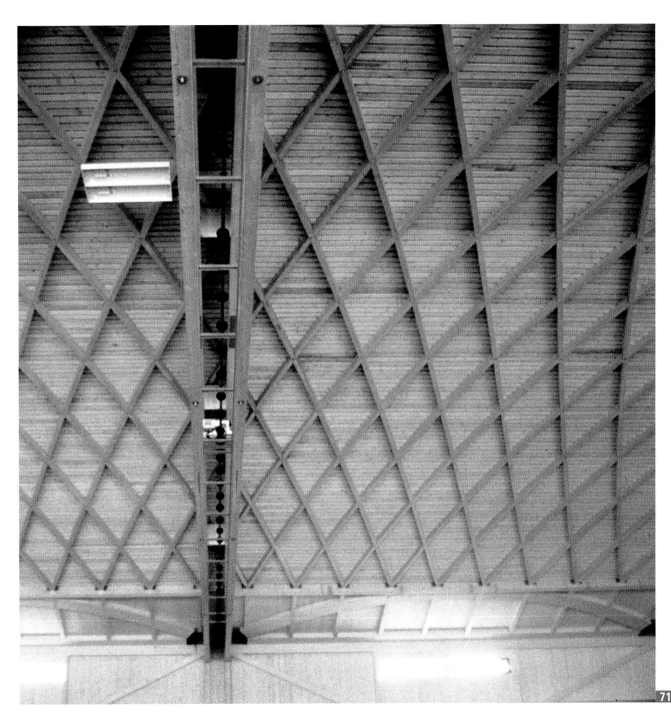

As far as the use of materials goes, shells are minimalist forms. Engineers find it a special challenge to optimize their design and push them to their limits. The precise, intelligent use of materials, coupled with the potential to span impressive distances elegantly and gracefully, has led to extraordinary structures throughout the world.

The involved, partially manual construction work with exact teachings and finely adjusted frames often has an adverse effect on the commercial results of shell structures made of boards. The development of new connection techniques has meanwhile created a genuine alternative since they enable shells to be designed as structures of linear members. This has led to standardized members and processes, with a beneficial effect on planning, production and assembly.

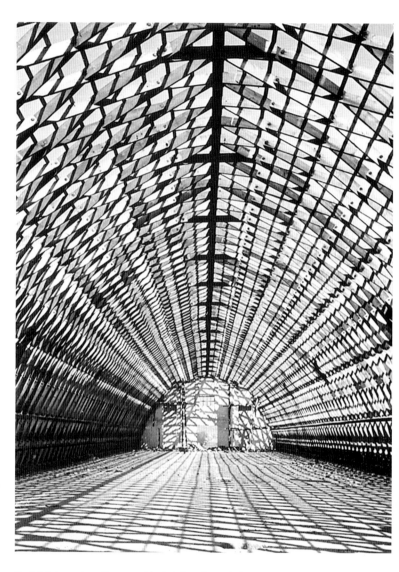

The *Zoll System,* patented in 1910, can be seen as a forerunner to the standardized stave construction method for shells. The principle is based on a diamond pattern in which the staggered members (individual boards placed edgewise) run across two fields to form a stiff, arch-shaped structure. The 1.7- to 2.5-meter-long boards are of identical dimensions and alternately abut at every second intersection point, where they are screwed together. Unfortunately, this impressively simple joint has low flexural rigidity, resulting in severe deformation in larger structures.

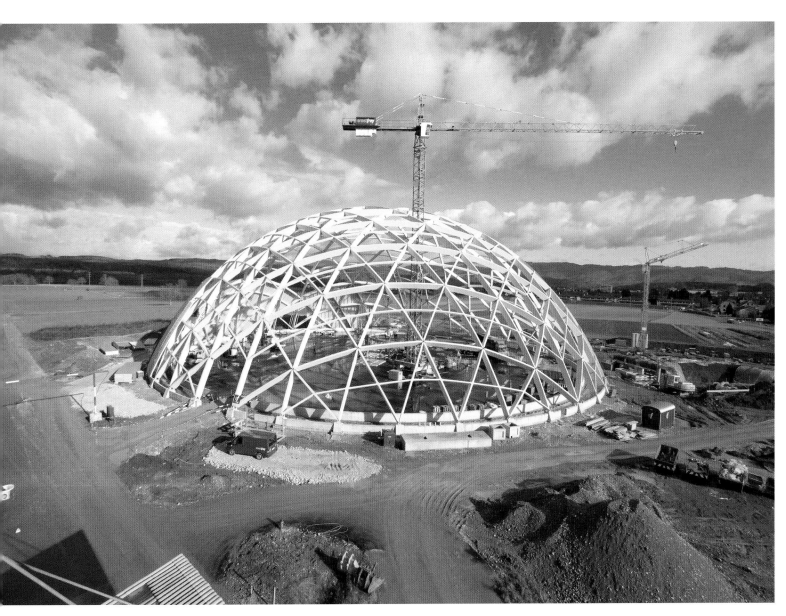

Both the expanded range of glulam offerings and the progress in connection technology have given rise to new developments and systems for shells with linear members. One example is the Ensphere concept developed by the Swiss-born engineer and architect Wendell E. Rossmann. The centerpiece of these triangulated shells is the node element, which ensures that the glulam members are joined in a connection with high flexural rigidity. The Swiss company Häring in Pratteln refined this system and used it successfully in a number of structures in Switzerland and abroad. One example is the Saldome in Schweizerhalle (Basel-Land Canton), built in 2004 for Swiss Rheinsalinen. The new salt storage hall, which can hold up to 80,000 tons of salt, is the largest dome structure in Switzerland, with a height of 31 and a diameter of 93 meters.

Laminated Timber Construction

Laminated timber construction was a revolutionary development and heralded in a new era of wood construction. Between 1850 and 1900, timber, which for centuries had been a standard building material, all but disappeared from bridge and large hall construction due to the growing competition from steel and concrete. Among the fields of application that remained were homes and auxiliary structures. With the introduction of lamination technology, timber sections could be produced in shapes and lengths that were no longer restricted by the dimensions of tree trunks. It was possible to fabricate these sections mechanically and calculate the properties of the materials reliably. Engineers benefited from this entirely new situation: a natural material had become a technical product. Wood stepped out from behind the shadows of other building materials to become a rival in constructing wide-span load-bearing structures in a great variety of shapes.

Laminated sections were first used to erect load-bearing systems some 200 years ago, but initially these were few in number. The lack of suitable glues and effective production methods prevented this form of construction from spreading. Otto Hetzer made a breakthrough in Weimar in 1906 with his patent for the Hetzer construction method. Swiss engineers, scientists and glue manufacturers have played a vital role in launching and advancing modern laminated timber construction. The structures built by Swiss construction companies using Swiss products have set the tone for new developments.

Glued laminated timber, formed by bonding individual boards together, has made it possible to overcome the cross-sectional limitations of wood. This has opened up new technical and formal prospects for timber while considerably improving its competitive edge. "Glulam" timber is characterized by variable quality, dimensional stability, large and long sections, pre-fabrication, simple assembly, and cost-efficiency.

Strength

Trees and the wood they produce are so wide-spread and familiar that many people associate wood more closely with an age-old crafts tradition than with engineered structures built with a versatile natural material.

With few exceptions, nature has developed strong, lightweight structures. Wood is one of the most important building materials supplied by nature and shows remarkable strength in load-bearing structures. In this connection, it is interesting to note that wood has been used as a basis for developing synthetic composite materials. However, a comparison illustrates that even the most modern fiber and synthetic resin composites are not as strong as wood when used in load-bearing systems. The role traditionally assigned wood in house and fence construction may lead us to overlook the potential that lies in this unique engineered material. Stunning, impressive structures demonstrate all that wood can do.

Measured parallel to the grain, wood has tremendous strength in relation to its weight. This is ultimately the reason that wood (glued laminated timber) is used today to erect lattice shell domes with extremely large spans. An impressive example is the dome in Tacoma, USA, with its span of 162 meters (erected 1982).

From a mechanical perspective, wood's distinguishing characteristic is the directional dependency of its strength: parallel to the grain, it is roughly 50 to 100 times stronger than across the grain. This explains why open trusses or adapted structural shapes like the arch and shell predominate in large timber structures.

The SkyDome in Tacoma, USA, provides breathtaking proof of timber's great load-bearing capacity. The Swiss-born engineer and architect Wendell E. Rossmann developed the *Ensphere Concept* and applied it to build this dome with its 162-meter span, which consists of relatively small glued laminated timber components.

Normal forces ultimately result from optimizing materials so that they will withstand stresses parallel to the grain. Material-specific efficiency can be demonstrated most readily by means of tensile force since, in the case of failure, a break is normally not influenced by other factors such as different stability parameters. The reference value that indicates the relationship between mass and tensile strength is known as the breaking length. It identifies the maximum length a material can have before collapsing under its own weight. The excellent status of wood among other tensile-oriented materials reflects its extraordinary strength and disproves the traditional view of wood as an unimportant ancillary building material.

Material	Breaking length
Spruce (free of structural flaws)	21 km
Spruce (timber)	> 5 km
Birch	27 km
S 235 structural steel	4.6 km
S 355 structural steel	6.5 km
Prestressing steel	23 km
Aluminum (AlMgSi1)	12 km
Human bone	7 km

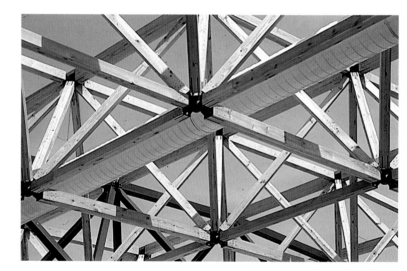

We generally refer to lattice structures as frameworks. They consist of straight members that are subject to both compressive and tensile stresses and which, in diverse three-dimensional arrangements and various large two-dimensional shapes, can be combined to form planar or three-dimensionally curved load-bearing systems. As finished structures, such frameworks can also accommodate "bending." Three-dimensional frameworks can be used in place of solid building components, making relatively lightweight structures possible. An eye-catching example is the roof structure of the Seeparksaal, with dimensions of 27 x 45 meters, built in Arbon (Thurgau Canton) in 1984. A conceptual comparison brings home its strength: if the total volume of wood used in the lattice load-bearing structure were distributed along the roof surface, it would result in panel thickness of just four centimeters.

The laminated curved beams of the Tacoma Dome in Washington, USA, are made of Douglas fir. Fifteen meters long, 76 cm high and 17/22 meters wide, they form the basic triangle of the lattice shell with its 162-meter span and 48-meter rise. A total of 1,608 main and secondary beams were assembled in less than two months without scaffolding. The estimated cost (29.3 million dollars) was about twenty percent less than the next best bid, which was for a steel structure.

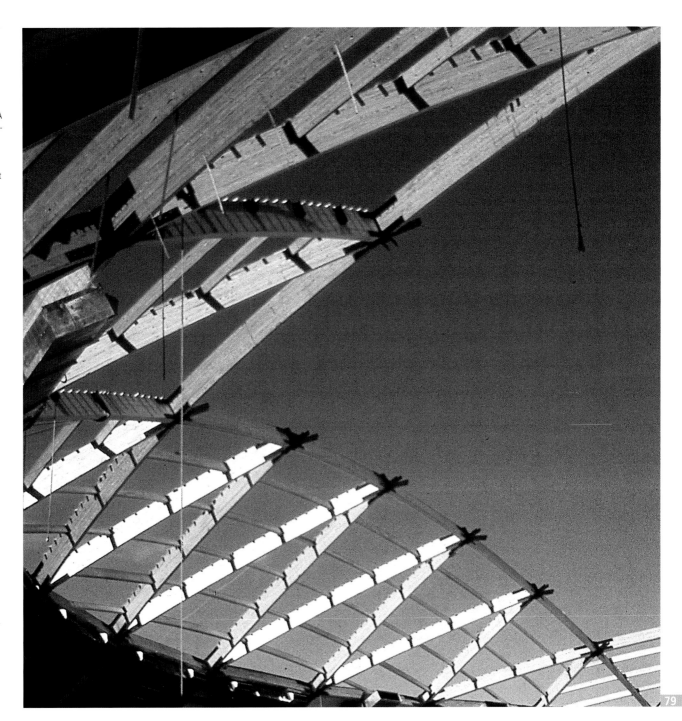

The radio towers built in the 1930s are probably the most astonishing and sensational examples of the strength of timber. Rising as high as 190 meters, they demonstrate the great potential of open timber frameworks and show how ingeniously they were used by engineers.

Relatively small timber sections were attached with shear or toothed plate connectors to form a delicate-looking framework. Resistant wood species such as the American pitch pine as well as rigorous structural timber protection helped guard the multilayer constructions from the direct effects of weathering, thus making them more durable.

In the years leading up to the Second World War, a number of radio towers were built of wood in Switzerland. However, their dimensions were not as breathtaking as those of comparable German towers. The photograph shows the construction of the 26-meter-tall antenna tower at Sternenfeld Airport of Basle (Baselland Canton).

A few of the most impressive timber radio towers in Germany:

Location	Year built	Height	Connectors
Neumünster	1910	50 m	Meltzer dowels
Königsberg	1926	80 m	Toothed plate connectors
Mühlacker I	1930	100 m	Kübler dowels
Leipzig	1932	125 m	Meltzer dowels
Breslau	1931	145 m	Spiked ring connectors
Erding	1932	115 m	Meltzer dowels
Ismaning	1933	163 m	Kübler dowels
Berlin	1934	165 m	Spiked ring connectors
Mühlacker II	1934	190 m	Spiked ring connectors

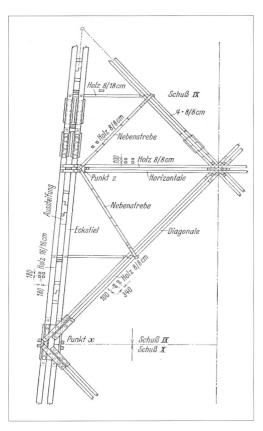

All tall towers make use of the same structural concept: the tower consists of a statically determinate frame with four truss walls combined in the square cross section. The chording and nogging are made of several parts, as the construction plan for the 140-meter-tall radio tower in Breslau-Rothsürben shows.

Rising to a height of 163 meters, the radio tower in Ismaning near the German city of Munich – erected in 1932/33 – is one of the most impressive structures made of sawn timber. Four individual cross sections with side dimensions of 28 x 28 cm form each of the four main columns. The connections are made of Kübler dowels and bronze bolts. The tremendous loss of energy resulting from the use of steel structures in broadcasting was a main reason for choosing timber.

The "Hughes Flying Boat" – the largest airplane built to date (maiden flight: 2 November 1947) – is a stunning example of wood's great strength. The airship was called the Spruce Goose because it was made almost entirely of wood. With their grid work and planking, the fuselage and the wings behaved structurally much like a shell load-bearing system.

Extensive preparations and studies were necessary to construct the enormous wooden plane, which had a 97-meter wingspan, weighed 181 tons and was 66.7 meters long. Hughes, an experienced wooden plane designer, originally chose birch as a building material, but was later forced to switch to fir, cottonwood, maple and balsa when birch supplies ran low. The wood was cut into 0.4 to 3.5-mm veneer for the paneling and bonded together to form 12.7-mm plywood. The actual grid structure of the fuselage and wings makes use of glued laminated wood (lamination thickness: 12 mm). The longitudinal body spar has a cross section of 250 mm x 250 mm, and the wing spar is 150 mm x 220 mm. The plane lifted off the water on 2 November 1947, flying 1.5 kilometers at a speed of 150 km/h – just 20 meters over the water's surface. This was its first and last flight. Delayed by three years, it was no longer needed as a large military transport plane.

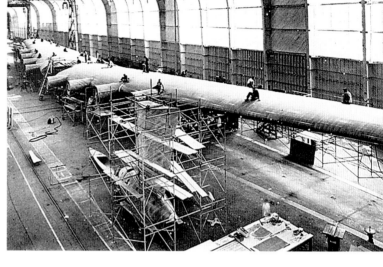

Construction of the Spruce Goose's 97-meter wing (the wingspan of the new Airbus A380 measures 74.8 meters). Eight tons of nails exerted the compressive force necessary to bond together the veneers of the 12.7-mm-thick outer skin. These nails were removed after the glue had hardened. The assembly hall was also made entirely of wood and was one of the largest timber sheds of its day, measuring 75 x 30 x 225 meters (height x width x length).

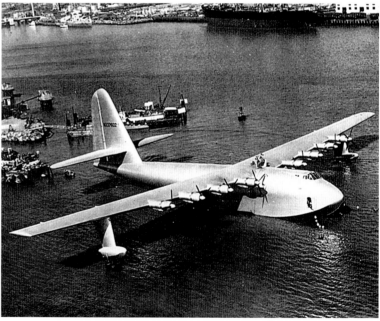

The enormous dimensions of the wooden water plane can be seen by its 15-m-tall stern rudder and the eight double wasp engines, each producing 3000 PS.

Bold Uses of Sawn Timber

The mother of all wooden structures is the tree trunk. Even when sawn into boards, its natural dimensional limitations are still apparent. Particularly in earlier periods when jointing technology was ineffective or non-existent, builders needed a profound understanding of structures to make up for the unavailability of wood in any random size.

Builders have been able to overcome the natural cross-sectional and longitudinal limitations of lumber by cleverly choosing structural forms and adapting connections between individual parts. This has led to open structural systems that resemble delicate latticework. Ingenious, well-developed engineering concepts have produced remarkable structures and, at times, a quite daring use of sawn timber.

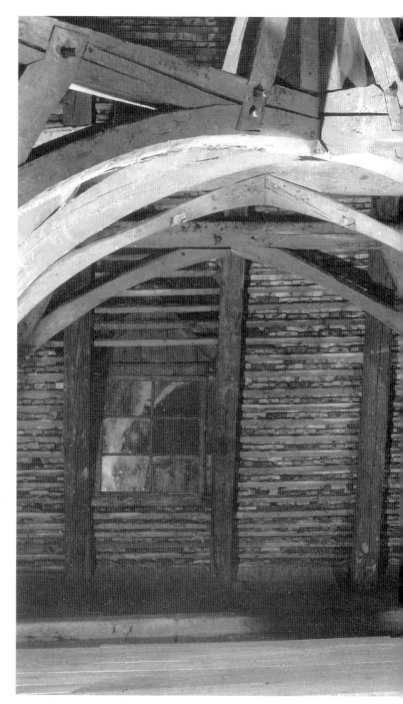

Many early timber structures reveal their builder's profound understanding of materials and highly developed knowledge and sense of structure. Bridges, church towers and roof trusses testify to the ways intelligent design and ingenious craftsmanship were able to compensate for both the dimensional restrictions of beams and the weaknesses of the known connections. The roof truss of Mariaberg, a former monastery erected in the fifteenth century in Rorschach (St. Gallen Canton), impressively demonstrates the craftsmen's skills.

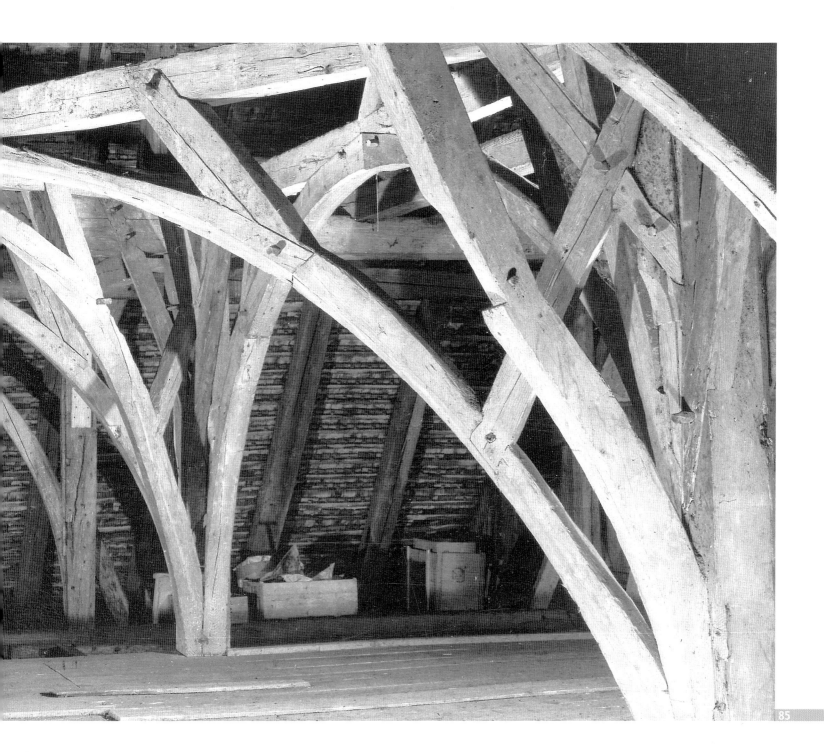

The festival and exhibition halls built in Switzerland in the late nineteenth and early twentieth centuries represent a special chapter in the history of sawn timber construction. These temporary structures did not survive as historical witnesses and were therefore quickly forgotten.

Even so, with their impressive dimensions, the buildings of the Swiss marksmen's fairs and choral festivals demonstrate the routine and, at times, quite daring use of sawn timber.

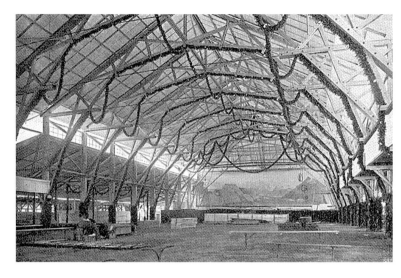

The festival hall at the Eidgenössische Schützenfest in Bern (Bern Canton), boasting a span 30.5 meters, was built in 1910 using sawn timber. The construction process was detectable in the finished work: the visible frame dominated the appearance of the architecture:

Its designers investigated hall stability by applying test loads to a scale 1:25 model since they were unable to compute the safety of the construction without error by mathemati-cal means.

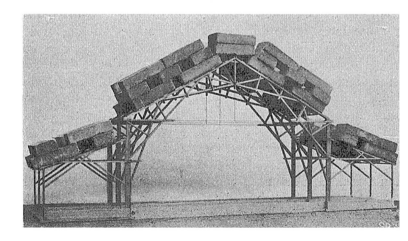

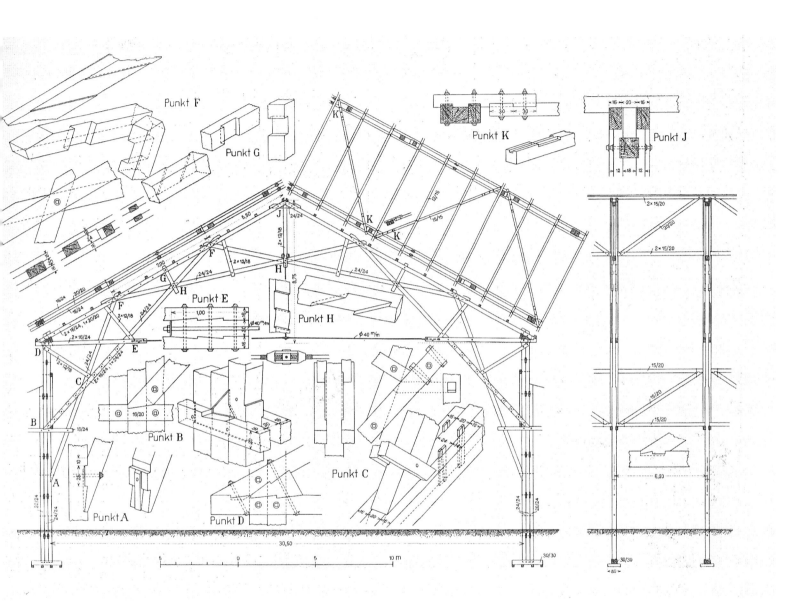

Punkt F

Punkt G

Punkt K

Punkt J

Punkt E

Punkt H

Punkt B

Punkt C

Punkt A

Punkt D

The load-bearing ribs of the
festival hall built for the
Eidgenössische Schützenfest in
Bern in 1910. The doweled
connections testify to the
builders' great craftsmanship.

The bold use of the ancient material of wood results in fascinating and astonishing structures even today. The unusual timber structures include the Galilei Tower in Zurich, built of round timber in 1991, and the eye-catching centerpiece of the Heureka national research exhibition. Some 580 sawn logs form the load-bearing system of the 50-meter-high tower. A ramp spiraling up over ten stories and 3,000 square meters of exhibition space to which the ramp provides access were integrated into the tower.

The halved tree trunks were connected to the logs with a specially developed joint: a hole was drilled through the columns, and a seamless steel tube with a matching cross section was inserted. A steel angle section with a corresponding hole was hung on both of the protruding ends to provide a support for the semicircular pieces of wood. The bolt running through the steel tube held both parts of the support together and prevented them from bending. The load-bearing behavior of this joint design was verified in tests.

The vertical load-bearing structure of the 52-meter-tall Galilei Tower consists of log columns arranged in a spiral and halved logs that serve as horizontal beams. The design features a ramp that spirals up ten of a total of twelve floors and provides access to the individual inner-lying exhibition levels. The ramp also forms the roof. The columns are 30–45 cm in diameter and rise at least three stories. They are connected with halved joints and secured by round plates and threaded rods.

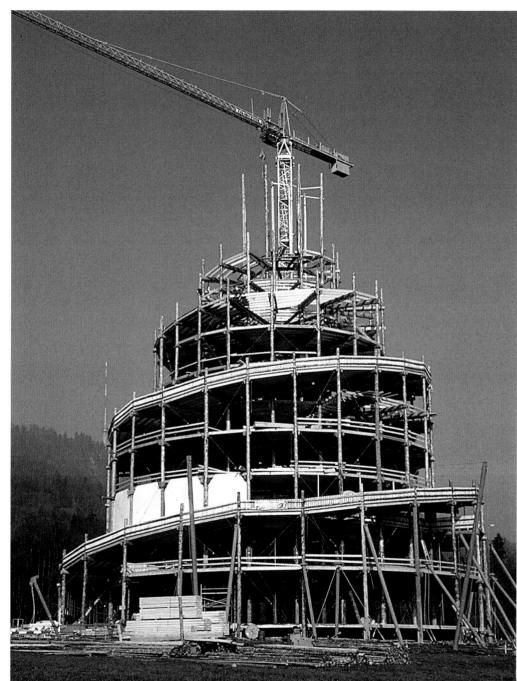

Compound Cross Sections

To overcome the natural cross-sectional limitations of timber, carpenters used the most obvious and probably the simplest tool at their disposal: they placed single pieces of squared timber, or several boards, on top of each other. In the process they recognized that the boards shifted under load, and that significant advantages could only be achieved by structurally combining the components. Nowadays the multi-layered cross sections thus created are called composite beams.

The individual cross sections were connected by purely mechanical means. The larger pieces of squared timber were joined with a form fit or by wooden pegs. When boards were stacked, wooden pegs or iron bolts inserted through them prevented shifting. Carpenters were able to overcome existing limitations on length by staggering the individual boards.

The Schüpbach bridge, built in 1839 over the Emme River in Emmental (Bern Canton), has a 49-meter span. Its arch consists of individual pieces of squared timber firmly connected by dovetail joints and additional hardwood dowels.

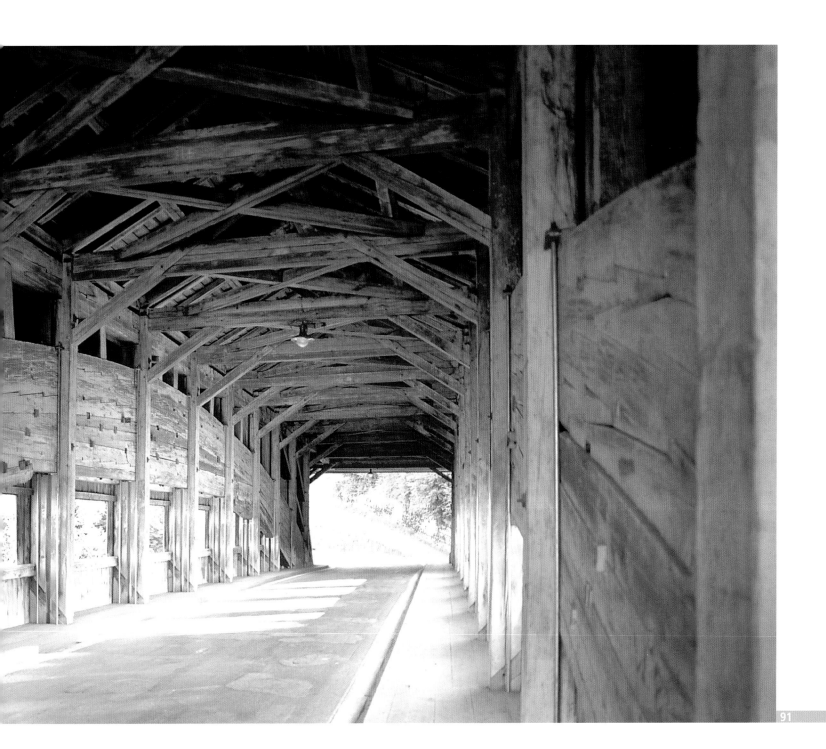

The first compound beams were created with a saw-tooth fit between the stacked wooden layers. Precise craftsmanship was essential to produce non-slip and thus shear-resistant connections. Doweling was an elegant way of sidestepping precision requirements. The hardwood dowels were produced in two parts in wedge form, and builders were able to compensate for existent geometrical incongruities by driving in the one dowel wedge.

True dovetailing or dovetailing with additional wedges were used to join the individual beams in 60-meter arch of the bridge over the Grosse Emme, built in 1838 in Hasle-Rüegsau (Bern Canton).

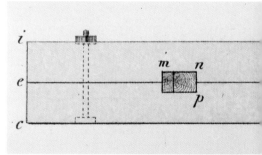

The individual beams in the arch of the Schüpbach bridge, built in 1839, are connected with hardwood plugs in the abutment area.

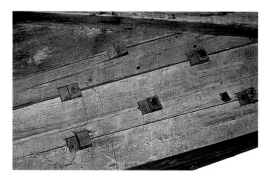

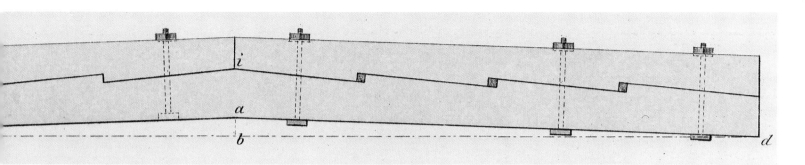

As they became more experienced and skilled, carpenters no longer placed the boards on top of each other lengthwise, but dovetailed and bolted them together to form a single load-bearing cross section. The precision they achieved in the process was viewed as a special accomplishment. Frequently the lower board was slightly bent to prevent slippage in the saw teeth and the resulting large deformations. To correct imprecise execution, narrow wedges or dry oak wood "clasps" were driven between the boards (see right side of the beam in the figure).

Doweling gradually replaced time-consuming, demanding dovetail connections. Doweled beams can be produced more easily and offer the same advantages. Two-part wedges are driven between the connected surfaces to compensate for imprecision.

In France, Philibert de l'Orme (1514–1570) chose a different method for improving the load-bearing capacity of compound boards. Confronted with a shortage of long thick cross sections, he built his arch structures of short boards placed edgewise. He had the boards or planks sawn into an arch shape based on a template, then arranged these next to each other in several layers, staggering the joints and connecting them with wooden pegs. This form of construction is considered the forerunner of today's laminated construction.

It was not until 1823 that the Frenchman Armand Rose Emy (1771–1851), an engineer and colonel in the engineering corps, made fundamental improvements to this method. Although he also incorporated boards into his arches, he lay them on top of each other. The individual boards could be bent into the desired shape without additional cutting. Afterward the entire sandwich construction was bolted together and the frictional connection achieved by the effect of dowels. With their extraordinarily long spans, Emy's arches were a sensation.

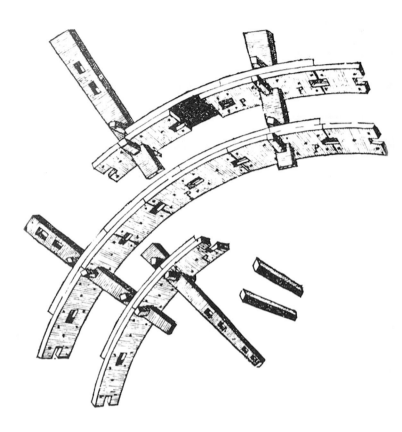

This illustration shows the arch construction method pioneered by Philibert de l'Orme. The boards are sawn into an arched shape, placed edgewise in layers, and connected with wooden pegs. The disadvantage of this method is that thick arches require correspondingly wide planks. In addition, these planks must be cut according to arch profile, making massive tree trunks necessary.

Emy's design for an arch structure with a 100-meter span. All Emy's arch designs were extremely slender, and he endeavored to improve their overall strength by using three arches, optimal infilling and fixed supports.

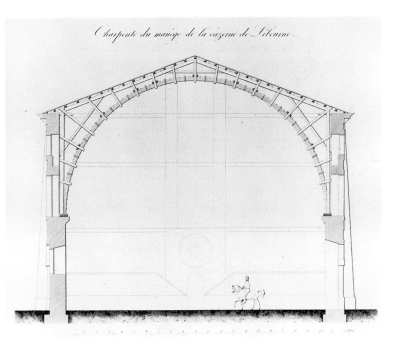

Charpente du manège de la caserne de Libourne.

Fig. 8.

By placing the planks in his arches on top of each other instead of edgewise, Emy was able to bend them into shape without additional cuts. The frictional connection between the layers was created by compression and wedged-in dowels. In 1826, Emy used this method to build the hall in the barracks in Libourne (France). His arch, which has a 21-meter span, consists of five to eight layers of planks. The detail shows the design of the arch and its support.

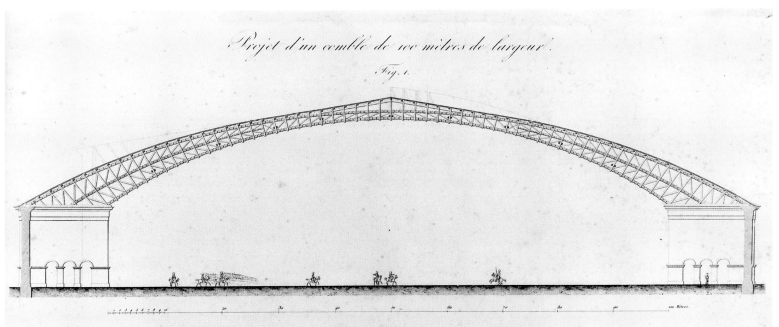

Projet d'un comble de 100 mètres de largeur.

Fig. 1.

The Beginnings of Laminated Timber Construction

A basic problem in the development of timber structures was the elasticity and weakness of the connectors. The weakness of the mechanical joints was particularly evident in composite beams, whose elastic behavior caused the individual parts to shift, adversely affecting the load-bearing capacity and stiffness of the entire element.

The advantages of bonding surfaces rigidly and evenly are obvious, yet it was not easy to find suitable, reliable glues. The shrinkage and swelling of timber, the influence of moisture, as well as the durability and long-term behavior of the adhesive itself posed the greatest problems. As they were impossible to transport, longer building components had to be produced on site, which further complicated matters. As a consequence, there were only a few applications until Otto Hetzer (1846–1911), working in Weimar, developed new techniques that ultimately led to the breakthrough of laminated timber construction.

In Switzerland, the construction method patented by Otto Hetzer spread with remarkable speed. The first timber structures with laminated beams were constructed as early as 1909. In just ten years, over 200 structures were completed, some with impressive dimensions.

The street car depot erected in Basle in 1915 testifies to the bold application of Hetzer's ideas in Switzerland. Curved laminated beams, trussed with a steel tie, gracefully span 21.5 meters in each of the hall's two bays.

The arch bridge over the Alz River in Alten-markt, Bavaria – designed by Friedrich Wiebe-king (1762–1841) and completed in 1809 – was one of the first engineered structures to make use of laminated timber cross sections. Oak boards approx. 5 cm thick were bent under an open fire and subsequently glued together on site to make the arches. With a span of 42 meters and cross sections of 24 x 27 cm, they were extremely slender. The arch rise was 3.9 meters.

The beams of the roof truss in King Edward's College in Southampton, constructed in 1860, are probably the oldest surviving casein-lami-nated building elements.

The bridge over the Alz River in Altenmarkt, Bavaria, has a 42-meter span and was built by Wiebeking in 1807–1809 with boards bonded together on site to make the arches (original copper engraving by Wiebeking, 1807). The load-bearing structure was extraordinarily slender: the ratio between beam height and span was 1:155. The inadequate lateral bracing made the bridge highly vulnerable to lateral vibrations. The timber was not protected, which resulted in damage to the glued joints and an additional loss of stiffness – and which adversely affected the bridge's load-bearing capacity and dimension-al stability. Like many of Wiebeking's bridges, this pioneering structure over the Alz River was not destined to stand for any great length of time. In his 1822 report *Zustand des Wassers und Strassenbaus im Königlichen Baiern* (State of Water and Street Construction in Royal Bavaria), Wiebeking's successor wrote: "Despite the high maintenance costs that we have defrayed since their construction – and which in many cases are more than half the original construction costs – most of Wiebeking's wooden bridges are in such an abom-inable state that they will have to be entirely rebuilt. One can predict with certainty that in just a few years nothing will remain of all these bridges other than the memory of this expensive architectural experiment . . ." In a talk with Wiebeking, Ludwig I provided an even pithier assessment: "Your excellence, you are surviving all your bridges."

The roof truss at King Edward's College in Southampton (Eng-land), built in 1860, is one of the oldest existing laminated beam structures.

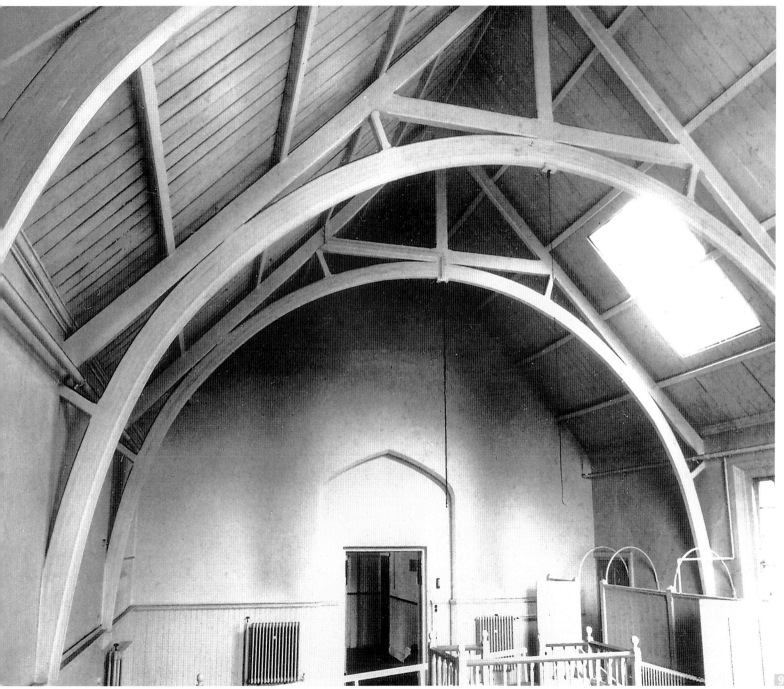

With his persistent and resourceful work in Weimar, Otto Hetzer made a decisive contribution to the development and widespread use of laminated timber construction. Hetzer recognized the great value of a sound mastery of gluing techniques. Based on his twenty-year experience in carrying out intensive tests and experiments on buildings, he patented a curved glulam beam in 1906 that consisted of two or more laminations. This marked the birth of modern laminated timber construction. Due in part to the "Hetzer beam," this form of construction was associated with his name for decades.

Wiebeking and Valentine were already gluing boards together to form load-bearing components in the nineteenth century, but it was only the persistent efforts of Otto Hetzer that paved the way for a real breakthrough in laminated timber construction. Hetzer's various patents show the extent to which he was preoccupied with the idea of a laminated timber cross section. In 1903, three years before the actual "Hetzer" patent was issued, he set about patenting his ideas on laminated composite beams. In his system, a spruce cross section was sawn open lengthwise in a parabolic shape. A middle board of beech was placed in the joint, and, finally, this "sandwich" was glued together to make the composite cross section. The middle layer had a reinforcing effect on the hybrid cross section.

KAISERLICHES PATENTAMT.

PATENTSCHRIFT

— № 163144 —

KLASSE 37b.

OTTO HETZER in WEIMAR.

Verfahren zur Herstellung eines zusammengesetzten Holzbalkens.

Patentiert im Deutschen Reiche vom 10. Mai 1903 ab.

Durch vielfache Versuche ist festgestellt worden, daß Holzbalken, die aus mehreren Teilen zusammengesetzt sind, wie z. B der zusammengesetzte Holzbalken nach Patent 125895, eine größere Bruchfestigkeit besitzen wie volle Balken von gleicher Höhe und Breite, wobei allerdings die vorteilhafte Anordnung und Verteilung der einzelnen Holzteile von wesentlichem Einfluß ist.

So läßt sich auch gemäß vorliegender Erfindung ein verstärkter Holzbalken dadurch erzielen, daß man einen vollen Balken der Länge nach in einer parabolischen Linie aufschneidet, zwischen die Trennflächen ein Brett, wie üblich aus Langholz geschnitten, einschaltet und das Ganze dann miteinander zur Balkenform vereinigt.

Die Zeichnung veranschaulicht in beispielsweiser Ausführung einen derartig hergestellten verstärkten Holzbalken.

Ein voller Balken a, dessen Höhe größer ist wie die Breite (Fig. 1 und 2), wird nach der punktierten Linie, die ganz oder annähernd eine Parabel ist, der Länge nach in wagerechter Richtung aufgeschnitten. Es entstehen auf diese Weise zwei Trennteile, ein Fischbauchträger b (Fig. 3) und ein abgeflachter Bogenträger c (Fig. 4). Zwischen die beiden Trennteile b und c wird ein passendes Brett d (Fig. 5) gelegt, nachdem die Trennflächen oder auch die Brettflächen mit einem Klebemittel versehen worden sind.

Nunmehr werden die drei Balkenteile fest zusammengepreßt, wobei das Brett d sich in die parabolische Linie biegt. Nach dem Trocknen des Klebemittels ist dann ein aus drei Teilen bestehender Balken (Fig. 6 und 7) entstanden, dessen Bruchfestigkeit erheblich größer ist wie diejenige eines vollen Balkens von gleichen Abmessungen.

Das geschilderte Verfahren bietet den großen Vorteil, daß sich der verstärkte Balken aus einem vollen Balken und einem Brett ohne jeden Abfall an Holz herstellen läßt. Dann kann zur Herstellung eines Balkens von bestimmter Tragfähigkeit infolge der größeren Festigkeit schwächeres Kantholz und ein schmales Brett genommen werden, um einen Träger zu erhalten, dessen Kosten geringer sind als die Kosten des Vollbalkens, da bekanntlich die Kosten für Holzbalken und Bretter mit den Höhen- und Breitenabmessungen wachsen.

PATENT-ANSPRUCH:

Verfahren zur Herstellung eines zusammengesetzten Holzbalkens, dadurch gekennzeichnet, daß ein voller Holzbalken der Länge nach parabolisch durchschnitten und die Trennteile unter Einschaltung eines Langholzbrettes durch ein Klebemittel unter Druck wiederum miteinander vereinigt werden.

Hierzu 1 Blatt Zeichnungen.

(2. Auflage, ausgegeben am 6. Januar 1908.)

BERLIN. GEDRUCKT IN DER REICHSDRUCKEREI.

Fig.1. Fig.2. Fig.3. Fig.4. Fig.5. Fig.6. Fig.7.

Zu der Patentschrift
№ 163144.

PHOTOGR. DRUCK DER REICHSDRUCKEREI

KAISERLICHES PATENTAMT.

PATENTSCHRIFT
— № 197773 —

KLASSE **37***b*. GRUPPE 3.

OTTO HETZER in WEIMAR.

Gebogener Holz-Bauteil für vereinigte Dach-Pfosten und -Sparren.

Patentiert im Deutschen Reiche vom 22. Juni 1906 ab.

Es ist bekannt, gerade Holzbalken der Länge nach in parabolischer Krümmung zu durchschneiden und die auf diese Weise getrennten Teile nach Einfügung eines Langholzbrettes durch ein Bindemittel unter Druck wiederum miteinander zu vereinigen.

Den Gegenstand der Erfindung bildet ein gebogener Holz-Bauteil für vereinigte Dach-Pfosten und -Sparren, der aus mehreren in gewünschter Form gebogenen Langholzstäben unter Zwischenfügung eines in Feuchtigkeit nicht löslichen Bindemittels zusammengepreßt ist.

In der Zeichnung ist ein Stück eines solchen Holz-Bauteils wiedergegeben.

Drei aus Langhölzern hergestellte Teile *a*, *b* und *c* sind in der nötigen Form gebogen und unter Anwendung eines in Feuchtigkeit nicht löslichen Bindemittels *d* unter Druck zusammengefügt. Nach dem Trocknen des Bindemittels behält der Bogen die ihm gegebene Form, ohne sich wieder gerade zu strecken. Dies ist darauf zurückzuführen,

daß die harten Jahrringe des einen Langholzes bei Ausübung des Preßdruckes in die weichen Teile des benachbarten Langholzes eindringen und unter Mitwirkung des Bindemittels ein untrennbares, festgefügtes Ganzes bilden, das selbst bei einem versuchten gewaltsamen Geraderichten ein hierzu notwendiges gegenseitiges Verschieben der Berührungsflächen nicht mehr zuläßt.

Der Bauteil kann schon aus zwei, aber auch aus mehr als drei Stäben zusammengefügt und in einer dem Verwendungszweck entsprechenden Weise gebogen werden.

PATENT-ANSPRUCH:

Gebogener Holz-Bauteil für vereinigte Dach-Pfosten und -Sparren, dadurch gekennzeichnet, daß zwei oder mehrere in gewünschter Form gebogene Langholzstäbe durch Zwischenfügung eines in Feuchtigkeit nicht löslichen Bindemittels unter Druck zusammengefügt sind.

Hierzu 1 Blatt Zeichnungen.

(2. Auflage, ausgegeben am 11. August 1908.)

BERLIN. GEDRUCKT IN DER REICHSDRUCKEREI.

Zu der Patentschrift
№ 197773.

PHOTOGR. DRUCK DER REICHSDRUCKEREI.

Hetzer's decision to apply for a patent for an arched post may appear surprising at first, but not on closer inspection. In itself, the use of glue was not an innovation. The casein-glued beams in the King Edward College assembly hall in Southampton (1860) were certainly well known. This is presumably why Hetzer had to confine himself to patenting an ancillary building component – that is, a curved post that fulfilled the function of both a support and a bending element.

The German Reich patent issued to Otto Hetzer of Weimar on 22 June 1906 (No. 197773) must be regarded as the birth certificate of laminated timber construction. Its most important passage reads: "Curved wooden board for combined roof posts and rafters, made of two or more long wooden members that are bent into the desired shape and connected under pressure by a non-water-dissolvable glue.

Only a few years after Hetzer filed his patent, the Zurich engineering office of Terner & Chopard acquired the exclusive rights of use in Switzerland. The Zurich-based company Fietz & Leuthold became the first to build load-bearing structures with laminated elements. After additional licenses were awarded to timber companies, several players joined forces to form the Schweizerische AG für Hetzersche Holzbauweise, headquartered in Zurich. Its extraordinary success was based on the achievements of the engineer Charles Chopard (1879–1954), who is regarded as the true pioneer of glued laminated construction.

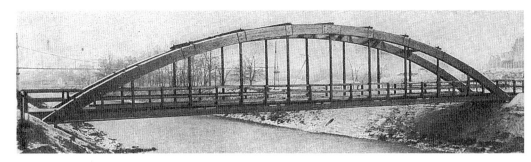

In the decades following Hetzer's patent, many structures were erected with glued laminated timber. However, there were only two bridges, both designed and constructed in Switzerland by Charles Chopard.

The pedestrian bridge over the Wiese River in Basle – which was built in 1910 and had an arch span of 33 meters – was one of the first larger structures in Switzerland to make use of laminated timber. The two beams on each side, which were bent into a parabolic shape and had cross sections of 140 mm x 600 mm, formed the main load-bearing structure, which was designed as a two-hinge arch with a soft steel tie (diameter 54 mm). With a selected live load of 350 kg/m² walking area, the maximum calculated stress was 6.6 N/mm², which was nearly equal to the 7/mm² permissible at the time. The bridge was built in just six weeks and cost half as much as a rival project proposed by iron engineers. The arches were not only impregnated, but also given two coatings of carbolineum and protected by galvanized iron sheet on top; even so, the weather quickly took its toll on the laminated beams and necessitated replacing the bridge after only eighteen years.

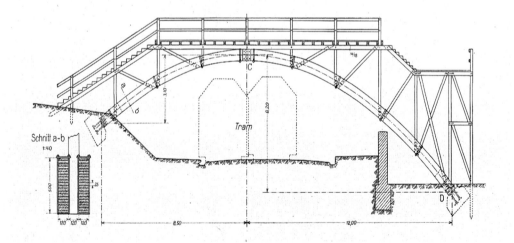

The pedestrian bridge in Beaulieu near Lausanne (Waadt Canton) was erected in 1910 as a temporary overpass over the street. It had twin arches on each side with a span of 20.5 meters.

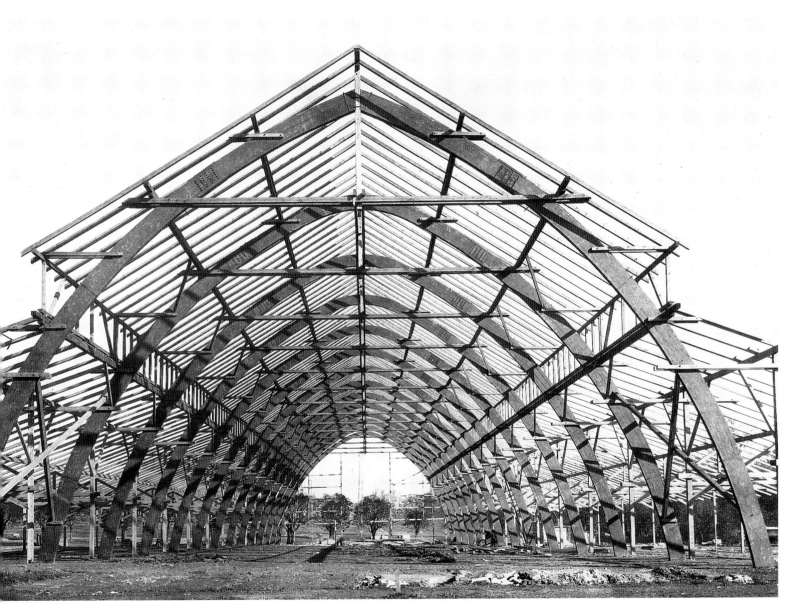

In a very short time, over 200 structures were built in Switzerland using so-called Hetzer beams as the main load-bearing elements. In temporary festival and exhibition buildings, this new method of bridging large distances with relatively slender, lightweight and easy-to-assemble components quickly replaced the previously popular filigree sawn timber constructions. The hall built in 1924 for the Eidgenössische Schützenfest in Aarau (Aargau Canton) is just one stunning example. Charles Chopard designed the three-pin arches with their 30-meter spans.

The Schweizerische Bundesbahnen (Swiss Railways, or SBB) played a remarkable role during the turbulent early years of laminated timber construction, helping to spread this form of construction. The SBB's experience with iron platform and shed roofs (which were badly cor-roded by locomotive emissions) as well as the new potential of laminated timber construction compelled the company to accept the new method. The low maintenance and construction costs were a decisive factor. Due to initial uncertainty and a lack of both know-ledge and experience, the SBB carried out load tests and comprehensive studies of certain aspects of glue technology. With these tests and studies, the SBB inspired additional devel-opments, in particular in the area of evalua-tion.

The discovery that wooden boards could be glued together reliably encouraged a variety of timber builders to pursue their own projects. One remarkable development in Switzerland is the Turnherr laminated building system. Draw-ing on the principle underlying de l'Orme's work, the laminations are placed edgewise and arranged in several layers on top of each other. One or two laminations are positioned diago-nally to the direction of the other members, which ensures cohesion and improved shear behavior. However, although this solution was of technical interest, it was hardly ever used.

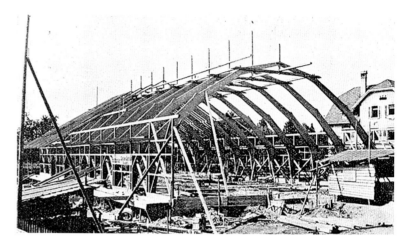

The Turnherr system, also known as the "vertical lamination system," differs from the Hetzer method in terms of the position of the laminations. These are placed edgewise, arranged next to each other in many layers, glued and finally nailed together. One or two layers are set diagonally to the axis of the beam in order to improve cross-sectional stiffness and cover the joints of the longitudinally placed laminations. The Turnherr method never caught on; only a few structures ever incorporated it.

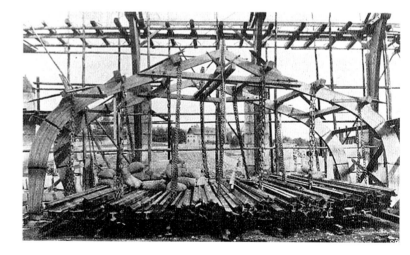

With their buildings, the Schwei-zerische Bundesbahnen played an important role in spreading laminated construction. The four-bay locomotive shed built in Bern in 1912 is a prime exam-ple of its work featuring spans of 21 to 24 meters.

In order to substantiate and ex-pand weak evaluative founda-tions, breaking tests were performed on models of the real arches in the Aebigut shed in Bern (scale 1:3). An ultimate strength was achieved that was four to five times greater than the permissible maximum bending stress of 7 N/mm^2.

Further Developments in Laminated Timber Construction

From 1938 on – following the development of the first synthetic resin glues – Swiss researchers and entrepreneurs once again focused on laminated timber construction. The German and British airplane industries did pioneering research into better-quality bonding agents. Synthetic resin adhesives as well as urea- and melamine-based glues offer enhanced water-resistance and greater protection against pests compared to the previously favored casein glues.

The new generation of glues, which CIBA in Basle helped develop, spurred additional advances in laminated timber construction. The ongoing scientific development of computational models ultimately made laminated timber a serious rival to steel and concrete with respect to engineering. The work of Graf and Egner in Stuttgart played an important role: in 1938 the two men began using glued finger joints in place of butt joints between boards, thereby improving product strength and reliability.

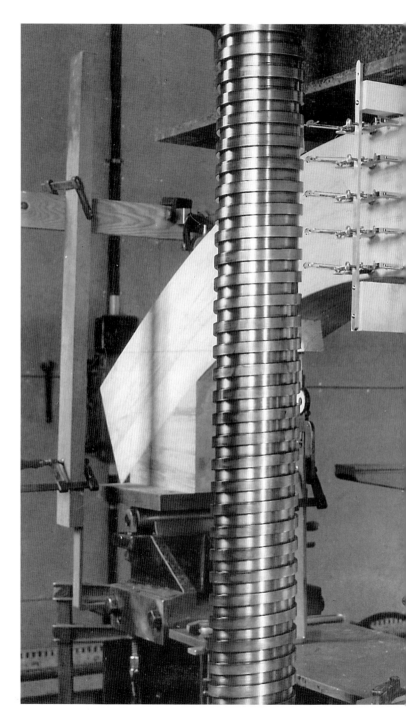

Tests conducted on laminated timber cross sections by the Eidgenössische Material-Prüfanstalt (EMPA) in the 1940s revealed just how much the strength of a bond was influenced by the physical and chemical properties of both the glue and the wooden surface. These tests were supplemented by the systematic study of the behavior of bent beams.

11176

With an effective span of 45.5 meters, the load-bearing structure of the Basle trade fair hall, built in 1941/42, exemplifies developments in laminated timber construction. Research into the use of Melocol glues, carried out by Mirko Ros (1879–1962) at the Eidgenössische Materialprüf- und Versuchsanstalt in Dübendorf (EMPA), provided the technical foundations for planning and producing the hall's three-hinge arches. Large-scale experiments analyzed the behavior of the glued connection between the wood tie and the arch (1 m^2 shear surface).

The development of glues was not immune to setbacks, as shown by the failed laminated connections in the roof beams of the post office garage in Bern-Stöckacker. Kaurit glue was "emaciated" with an extender to keep the connections from becoming brittle, but the problem of moisture susceptibility remained. What was lacking was a true water-resistant and weatherproof glue for universal use. This need was finally met by resorcinol-formaldehyde-based synthetic resin glues.

Drawing on advances in the USA (Penacolite), the Swiss company CIBA developed the first resorcinol resin glue in Europe in 1944, which it marketed in 1947 as Aerodux 184. The name is a reference to the glue's intended use in aircraft construction.

Military aircraft construction set the stage for advances in glue technology. With the birth of industrial airplane production in 1910, an intensive search began for high-quality bonding agents. The lightweight Mosquito fighter-bomber, constructed by the British in the Second World War, is an impressive example of their profound expertise in laminated wood construction. A total of 7,781 of these "Wooden Wonders" – designed by Geoffrey de Havilland – were manufactured, and the aircraft became one of the most feared planes of the war. The fuselage was constructed entirely of glued wooden ribs and planks. The "skin" consisted of molded plywood boards whose outer birch veneer plies (2 mm) were laminated to a balsa middle layer (20 mm). This extremely stable sandwich construction proved practically invulnerable in battle and was considerably less sensitive than comparable metal structures.

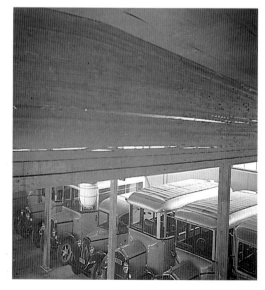

The development of glues was not immune to setbacks, as shown by the failed laminated connections in the roof beams of the post office garage in Bern-Stöckacker. Kaurit glue was "emaciated" with an extender to keep the connections from becoming brittle, but the problem of moisture susceptibility remained. What was lacking was a true water-resistant and weatherproof glue for universal use. This need was finally met by resorcinol-formaldehyde-based synthetic resin glues.
Drawing on advances in the USA (Penacolite), the Swiss company CIBA developed the first resorcinol resin glue in Europe in 1944, which it marketed in 1947 as "Aerodux 184". The name is a reference to the glue's intended use in aircraft construction.

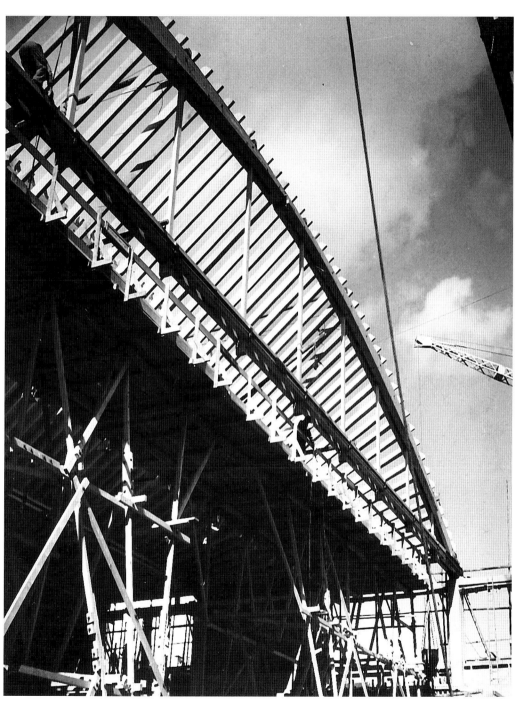

The three-hinge laminated timber arches built in 1941/42 for Hall VIII at the Basle trade fair had an effective span of 45.5 meters. For a long time the arches formed the largest spanning timber structure in Switzerland.

Due to insufficient experience and a lack of technical specifications, tests were run to determine the strength of the large shear surfaces in the bonded connections between arch and tie. The comparatively low shear strength values that came to light compelled the designers to reinforce the structure with additional round steel tension members.

The "Bestimmungen für geleimte Holzkonstruktionen" (Regulations for Glued Laminated Wooden Structures), published by the Schweizerische Bundesbahnen (Swiss Railways, SBB), drew on the railways' broad experience as a builder and created a crucial foundation for later standards. The SBB commissioned a wide range of studies: their tests on the sharply curved cantilevered beams in platform roofs (on a scale of 1:1) are especially interesting and instructive, providing insights into the influence of the residual stress (originating in the curvature of the individual laminations) on load-bearing capacity. The railway's intensive study of laminated construction produced crucial insights into the method.

To find out more about the ways in which the curved, laminated supports of cantilevered roofs behave under load, the Schweizerische Bundesbahnen conducted tests on a scale of 1:1 that measured the influence of residual stress originating from the curvature of individual laminations. They were also interested in the limits of load-bearing capacity.

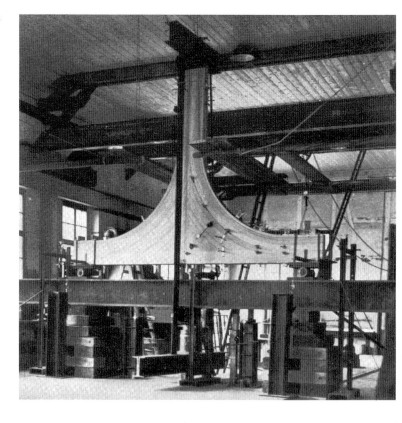

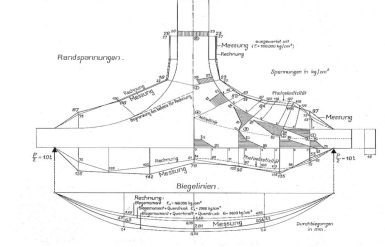

The results of tensometer measurements show the progression of actual stresses (in kg/cm²) compared with values obtained from a mathematical analysis of stresses conforming to twice the working load.

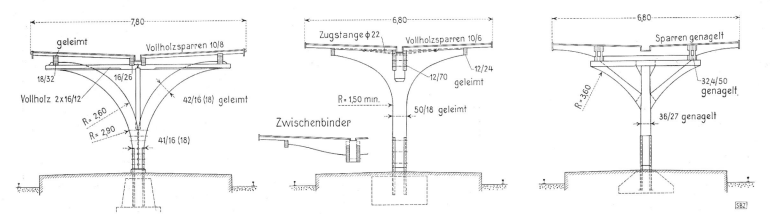

geleimt Vollholzsparren 10/8 7,80
18/32 16/26
Vollholz 2×16/12
42/16 (18) geleimt
R= 2,60
R= 2,90
41/16 (18)

Zugstange φ22 6,80 Vollholzsparren 10/6
12/70
12/24
geleimt
R= 1,50 min.
Zwischenbinder
50/18 geleimt

Sparren genagelt 6,80
32,4/50
genagelt.
R= 360
36/27 genagelt

SBZ

The costs of various structures were precisely computed and compared with similar steel projects in order to quantify the economic efficiency of cantilevered structures built with glued timber cross sections. It turned out that the timber structures were up to 15 percent cheaper.

A laminated cantilever beam with sharply curving laminations in the railroad platform roof in Sissach (Baselland Canton, erected 1944).

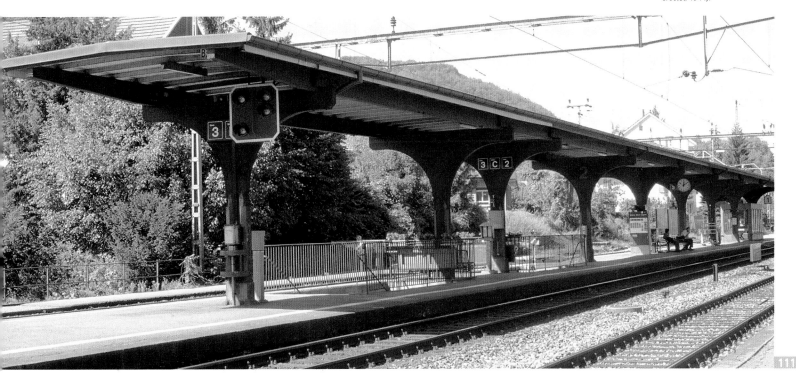

The I-beam that Gottfried Kämpf (1910–1966) of Rupperswil (Aargau Canton) patented in 1946 testifies to the greater confidence that new bonding agents inspired. It consists of boards placed edgewise, with the middle layer rotated by 8 to 12° in relation to the longitudinal axis. This material-saving beam has been used to erect a number of daring buildings. Today this type of cross section is called cross-laminated lumber.

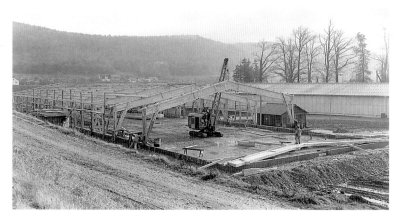

Boosted by postwar demand, Kämpf's I-beams were used in a variety of ways. The beam's enhanced shear and tensile behavior perpendicular to the grain (as compared to normal beams) made it possible to build shapes not otherwise suitable for timber construction. One example is the gable roof beam (deviation forces – tension perpendicular to the grain) used in two-hinge frames (connection problems with the tensile and compressive supports).

Kämpf's I-beam is a laminated plate girder with an I-shaped or box cross section. It is designed as a multi-layer board whose laminations have different orientations – the two or three laminated layers cross at a slight angle to allow for greater homogeneous strength.

8° bis 12°

Kämpf's I-beams form the main load-bearing structure of the round mix bed hall in Rekingen (Aargau), built in 1980 for the intermediary storage and processing of coal in concrete production. The angled frame girders, with a 68-meter span, are arranged radially over a 16-cornered ground plan.

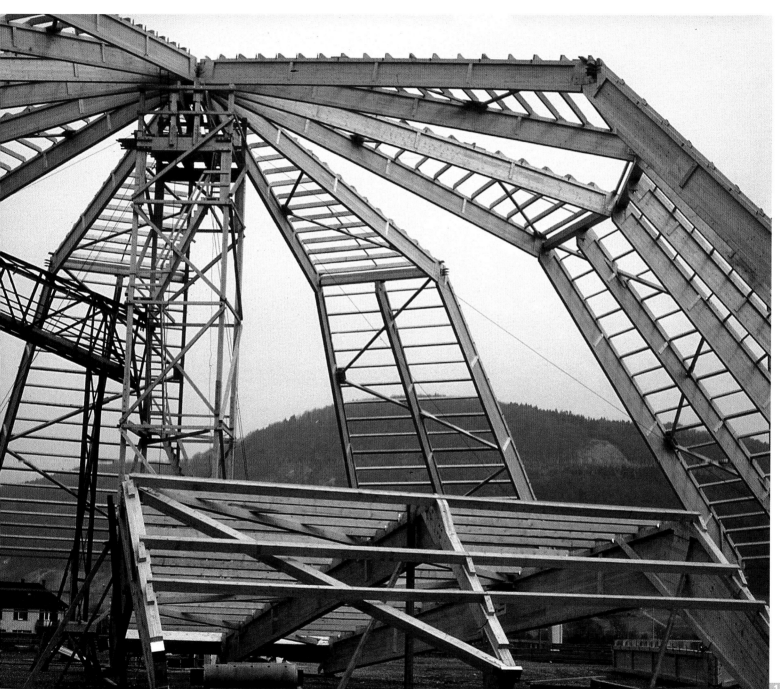

Memorable Buildings

In the 1960s and 1970s, laminated construction became widely accepted for use in engineered structures. For the first time, engineers could fall back on suitable, comprehensible construction standards that allowed for reliable planning and controllable production. The structural transition within the industry also played a role: individual carpentry businesses no longer produced the glued elements themselves, but purchased them from specialized manufacturers. With this division of labor, production became concentrated in the hands of just a few compa-nies, which led to greater economic efficiency and improved product quality.

The economic boom during these years made it possible to exploit the strength of laminated construction in breathtaking ways. Load-bearing glulam roof structures appeared over indoor swimming pools, tennis courts, riding arenas and ice rinks. A number of structures in Switzerland were highly influential.

The construction of impressive and unusual structures showed people that laminated timber was a genuine alternative to traditional building materials like steel and concrete. Three structures built in Switzerland were to play decisive roles: the hall erected for the 1964 Swiss national exhibition, and the ice rinks in Bern and Davos. They acted as beacons and are now acknowledged as milestones in the development and spread of timber construction techniques.

The hall built for the 1964 national exhibition in Lausanne (Waadt Canton) enclosed an area of 100 x 87 meters and aroused great admiration and enthusiasm among professional and lay visitors. The structure's lightness brought home the capabilities of the "new" laminated construction method.

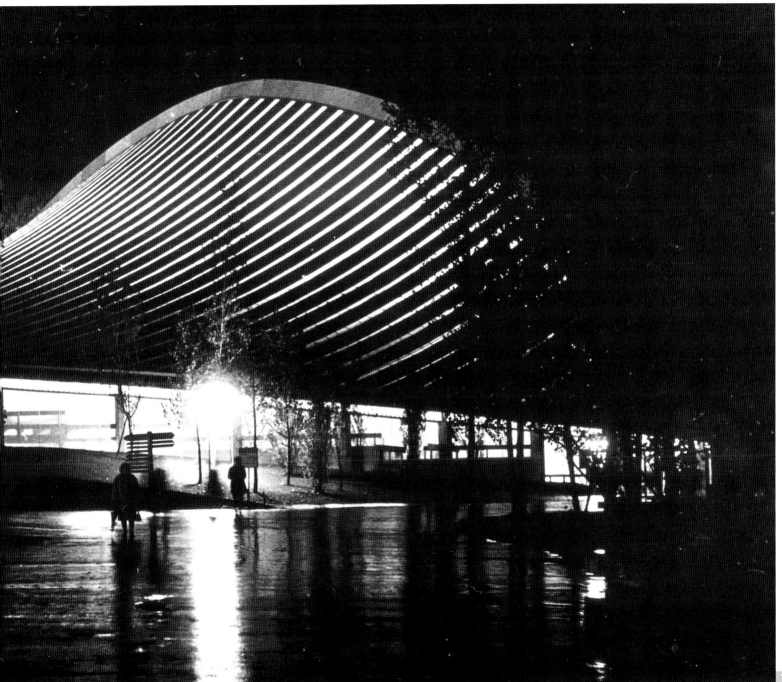

The hall erected in 1964 for the Swiss national exhibition in Lausanne was a technical and architectural masterpiece. Its spine was composed of a three-hinge laminated arch with an 87-meter span. Attached to its sides were plywood "straps" over 52 meters long, 1 meter wide and 13 millimeters thick. These parabolic tensioned ties formed the framework of the transparent roof skin.

The oval-shaped, three-hinge arch, with a span of 87 meters, formed the spine of the structure. The arch consisted of two glued laminated beams linked by cross pieces. The beams were 80 to 120 centimeters high, 20 centimeters wide, and additionally stayed by cables. The roof's translucent skin was supported by plywood "straps" that, as tensile elements, stretched from the arch to the base point on the glulam ring surrounding the oval. The connections were made with triangular steel sheet glued with Araldite (which did not prove durable). The one-meter-wide, 13-mm-thick plywood straps had three plies of 3-mm veneer with their grain running longitudinally, and a top layer of 2-mm veneer with its grain running perpendicular. Bracing cables that ran diagonally across the plywood pre- vented the roof from being torn off in high winds.

Architects:
A. Lozeron, M. Mozer,
C. Michaillet, G. Châtelain,
F. Martin, Lausanne/Genève

Engineers:
R. Perreten, P. Milleret, Carouge

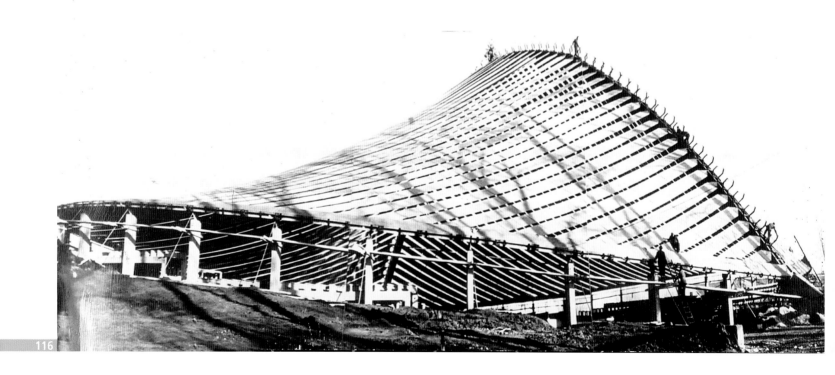

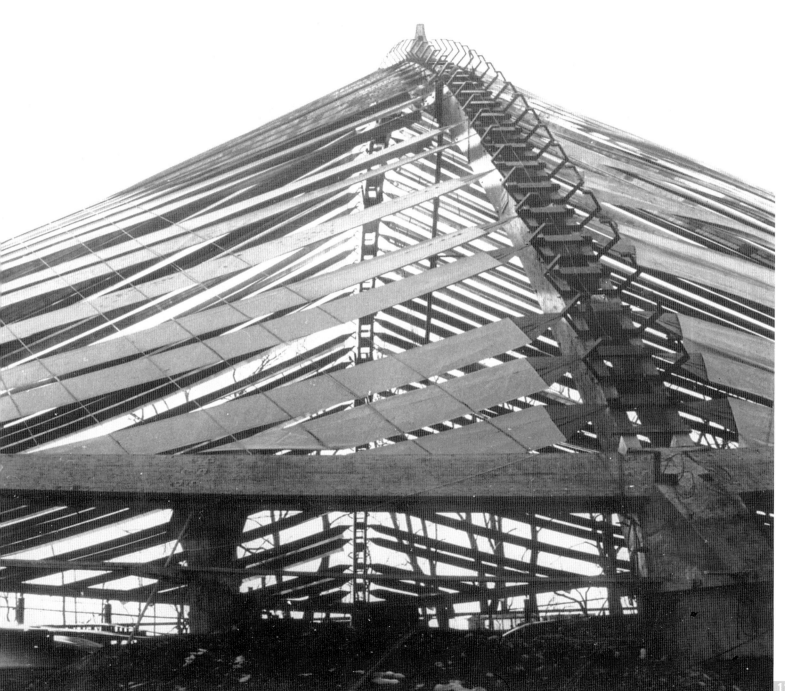

A particularly impressive, pioneering example of laminated timber engineering is the roof over the ice rink in Allmend Bern, built in 1970. The architects' primary goal was to span 85 meters without any columns, which they achieved using two-hinge arches with ties. The individual arches were produced in three parts in the workshop. Workers then assembled them on site, placing them on their sides and screwing and gluing the connections together. Finally the arches were lifted into place with a mobile crane.

Although the timber roof – which was the largest (12,000 m²) in Switzerland at the time of its construction – was designed as a purely functional structure, it proved the "engineer-ability" of laminated construction. It not only challenged deep-seated prejudices but inspired engineers to emulate and refine previous accomplishments. It established wood as a technical building material that equaled engineered materials like steel and concrete.

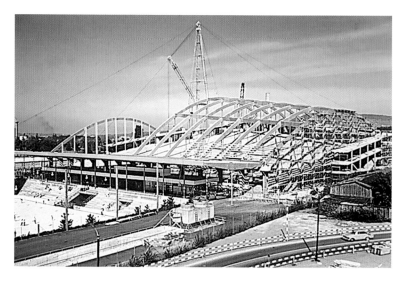

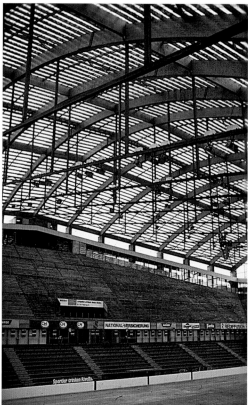

The thirteen ribs spanning the ice and the bleachers of the Allmend ice rink in Bern were designed as laminated parabolic two-hinge arches with ties. They consist of two glued laminated beams 14 cm wide and 120 cm tall with a hollow box cross section.

Architects:
W. Schwarz, F. Zulauf, Bern
Engineers:
H. Vogel, Emch & Berger, Bern

Because of the large dimensions, the connections were assembled on site. The box girder elements, delivered in three pieces by special vehicles, were placed on their sides and glued and screwed together to make the entire arch. This was stiffened with temporary stays and then hoisted into an upright position with a mobile crane. A derrick crane was used to place the arch in its final position. The ties, attached to the arch approx. every ten meters, consist of a steel tube with a square cross section and exterior dimensions of 20 x 20 millimeters.

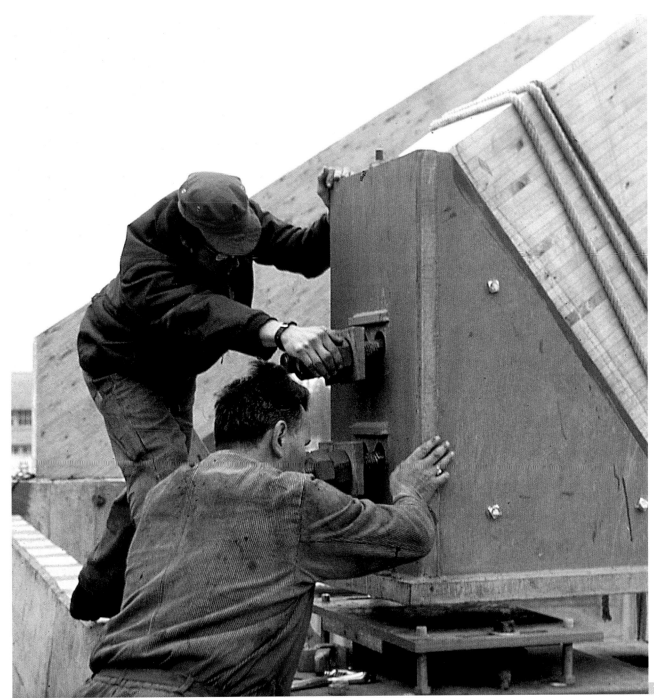

Another milestone in laminated timber construction is the roof over the Davos ice rink, erected in 1980. The project beat out its rivals due to its lower construction and maintenance costs – and also because of its short construction time. The glued laminated roof is shaped like a cross-vault ribbed dome with three-hinge arches.

Both the technical mastery and formal elegance of the rink are stunning. The new formal-structural design using a traditional building material – which no longer conceals but openly demonstrates and celebrates timber construction – has continued to inspire architects and builders. Timber has gradually gained a firm foothold, even for architectural showpieces.

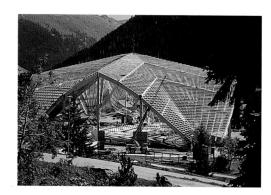

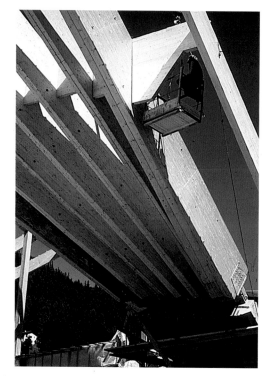

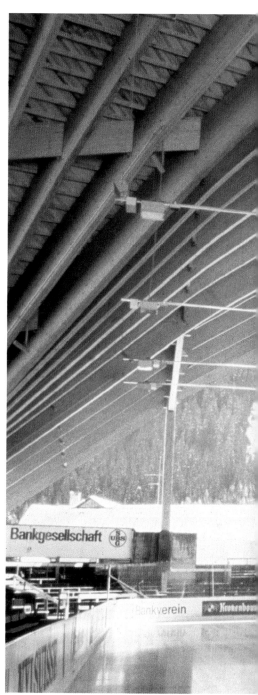

The wooden load-bearing structure of the Davos ice rink (Graubünden Canton) consists of a three-dimensional system of crossing three-hinge arches, with the largest arch spanning 75.6 meters. The building, which resembles a half-open umbrella, has an astonishingly sleek and elegant appearance despite its capacity to withstand anticipated snow loads of up to 800 kg/m².

Architects:
Krähenbühl, Davos
Engineer:
W. Bieler, Bonaduz

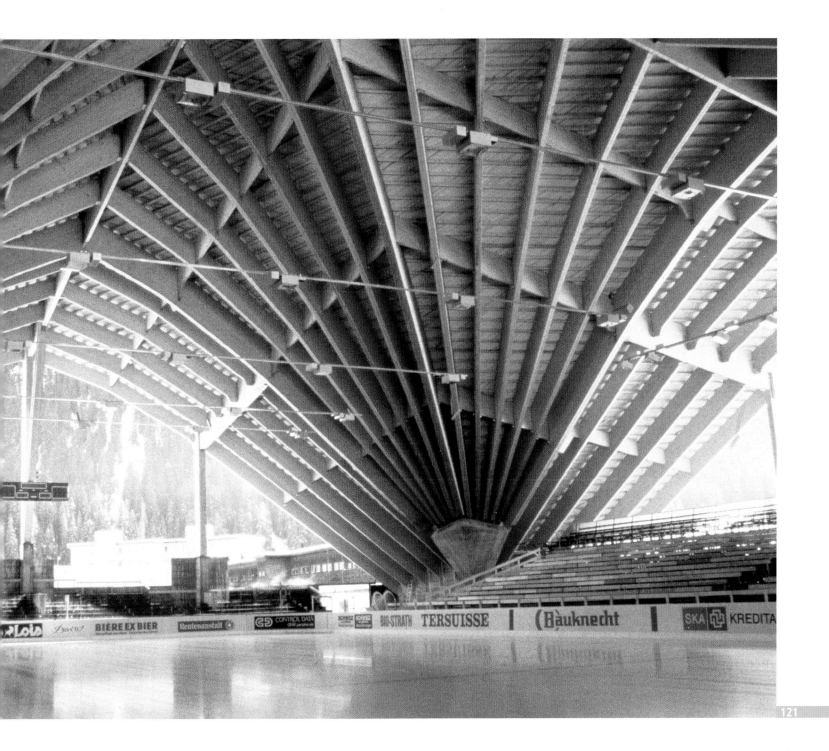

New Dimensions

By gluing laminations together to make layered cross sections, builders achieve genuine material-technological advantages over sawn timber. Growth irregularities and shrinkage cracking can for the most part be eliminated by sorting boards, predrying them in a controlled process, and cutting out their defective parts. This results in greater tensile strength and improved dimensional stability – properties that make glued laminated timber the superior and more economical choice, even for straight building elements (e.g. cross sections in lattice beams and large panel elements). This, in turn, opens up new dimensions for timber engineering.

Wood has a natural tendency to grow straight. Its inner structure has a longitudinal orientation, which is ultimately reflected in the shape of the tree trunk. While it is possible to bend a small board with very little force, it will spring back into its original straight shape when the force lets up. One can only ensure that an element retains it new shape by bonding together layers of prebent boards: the restorative force of the individual parts is rendered negligible, restrained by the much greater stiffness of the new cross section. This technique gives timber an additional advantage: it can be molded into almost any shape, and these can be produced in very large dimensions.

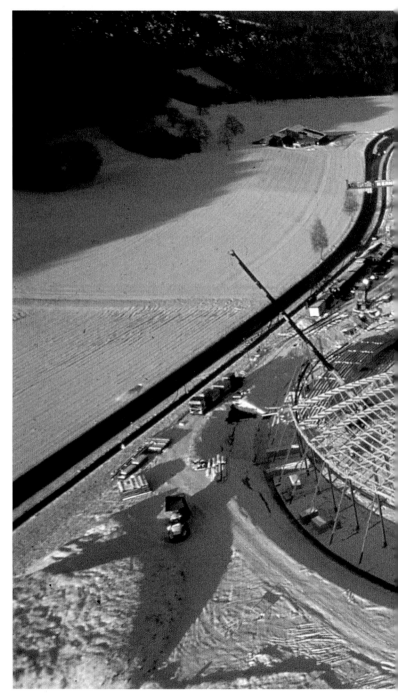

The roof of the electromagnetic accelerator facility at Paul Scherrer Institut in Villigen (Aargau Canton) consists of 60 slightly curved, radially arranged glulam timber beams with a span of 34 meters. They are supported on the outside by sixty steel columns; inside they rest on a ring-shaped three-story concrete office block. All the beams, which span the ring area without columns, are prefabricated single arches with a rise of four and a length of 43 meters. Bottom chords in the form of a tension rod prevent lateral buckling and join the beams together to create a lightweight system that approximates the structural principle of a shell (erected 2001).

Structural engineering:
Häring & Co. AG, Pratteln

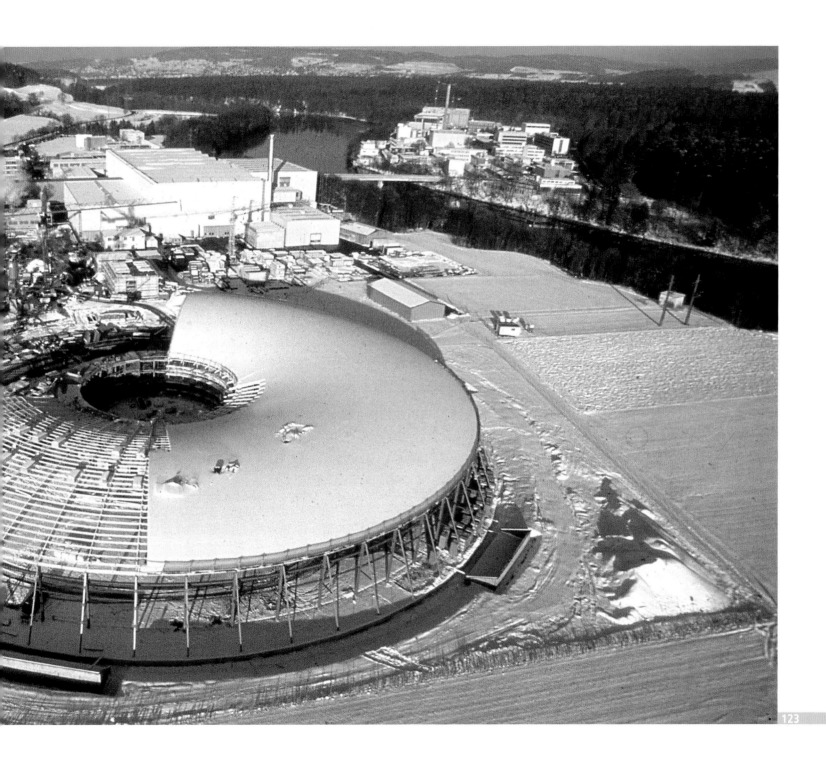

Glued laminated cross sections have improved the quality of truss structures and opened up entirely new dimensions for their use. Ever greater difficulty in procuring sawn timber in the required dimensions and quality has imposed structural and economic limitations that laminated cross sections can help overcome. With relative ease, they offer the dimensional accuracy and stability required by new connection technology and the corresponding production processes.

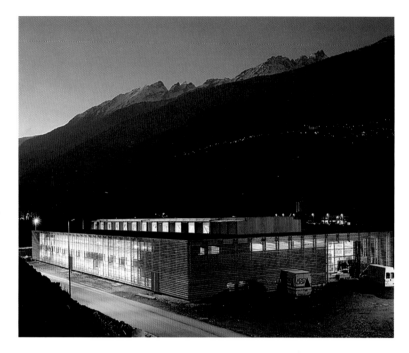

The roof truss over the carpentry workshop erected in Visp (Wallis Canton) in 2001/2002 consists of glulam ash wood members. The laminated cross sections permit a high degree of precision in production and assembly and give the structure the sophisticated, elegant appearance of a fine piece of furniture.

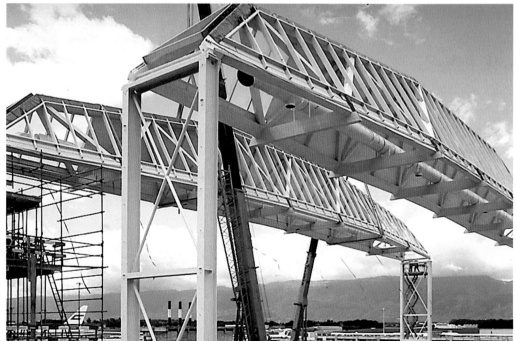

The lattice girders of the Palais d'Expo exhibition hall in Geneva were made possible by Glulam timber cross sections and powerful connection technology. The hall was built in 1995 and has a span of over 70 meters.

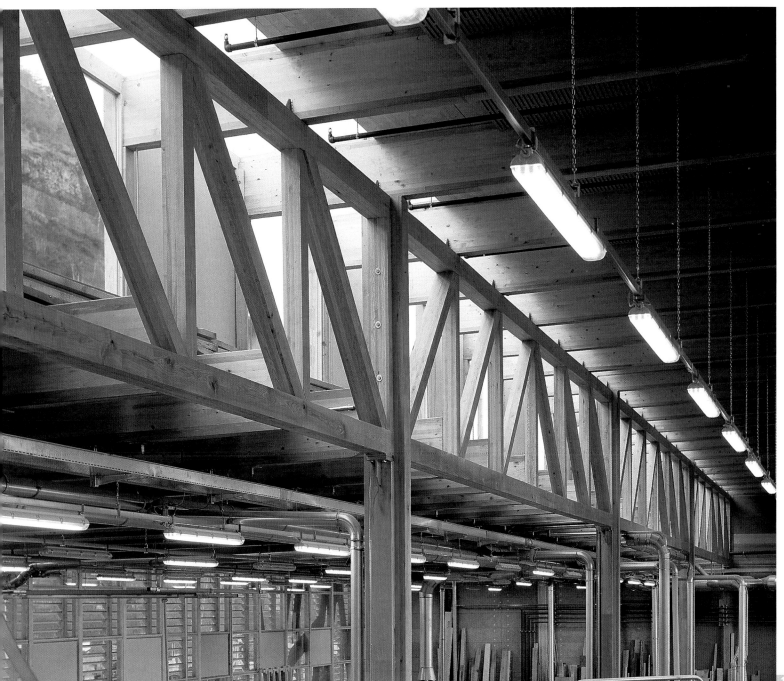

Large glulam timber elements have brought decisive advances to bridge building. Deployed as single deck slabs and generally prestressed crosswise, they are replacing planking in the construction of rigid bases, since planking is "jumpy" and less stable. In addition, they can perform a bracing function as structural panels.

Developments in bonding technology have not only benefited glued laminated timber components. Other applications are obvious, and new adhesive products are being marketed at regular intervals. Most aim at a more efficient use of the original material and a greater homogenization of wooden products.

The search for methods to limit the growth-related structural disadvantages of wood has given engineers a new generation of laminated wood-based materials, one example of which is parallel strand lumber. Here veneer strips roughly 16 mm wide and 3 mm thick are staggered lengthwise and bonded to form beams in a through-feed process. The resulting enhanced strength is especially advantageous for large truss constructions.

The indoor go-cart track built in 1999 in Bonaduz (Graubünden Canton) is crowned by roof girders with a 45-meter span. They were designed as a Pratt truss with compression diagonals. The chords and diagonals are made of laminated veneer timber (Parallam). The greater strength permitted the use of dado joints and resulted in relatively small cross sections.

The deck slab on the List Bridge (Appenzell Ausserrhoden Canton) is made of glulam elements that are 35 meters long, 4 meters wide and 22 centimeters thick. They were manufactured as a single piece, prestressed crosswise, and transported to the construction site (erected 1997).

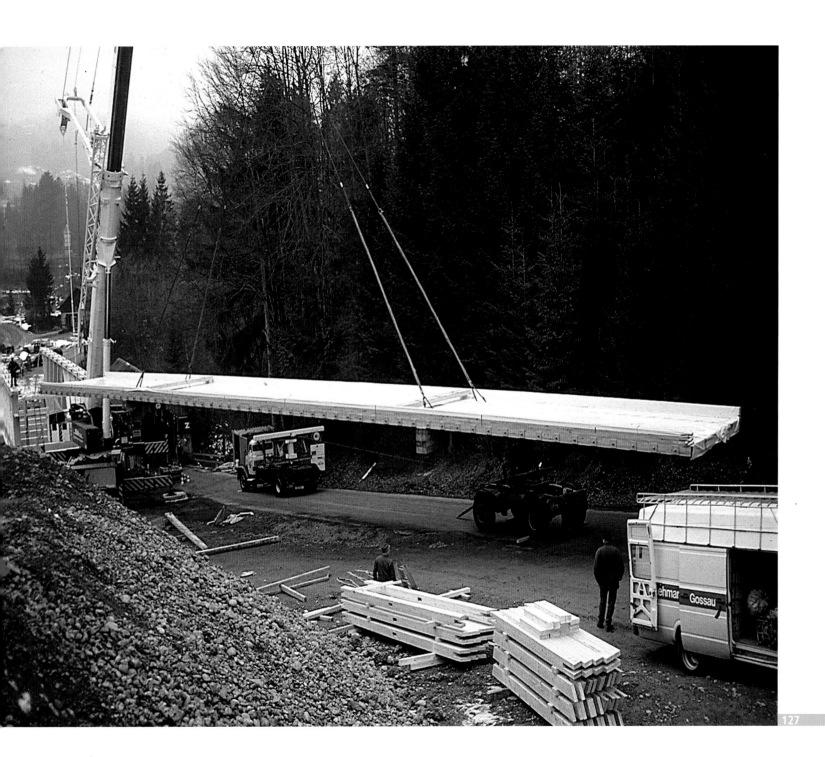

Large glulam panel elements have liberated timber construction from the natural structural and design constraints of stave construction. Load-bearing timber panel structures, such as the footbridge that Swiss architects and engineers built in Murau (Austria) in 1995, illustrate the entirely different interpretation of wood inspired by this form of construction.

Large vertical or horizontal glulam panels have given rise to entirely new designs, as the sculptural appearance of the wooden footbridge in Murau (Steiermark, Austria) illustrates. The Mursteg bridge is based to some extent on a unitary construction principle: the laminated wood panels that serve as load-bearing elements are connected to form a structural frame with lower and upper chords and shear panels (bridge cross section). At the same time, these supports serve as the bridge's basic three-dimensional, functional elements. The horizontal panels form the roof and the walkway, while the vertical shear walls have been moved to the bridge's interior and support areas. The load-bearing structure and visible exterior of the bridge comprise a unity that resembles a large molded piece of wood (erected 1995).

Architects:
Marcel Meili and Markus Peter, Zurich
Engineer:
Jürg Conzett, Chur

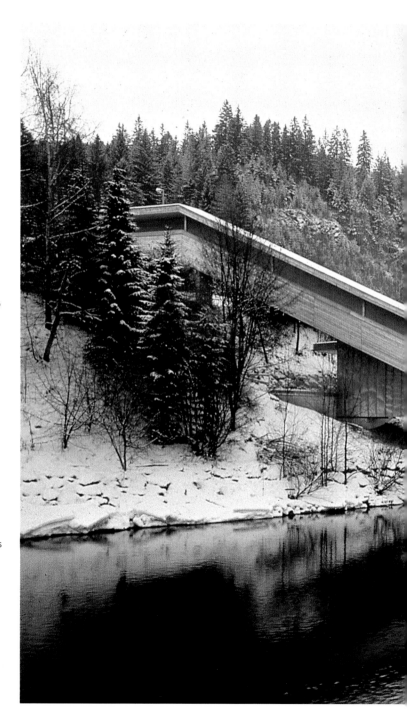

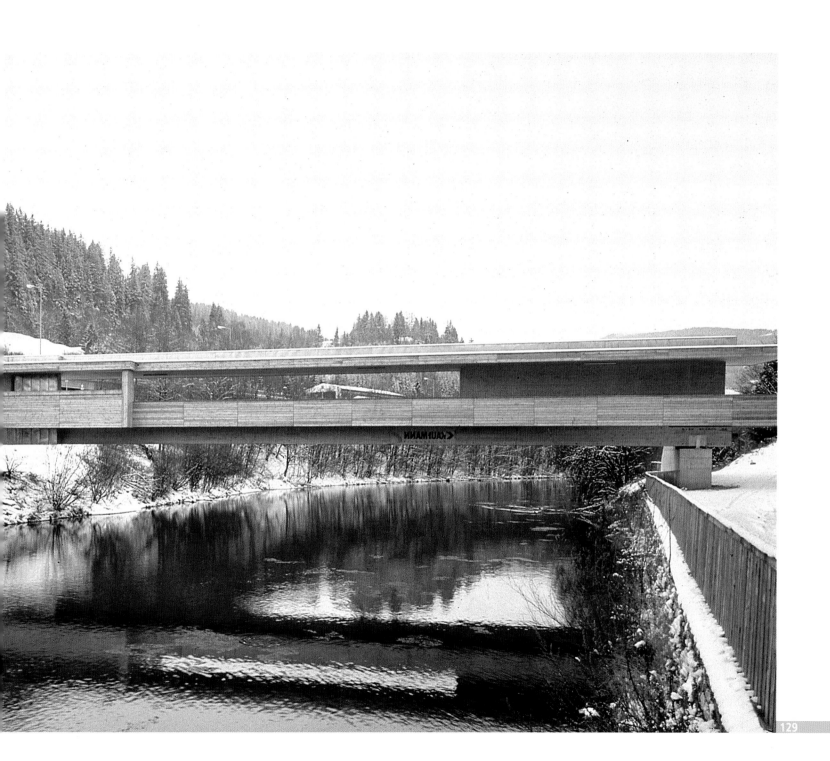

Thanks to its economic efficiency, the simple glulam arch has now become a permanent fixture in the repertoire of planners and engineers. Parabolic arches optimally exploit the mechanical properties of wood, which ultimately accounts for their superior strength.

The fact that builders can shape wood without diminishing its excellent mechanical strength has considerably enhanced its structural and creative potential. As a result, it has become more appealing for architects, who now exploit this feature to striking effect in timber construction.

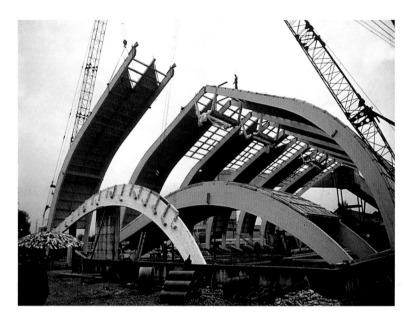

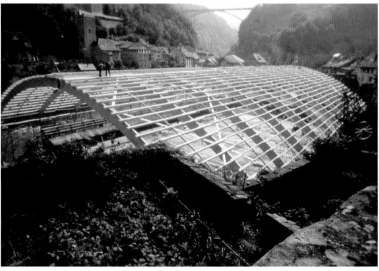

Arches are frequently used to span large areas in industrial, sporting and recreational buildings. As is well known, if the arch follows the catenary curve, evenly distributed forces will be standard forces, thus creating ideal load conditions for wood – namely, parallel to the grain. The great structural efficiency of the material gives birth to unique structures characterized by a high degree of prefabrication, simple assembly and short construction periods. The synthesis of shape and material normally produces highly aesthetic structures.

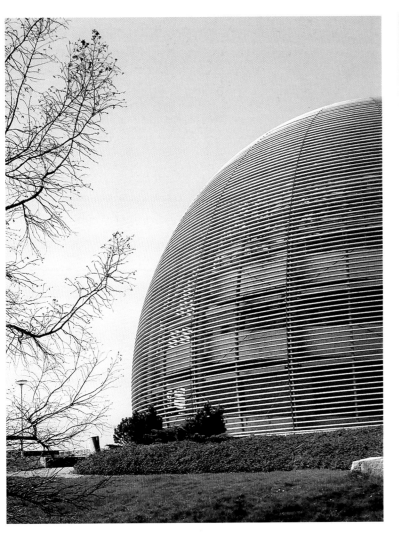

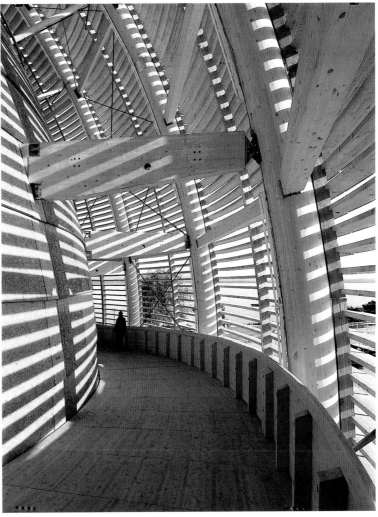

The load-bearing structure of the double-shelled Palais d'Equilibre sphere (at the EXPO 02 Swiss national exhibition) is composed of 18 glulam beams bent in a radius of 20.5 meters. The outer shell of the building, which is resistant to driving rain, is made of horizontally arranged 6-cm-thick glulam boards of Douglas fir. The inner sphere, reminiscent of a gigantic pearl, has a similar structure, but is sealed "tight" with OSB board. Starting from opposite sides, two ramps spiral up the semitransparent space in between.

The center of the wooden globe (diameter: 41 meters) is located some seven meters over the floor, creating a particularly dramatic effect: the sphere looks as if it has been propelled upward through the floor (erected 2002).

Concept:
Team Signe Productions, Geneva; Janus Film AG, Zurich; Gautschi Storrer Architekten, Zurich
Engineer:
Thomas Büchi, Perly

A large number of arch structures have been built, some with extremely wide spans. Combined with lamination technology, the arch has opened new avenues for architects in an age-old discipline – bridge building.

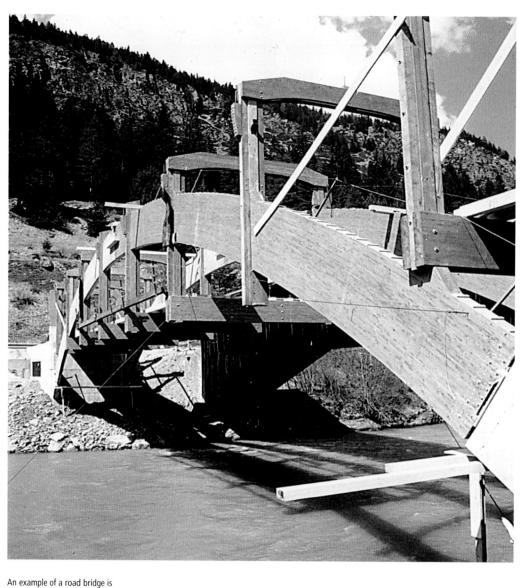

An example of a road bridge is the structure over the Inn River near La Resgia (Graubünden Canton) in 1992. Two arches with a 43-meter span and a cross section of just 22 x 173 centimeters support the single-lane carriage way and accomodate normal road traffic conditions.

The structural action of the arch has made it a compelling choice as a main load-bearing structure for pedestrian and road bridges. With its 53-meter span and slender, elegant design, the bicycle/pedestrian bridge over the Broye River shows the great strength of timber arch structures. It was constructed between Ins and Bas-Vully near Sugiez (Freiburg Canton) in 2001.

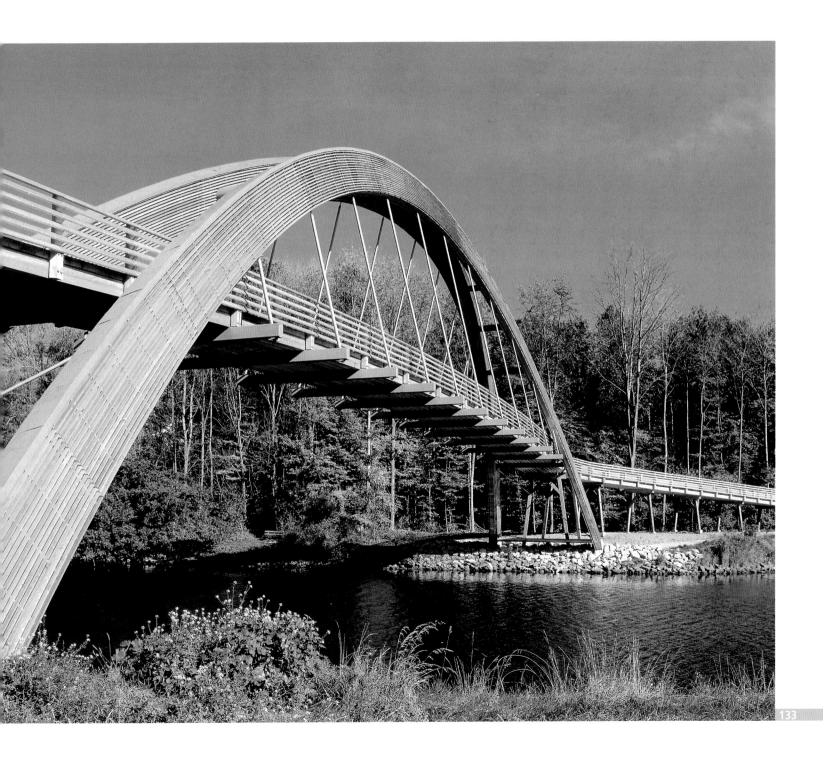

One of the great advantages of laminated timber lies in its pliability, which permits builders to overcome wood's natural straightness. It is now possible to reliably manufacture one- and three-dimensionally curved elements.

The roof over the Solebad swimming pool in Bad Dürrheim (South Germany) – now a design classic – exemplifies the virtuous use of this technology. Resembling a suspended net, the three-dimensional roof shell swings from tree-like column to tree-like column and drapes down to the arch-shaped edges. The columns, up to 12 meters tall, have branches that support the rings of the membrane roof structure. Laminated construction has helped create a new spatial experience with stimulating, flowing rooms – and it has resulted in a pioneering work in both technical and formal terms.

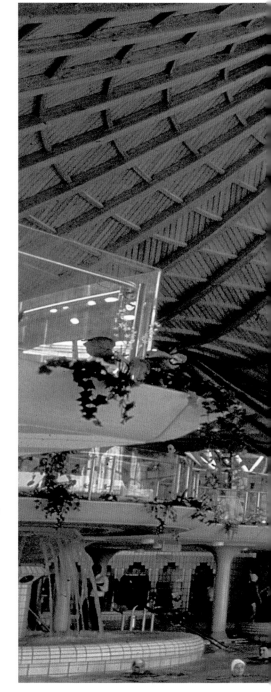

The sculptural tree-like columns of the Solebad swimming pool, built in Bad Dürrheim (Germany) in 1987, support the spherical membrane structure with its exposed, three-dimensionally curved ribs and tips. The load-bearing structure uniquely demonstrates the aesthetic and structural potential of laminated timber construction.

Architects:
Geier & Geier, Stuttgart
Engineers:
Wenzel, Frese, Pörtner, Haller & Barthel, Karlsruhe

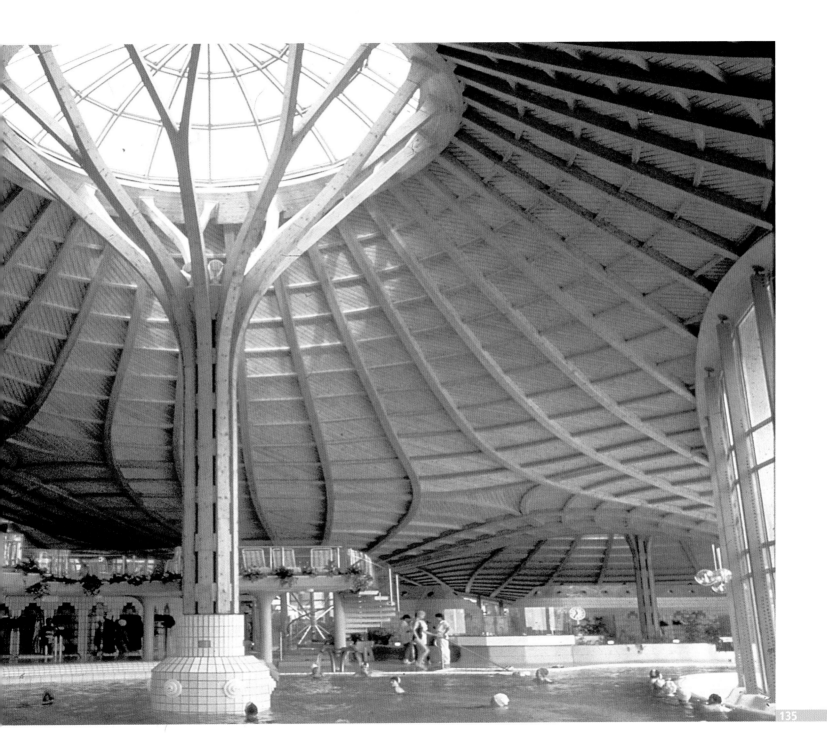

Connections

Progress in engineered timber construction is directly related to developments in connector technology. Connections are of central importance in timber construction. With hardly any other building material does the connection play as crucial a role in determining the choice of load-bearing structure and the form of the structure as it does with timber. This is due to wood's anisotropic behavior, i.e. the great differences in its physical properties in relation to the direction in which forces act upon it, in other words, whether these are acting parallel or perpendicular to the grain. Ultimately, such factors have a decisive influence on the form of the joint and connector chosen.

For many centuries, developments in connectors and joints depended on the craftsmanship and experience of the builders. Although builders selected timbers with sufficiently strong cross sections from the earliest times, they could not accurately establish the forces acting on the connectors, nor the load-bearing capacity of the connectors themselves. It was only in the twentieth century that new types of connectors – so-called engineered connections – were tested and reliable pronouncements could be made. Thanks to subsequent developments and progress in connection engineering, an unprecedented variety and quantity of engineered timber structures are now available.

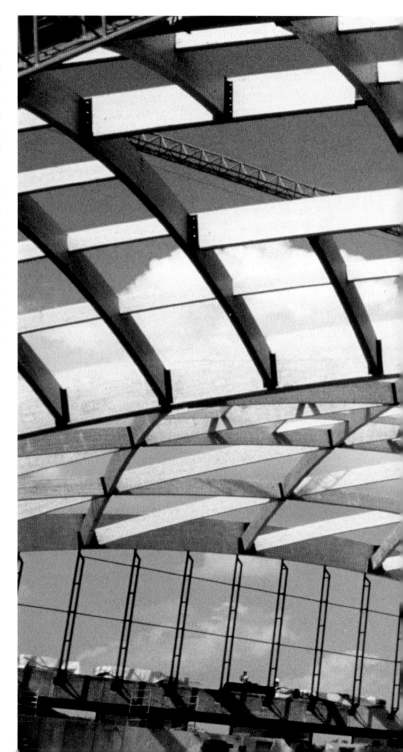

The vaulted roof surface (25,000 m²) of the National Sport and Cultural Center that opened in Kirchberg (Luxembourg) in 2002 is supported at nine points only. The basic element of the spatial structure is the triangle in which the single bar is connected stiffly in a node using the BSB connector system developed in Switzerland.

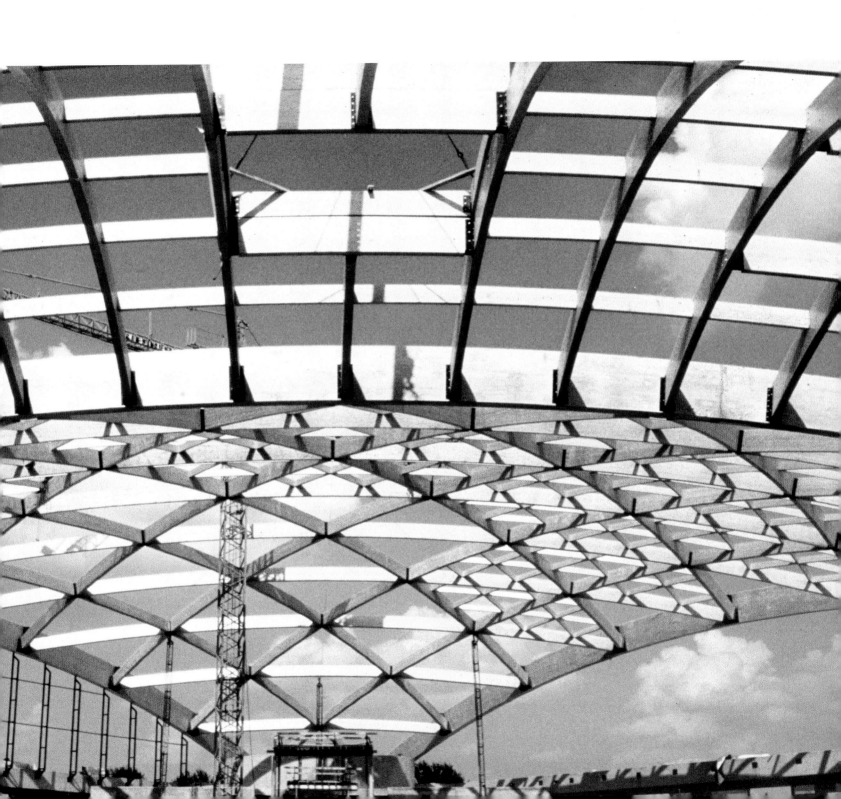

Custom-Built Load-Bearing Systems

Builders of wooden structures are repeatedly faced with the decision of which type of connections to use. Only when they join large sections and connect bars to trusses can they transcend the natural limitations on the dimensions of wooden structures and build larger spans.

With wood, the obvious approach is to transfer forces via compressive contact. Over the centuries, a great variety of handcrafted connections have arisen: mortises, step joints, notched joints, scarf joints, etc.

Connections subject to tensile forces have been a special challenge to builders throughout the ages. From the very start, the development of engineered timber construction had to come to terms with the limited transferability of tensile forces. Two approaches have played a distinct role here. One attempted to optimize connections with skilled craftsmanship and ingenious structures. The other developed custom-built load-bearing structures designed to overcome the problem of low connecting strength. Regardless of the approach taken, the type of tension joint required has played a decisive part in the design and development of trusses.

The ridge beam in the roof truss built by Jakob Grubenmann in the church in Grub (Appenzell Ausserrhoden Canton) was designed as a hanging truss. The forces in the truss, which spans over 20 meters, are primarily transferred via pressure. The tension elements (string pieces and king posts) essential for equilibrium are structurally connected via connections in compression.

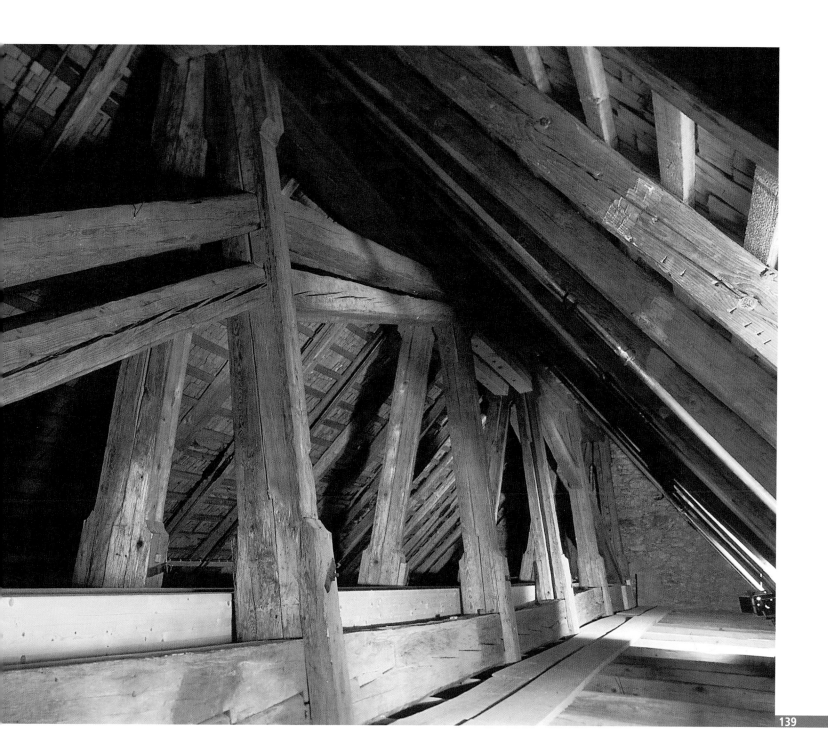

Engineered wooden construction dates back to a time when steel was not available as an auxiliary material for connectors. Wood on its own can transfer only compressive forces without difficulty. Consequently, highly skilled builders with an excellent knowledge of materials and good structural sense developed special truss forms.

The hanging truss, composed of braces, bars in compression, king posts and string pieces, is typical of this type of load-bearing system. The loads are transferred in such a way that the transitional points, which have to bear considerable loads, absorb the forces of compression while those bearing the lesser loads absorb the tensile forces. The "impossible" tension connection is transformed into a compression connector through the local redirection of the tensile forces through the step or scarf joints. The tensile force has been transformed into a force in compression.

In the 30-meter span bridge built by Hans Ulrich Grubenmann in Kubel (Appenzell Ausserrhoden Canton) in 1780, tensile forces are transferred by means of compression in the form of a wedged dovetail joint.

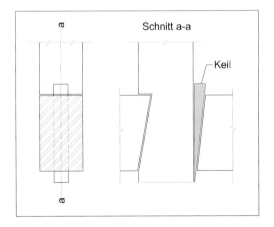

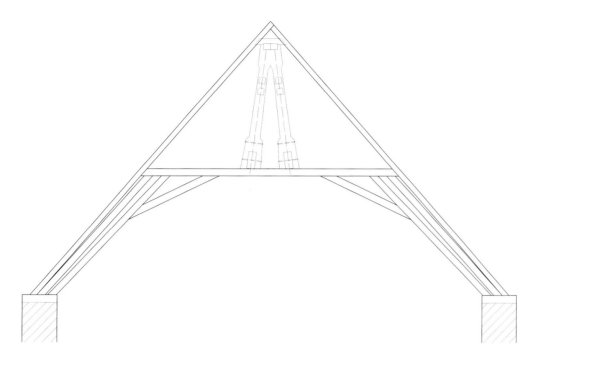

The main load of the roof designed by Jakob Grubenmann in 1752 for the church in Grub is not transferred by a truss system to the side walls, as was standard procedure at the time, but by a 20-metre-long ridge beam, which absorbs the load of both the upper part of the roof and the ceiling and transfers it to the gable masonry walls. This "ridge purlin", made of bars, is shaped like a five-sided polygon. The single bars are connected by means of step joints to form a truss. The two-part king posts are connected to the string pieces by means of a "vertical step joint," thus employing structural means transforming the tensile force into force of compression.

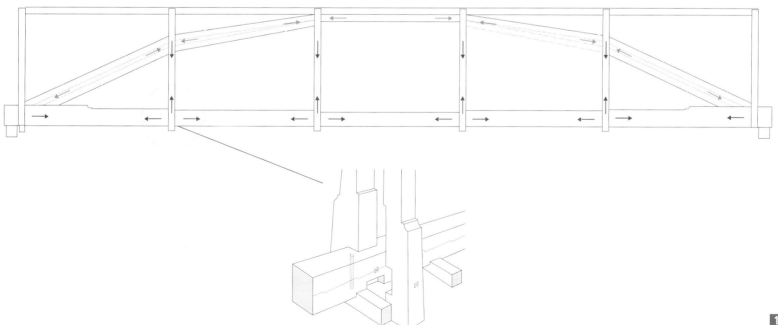

The limited transference of tensile forces led US engineers to design interesting types of trusses specifically for construction in wood. The immediate impetus was probably the insufficient skill of local craftsmen. Engineers simplified manufacture by consciously reducing the number of components to include only elements that occurred repeatedly in a single construction, an innovation that was also reflected in the price.

Ithiel Town (1784–1844), USA, for instance, developed a system based on the low efficiency of the tension joint. The close arrangement of the bars between two parallel upper and lower chords forming a lattice truss meant that the diagonal connections were relatively weak. The great advantage of the latticework was that it used smaller sections and lengths. Inspired by travel reports by Carl Culmann (1821–1881), a former professor at the ETH Zurich, Swiss builders recognized the advantages of these systems and used them to create unsurpassed structures.

With its filigree design and perfect craftsmanship, Rotenbrücke Bridge, built near Teufen in Appenzell Ausserrhoden Canton in 1862, is one of the most charming surviving examples of Town's mode of construction in Switzerland. The bridge has a span of 16.3 meters and the lattice infill is connected to the two chords of drift pins.

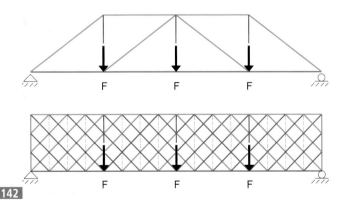

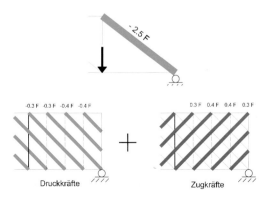

Druckkräfte Zugkräfte

Town replaced the simple and coarse-meshed infill based on the hanging truss with a fine-meshed lattice. The crisscrossing bars and their close arrangement considerably reduced the forces in the individual bars, so that the bearing reaction (especially the tensile force) of the individual elements was relatively small. Applying this method, tension connections once difficult to make can now be accomplished using simple structural solutions.

William Howe (1803–1852) solved the connection problem with a brilliant structural system: by adding prestressed iron king rods, Howe was able to avoid all tensile force in the connection. The tensile force in the individual struts was now bridged by the prestressed steel rod, and the troublesome tension connections were transformed easily into a connection under compression.

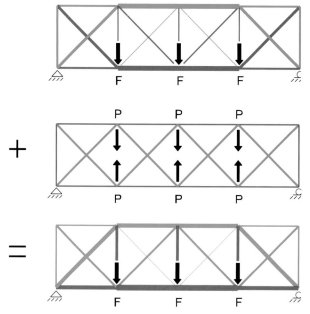

Howe's principle: the unavoidable tensile forces under the vertical loads in the lattice truss are bridged by pretensioning the iron rods. They are thus transformed into compressive forces.

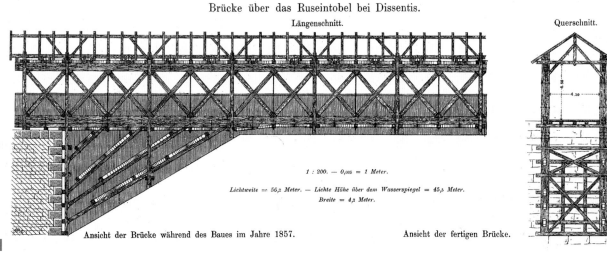

Brücke über das Ruseintobel bei Dissentis.

Längenschnitt.

Querschnitt.

1 : 200. — 0,005 = 1 Meter.

Lichtweite = 56,2 Meter. — Lichte Höhe über dem Wasserspiegel = 45,5 Meter.
Breite = 4,2 Meter.

Ansicht der Brücke während des Baues im Jahre 1857.

Ansicht der fertigen Brücke.

This bridge, which was built in Val Rusein over the brook between Somvix and Disentis (Graubünden Canton), is one of the most daring and finest examples of Howe's construction work in Switzerland. Its remarkable span of 56.3 meters was achieved using simple craft techniques.

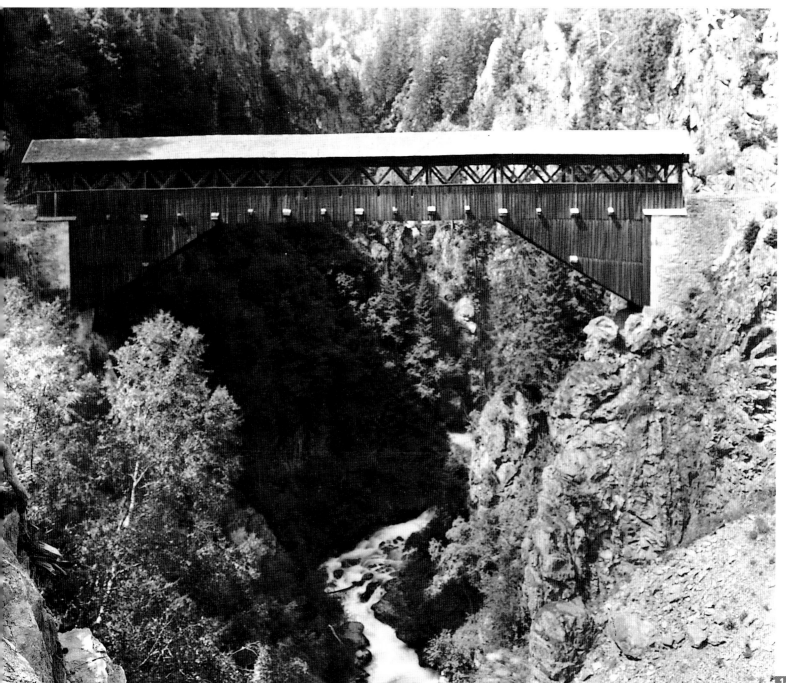

Connectors

The low shear strength of wood greatly reduces the strength of carpentry joints. This in turn affects the overall design of structures and encourages the use of bulkier forms. The appearance of new and stronger building components was a great step forward and turned out to be crucial for the development of new types of connections. The connector was invented!

Connectors made it possible to increase the local concentration of forces, thus permitting the construction of smaller – and stronger – connections. In addition to the choice of material and the manufacturing process, the eventful and involved procedure of making each individual connector was intended, above all, to ensure a balanced distribution of loads and to optimize the longitudinal compressive resistance in the wooden components that had to be joined together.

After suitable milling machines and drills were developed in the early twentieth century, carpenters were able to make round cuts and holes in wood with great precision and ease. Furthermore, steady progress in steel production meant that products could be manufactured in series cheaply and with great dimensional accuracy. These developments heralded a shift from rectangular to round connectors that were made of steel instead of hardwood. The mechanical connector had arrived!

On the basis of the Kübler disk dowel, the Swiss company Locher & Cie, Zurich manufactured one of the first split-ring dowels, whose behavior was methodically tested on a scale of 1:1. The test results provided the basis for the ring's subsequent design and dimensions.

Hardwood (deciduous wood) has a far greater shear strength than normal construction timber (pinewood). Bearing this in mind, builders began to replace mortises, notched joints and scarf joints with new elements in the form of rectangular hardwood dowels, which were sunk half their length into the wooden components they were intended to connect. This procedure simplified and made transparent what had hitherto been a complex process requiring considerable craft skill. It also greatly shortened production times.

At the beginning of the twentieth century, when iron became available at reasonable prices, metal connectors replaced hardwood dowels. The stronger material permitted the development and manufacture of more slender connectors. Flat iron plates were now bent to form U- and V-shapes and inserted into chiseled grooves, thus replacing hardwood dowels.

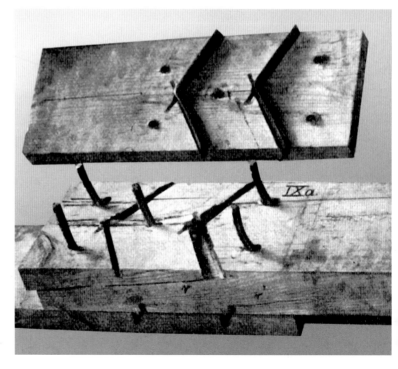

The use of V-shaped iron plates as dowels in place of the wider, rectangular oak dowels resulted in stronger and shorter connections.

Using a rectangular hardwood dowel as an additional connector, craftsmen were able to make a tensile splice for a roof-truss balk in a simple operation.

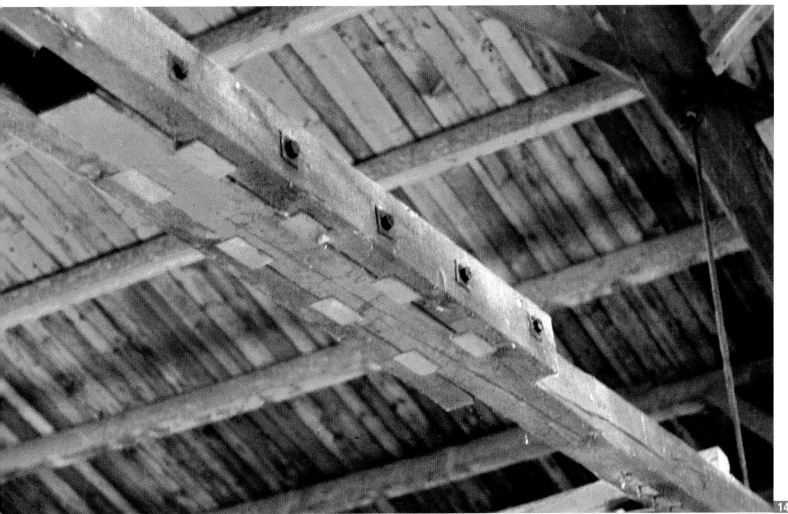

The emerging iron industry was able to supply carpenters with small machined parts ("connection aids") which facilitated the design and construction of connections. For the first time, connections could be standardized. This, in turn, broadened their range of technical application. Scientific methods and theories were developed to establish the load-bearing capacity of these new types of connectors. The new methods replaced the traditional and customary practice of measurement based on experience.

The new approach to producing connectors mechanically with the aid of mass-produced steel elements inspired builders and also triggered the development of a host of new connectors. The rectangular wooden dowel, for instance, gave way to the round dowel, which was, in turn, replaced by the steel ring: the so-called joint ring. The enthusiastic response to these new developments climaxed in the 1920s and 1930s when over sixty patents were registered for these types of connectors.

A particularly important role was played by the Rigling company and the Swiss firm Locher & Cie, Zurich. Drawing on experience gained with the doubly coned dowel (manufactured by Karl Kübler AG, Stuttgart), Locher & Cie was one of the first companies to manufacture the joint ring, which it patented under the name Holzkonstruktion System Locher & Cie, Locher joint ring dowel, in 1928. The two halves of the cast-iron ring grip the two connected pieces of wood, thereby transferring the bulk of the forces through the contact surfaces under compressive force. These connectors were used a great deal and produced efficient load-bearing structures as well as remarkable trusses.

The development of the dowel prompted research on an unprecedented scale. Detailed tests on tension joints provided a wealth of information on the load-bearing capacity of joint rings (the illustration shows the range of iron rings produced by Hoch- und Tiefbau AG Interlaken). The additional load tests carried out on lattice girders on a scale of 1:1 were standard procedure and provided the basis for building regulations governing the use of these types of connectors.

The airplane hangar in Dübendorf (Zurich Canton) was one of the first buildings in which the roof truss was built using the joint rings developed only a short while before by Locher & Cie, Zurich. The longitudinal beams had a span of 30.5 meters while the transverse beams spanned 28.5 meters.

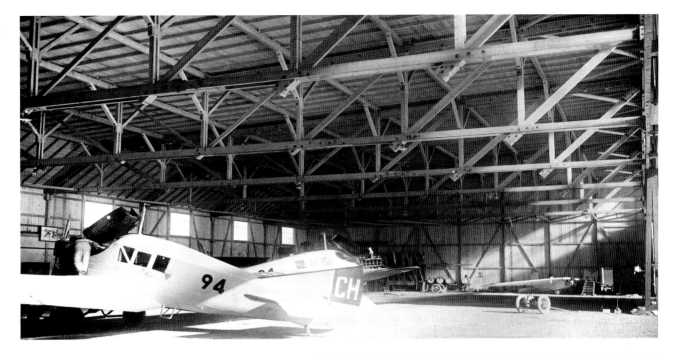

The roof truss of the hall built in Zurich Seebach in 1948 was constructed using Rigling dowels and had a span of 20 meters.

From Nail to Connector

Of all the connectors used by carpenters, the oldest is probably the nail. Although or precisely because it is so widely known and taken for granted, the nail – until recently, that is – was generally consigned to a subordinate role: it merely held things together and was not considered a structurally important connector in its own right. Hence, the nail, which is the easiest connector to use, was simply not considered suitable for transferring powerful forces.

After scientific tests around 1925 demonstrated its reliability, load-bearing capacity and stiffness, attitudes began to change and the nail finally established itself as a bona-fide engineering connector. With the shortage of materials and skilled labor during the Second World War, building constructors began to use nails on a wide scale, and they appeared in some highly regarded and very impressive structures. The crisis years are now considered the heyday of the nail's use in timber construction. In the meantime, the nail has lost much of its former glory as a connector for engineered structures, even though it has recently provided the basis for the successful development of special kinds of connectors and other uses.

When materials became scarce in the areas of steel and solid construction during the Second World War, nails, which are economical on resources, became popular as connectors in building construction and were used to build some impressive structures.

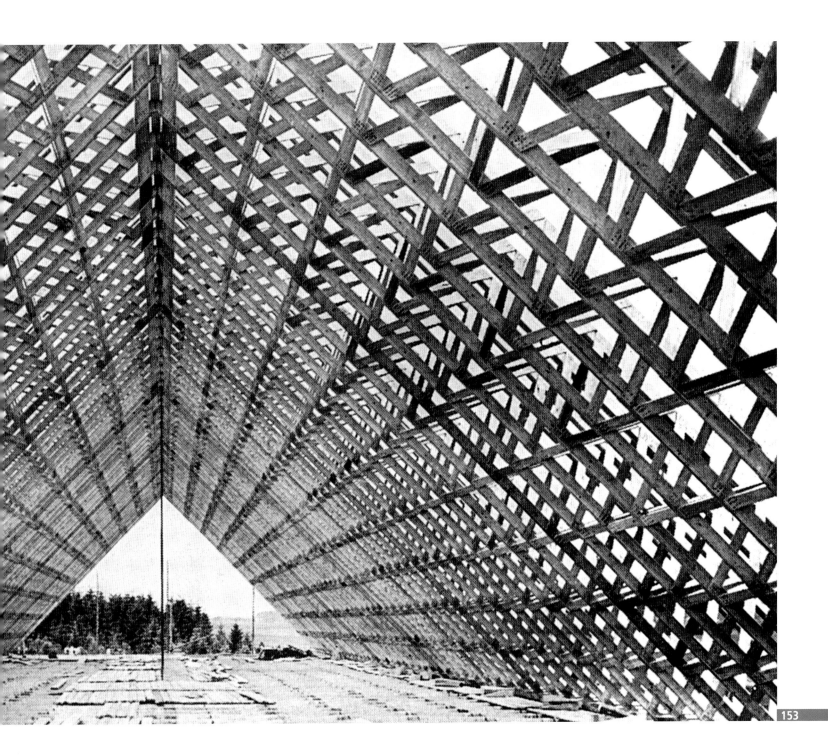

The nail allows carpenters to join small wooden sections with great ease. Using nails, they can make efficient and inexpensive frame structures with a modest degree of skill and without the need for additional components. The nail's characteristic structural feature is its slenderness. This not only limits its structural impact on the wooden element to be connected but also the connectable volume. In bar connections this allows the desired even distribution of forces, which obviously can only be obtained using a large number of connectors.

The load-bearing behavior of nail connections has been tested experimentally not only on single components but also on constructed trusses. Such tests not only allow technicians to verify design guidelines but also to evaluate how the structural design of the details influences the behavior of the structure as a whole.

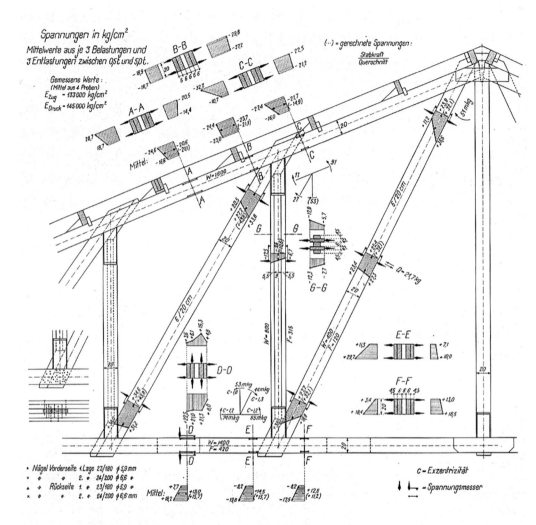

This "flat" bar joint connection, incorporating a group of nails, clearly ensures end restraint. The EMPA measured the deflection in the bars of a roof truss in a warehouse on Brüningstrasse, Lucerne, in 1938–1939, and confirmed the (suspected) existence of moments of secondary flexion.

During the Second World War, a large number of buildings were constructed as nailed structures. The warehouse in Brüningstrasse in Lucerne, is a typical example. The roof truss and the supports were executed as nailed truss sections and the roof was covered with Eternit corrugated sheets. Two rails run along the lower truss chord, allowing a crane bridge with a 3-ton trolley to travel the entire length of the warehouse (60 meters).

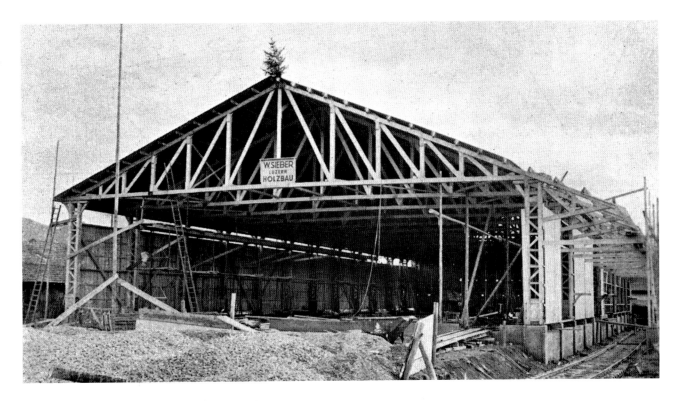

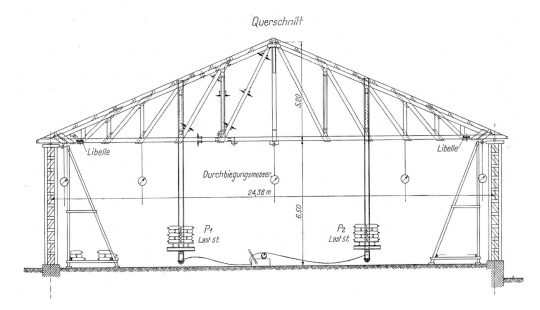

The EMPA conducted static load tests to investigate the load-bearing behavior of the nailed roof truss. The working load, which comprised the combined loads of snow and the crane, was simulated by putting pieces of steel and sacks of cement on a platform hanging from two intersection points on the upper chord.

In the course of time, it became possible to calculate the nail's performance accurately. This fostered the development of new trusses and section designs, which also meant that innovations in glued laminated beams became very important. Builders could now use nails to join small timber sections and create solid beams covering long spans. However, this process was rather labor-intensive. This method provided an alternative to the truss girder and rekindled interest in Town's use of connectors.

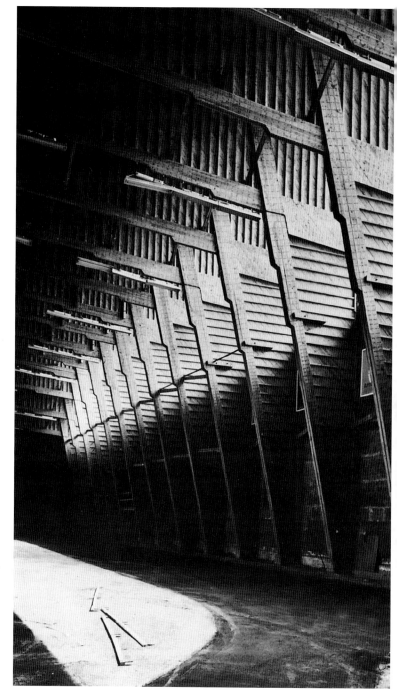

Renowned architects found the idea of designing structures with the new form of the "closed" truss very challenging. In 1950, Alvar Aalto designed the truss for the Helsinki Olympics Sports Hall, using solid nailed trusses to create an impressive piece of architecture.

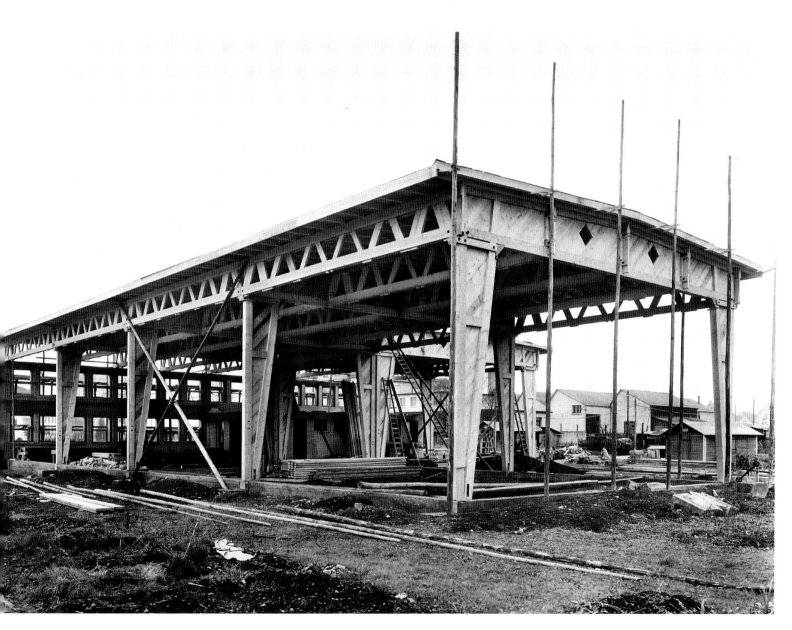

Trusses and nailed-laminated web beams as supports form the two-hinge frame of the main truss in Küderli & Co's warehouse and factory building in Zurich. The purlins have been executed as nailed trusses.

In nailed trusses, the beam is composed of two rows of crisscrossing diagonal boards. The two sections are nailed at short intervals to connect the beam and the multi-layered longitudinal chords.

During the Second World War and the postwar years (when jobs were being created and there was a widespread scarcity of materials) this labor-intensive approach was willingly adopted as it seemed to be the most sensible solution.

Owing to its lattice-like structure, the solid section, which is made of boards, is reminiscent of Town's trusses. In the case of the nailed truss, the forces that are to be connected are distributed along the entire length of the chord. Consequently, the design succeeds in reducing the forces at the connection, making this very simple mode of construction structurally very efficient. Improvements in connector technology, especially in the area of adhesives, gradually made this labor-intensive and relatively inefficient mode of construction redundant.

The load-bearing structure of the Dätwyler AG cork warehouse, built in Altdorf (Uri Canton) in 1954, shows the synchronized juxtapositioning of two different types of sections in nailed constructions. In an area primarily subjected to bending loads, the truss has been designed as an open latticework structure. In the load-bearing zone, in contrast, the builder has used a solid section. The supports, made of nailed lattice beams, follow the same principle.

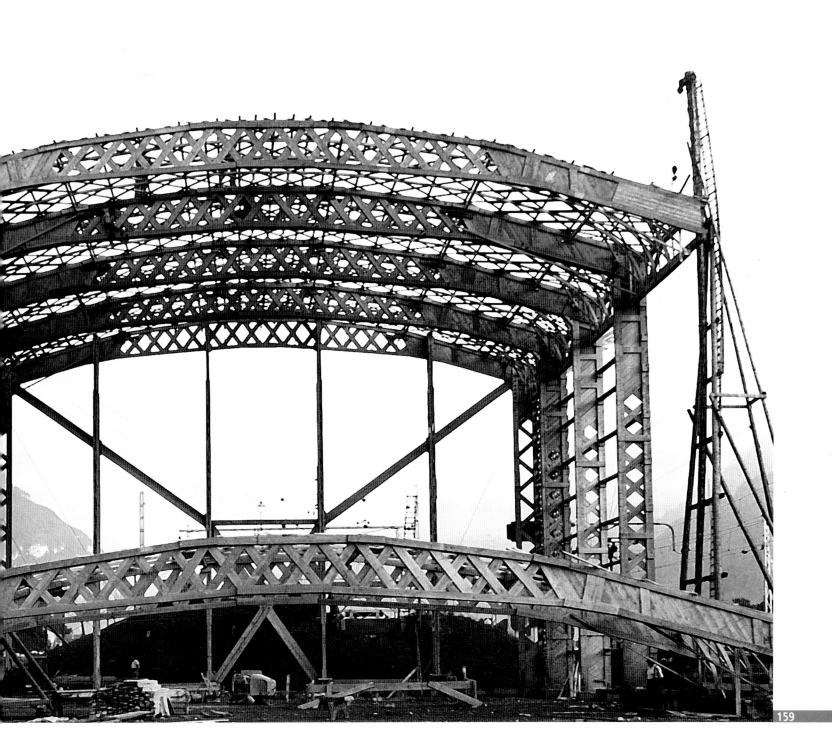

Though the nail has lost much of its former importance as a connector in engineered trusses, it has in recent years provided the basis for the successful development of special connectors and usages. The pressure to rationalize has produced different kinds of nail plates. Other developments also exploit the nail's ability to transfer forces favorably and equally. Greim's use of the nail to create multiple-shear connections in construction work provides an impressive example of this.

Walter Greim (Munich, Germany) recognized the limitations of the traditional approach to nailed constructions at a very early stage. Impressed by the irresistible simplicity of nail connections, he concentrated his tests and proposals on improving their efficiency. Starting with thin steel plates nailed onto wood, he finally arrived at multiple-shear wood/steel-plate connections. What distinguishes these connections is the fact that the nails are driven through three or four plates without requiring any predrilling. Unfortunately, the standard nails of Thomas steel wire available at the time were not suitable for this purpose. As a result, Greim had special nails made of superior grade Siemens-Martin steel for his "wood-steel constructions." In Switzerland the spread of Greim's building approach is closely associated with the name of the engineer Hans Banholzer of Rothenburg (Lucerne Canton). Many of his trusses, which are exemplary in design and structure, testify to the efficiency of this type of connection.

Greim's suggestion to improve nail connections by using them as multi-shear connections has meanwhile become well established and has resulted in the construction of some remarkable supporting frameworks, such as the roof truss (spanning 26.4 meters) of this sports hall designed by Banholzer in Ebikon (Lucerne Canton) in 1974.

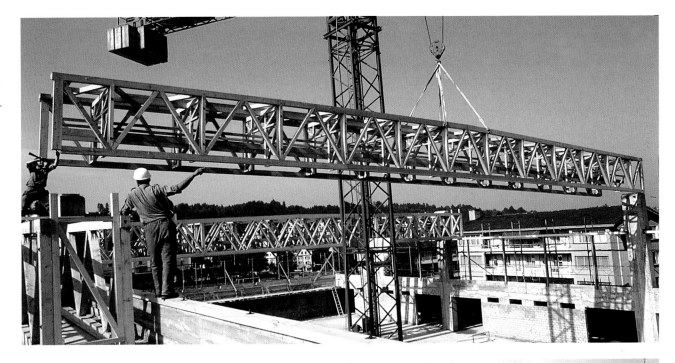

The principle behind Greim's approach:
The nails are driven directly – without holes being predrilled – into the thin gusset plates (1.00 mm to 1.75 mm) placed in the sawn grooves.

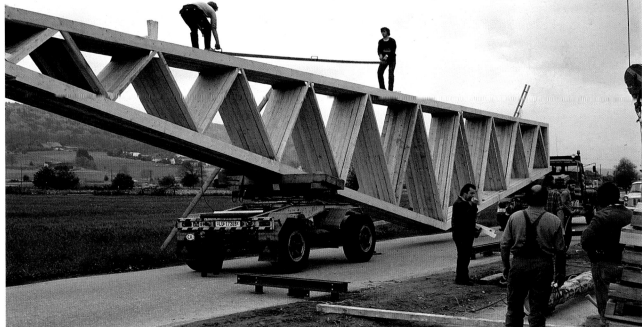

Willi Menig (St. Gallen) and his nail plate (the so-called Menig nail plate) occupy a special place in the field of nail connections.

Menig's nail plate was inspired by the twin-shaft nail. His fine wire nails, which are 1.6 mm in diameter and pointed at both ends, are driven half their length into the two wooden elements that are to be connected. To ensure equal penetration at both ends, the nails, which are set out alongside one another at short intervals, are connected at the center of their length by a three-ply artificial resin sheet. In conjunction with board sections, Menig nail plates can be used to make efficient supporting frameworks.

Willy Menig (St. Gallen) conducted his own experimental tests to verify his theories about the load-bearing behavior of Menig nail plates.

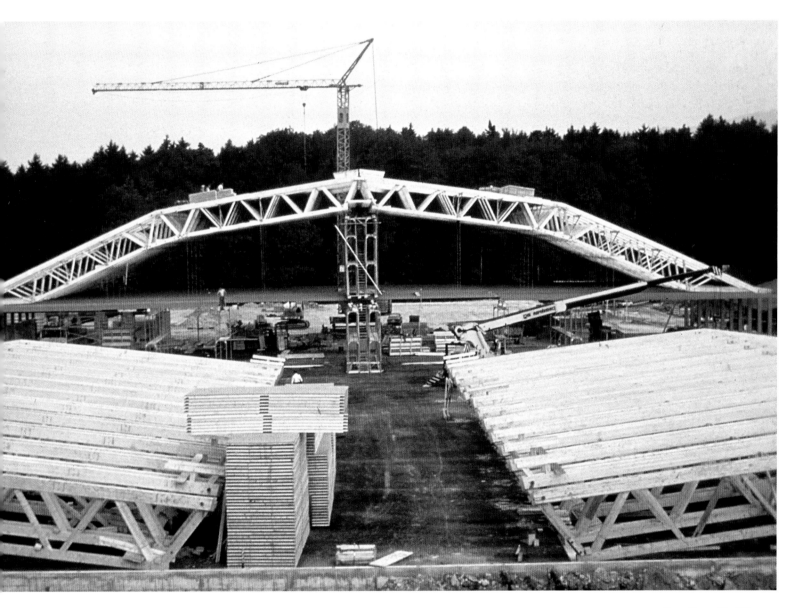

The roof truss of the CCA wholesale market in Jona (St. Gallen Canton), which was completed in 1974, has a span of 60.4 meters. It is an impressive example of the efficiency of structures built using Menig nail plates.

The nailed hinge-pin, which was introduced by Julius Natterer (EPF Lausanne), is designed for connecting large sections. Even though the hinge-pin uses a nail of greater diameter – normally 4 to 6 mm – it also exploits the equal transfer of forces to the benefit of the timber structure. The centric arrangement of the nailed hinge-pins thus transfers the connecting forces via the steel plate by means of the nails so that they spread extensively along the wood. The result is a connecting system that allows the connection of relatively large forces by relatively simple means. Breathtaking supporting structures can be created in this way.

The construction and operation of a nailed hinge-pin showing the site connection of a truss joint and tension chord composed of two members.

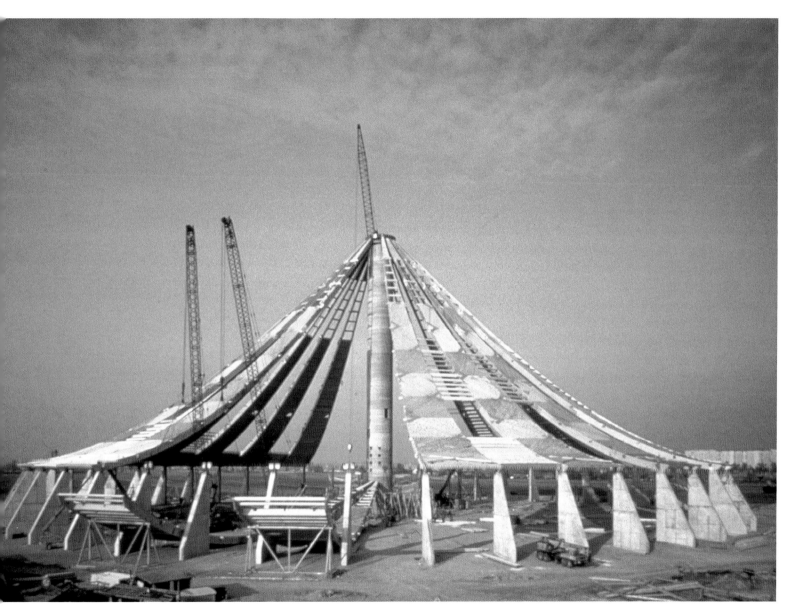

Nailed hinge-pins were used to construct the tension connection at the end of the 101-meter-long suspended ribs of the Vienna recycling hall designed by Julius Natterer in 1981.

Architect:
L. M. Lang, Wien
Engineers:
E. Janubec and F. Meneik, Wien
Timber engineer:
J. Natterer, Lausanne;
Dittrich, Munich

The Decisive Development of Multiple-Shear Connections

The development of engineered timber construction is closely linked to progress in connection technology. At the beginning and in the middle of the last century, two engineers – Paul Metzer (Darmstadt, Germany) and Konrad Sattler (Graz, Austria) – paved the way for the multiple-shear use of screw-bolt connections. The principle is simple: a connector (a cylindrical rod) is fixed firmly in a predrilled hole and transfers its forces perpendicularly to its axis. (The rod is generally made of steel, but sometimes a different metal – or even wood – is used.) Such connectors sometimes take the form of bolts, although nails passing through predrilled holes also serve this function. As the pin is slender in relation to its length, its effect on the surrounding wood is limited. The desired increase in efficiency is obtained by using a large number of connectors of the same type with wood of thicknesses that compensates for their slenderness. The wooden section to be connected is cut into a number of single sections or provided with sawn grooves into which stay plates or gusset plates are inserted.

The development of multiple-shear screw-bolt connections or bolted connections was a milestone in the history of timber connections. In Switzerland, pioneering contributions have been made by the ETH Zurich, as names such as Ernst Gehril and Hermann Blumer testify.

Recent research on and substantial developments in multiple-shear bolted connections have made them the most efficient types of connections in timber construction. This work has contributed greatly to improving the competitiveness of engineered timber construction.

Inspired by riveted iron structures, Paul Meltzer (Darmstadt, Germany) developed a method, around 1910, of using press-fit dowels to construct timber frameworks. His cylindrical pins of extruded steel were modeled on the rivet. The wooden elements that are to be connected are overlapped so that the pins form a shearing connection that transfers the forces.

Stunning structures have been built in this way. However, Meltzer could hardly have imagined that his method, based on "iron structures in timber," as he puts it, would lay the foundations for future developments in connector technology.

Another decisive step was taken by Konrad Sattler (Graz, Austria) in 1948 with his proposal to improve connections by inserting additional gusset plates. This measure increased the compressive strength of the junctions and, by making use of multiple-shear connectors, made it possible to transfer much greater forces. This created the basis for multiple-shear bolted connections that are used so successfully today.

In 1948, Sattler carried out tests on a butt joint with two steel plates placed between each board. This marked the birth of multiple-shear connections. Additional steel plates consisting of truss plates or butt straps, used in conjunction with bar-shaped connections, considerably increase the resistance of the connections, equalizing joint forces in the gusset plate and not in the wood. Furthermore, this approach eliminates unfavorable transverse loads in the wood, since the forces are now transferred parallel to the grain, which is the optimal solution. The advantages of multiple-shear connections are obvious: the metal plates placed either between the boards or in sawn slits transfer the forces far more evenly and allow for more compact connections.

These 125-metre-high wooden broadcasting towers were erected in Wiederau near Leipzig in 1932. The connections were made using press-fit dowels (so-called Meltzer-Stifte with a diameter of 10, 12 and 17 mm. A total of 28,520 dowels were used in each tower).

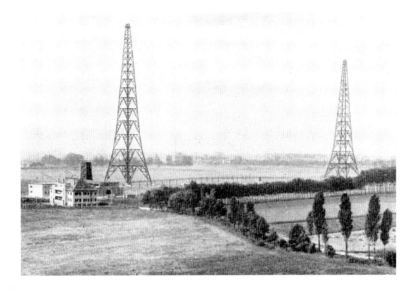

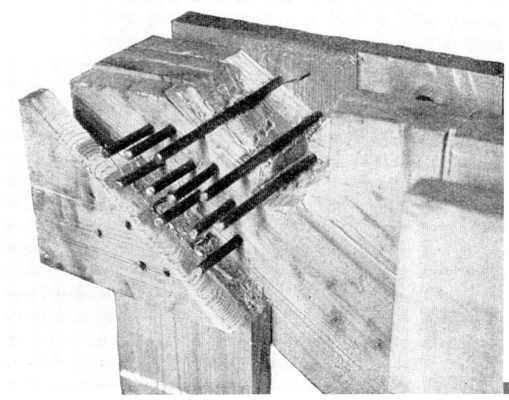

This exposed framework joint shows the principle behind the Meltzer construction method: thin steel bolts with press-fit dowels connect the wooden planks at the joint.

Recently, there has been a revival of Sattler's idea of using the multiple-shear connections. It is based on the insight that the resistance of a connection depends on the way the forces flow at the connection. The design aims for a uniform transfer of force with minimum disturbance and maximum efficiency. The multiple-shear wood-steel connection comes very close to fulfilling these requirements.

Proceeding from Sattler's idea, the ETH Zurich conducted thorough tests with the aim of optimizing this connection. It arrived at some significant results, the most important being the development of high-strength steel bolts and designing the geometry of the connection to achieve ductile load-bearing behavior. The tests also revealed the importance of ensuring that the bolt is slender in relation to equalizing the forces by means of plastification and ensuring the connection's overall ductility.

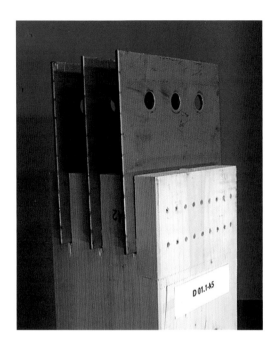

Detailed theoretical analyses aiming to optimize the connection's design were verified in many tests on tensile connections at the ETH Zurich.

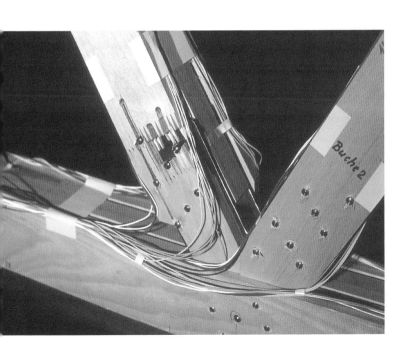

Tests were carried out on a tensile connection to establish how it is affected by its structural environment. In this context, the behavior of the connection in framework joints was also experimentally tested and analyzed.

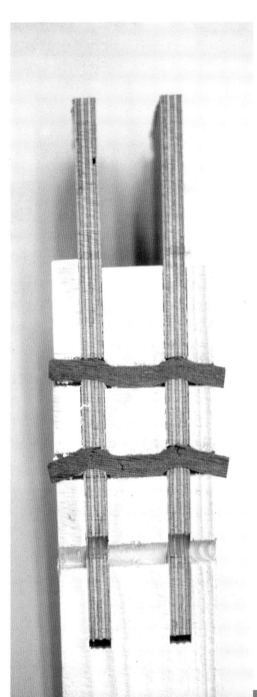

This illustration of the cross section of a connection made of plywood gusset plates and hardwood bolts demonstrates the principle of equalizing forces locally by plastifying the connectors.

Further work was done to develop multiple-shear wood-steel connections with steel dowels. The goals were to optimize load-bearing behavior, produce components economically and standardize their dimensions.

The research conducted by Ernst Gehri at the ETH Zurich in the 1980s and the work of Hermann Blumer (Waldstatt) led to qualitative improvements in multiple-shear bolted connections. They paved the way for the now widely accepted BSB system (Blumer-System-Binder) frame. No other mechanical connectors can compete with them when it comes to resistance, planning and manufacture.

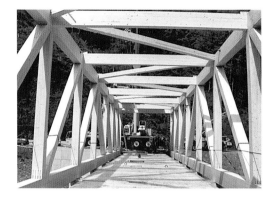

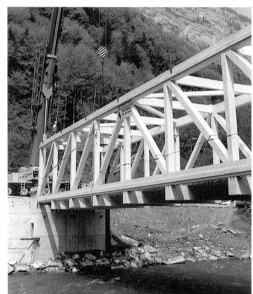

Optimized multiple-shear bolted steel-wood connections allow for the construction of supporting structures with large spans and have also opened up new fields of application for timber engineering work such as bridge building. This example shows both the load-bearing structure of the Selgis Road Bridge, which was built over the Muota in Schwyz Canton, in 2001, and the main trusses of the Gurlaina Sports Hall, built in Scuol in Graubünden Canton in 1998.

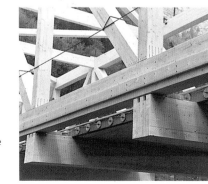

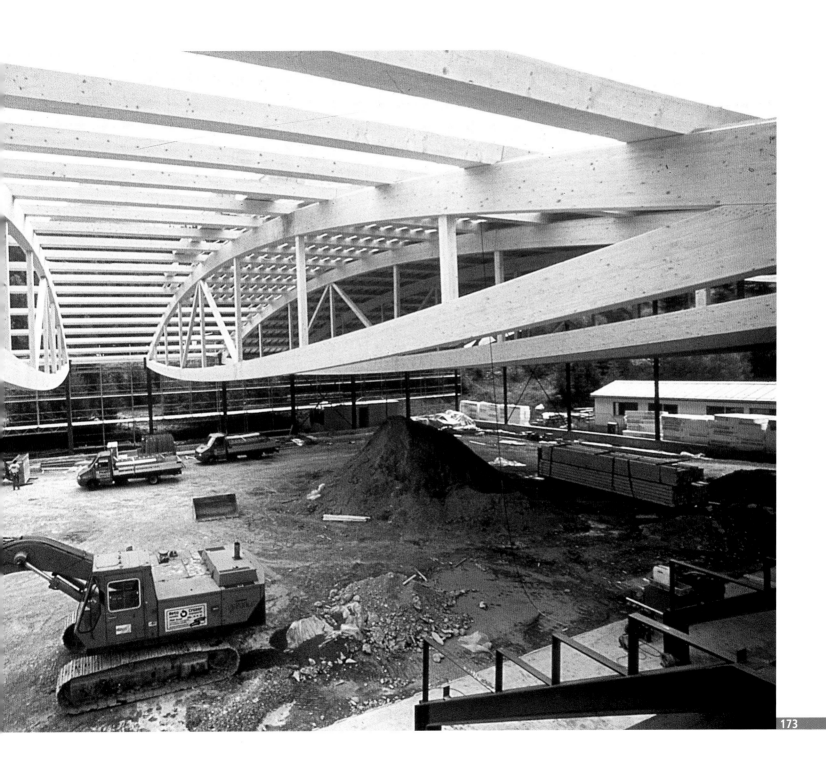

On the basis of research into multiple-shear bolted connections, the ETH Zurich developed a joint system employing standardized connections and bar cross sections for the construction of space frames.

A cast, fork-shaped splice piece, a high-strength screw and a forged steel ball form the heart of the node. This was the first time that glued sections of beech were used for bars bearing heavy loads. This formally and technically elegant solution compensates for the lack of space at the node, which is a geometrical feature of space frames. Beech's greater density and load-bearing capacity allows for more slender bar cross sections and permits greater forces at the node than would be the case using the standard softwood solution. The theoretical analyses were backed up by intensive tests on the load-bearing capacity and stability behavior of the space frame. Thanks to this work, space frames can now be built in wood on a scale that people had previously thought only possible with steel.

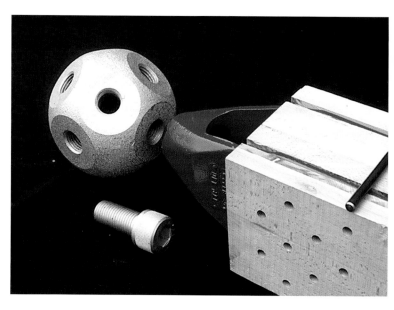

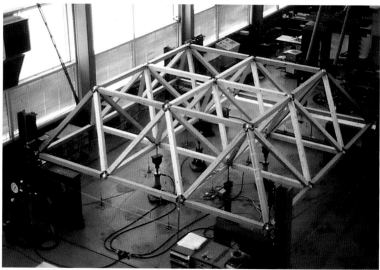

The node design principle in space frames: the steel node ball, high-strength screw, forged connecting fork, high-strength bolt and wooden bar.

Experimental setup (1982–1983) for a space frame section on a scale of 1:1 at the ETH Zurich. The experiment was designed to verify the frame's load-bearing and deformation behavior.

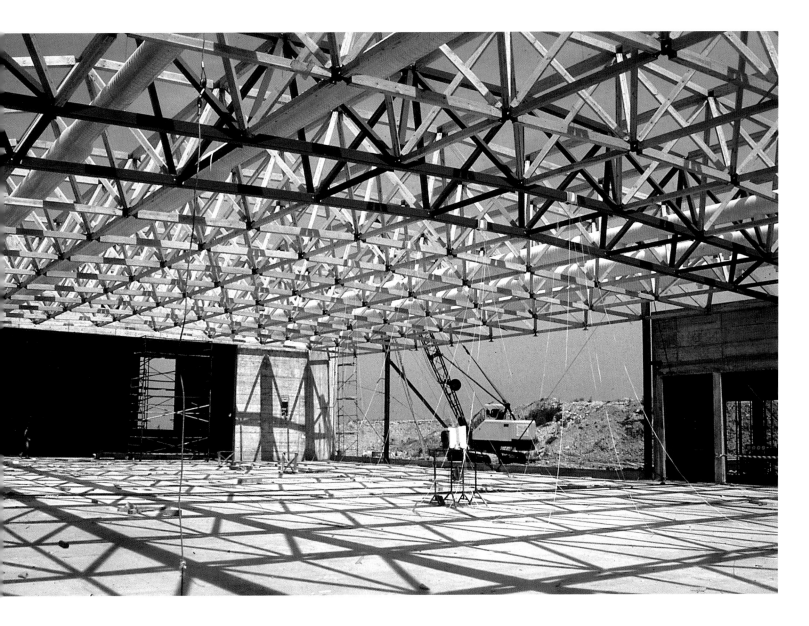

A space frame used as a roof truss at Arbon Seepark (Thurgau Canton). The load-bearing frame, which spans an area of 27 x 45 meters, was assembled on the ground from 1,284 industrially prefabricated bars to create a space-frame truss with a mesh size of 3 x 3 meters. It was erected to its full height within a few hours. (Construction year, 1984)

Architects:
O. Haas et al., Arbon
Engineers:
Wälli AG, Arbon/Rorschach

Manufacture and Assembly

The efficiency of any type of connection is judged not only by its resistance, but also by whether it can be manufactured industrially at a reasonable cost. There are still many different ways and means of processing wood in the construction sector, ranging from traditional craft methods to highly industrialized and automated manufacturing processes.

The relocation of construction from the building site to the factory and the greater ease with which ever larger timber cross sections can be connected efficiently are leading to changes in the types of connections available on the market. The construction of bigger buildings with greater spans calls for new connection designs in which components can be conveniently broken down into smaller elements suitable for transport and assembly.

In no other area of construction are manufacturing processes as completely mechanized as in timber construction and, above all, in the production of connectors. Hence, the CNC controlled drill, which was specially developed for BSB connections and allows the high-precision drilling of bolt holes, is part of an almost fully automated planning and production chain.

The production of multiple-shear bolt connectors is almost completely mechanized and extremely efficient, although the costs are correspondingly high. With this in mind, the self-drilling bolt was developed in cooperation with industrial companies such as SFS-Stadler AG so that small and medium-sized timber-construction companies could use these powerful connectors, too. (This development was initiated by the ETH Zurich.) The end of each bolt now has a special tip so that it can be driven through preassembled pieces of wood and an inserted steel gusset plate in a single operation, without any additional preparation or predrilling.

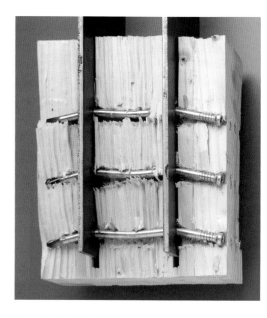

The recently developed self-drilling bolt has two distinguishing characteristics: the hi-thread and the tip. The hi-thread not only ensures that the bolt remains firmly in place but also makes it possible to unscrew it at a later date (for the purpose of disassembly, for instance). Furthermore, the bolt's specially designed tip means that it can be used in both wood and steel without any risk of the bore chips in the steel plate widening the drilled hole in the wood. It thus ensures a tight fit. Self-drilling bolts can be obtained from trade merchants in diameters of 5 mm and 7 mm, and in lengths varying from 73 mm to 193 mm, and 113 mm to 233. These bolts can be used to drill through a maximum of three steel plates with a thickness of 5 mm. The 7 mm bolts will even pass through steel sheeting 10 mm thick.

The load-bearing behavior of connections made with self-drilling bolts has been analyzed theoretically and tested experimentally. As the illustration shows, the desired ductile behavior can be achieved if the bolt has a suitable degree of slenderness and the geometry is right. The bolt (and not the wood) fails, but only after first undergoing considerable deformation.

Self-drilling bolts, like conventional multiple-shear bolted connections, can be used to make strong supporting structures without any drawbacks.

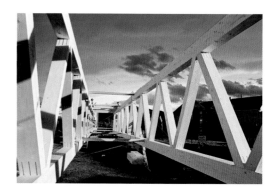

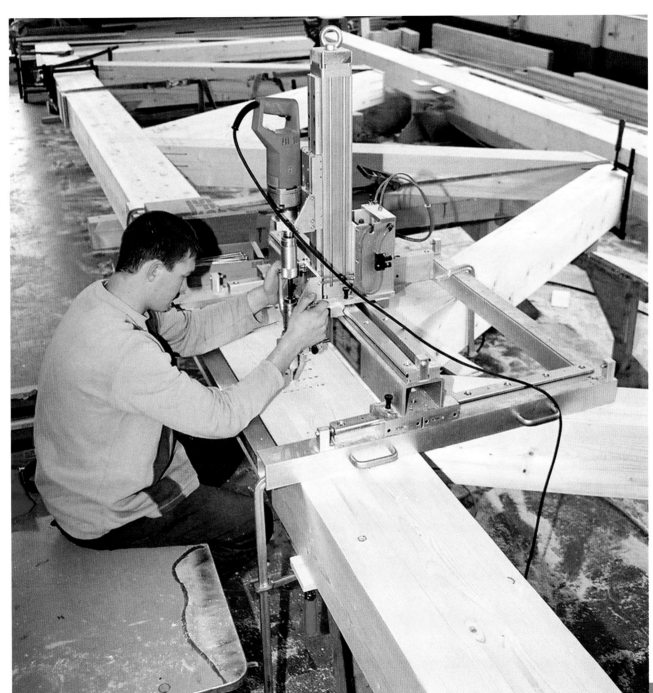

The multiple-shear connection with self-drilling bolts can be made quite economically using a simple setting tool.

Progress is constantly being made in optimizing the load-bearing behavior of multiple-shear bolted connections. Blumer, for example, has made an important contribution to the development of methods for standardizing and efficiently manufacturing cost-saving connectors. All things considered, these advances constitute a milestone in the development of connection technology.

Another pioneering contribution has been the standardization of connections and their industrial planning and manufacture, which was made possible by the development of the BSB system. For some time now, computers have been used for designing and dimensioning supporting systems and connections in a process that requires close cooperation with workshop planners. The data is sent without any intermediate processing to specially developed CNC-controlled automatic machines which cut the wood and completely process both the areas to be connected and the gusset plates. From planning to execution, all stages are fully automated. This allows for the design of complex, high-quality connections that are manufactured with great precision.

Rugged, quickly made and simple connections are also needed for assembly. The hall built in Kirchberg (Luxembourg) provides a vivid example of this. As the hall was to be a large structure, connections were needed that would absorb and transfer considerable forces. Moreover, the supporting structure had to be manufactured in elements that could be easily assembled. The BSB system offered the perfect solution, since the company's specially made hinge connections allowed for easy and rapid assembly of the component parts.

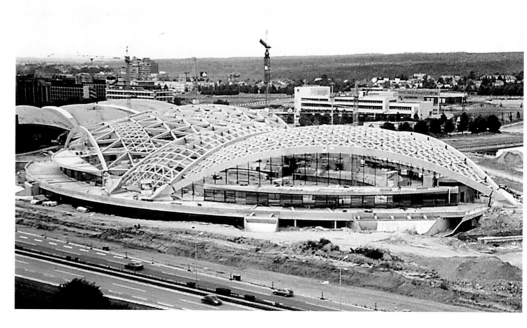

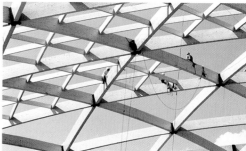

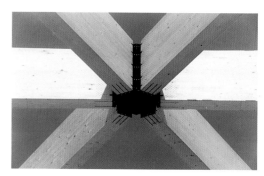

The vaulted roof top (25,000 m²) of the National Sports and Cultural Centre in Kirchberg (Luxembourg) is supported at nine points only. The basic element of the roof structure is a triangular frame in which each single bar in the node is rigidly connected using the BSB system.

Architect:
R. Tallibert, Paris
Wood construction engineer:
Ingenieurbüro Steiner, Jucker &
Blumer, Herisau

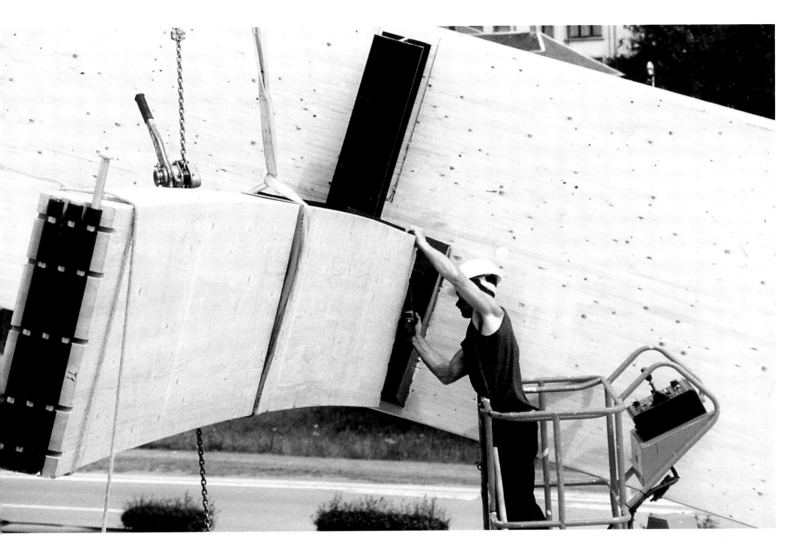

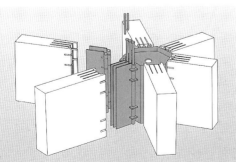

A particularly impressive and consistently designed solution in this context is the standardized BSB hinge system developed in Switzerland for easy-to-assemble connections. The prefabricated "hinge" connection with socket pins permitted smooth and quick assembly of the secondary beams at the centre in Kirchberg.

Connections are very important in wood construction. It is therefore hardly surprising that builders are constantly searching for new ways and means of connecting timber. The uses for which they are designed are many and varied. At times priority is given to structural efficiency, economic manufacture or inexpensive assembly, at others, the emphasis is on the formal design of a connection or the shape of a particular supporting structure.

The above is clearly illustrated by another development in Switzerland, which addresses the issue of transferring forces axially at the rod end, namely at the connection to the supporting frame, proceeding from the glued joint of the glued threaded rod.

The threaded rod, which is glued using a mixed adhesive with an epoxy resin base, is the key element in the Ferwood or GSA anchor system. It completes the bar connection in the supporting system, absorbing the bar force parallel to the grain of the wood and transferring it, in line with the connecting angle, against the grain into the chords. Consequently, the connector remains invisible from the outside, which – formally considered – gives the connection a furniture-like quality. The users hope to achieve connections with an effectiveness of 80 percent. Quite an impressive figure!

The diagonals of the 40-metre main roof truss over the ice rink in Neuchâtel (Neuenburg Canton) were connected to the chords by means of glued threaded rods in accordance with the Ferwood system.

The principle of manufacturing the connection is as follows: holes – bored to match the diameter and the anchorage length of the individual threaded rods – are drilled in the elements to be connected. The rods are then placed in the elements to be connected and the required resin injected into the spaces to glue the elements together. This operation demands a considerable amount of experience. Special equipment has been developed to control the injection of the resin.

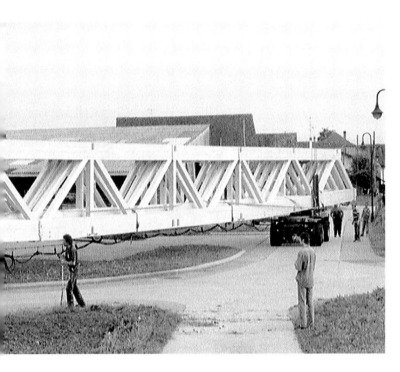

This type of connection is based on the principle that it is advantageous to transfer forces parallel to the grain by using glued threaded rods that absorb the forces as thrust, which is then transferred into the element to be connected. The truss diagonals are connected to the chord with the required number of threaded rods in the cross-sectional area.

This connection technique can be used to make relatively simple transitions between different materials as, for example, with the actuated and positive flexural connection of the main truss to the steel column.

Building Construction

With the exception of the Mediterranean region, most ordinary buildings in Europe were still being constructed of timber well into the nineteenth century. For secular buildings, wood was simply indispensable. At this time, the Swiss farmhouse was regarded as a paradigm by many master builders, who copied and adapted it to a multitude of forms throughout Europe and the USA.

Industrialization radically transformed building construction. The new products, whose properties could be clearly determined and verified, usurped wood's role as a traditional building material. However, during the crisis years of the Second World War, there was increased demand for impromptu, quickly erectable structures. With regard to production, transportation and assembly, wood was the obvious choice. This trend was also accompanied by a shift in values, with wood's status deteriorating dramatically: to many, the new architecture was reminiscent of army barracks.

The switch to multilayer wall systems as well as new technical developments in the areas of safety, quality, comfort and durability have given wood a new role in modern building construction. The stricter requirements of building physics, fire protection and structural engineering have transformed building construction from a field of master craftsmanship into a specialized engineering discipline. New technologies and materials, as well as architects' changed perception of wood, have fundamentally changed both the appearance of timber buildings and the standards of value applied to them.

The forestry school in Lyss (Bern Canton, 1995) makes extensive use of wood in its natural form in combination with new materials and a spacious architectural grid. A stimulating, unusual vocabulary of forms has emerged.

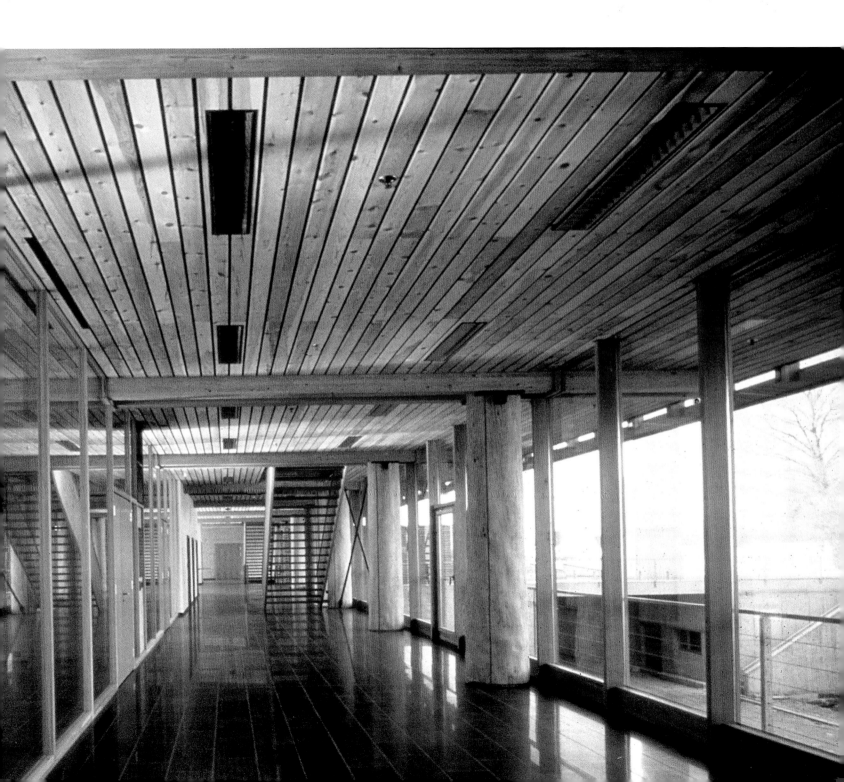

Wooden Buildings in Transition

Having a roof over one's head is a basic human need. The shape and character of this "roof" not only reflect the culture that has produced it but also provide a wealth of information about the state of its building technology. In regions where trees grow abundantly, timber has always been an obvious choice for building construction. Wooden homes have been part of everyday life and culture in Switzerland for centuries, leaving an indelible mark on its architectural tradition.

A true architectural gem can be found in the village of Mühlebach in Goms (Wallis Canton): centuries-old houses forming the oldest cohesive wooden ensemble in a village center in Switzerland. Throughout the centuries, the inhabitants used larch wood and nearly the same form of log construction to make their homes and agricultural buildings (including storehouses and barns). Since these old structures, with their unusual design, were built prior to the Christianization of the region, people called them Heidenhischer (heathens' houses). Scientific studies show that all twelve existing houses in the village center – which are still occupied today – were constructed between 1381 and 1496.

The first wooden houses were simple and strong structures, sometimes modest or even primitive. But they have stood the test of time in these solid forms.

Despite regional differences, the traditional wooden house is characterized by its austere and simple appearance. The focus is on function; its form is defined by daily needs.

The Bethlehem House in Schwyz (Schwyz Canton) has borne mute witness to all periods of Swiss history, and it tells us much about living conditions in the early years of the Swiss Confederation. Because it was occupied by ordinary people for the greater part of its existence (up to 1986), it was known in the vernacular as Bättelheim (the Beggars' Home), which later became "Bethlehem." According to dendrochronological studies of wood samples taken from its oldest sections, the building was erected in 1287, making it the oldest known timber structure in Switzerland. The Niederöst, an older log building from 1170, stood not far away, but has since been dismantled. A remarkable fact is that, according to preliminary studies, these two buildings were not isolated structures but a type of dwelling widespread in Talkessel in Schwyz and built between the late twelfth through the fourteenth century. They demonstrate the surprisingly advanced state of log construction in the Middle Ages – in terms of both craftsmanship and differentiated three-dimensional structures.

As society evolved, new demands were placed on housing, and manual construction skills developed apace. The eighteenth-century carpenter was not only a businessman and a master builder, but a designer and artist as well. Building façades impressively reflect these developments and changes. The first façades were purely functional, hence their modest and austere character. After 1500, there was a pronounced trend toward architectural decoration and embellishment in a variety of styles. The buildings constructed in the Bernese Oberland in the second half of the eighteenth century not only expressed their owners' wealth but represent a pinnacle in the evolution of decorative form and the rich use of color.

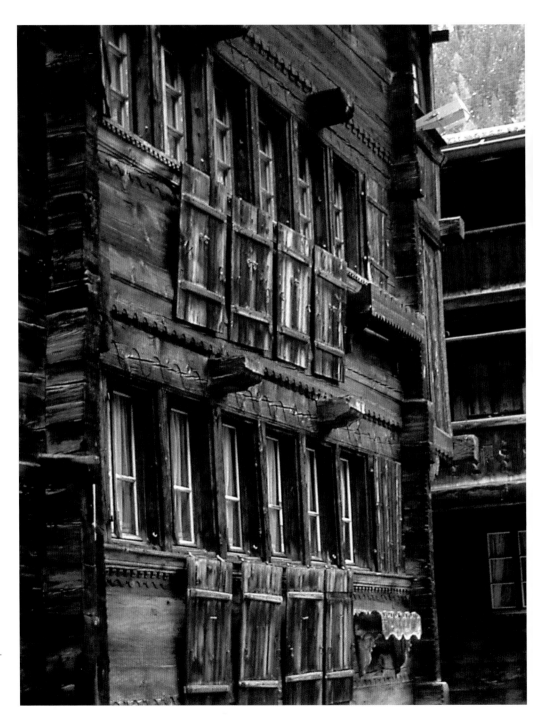

This rough wooden house has a simple façade whose form and character are based solely on function and forego all embellishment. The façade demonstrates in a simple way the principle of structure and form: constructed elements, organic growth, as well as lifestyle and design are conceived and experienced as one. The memorable design of traditional wooden buildings has been an enduring source of inspiration.

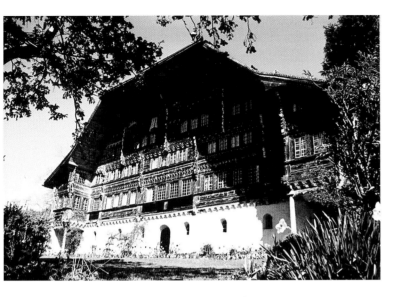

The Grand Chalet in Rossinière (Waadt Canton), which is 27 meters wide and 20 meters tall, is one of the largest residential buildings of the eighteenth century (built 1754). Its size has less to do with the wealth of its builder, Jean-David Henchoz, than with the additional space he required to switch over from the manual to the industrial production of cheese. The building was later used as a hotel and also served as the residence of the painter Balthus (Balthasar Klossowski de Mola, 1908–2001).

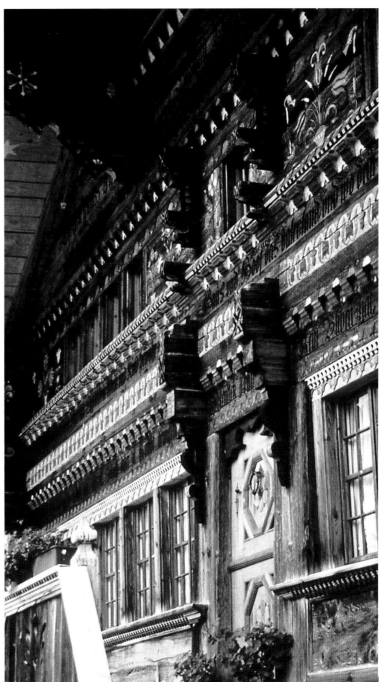

The façade of the Sälbeze farmhouse in Diemtigen (Bern Canton) reflects the great affluence of its owner. The inhabitants of the Diemtigtal valley prospered by breeding the prized Simmental spotted cattle and their own breed of horses. They expressed this wealth in the residential quarters of their farmhouses. The intricately carved, painted façade is crowned by a gently sloping, broad gabled roof (typical of Bernese architecture) and reveals much about the carpenters' skill and sense of form.

The second half of the nineteenth century saw the emergence of a new form of wood construction – the so-called Swiss Style. Developing from decorative trends, it exerted a sustained influence on the design of structures as diverse as private homes, train stations, festival tents and shooting galleries. The Bernese farmhouse, Jean-Jacques Rousseau's maxim of "retour à la nature" and the discovery of the Alps by tourists all paved the way for the remarkable spread of the Swiss chalet. Throughout the nineteenth century, the European bourgeoisie showed a marked predilection for the "Swiss house" architectural style. Their affection dates back to the age of the French Revolution, when Switzerland was perceived as a country "where freedom reigns and the customs and mores of the people are alive." The formal and technical features of the Swiss farmhouse not only conveyed but became the very symbol of these ideas. With the passage of time, the farmhouse spawned the popular "jigsaw architecture" visible in both country and holiday homes throughout Europe.

The Swiss chalet and the Emmental farmhouse were never directly imitated. The Swissness of the adaptations resulted from the specific formal and technical features of the architecture, which could be combined and applied in manifold ways.

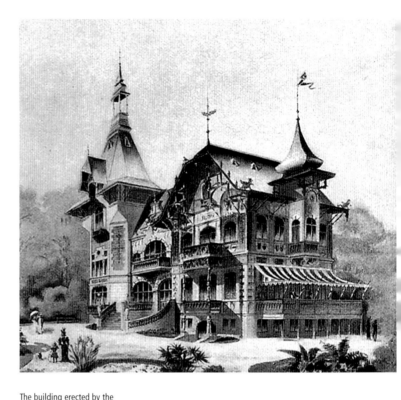

The building erected by the Swiss restaurant and hotel industry for the 1896 National Exhibition in Geneva perfectly embodies the Swiss Style and was highly lauded in the press: "As is well known, our country has a truly national architectural style when it comes to timber construction. In terms of its characteristic and original design, it ranks among the most accomplished and consummate artistic forms that has ever be attained in building construction here."

The Swiss Style was enthusiastically received as an architectural form that satisfied the needs of the modern world. Reinterpreting the rich façades of older farmhouses, it redefined timber as a building material, making it acceptable for the posh homes of the upper classes. The Maison Zwahlen, built circa 1890 in Interlaken (Bern Canton), shows just how high enthusiasm was running at the time. The brick building was designed in the new style, with balconies and projecting alcoves.

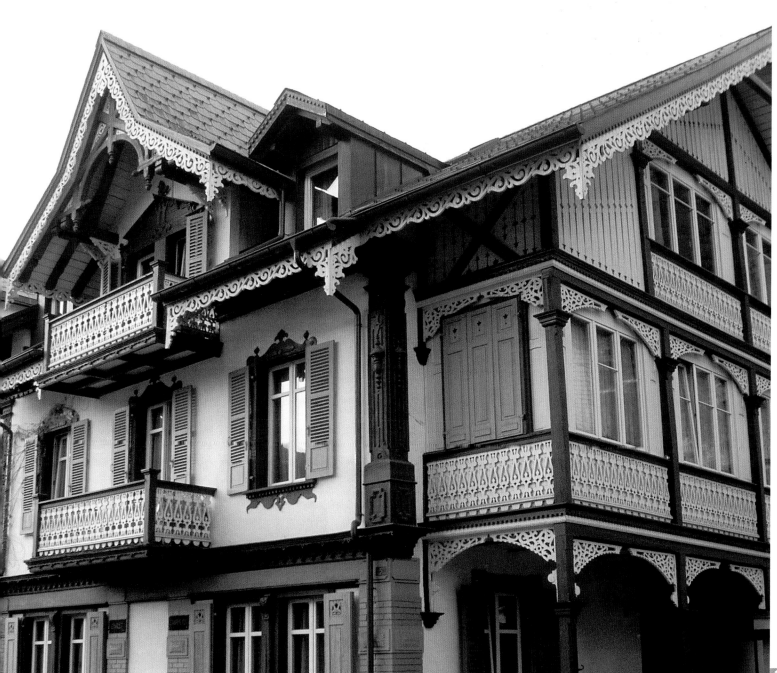

An aesthetic functionalism replaced the romantic timber construction of the nineteenth century. With its Competition for Modern Wooden Houses, organized in 1932 in cooperation with the Schweizer Werkbund, the Swiss working group for timber, Lignum played an important role in repositioning timber buildings.

The roofs of all the winning projects were either flat, had slightly sloping single pitches, or were gabled. Architects endeavored to employ dry construction methods with standardized elements to create simple structures. These modern solutions were intended to "counteract the discrediting of the wooden building, which has resulted from the use of poor wall constructions and toy-like, romantic (or otherwise inappropriate) designs based on misconceived ideas about the preservation of cultural heritage," wrote commentators.

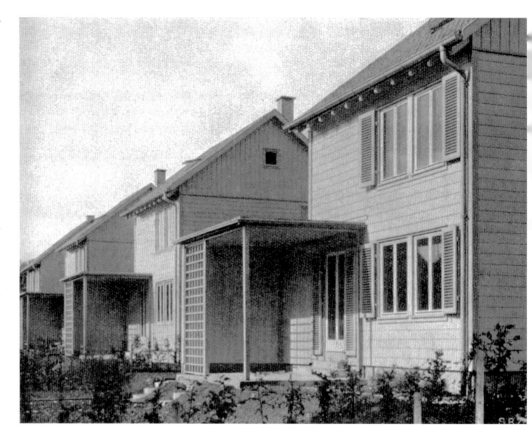

A byproduct of the wooden house competition in 1932: the Wülflingen colony of 14 wooden homes, constructed in Winterthur (Zurich Canton) in 1934. Including land, the finished single-family dwellings cost 32,000 Swiss francs each.

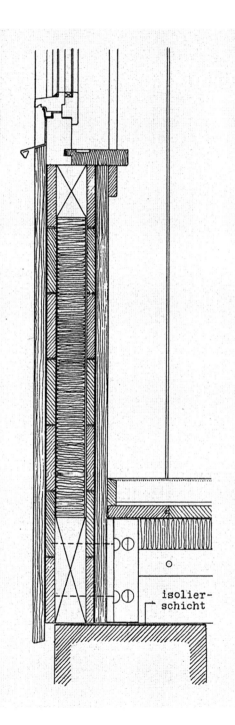

The 1932 Competition for Modern Wooden Houses, held by Lignum and the Schweizer Werkbund. 1st Prize, Group II, three-room row house, usable floor space: 50 m², construction costs: 13,240 Swiss francs.

Skeleton frame construction with the following wall system (exterior to interior):

– Façade: vertical planed cladding, 24 mm
– Roofing felt
– Horizontal unfinished timber cladding, 18 mm
– Ondulex insulation panel, 60 mm
– Horizontal unfinished timber cladding, 18 mm
– Roofing felt
– Vertical paneling, 24 mm

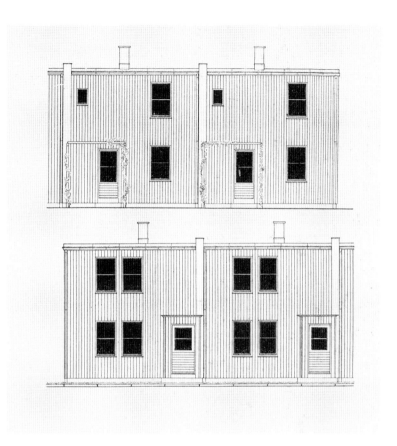

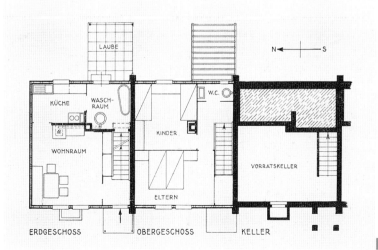

The 1920s and 1930s saw fundamental changes in Swiss architecture. A prominent symbol of the new formal debate on wood was the flat roof. The shift to prefabricated frame elements played an important role in this transition, along with the enhanced physical properties of the structures themselves. It is astonishing that, with its rich tradition of timber architecture, Switzerland was the scene of such a dramatic change in the twentieth century.

A trend-setting house was the Schlehstud, designed and constructed in 1933 by the Swiss architect/sculptor Hans Fischli (1909–1989). The forward-looking building, emerged from the spirit of the Neues Bauen movement, though without blindly adopting its dogma. Schlehstud offered a number of surprises beyond appearance alone. The architect chose wood less for its natural qualities than for its technical and structural benefits. The central design concept was revolutionary and featured a load-bearing steel structure infilled with prefabricated timber elements. This concept was not further developed at the time; its advantages are only being recognized today.

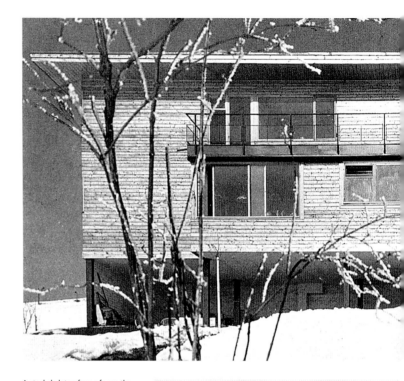

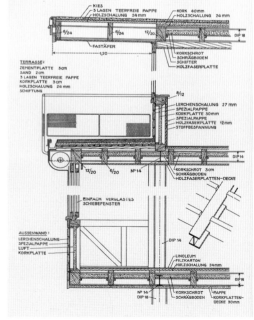

A steel skeleton frame forms the load-bearing structure of Fischli's house. Prefabricated ceiling and wall elements infill the steel structure and partition space – a dry construction technique that can be implemented in an extremely short time at considerable cost savings. After the steel skeleton was assembled, Fischli had the roof installed so that all further construction work could be carried out protected from the elements.

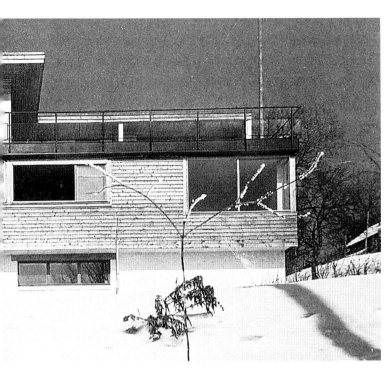

Schlehstud is a two-story, three-family house that catches the eye with its broad cantilevered flat roof and its interlocking cubic sections. It appears to embody Giedion's canon of beauty: "light, air, opening." Schlehstud makes its own contribution to the discussion on "minimum existence housing units" that was being conducted at the time: its utility rooms and bedrooms were kept to a bare minimum in order to create more space for the living room.

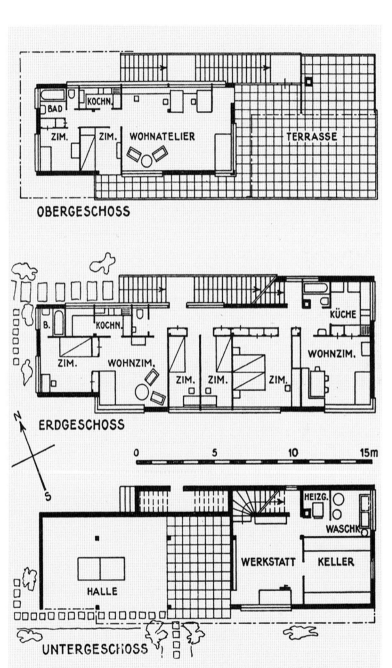

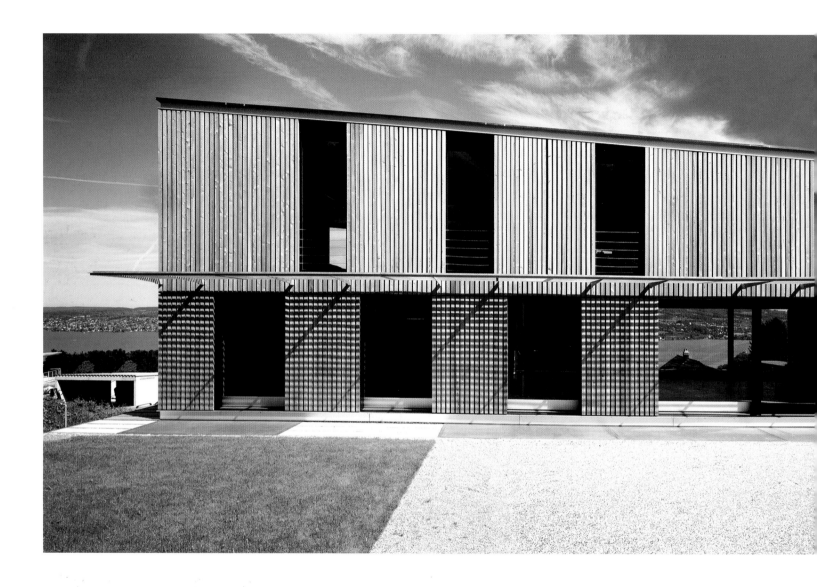

Although in the 1920s and 1930s avant-garde architects in Switzerland such as Paul Ataria, Hans Schmidt, Hans Fischli and Alfred Roth were designing trend-setting homes distinguished by great simplicity, it was not until the mid-1980s that wood began exerting a sustained, highly visible influence as a leading building material in a new, forward-looking architectural culture. Buildings are increasingly conceived as designed and engineered products. With their strict creative stance and changed structural interpretation of wood, dedicated Swiss architects have made a substantial contribution to pioneering modern construction methods.

Though built with the same material and method, each of these new timber homes creates a different impression. What initially seems unusual turns out to be unspectacular – and always executed with great virtuosity. In 1998, the Zurich architects Angélil, Graham, Pfenniger, Scholl designed the Trüb home in Horgen (Zurich Canton) using large timber construction elements.

From "House of the People" to Pavilion

The two world wars had a direct impact on timber building construction. The temporary shortage of materials, limited financial resources, and increased housing needs not only challenged people to revise their way of thinking but also promoted new lines of development. The result was a rise in prefabricated construction methods using building components.

Initially, the wooden elements were small due to the lack of hoisting equipment and restricted transportation capacities, but large-scale elements, some fitted out with building services, were already being designed and manufactured in the 1940s.

The "House of the People" was developed in Zurich in 1919 in response to the Taylorist approaches of the day. It shows conceptual parallels to the assembly line production of Henry Ford's Tin Lizzie. The erection of houses with standardized, prefabricated elements (produced in series) marked a progressive shift in timber construction in Switzerland.

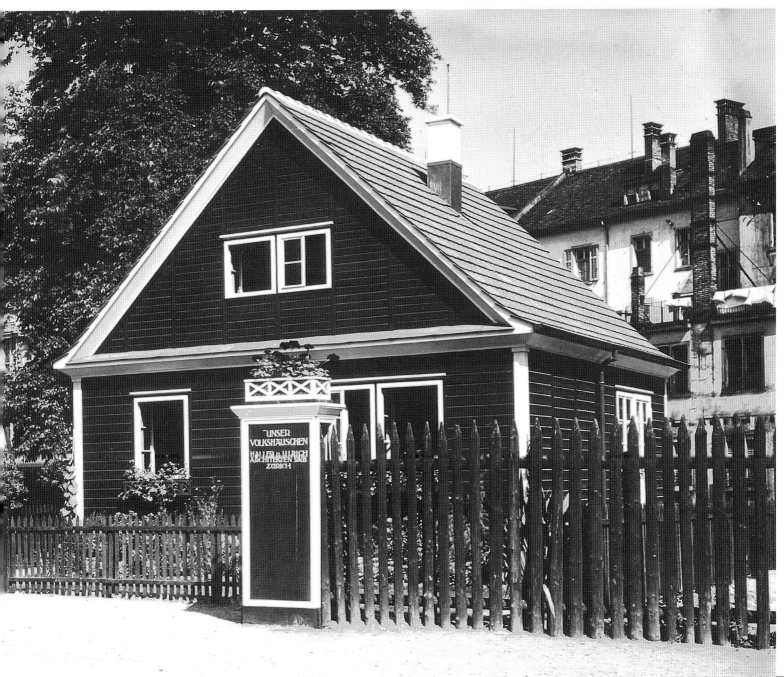

The "House of the People" (Volkshäuschen) was developed by the Swiss architects Haller, Ulrich & Pfister in 1919 in response to exorbitant construction costs in the postwar period. Its design exemplifies the dramatic changes in wood construction techniques. All of the house's compo-nents were prefabricated in series in the workshop and assembled on site. The building was erected in just two days' time. Small panel elements were set between posts to form the outer walls; standardized panels were placed side by side to make the roof.

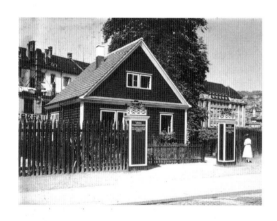

The Volkshäuschen was constructed much differently than other buildings. All of the house's components were serially produced in the workshop as ready-to-use panel elements (0.9 m x 2.5 m). Workers put these elements together on site, completing the house in just three days. This was impressively demonstrated when the model home was constructed on Werdmühleplatz in Zurich on 28–30 July 1919. At the time, the house cost 15,000 Swiss francs.

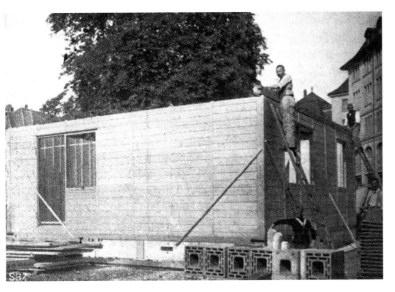

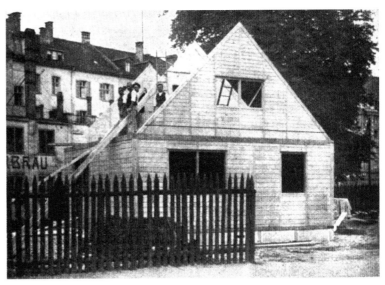

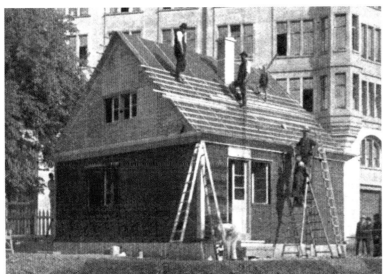

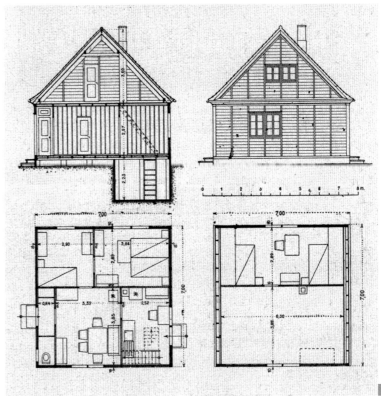

The Swiss department store "Magazine zum Globus", caused a sensation when it launched its Globus Heimeli to celebrate its 25th anniversary in 1932. This "single-family home for ordinary folk," which was intended to satisfy the desire of many Swiss to own their own homes, cost 21,000 Swiss francs at the time, including land. This translated into monthly payments of 95 francs for interest, amortization and fees.

In contrast to buildings with flat roofs, the Globus Heimeli, with its gabled roof and "solid" masonry, resembled the traditional, craftsman-built home. In truth, the Heimeli was made of standardized wooden components that were mass-produced and assembled in keeping with Neues Bauen ideals.

Many of the Globus Heimeli homes from the 1930s are still occupied today and look much as they did the year they were built.

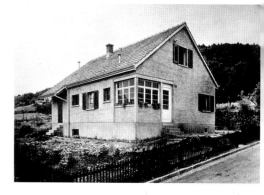

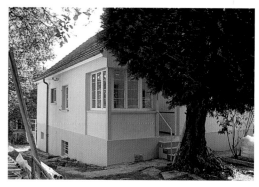

Sixty-nine freestanding single-family Globus Heimeli homes were erected in the Heimgärtli development on Triemlistrasse in Zurich.

The initial plan was "to create a house that can be put up by anyone with the aid of the supplied description and instructions." In any case, the department store wanted a 3¹⁄₂–5¹⁄₂-room house that did not require an architect and would fulfill the dreams of thousands of Swiss to escape their "apartment barracks." The standardized timber frame elements were pieced together like the pieces of a large jigsaw puzzle. On the inside, the story-high elements were paneled with plywood (which remained visible); on the outside they displayed timber cladding. The façade consisted of fire-resistant Gunit, the new dry-sprayed concrete.

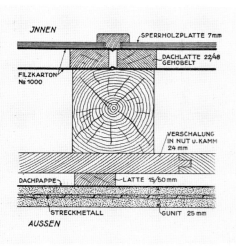

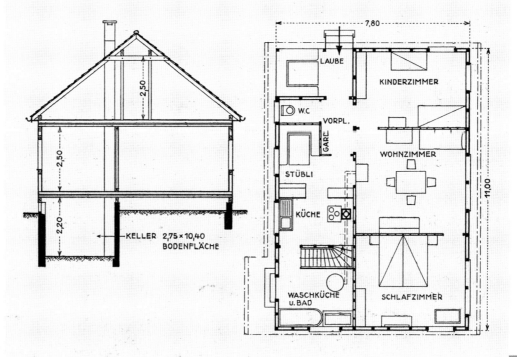

During the Second World War, the large demand for temporary, quickly constructed buildings spurred the development of prefabricated forms of construction: so-called wooden barrack architecture was born. Rationalization, standardization and prefabrication had been discussed for years, but now the shortage of steel and concrete, as well as the rigid regulation of the construction industry, refocused interest on timber and its benefits for prefabricated construction.

In terms of procurement, production, assembly, transport and utilization, timber had all the properties that were required to solve the problems at hand. Perceptions of both the timber barracks and the stop-gap prefabricated dwellings of the day have continued to influence the somewhat questionable status of industrial timber construction ever since.

UNINORM

Zerlegbare Holzhäuser

✣ Patent Nr. 182638 Ausländische Patente

UNINORM die Standard-Baracke der Armee

UNINORM für Bauunternehmungen
Industrie und Gewerbe

UNINORM als Wohnhaus-Weekendhaus
Club- und Skihütte, Schulhaus etc. etc.

The crisis years promoted the development of standardized, industrialized construction methods while creating welcome new fields of activity for the Swiss carpentry trade, which in part lived from dubious exports abroad. The resulting forms of housing construction worsened timber's already poor reputation.

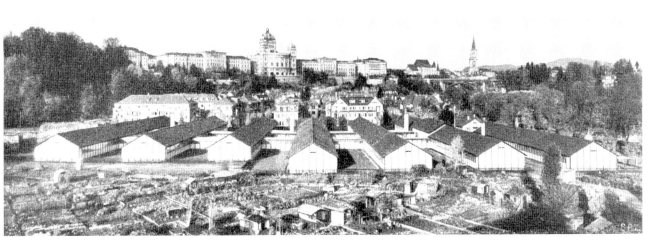

In just eleven weeks, provisional buildings were constructed in 1942 for the Swiss War Industry and Labor Office near the Bundeshaus parliament building in the capital of Bern. These structures featured load-bearing timber skeletons and Durisol wall panels (consisting of mineralized wood shavings and cement). The short construction period for the 5,000 square meters of floor space, the relatively low construction costs of 48 Swiss francs per m^3, as well as the experience gained, attracted public attention and stimulated interest in this construction method.

"Knockdown" timber barracks provided temporary housing on large construction sites throughout the war years. In 1954, rows of two- to three-story structures were put up in a short period of time for the men building the Lac de Moiry embankment dam (Wallis Canton) at a height of 2,300 meter above sea level. The buildings contained bedrooms, offices and dining areas, and were erected with lightweight, easily transportable, 1.22-meter-wide panel elements.

The acute shortage of space during the boom years of the 1960s and 1970s led to a brief renaissance of prefabricated wood construction for school and office buildings. In Switzerland, these prefabricated structures were called "pavilions." The urgently needed school and office buildings were erected as ready-built wooden structures from prefab wall elements that were part of a modular system. Rows of these lightweight panels positioned on set grids gave these buildings their distinctive appearance: the new "pavilion" category was born.

Building appearance betrayed the time constraints and tough competition that their builders faced. And although the prefabricated objects were not cheap, they looked it. Added to this were construction problems relating to joint design, windproof performance, thermal insulation and fire resistance.

The school/office buildings of the 1960s and 1970s that are still in use today bear testimony to an architectural style that was shaped by a particular construction method – the pavilion. Their appearance bears the stamp of prefabricated construction. The Durisol system, developed by the architect Alex Bosshard in conjunction with Durisol AG, is one of the best-known prefabricated building systems in Switzerland. The panels, which had a basic axis length of 150 x 50 cm, were used to enclose over one million cubic meters of space between 1941 and 1945. Over 1.2 million wall, ceiling and angled floor panels were manufactured during this period.

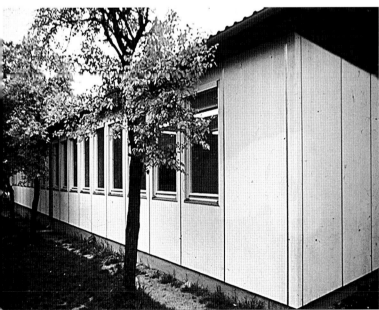

In order to meet the enormous construction demands, a new type of building was required, one that could be put up by unskilled laborers without heavy equipment. Prefabricated, transportable and standardized timber elements were the answer. They made it possible to enclose large areas in a short time, as the Wittwer Pavilion in Binningen (Basel-Land Canton) impressively shows.

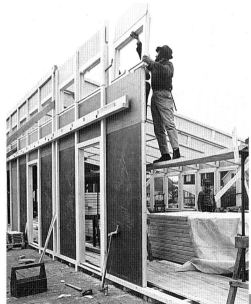

Prefabricated Construction Today

Over 90 percent of the one- to three-story residential buildings constructed in North America over the last century were made of wood, yet it was not until recently that the timber frame technique popular in the New World gained a foothold in Central Europe. Only with its adaptation and customization to local conditions in the 1990s did platform framing make a breakthrough here. The "Impulsprogramm Holz" (Timber Stimulus Program, 1986–1991) undoubtedly made an important contribution to the sustained revival of prefabricated timber house construction in Switzerland.

Two factors have played a crucial role in this turnaround: technical developments in the areas of safety, building physics, quality and durability; and new production processes that have liberated architects from "grid constraints" and considerably enhanced creative freedoms. Both factors have enabled prefabricated construction to break with its negative army barracks image.

Nowadays, timber construction differs considerably from traditional masonry methods, as can be seen by the different construction processes. Whereas in masonry construction, workers build structures by literally placing stone upon stone, in new prefabricated timber construction, entire elements are pre-manufactured in the workshop and assembled quickly and easily into the nearly finished house on the construction site.

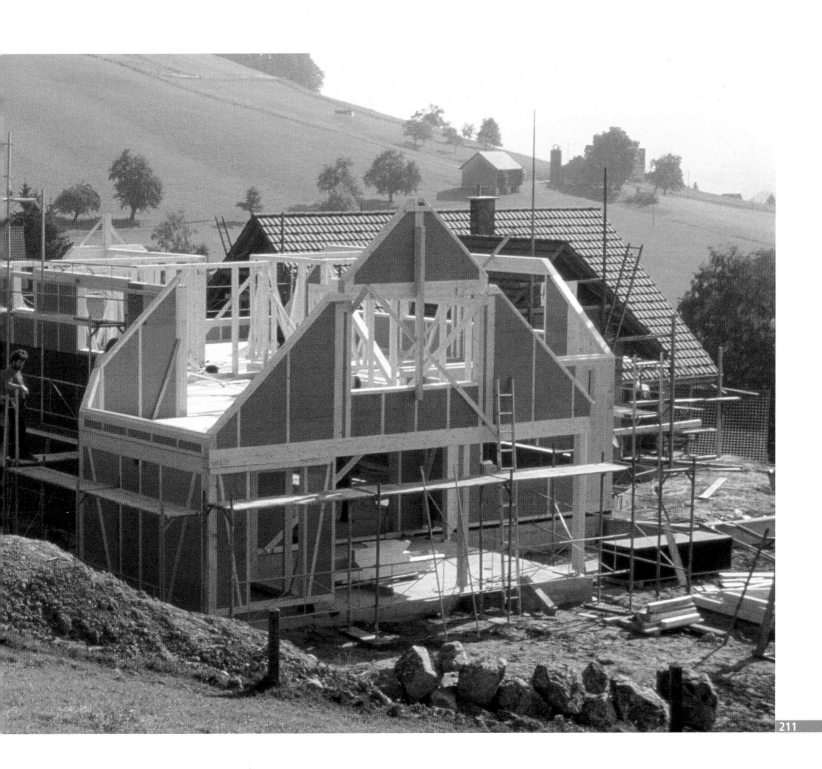

Wood as a building material and the component fabrication it facilitates favor planable construction. Most individual elements are no longer produced by hand. Rather, production is geared toward systematic building, which shifts production from the construction site to the factory. Entire structural elements and modules are prefabricated using industrial equipment. Compared to traditional construction methods, this drastically reduces the number of interfaces, improves compliance with deadlines and requirements, and enhances cost reliability.

In contrast to the modular construction methods and catalogued "ready-built houses" which have been promoted (and which have failed) in the past, current timber construction techniques are not based on the principle of modules or systems, but rather on a production-oriented, systematic building approach. The most important parameters are no longer grids and modules but a basic principle that – tapping the potential of industrial production – organizes and defines the relationship between the individual components of multi-layered systems. This approach not only exploits the advantages of industrial production, but also guarantees creative freedoms.

In principle any degree of prefabrication is possible. Although a large amount of work is still being done on site in North America, prefabrication and factory production are becoming increasingly popular in Switzerland. Thanks to their favorable "capacity-to-weight" ratio, it is now possible to produce large, fitted-out, near-complete elements. The transport and on-site erection of these large elements has become commonplace in timber house construction.

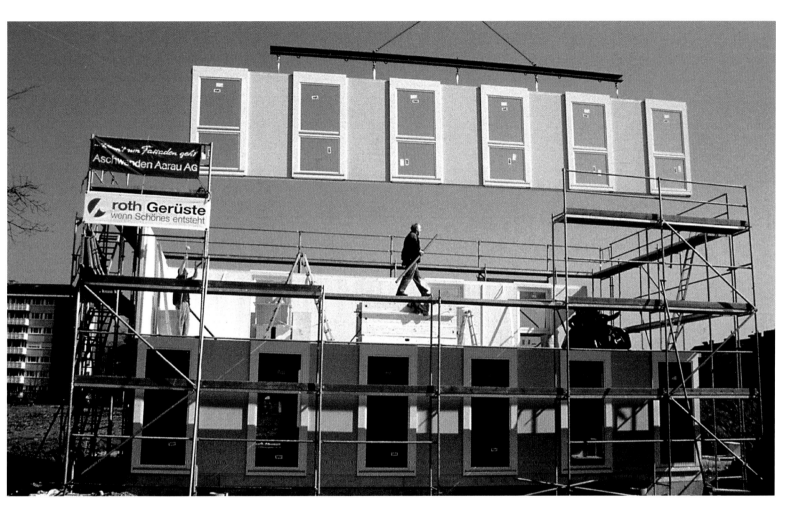

One of the biggest differences (and a difference with far-reaching consequences) is the means of production, that is, the actual process of "producing" the building. Whereas in traditional construction, houses are built piece by piece and successively finished on site, timber construction and its building systems call for prefabrication of entire components (normally wall and ceiling parts) in the factory using a basic system and industrial equipment.

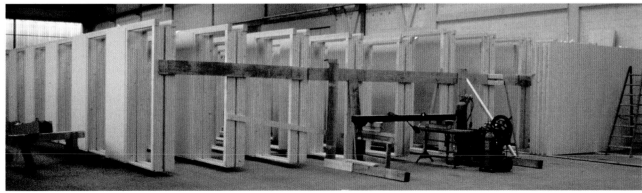

Numerous timber construction methods compete in today's market. In contrast to older panel systems such as fiberboard and particleboard, modern wood-based boards feature clearly defined structural strengths and have played an important role in developing new construction techniques and improving upon old ones. It is now possible to produce single, story-high (or larger) laminated veneer boards, three-layer particleboards, or cross-laminated solid timber boards. The resulting new forms of construction offer an alternative to traditional frame technologies.

Swiss timber builders have made an important contribution to these developments with self-developed systems and products that offer interesting alternatives to predominant frame construction methods. Noteworthy is the laminated beam construction technique that Julius Natterer (Swiss Federal Institute of Technology in Lausanne, Waadt Canton) adopted, refined and launched in various applications. This led to the Bresta construction system (Hochdorf, Lucerne Canton), in which the boards are stacked side by side and held together by beech wood rods instead of nails or glue.

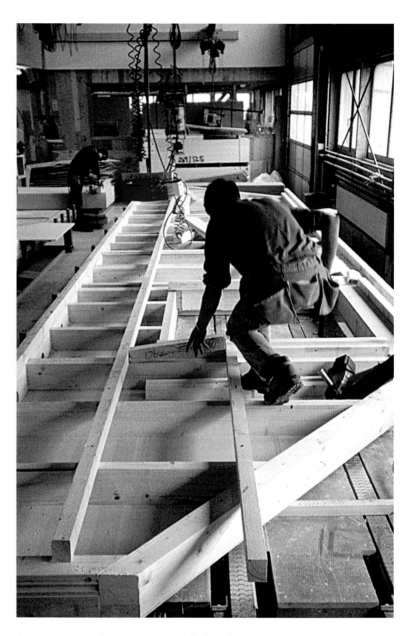

Frame construction remains the dominant method of timber house building. It is based on a simple, adaptable structure and requires only little or modest equipment. However, this approach is facing increasing competition from so-called panel construction methods.

Today, the principle of laminated beam construction is applied to panel construction in a variety of ways: from manually nailing boards on site to joining industrially produced modules via different connections to form finished stacks of boards in the factory.

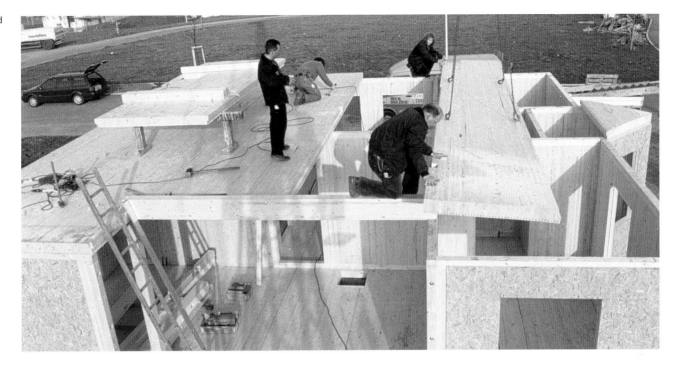

The Schuler system (Rothenturm, Schwyz Canton) is typical of the various panel construction methods (Homogen long particle board, solid wood board, etc). In contrast to frame construction, the inner panel performs all the important functions. The large yet relatively thin three-ply panels (ribs keep them from buckling) form spatial boundaries and fulfill structural functions.

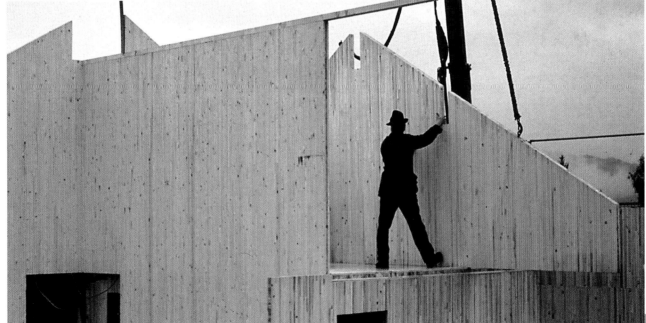

Modular Construction

The prefabrication of entire modules is becoming increasingly popular. High-quality, modular building units epitomize energy optimization in production and utilization and cost-saving, ecological construction.

In the construction world, the word "module" is primarily associated with fixed dimensions, serial repetition and three-dimensional expandability. Two modular timber construction systems stand out in Switzerland: the large room module and the small STEKO block used as a wall component. Both exploit the lightness of wood and profit from improved quality and cost and time savings.

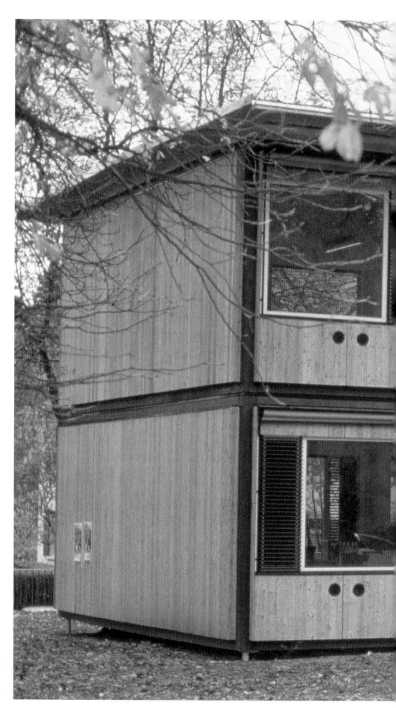

The basic building block of this Zurich school (erected 2000) is a room module of lightweight timber (6 m long, 3.8 m wide and 3.45 m high). Modular systems are based on the concept of addition. The individual prefabricated room modules are fully assembled in the factory, transported to the construction site, and stacked vertically or horizontally.

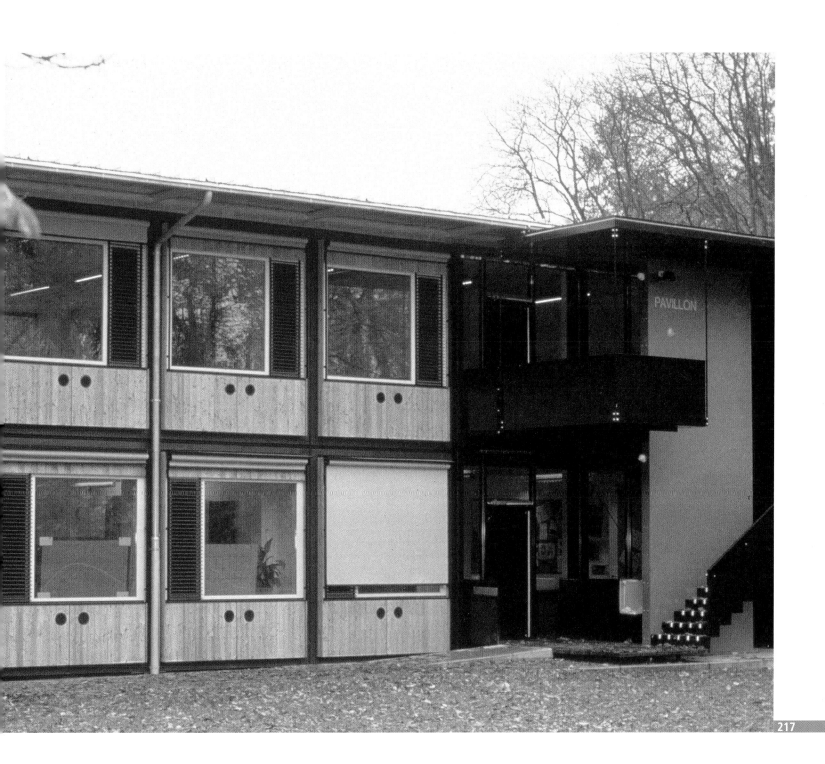

In modular construction, individual room elements are manufactured industrially and erected on site. It is becoming increasingly common to finish these room modules in the workshop. Fitted out with nearly all services, they ensure short construction times, a consistent, controlled quality as well as budget reliability.

In terms of its design, the room module has much in common with frame or panel construction. Entire modules – including walls, ceilings and floors – are fitted out with services and fixtures in the factory. They are then transported to the construction site and assembled in a short time to create the finished building. There are considerably fewer hand-over points both in planning and technical execution, which eliminates a main source of error. The repeated use and practical demonstration of the same components in the real world facilitates feedback, adaptations and improvements. All told, industrial production permits a more exact definition of construction standards and enhances quality assurance.

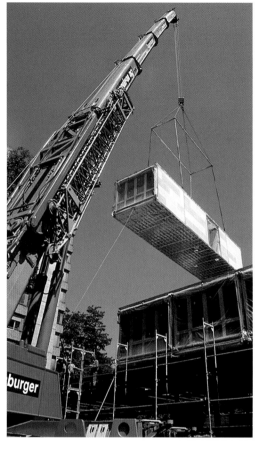

The Canton Hospital in Zug increased its bed capacity in a short time by combining completely fitted-out box modules to create 35 new rooms (erected 1996). The 3.8-meter-wide units extend 16 meters across the entire width of the building and include part of an access corridor and rooms for patients on both sides.

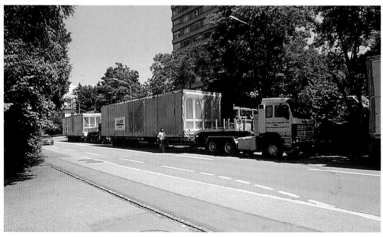

The three-story research and development building constructed in 1998 for Schindler in Ebikon (Lucerne Canton) consists of 66 wooden "boxxin" modules designed by the Zurich architects Kündig & Bickel. This building block system is based on a single module (3.5 m x 3.5 m x 7.5 m) plus a small number of additional components. Efforts to define both the structural relationship between the system's components and their joints played a formative role in its development.

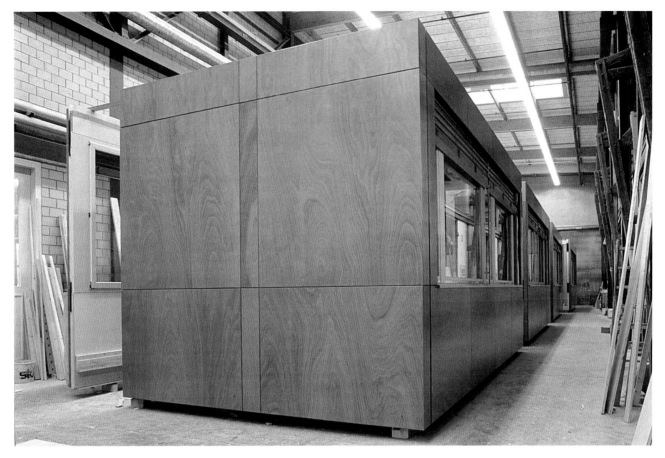

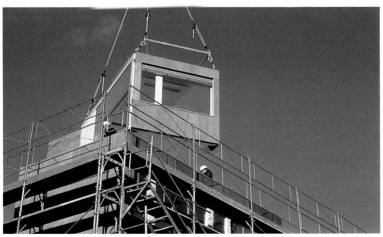

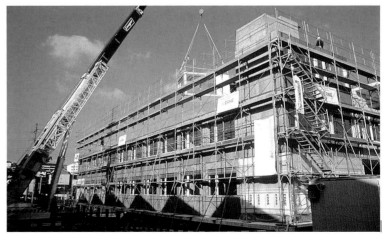

The Bauart architects in Bern must be given credit for important advances in timber room module construction, which they reinterpreted architecturally. The starting point was the provisional three-story office of the Swiss Federal Statistics Agency in Neuenburg, which they designed in 1993.

In close cooperation with a timber construction company, Bauart developed a new prefabricated modular construction system called Modular-T on the basis of the agency's temporary offices. The system has proved extremely adaptable. To date, over 500 room modules have been produced and erected as additions to school and office buildings.

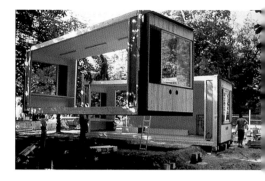

The lightweight Modular-T wooden room module has proved extremely adaptable. Once optimized, it became a valuable component for school construction as it facilitated construction of large spatial volumes by horizontal or vertical stacking. The system can be dismantled after a specific period of time and reassembled at new locations.

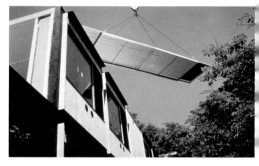

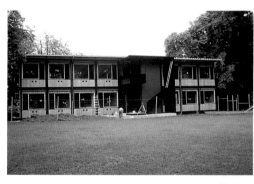

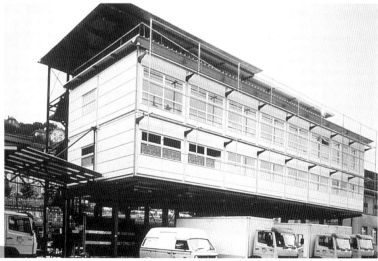

The temporary three-story construction office for the new headquarters of the Swiss Federal Statistics Agency in Neuenburg consists of 57 identical, full prefabricated room modules.

Simple assembly of a load-bearing structure with a floor slab, four columns and a ceiling panel. The structure is stabilized by wall elements that match the building design and floor plan.

The Modular Hotel Competition held in 1996/97 by the Schweizerische Holzwirtschaftskonferenz (Swiss Wood Manufacturers' Conference) provided additional stimulus for modular construction. All told, a new timber construction culture has evolved over the last few years, replacing the bland provisional solutions of the past.

Coordinated planning is necessary to exploit the advantages of room module construction. "Rolling production" is ineffective. The entire structure must be defined prior to construction – that is, prior to actual production. The basic requirement is that construction details be specified before contracts are awarded. During the construction phase, there should be no changes, which only drive up costs. The design must take the specific needs of the respective systems into account if it is to exploit their economic benefits.

Room modules were used to build this double kindergarten in Buchholz, Thun (Bern Canton) in 1997. Despite the simple "additive" construction method, the building does not have a provisional, monotonous or barrack-like appearance. Quite the contrary – it is appealing and thoroughly functional architecture.

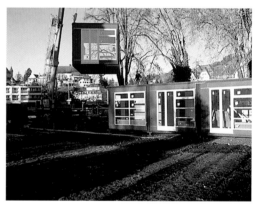

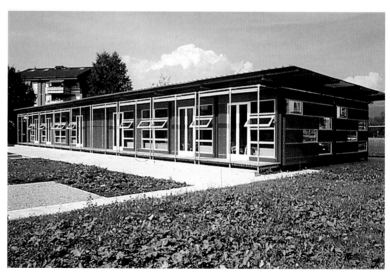

Room modules have generally been designed for buildings with a medium life span. The STEKO module, developed between 1994 and 1996 by the Swiss Institute of Technology in Zurich in conjunction with the timber construction industry provides an alternative to conventional frame construction. Like Lego blocks, the small STEKO wood components can be fitted together quickly and easily without mortar or glue. This modular system combines the benefits of industrial production with the advantage of individual construction.

At the core of the STEKO wall system is a wood block measuring 160 mm x 320 mm x 640 mm. This easy-to-use component features five layers of solid cross-laminated wood, which ensure a high degree of dimensional stability. The blocks are slotted together with a special plug system that ensures optimal corner and wall-to-wall connections.

Specially designed blocks for wall ends, windows and door openings round off the STEKO system and allow for easy wall construction with just a few standardized pieces. Building services can be run through the hollow cavities. The modules are subsequently filled with isofloc cellulose insulation to ensure efficient thermal protection. An additional external insulation layer improves thermal performance and makes the system suitable for constructing low energy and passive energy houses.

Over the past few years, STEKO wood modules have been used to build over 500 houses all across Europe, from Greece to Greenland.

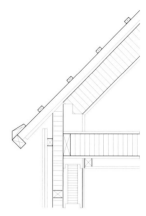

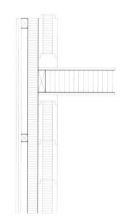

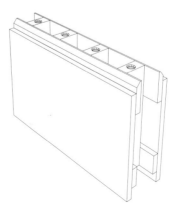

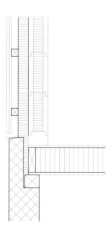

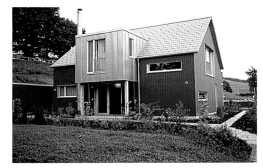
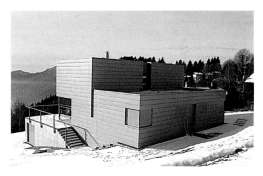

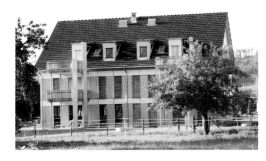
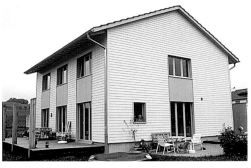
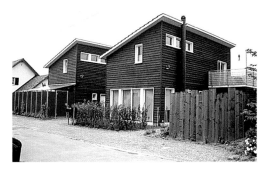
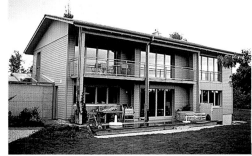

The STEKO system has been designed to be easily combinable with other readily available commercial window, door, ceiling and roof systems. Combinations of the STEKO wall system with standardized supplementary elements allow for an integrated, homogeneous, high-quality construction system. The consistent, advanced systematization reduces both the number of interfaces and the planning work without restricting creative freedoms.

The modules permit easy construction of right-angled corners and wall-to-wall connections. Obtuse and acute angles can be made with saw cuts. The exterior and interior walls are both load-bearing and partitioning and can be put up quickly without special hoisting equipment.

The buildings recently constructed with STEKO modules include the three-story homes in the housing development in Hohlenbaum, Schaffhausen (1999).

Fire and Fire Protection Concepts

The element of fire has played a decisive role in human evolution. If controlled, fire can provide not only warmth and light, but security and power. Uncontrolled, it can cause death and destroy property, buildings and even entire cities.

Our houses must protect us and our valuables from the effects of fire, even in cases where we carelessly disregard its dangers. This poses a special challenge to timber engineering. Over the years, fire protection has become a special engineering discipline. Comprehensive fire protection concepts, based on effective technical, organizational and structural measures, can help assuage our fears about fire while making our wooden homes safer.

In human consciousness wood, as both a fuel and a building material, is inextricably linked with fire, with its benefits and horrors, and with the contrasting images of a cozy fireplace and a destructive conflagration.

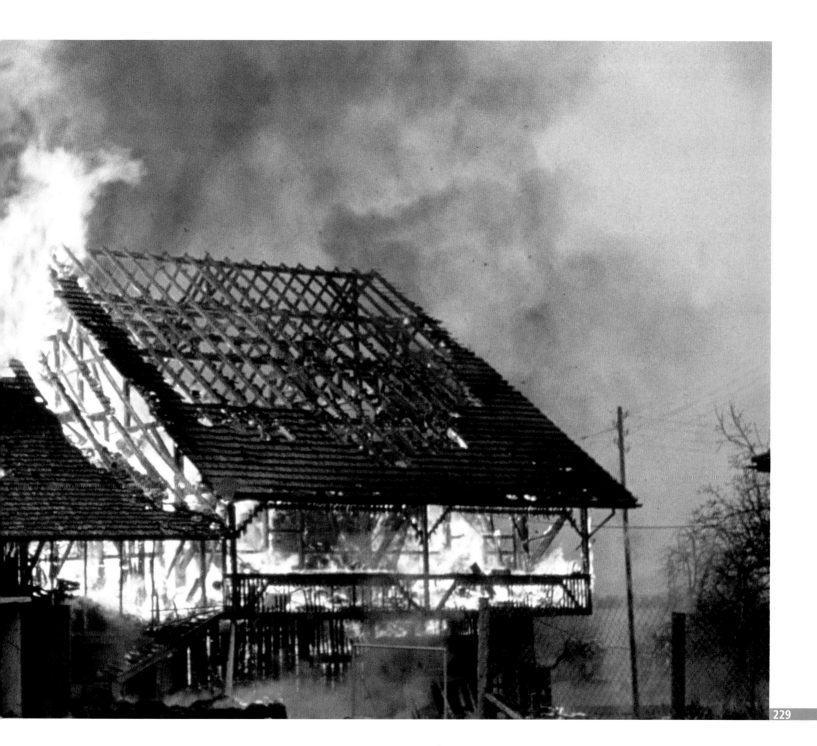

The flammability of wood and the added fire load of timber partitioning and load-bearing structures are inconvertible facts which have undoubtedly had consequences for the use of timber in construction. Relative safety can only be achieved if these facts are carefully considered in the design and construction of timber buildings. An additional fact is that wood only burns on the surface. Solid wood sections can withstand fire for long periods of time and prevent it from spreading rapidly from room to room or from house to house.

The most important indicator describing the fire behavior of wood is its combustion rate – the speed at which it turns into charcoal. The combustion rate of the softwood commonly used by the construction industry is 0.7 mm per minute. Charcoal protects the underlying wood from the heat of the flame, with the temperature in the transformation zone ranging from 250° to 300° C. Roughly 2 cm deeper, the wood is room temperature, so that it retains its full load-bearing capacity in the remaining cross section. As a result, stressed wooden beams with a width of 10 cm can withstand a fire for roughly 30 minutes; 18-cm-wide beams for as long as 60 minutes.

Wood burns relatively slowly from the surface inward. This means thick cross sections can withstand fire for a long period while retaining their load-bearing capacity.

When Lignum was established in 1931, its directors made "fire protection for timber" one of their top priorities.

In 1936, Lignum arranged to have a two-story, sixteen-room building with an attic story constructed and set ablaze on the Zurich commons in order to debunk the myth of the blazing wooden house.

A curiosity from today's perspective is the attempt by the Zurich fire department to study the effect of fire bombs on timber buildings: the officials had fire bombs dropped on a building in order to demonstrate that legislators treated this material narrow-mindedly and that banks and insurance companies unfairly discriminated against it. The fire department also wanted to show the different ways both empty and cluttered attic spaces influenced the development of fire. At the time, the Swiss air raid protection authority required the population to keep attic spaces free of flammable materials.

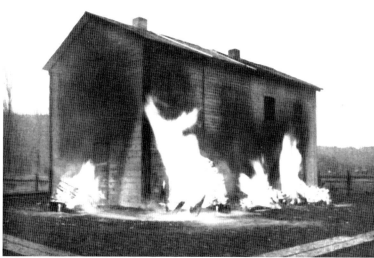

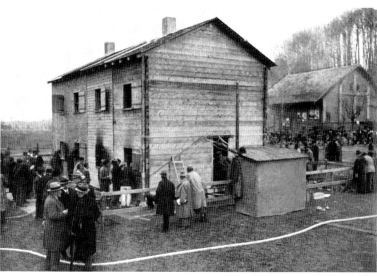

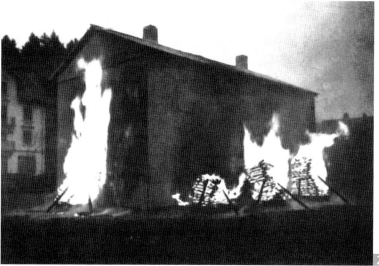

The serious scientific studies of the past decades have focused on the fire behavior and safety of wood and wooden components, presenting these issues in a new light and soundly advancing the cause of wood. Universities, colleges and research institutions around the world have devoted themselves to this subject. Their theories, experiments, fundamental research and applied projects have provided an urgently needed basis for evaluations – one that is reliable, differentiated and easily comprehensible.

Fundamental theoretical studies and experiments conducted by the Swiss Institute of Technology in Zurich have resulted in important discoveries that will make it possible to engineer fire-resistant, load-bearing timber structures in the future. Research on the fire behavior of connections made with steel parts has led to new insights and methods of evaluation in an area that ranks among the most important in engineered timber construction.

The Swiss Institute of Technology in Zurich has analyzed the behavior of different types of connections under fire conditions. The studies aim to establish proven methods for computing the fire resistance of both normal connections and those with added fire protection. This theoretical work has been supplemented by fire tests at the EMPA Academy in which butt joints are stressed to working load levels in the fire box under conditions conforming to the standardized combustion curve.

There were marked improvements when joints were covered on all sides. If, for example, 25-mm-thick multi-ply wooden boards were used to cover connections, fire resistance periods improved to over 60 minutes.

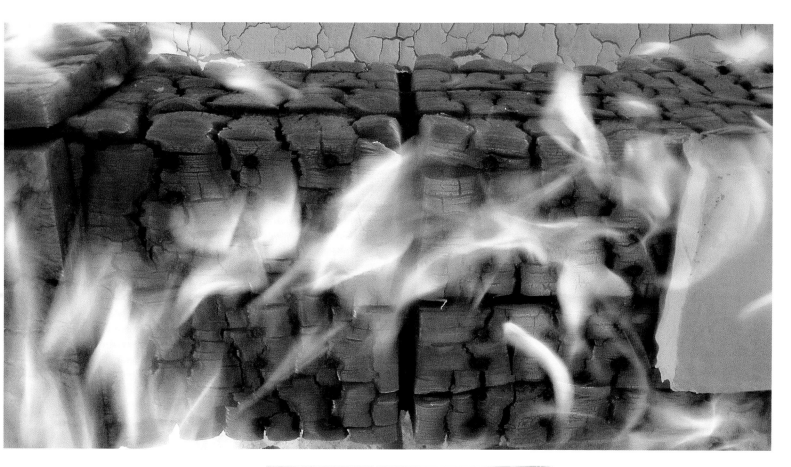

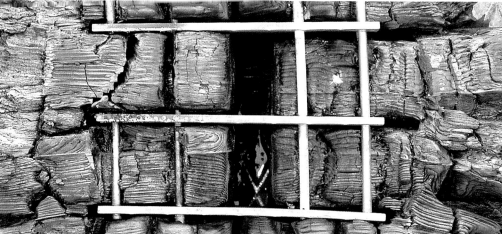

The fire box tests primarily focused on multiple shear dowel connections because of their importance for engineered timber construction. When timber was stressed to roughly 30 percent of load-bearing capacity, this type of connection achieved fire resistance values of between 30 and 35 minutes in fire tests (without additional protective measures). At lower load levels, the fire resistance period increased slightly by three to eight minutes. The number and diameter of the dowels played a negligible role.

Laboratory experiments and tests under natural fire conditions have led to a variety of findings. Fire tests were conducted on room modules to evaluate both the influence of flammable surfaces on fire intensity and the spread of the fire via façades, windows, walls and ceilings. The need to study the safety of modular timber hotels planned for EXPO.02 provided an incentive for this research.

The tests showed that purely structural measures prevented the spread of fire to an adjacent module for a period of sixty minutes. Additional tests demonstrated the effectiveness of sprinkler and automatic fire detection systems.

All told, the tests led to an improved and more profound understanding of the fire behavior of wood and provide a foundation for reliable and objective evaluations. However, research has not confined itself to wood's flammability and fire behavior, but has also addressed theoretical aspects of comprehensive safety concepts – including passive construction measures, active measures such as sprinklers and fire alarm systems, as well as simulations and probability theory. These concepts have made it possible to exceed existing safety levels of solid wood construction – surely a sign of great progress in wood construction.

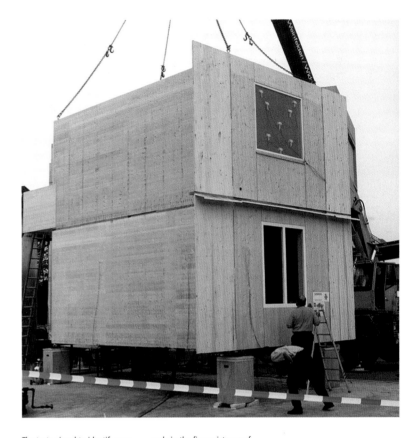

The tests aimed to identify possible fire safety flaws in two vertically combined timber frame room modules (3.1 m x 2.8 m x 6.6 m) and to collect basic data on the fire behavior of multistory timber buildings. The researchers were interested not only in the fire resistance of load-bearing structures, but also in the spread of fire on flammable and nonflammable surfaces. In addition, they studied the influence of sprinkler and fire alarm systems on fire protection.

The tests provided visible evidence of the influence of flammable and nonflammable interior cladding. There are distinct differences between the flammable 18-mm OSB board (upper row of photographs) and the nonflammable 18-mm gypsum fiberboard (lower row). The tests were run under the same conditions in all cases.

When no measures were taken to extinguish the fire (no fire department and deactivated sprinkler system), it always spread, regardless of whether the interior cladding was flammable or nonflammable. Yet energy release was significantly lower in the tests with non-flammable materials, and the fire only spread to the upper module after roughly 42 minutes. In the module with flammable interior cladding, in contrast, it spread after a mere eight minutes. The tests also showed that a sprinkler system in the upper module could effectively prevent the fire from spreading to this module via destroyed windows or doors.

In the tests without a sprinkler system, the researchers observed a flashover with temperatures of approx. 900°C five minutes after they ignited the furnishings using 4 dl of a combustive agent. In tests with the sprinkler system, in contrast, the fire was extinguished in its initial phase, and there were no burn marks on the wooden surfaces of the walls and ceiling.

Steel sheeting mounted on the top edge of the module separated the back ventilation level between the two modules, providing both floors with separate ventilation. The sheeting not only prevented the feared spread of the fire to all floors through the ventilation space (chimney effect) but restricted damage to the façade.

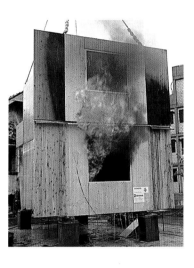

After five minutes

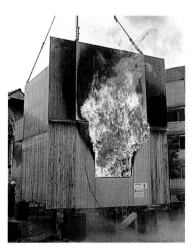

After ten minutes

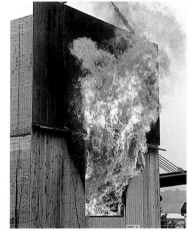

After fifteen minutes

After twenty minutes

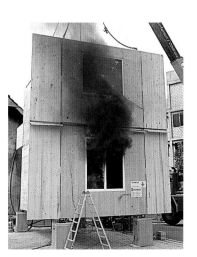

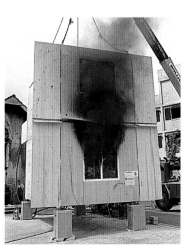

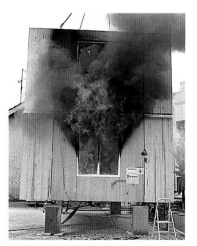

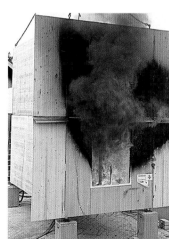

Multi-Story Timber Construction

Although Switzerland can look back on a long tradition of multi-story timber construction, the log construction techniques used 250 years ago can hardly be expected to meet the increasingly strict comfort and safety requirements of the present day. With the emergence of masonry construction, the structural deployment of timber in housing developments was until recently confined to roof trusses or, at best, ceiling joists.

The use of layered wall designs in modern construction systems finally gave wood a second chance in multi-story construction. If constructed carefully, timber buildings can effectively and functionally satisfy today's strict building performance requirements in terms of sound, heat and moisture insulation. Over the past few years, a number of factors have made a significant contribution to the construction of multi-story timber buildings in Switzerland: the systematic study of the fire behavior of both wooden building components and composite elements, and new fire protection concepts that incorporate active measures such as sprinkler and fire alarm systems.

An additional factor is the architectural treatment of timber. Though timber applications have gone unnoticed at times, they have still caught people's attention with their unusually quick construction times. Many respected Swiss architects have devoted themselves to this building material, creating "new" designs and "new" conditions for the use of wood in building construction. In their creations they have put new ideas into practice in a manner that is aesthetically and structurally impressive. They have effectively demonstrated the potential of the new forms of timber construction.

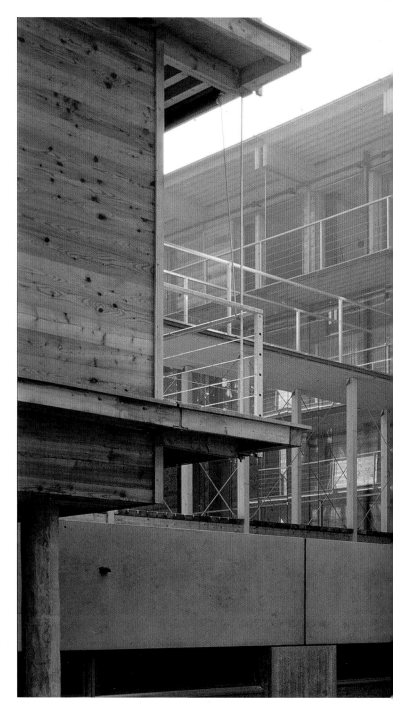

New multi-story timber buildings have helped overcome existing reservations about wood. An excellent example is the three-story, 160-meter-long forestry school built in 1995 in Lyss (Bern Canton). Thanks to its innovative fire protection concept, it proved possible to use wood for all structural components. The school building with its large rooms is supported by a timber frame of silver fir columns approx. 50 cm in diameter.

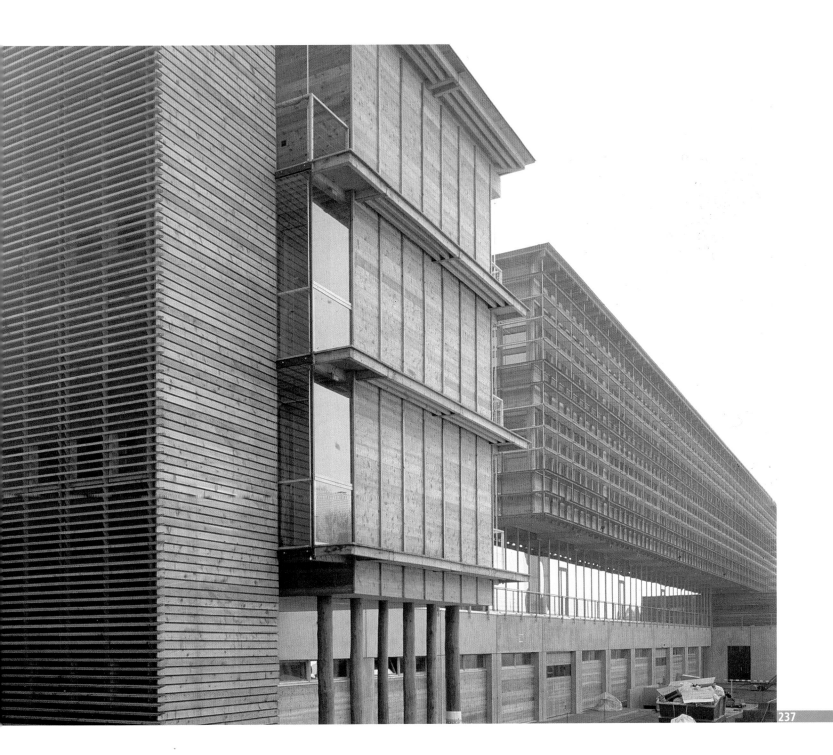

Though multi-story timber construction is not yet commonplace, it is far from exotic. In residential, office and school architecture, timber used to be associated with a backward conservatism. Many thought it was best suited for temporary structures. But its image has changed dramatically in recent years.

Over 250 years ago, Swiss carpenters applied log construction techniques to build timber buildings over five stories tall, yet timber construction did not develop apace with industrialization processes that churned out inexpensive bricks and mortar. Timber was rigorously eliminated from housing construction, which meant that for about a century there was no scientific or architectural debate on multi-story timber construction. Not only the technical developments of the last few years, but also the fundamental change in architectural values has sparked new interest: attitudes about timber buildings are changing. A number of breathtaking buildings in Switzerland have paved the way for these developments.

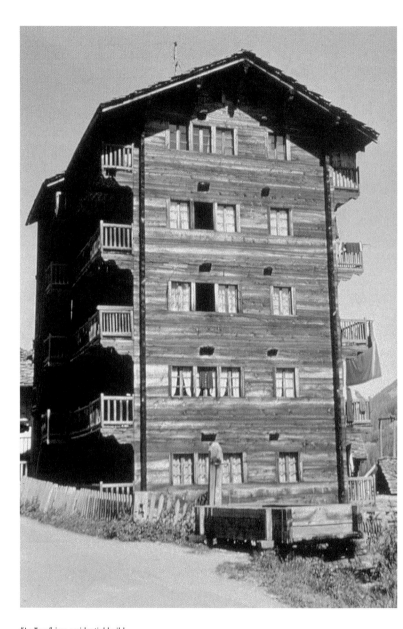

"La Tour" is a residential building in Evolène (Wallis Canton). Over 250 years ago, carpenters in Wallis constructed multi-family log buildings that were up to five stories tall.

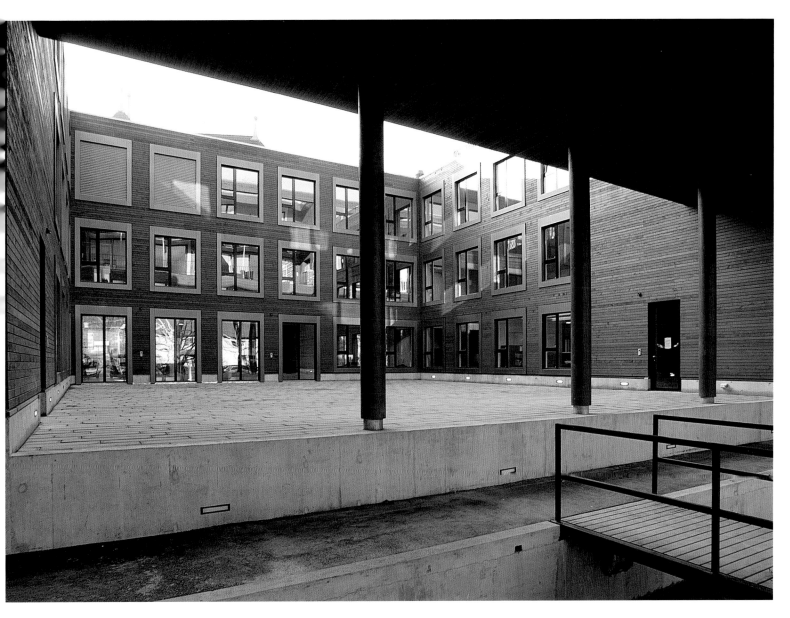

The four-story Renggli office building – erected in 2002 in Sursee (Lucerne Canton) – is typical of modern multi-story timber construction. The architecture is not loud and strident; it philosophizes quietly. Concealed within is a solid timber frame with outstanding energy performance.

The development of new wooden ceiling systems has played a key role in the breakthrough and optimization of multi-story timber construction. Planners today can choose from a number of ceiling structures to meet their specific needs, ranging from pure timber solutions to applications in which wood is structurally reinforced by concrete.

Swiss timber designers have made an important contribution to the advancement of timber house construction with various systems based on laminated beams and composite timber-concrete slabs – and with the development of standardized, laminated hollow components.

These components were originally designed as elements for restoring rural buildings, but progressive architects discovered their true potential. A differentiated development process gave rise to Lignatur case and surface elements, used as load-bearing floor or ceiling compo-

nents. Their high degree of prefabrication and light weight have transformed construction site assembly into a series of quick and easy installation processes.

Balkenlage

Hohlkasten-Elemente

Voll-Elemente

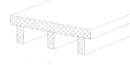

Holz-Beton-Verbund

Holz-Beton-Verbund

The options for constructing ceilings are as varied as the demands placed on them. In addition to fulfilling structural

requirements, ceilings perform many tasks required by building physics including noise insulation and fire protection. Numer-

ous newly developed timber ceiling systems are available today alongside traditional wood ceilings.

The four-story residential building of the Allgemeine Wohnbaugenossenschaft – built in 2002 in Zug – has composite timber-concrete ceilings made of laminated Bresta wood elements and concrete poured on site. The elements are profiled on the upper side (100/120 mm) and doweled with hardwood anchors without glue. The ceiling has excellent noise insulation properties and a fire resistance period of 60 minutes.

The flaws in the building physics of 1950s timber homes and office buildings, which gave them their "barracks" feel, have been known for some time. They can now be eliminated thanks to scientifically established standards and specifications. In fact, the earlier, fatal flaws have inspired timber construction of unprecedented quality. The catchwords here are low energy and passive energy homes.

The new building concepts are based primarily on the principle of multilayer wall and ceiling construction, which effectively and intelligently counteracts the unpleasant physical properties associated with timber constructions, including low sound insulation on the inside and a tendency toward heat built-up in summer. Not only that, the thermal insulation possible today makes energy performance values possible with thin walls. Such values were previously inconceivable or only possible at a high cost with very thick walls.

Future developments will be spurred not only by low and passive energy standards, but also by a stringent overall energy balance, which includes length of use. The benchmark will be set by energy consumption in production, transport, installation, maintenance, building material disposal, and building technology systems – all of which make a strong case using timber as a building material.

"Wechsel" is a four-story, eight-family residential building constructed in Stans (Nidwalden Canton) in 2001. Thanks to its timber frame construction, a matching high-quality building envelope (300-mm insulation panels), state-of-the-art building technology, as well as active and passive use of solar energy, it produces more energy over the year than is required for its operation.

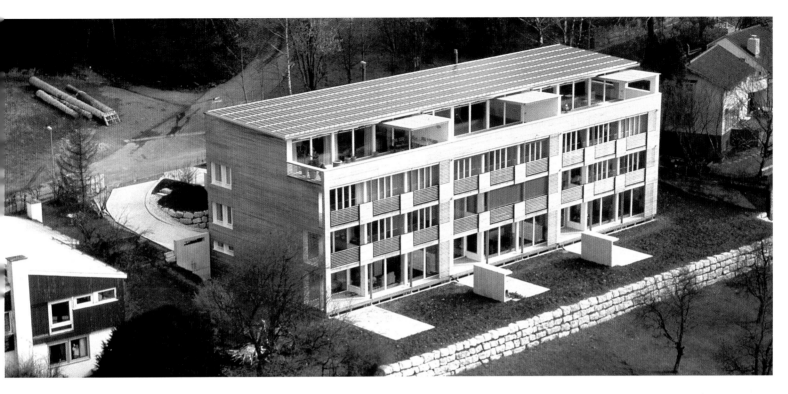

Sunny Wood, a four-story residential building erected in urban Zurich in 2001, reflects its designers' clear concept with regard to aesthetics, environmental materials and energy efficiency. The timber panel construction profits from a strict energy concept.

Wall system (from interior to exterior):
Plasterboard, 15 mm
Mineral wool/batten, 30 mm
Solid wood panel/rib, 35/300 mm
Mineral wool, (40 kg/m³) 100 mm
Mineral wool (22 kg/m³) 200 mm
Wood-based panel, 15 mm
Larch batten, 24/48 mm
Cedar cladding, 35/50 mm

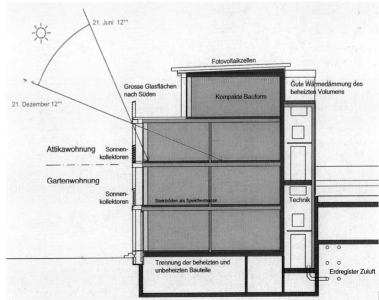

21. Juni 12°°

Fotovoltaikzellen

Grosse Glasflächen nach Süden

Kompakte Bauform

Gute Wärmedämmung des beheizten Volumens

21. Dezember 12°°

Attikawohnung Sonnen-kollektoren

Gartenwohnung

Sonnen-kollektoren

Steinböden als Speichermasse

Technik

Trennung der beheizten und unbeheizten Bauteile

Erdregister Zuluft

If one lists the buildings that have foreshadowed and spurred developments, it is quite apparent that, in Europe, Switzerland ranks among the pioneers in multi-story timber construction. The architectural preoccupation with wood in creative, large-scale applications, as well as the shift away from the common cliché of the grand chalet, has produced a large number of buildings with a simple yet regal look. Despite their dimensions, they are reminiscent of finely crafted furniture. In addition to demonstrating technical feasibility, they have opened the way for new schools of thought in architecture.

Nowadays, multi-story timber buildings are built using different techniques and designs, and come in a wide range of styles. They continue to set trends while focusing attention on a potentially high-quality alternative to traditional forms of timber construction.

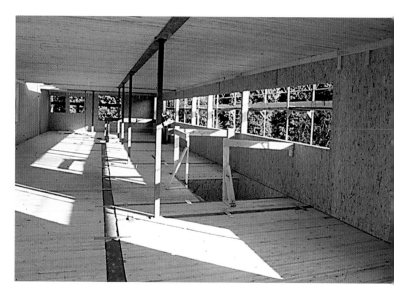

Multi-story timber buildings come in a variety of designs: some conceal the use of timber from the outside gaze, others celebrate it.

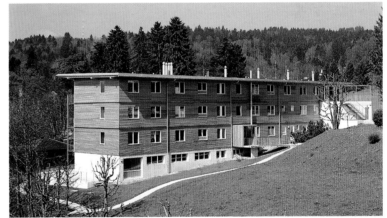

Residential building
Maienzugstrasse in Aarau,
built 2003

Holzfachschule in Biel,
built 1999

Stirnrüti residential building
in Horw, built 1998

Bois gentil residential building
in La Chaux-de-Fonds
built 1998

Chemin Vert residential building
in Carouge, built 2000

Simmen residential building
in Brugg, built 2003

Bridge Construction

Bridges have always played an extremely important role in the lives of human beings. Every bridge that is built brings human beings into contact with one another, and this – over and above its purely technical character – makes the bridge both a symbol and part of our culture. As structures, bridges are not only a part of human history, but also a measure of the planning expertise and technical skill we have attained.

One reason why wood has remained indispensable for constructing bridges for thousands of years is that, like stone, it is a natural material. The first bridges were made of simple, unhewn tree-trunks. To this day, the basic types of load-bearing structures – namely the beam (stretching over one or more spans) and the arch – have not changed since human beings first attempted to make them.

Well into the eighteenth century, the basic forms of supporting structures changed only slightly. But then a decisive step was taken by Swiss builders when they combined the basic elements to form increasingly complex bridge structures such as bar systems, trusses and arches that were made entirely of wood. Exemplary bridges arose that testified to their constructors' profound grasp of statics and displayed a boldness unsurpassed for a long time. Some of these works still exist.

The new materials – iron and concrete – soon replaced wood as a material for constructing bridges in the nineteenth and early twentieth centuries. Indeed, the continuous progress in the development of materials allowed for spans that nobody would have thought possible previously. Wood fell out of favor.

It is only with the relatively recent development of new wooden materials with large dimensions, a high load-bearing capacity and improved connections that wood has again attained novel and independent status in the engineering field of bridge construction. This has resulted in new footbridges and road bridges, characterized by original, high-quality design and impressive dimensions.

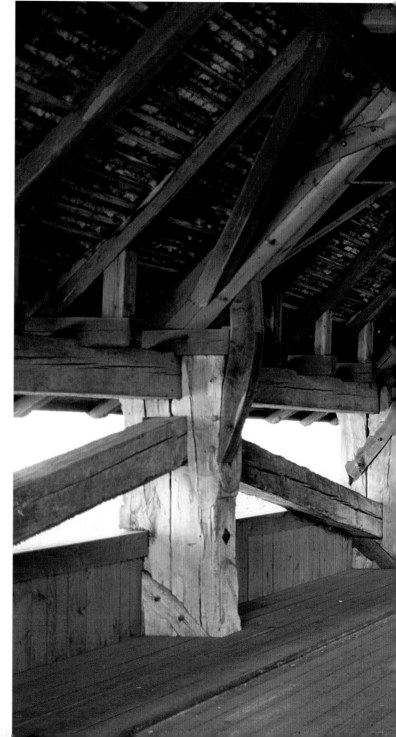

The Gümmenen Bridge built across the Saane River (Bern Canton) by Velti Hirsinger in 1555 is one of the oldest surviving road bridges.

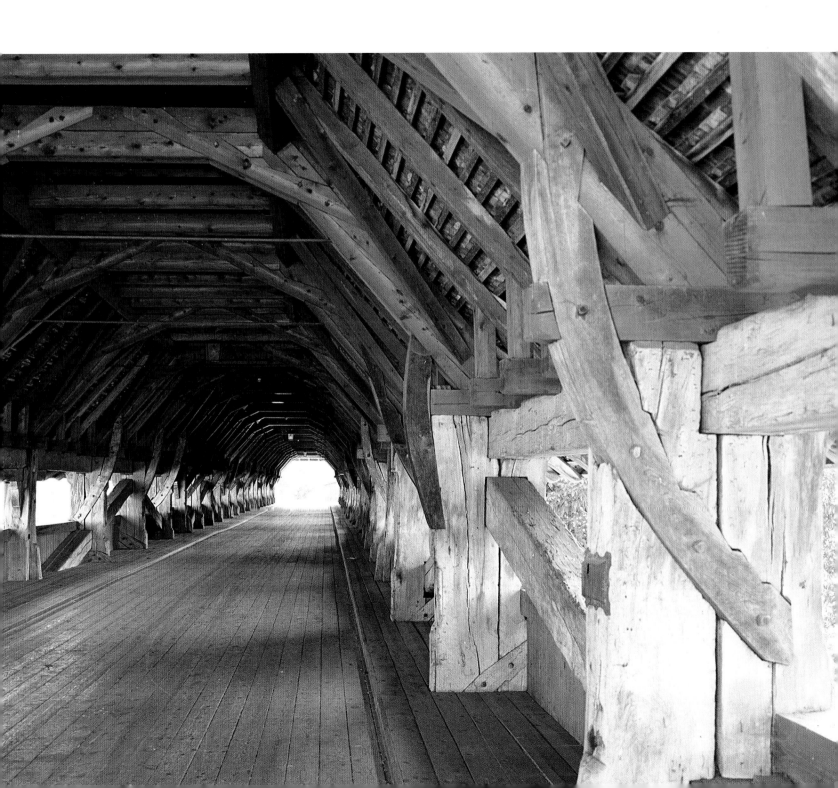

Transitional Structures

A tree trunk, once felled and laid across a ditch or a river, creates an easily made crossing and, for this very reason, also represents the original form of the bridge. The beam bridge is probably as old as mankind. Corbels fixed to stone blocks, or pile foundations embedded in a river and covered with single beams to form a pile bridge, made it possible to construct crossings that exceeded the limited length of the tree trunk. Even so, the spans thus achieved remained relatively short, so that floods and drift ice frequently swept such bridges away. Nevertheless, beam bridges have the advantage that they can be easily reconstructed or – in the case of war, for example – quickly dismantled.

The addition of struts enhanced a beam's load-bearing capacity and allowed for greater spans. These struts, inclined wooden rods resting on supports, created an intermediate reinforcement which, in turn, led to the development of new load-bearing structures: the trussed frame (if the beams are supported) or the hanging truss (if they are suspended).

In early times, cantilever bridges, as can still be found in Nepal, were quite commonly used in the European Alpine region to extend tree trunks and to thereby overcome their natural limitations in length. However, owing to constant changes in moisture and recurrent flooding, the wooden corbels held firmly in place by stones have a short life span.

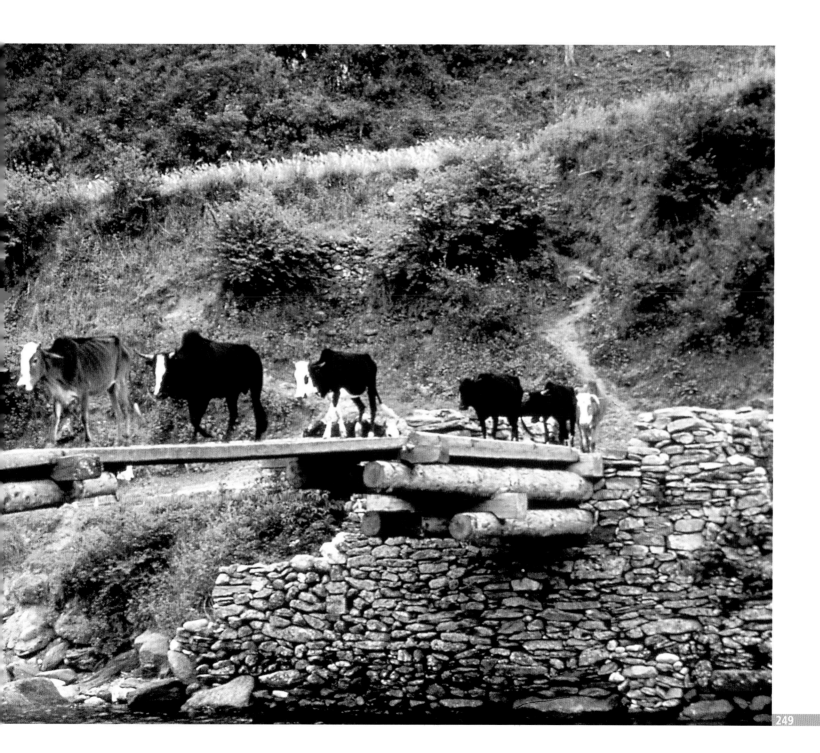

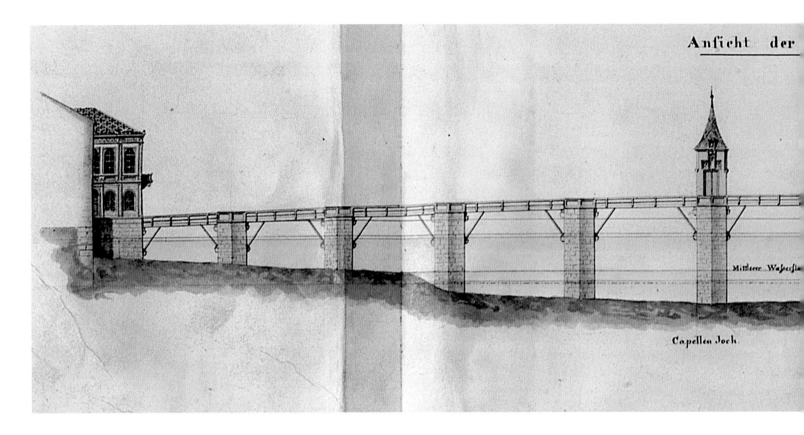

Mittlere Wafferfla

Capellen Joch.

Cantilevered bridges and pile bridges are generally considered the original form of the wooden bridge. These bridges were inspired by the idea of using a simple beam, which is such an elementary, commonly found structure that the historical origins of such bridges have faded into oblivion. We only know of a few isolated structures that have been historically documented due to remarkable incidents and notable uses associated with them: the 400-meter-long bridge crossing the Rhine River at Neuried, Germany, for example, which was built by Julius Caesar in 55 BC, and the Kappell Bridge in Lucerne, which was constructed as a fortified structure in 1333.

With respect to transport and strategic significance, one of the most important trestle bridges to be constructed on Swiss soil was the Middle Rhine Bridge built in Basel in 1225. Initially, it had eight wooden trestles of oak piles and five stone piers. For a long time, life in Basel centered on this bridge. Court judgments were executed on this bridge and the "slovenly wenches and child murderers washed away." During the course of their long history, bridges have been repeatedly damaged by floods and even swept away completely, only to be reconstructed later. The Middle Rhine Bridge survived in this way until 1903.

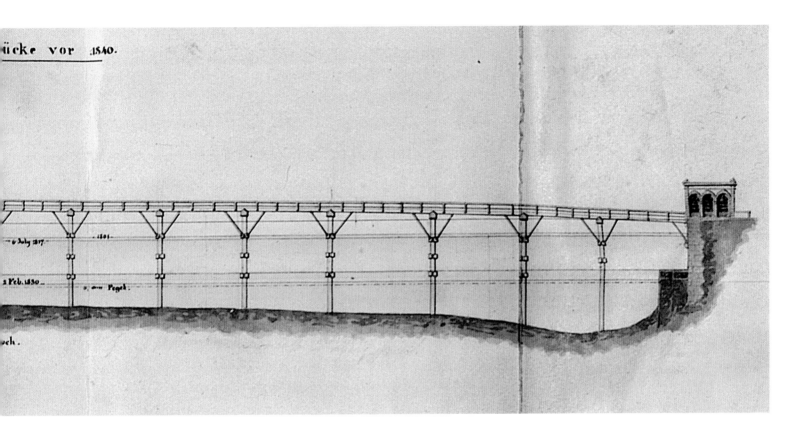

The Middle Rhine Bridge in Basel was built in 1225. At the time of its construction there was no permanent Rhine crossing between Basel and Constance. The wooden trestles, also known as arches, were only later replaced by stone piers on the Kleinbasel side. The Käppelijoch Chapel of Atonement, which was built on the bridge, serves as a reminder of the trials by ordeal that were a typical feature of medieval justice. Initially, the bridge served local needs only. After a while, however, it came to play a very important role internationally for transport after the road over the St. Gotthard Pass was constructed in the fourteenth century. From then on, the crossing permanently influenced Basel's economic development. The colored pen-and-ink drawing shows the bridge before 1840.

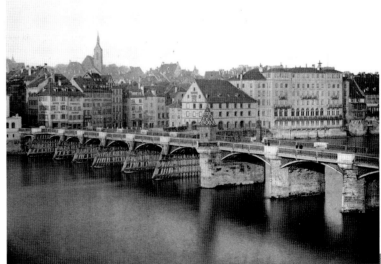

Massive wooden piles lent Basel's Middle Rhine Bridge its distinct appearance until it made way for a new bridge in 1903.

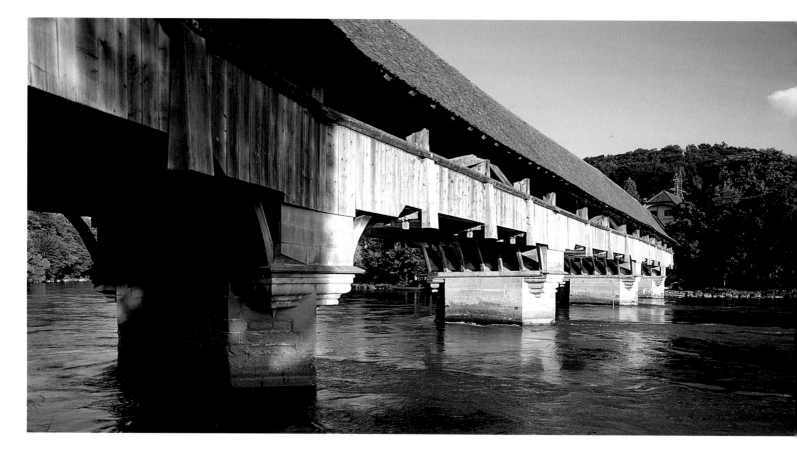

Swiss builders made a substantial contribution to the development of structural forms from the beam to the trussed frame and the hanging truss. The roofing and siding, a rare feature in the old days, offered bridges better protection against the vicissitudes of the weather, whilst the truss above the deck increased its capacity to withstand the effects of flooding. These were great qualitative improvements in every respect, and they are still evident in the bridges that have survived up to the present. A wonderful example of this is the Neubrügg Bridge built near Bern in 1535. Simple hanging trusses cover five spans whose lengths vary between 16.48 and 20.95 meters.

The five spans of the 91.2-meter-long Neubrügg Bridge near Bern are composed of simple hanging trusses.

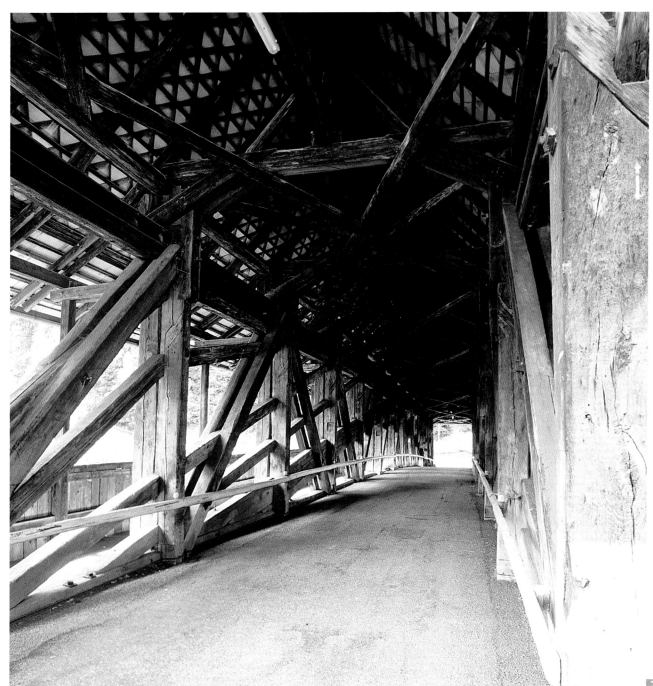

Interlocking hanging trusses are wonders of engineering that transcend natural limits and make it possible to increase the length of the spans. The Thurbrücke Bridge in Lüthisburg (St. Gallen Canton), which spanned more than 58 meters when it was built in 1789, was given two piles and reinforced by additional trussed frames in 1885.

Grubenmann's Influence

The remarkable developments in bridge construction in the past centuries bear witness to the excellent knowledge of materials and the rich experience of individual builders. They managed to construct large spans by overcoming wood's naturally limited dimensions with their structural skills and by employing ingenious and specially adapted load-bearing structures. Although they had no theoretical knowledge of statics, they built some very successful structures.

Unparalleled achievements in bridge construction made the Grubenmann family (from Appenzell) famous the world over and distinguished them – and particularly Hans Ulrich Grubenmann (1709–1783) – from other master craftsmen of the time. H. U. Grubenmann's load-bearing structures testify to the extraordinary clarity of his structural concepts. In addition to his fine craft skills, he also had a gift for intuitively grasping the interplay of forces. He carefully studied the behavior of constructed buildings over a long period of time, partly with the aid of models, and put his conclusions into practice in his subsequent load-bearing structures.

"… If one considers the size of the building and the boldness of the structure one is surprised to learn that the master builder was originally a carpenter without the slightest general education whatsoever, without any knowledge of the mathematical sciences and not at all versed in the theory of mechanics. This extraordinary man's name is Ulrich Grubenmann. He was born in Teufen, a small village in the Canton of Appenzell Ausserrhoden. Highly skilled and with an astounding mastery of practical mechanics, he has worked his way up into a superior position and may rightly be regarded as one of the most outstanding master builders of the century …"
From the travel book *Sketches of the Natural, Civil and Political State of Switzerland* by William Coxe 1778

Illustration of the Rhine Bridge in Schaffhausen by Johann Heinrich Bleuler, ca. 1790.

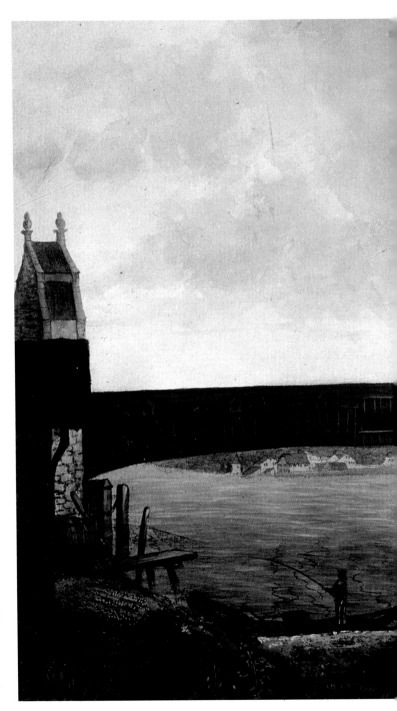

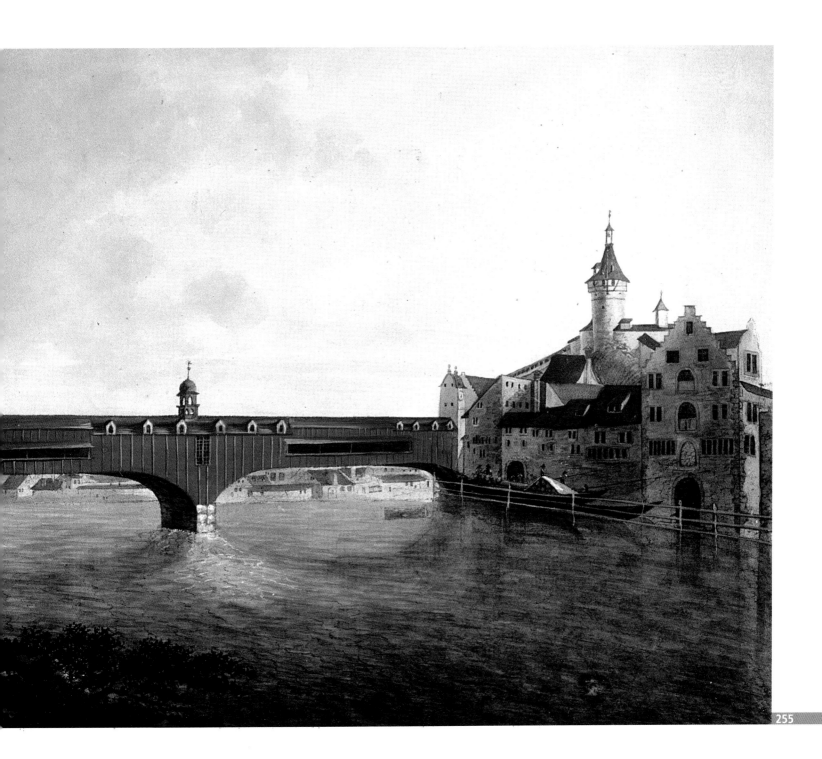

The Achmühli Bridge was built in Speicherschwendi (Appenzell Ausserrhoden Canton) as early as 1701. Its funicular arch, composed of a series of connected compressed beams, displays the vault-like action of an arch.

There were natural limits on the span of the single trussed frame or hanging truss. However, by integrating these load-bearing systems over a number of spans it was possible to create spans of up to 30 meters. And by skillfully overlapping hanging trusses and trussed frames, builders could increase the stiffness of load-bearing structures. The angular curve created by the connected upper compressed beams of the hanging truss displays vault action. The striving to create ever longer spans resulted in increasingly flat tension bars, which diminished rigidity, thus making additional counter braces necessary. This development finally spawned two new concepts for load-bearing structures: the trusswork and the arch.

The Urnäsch Bridge was built by H. U. Grubenmann in Hundwil (Appenzell Ausserrhoden Canton) in 1778. Its five-span tension beam extending 32 meters forms a distinct polygonal arch.

The bridge over the Glatt River in Oberglatt (Zurich Canton) was constructed by H. U. Grubenmann's brother Johannes Grubenmann in 1766–1767. It clearly shows the development from the hanging truss to the arch. In 1950, the bridge had to make way for a road, so it was dismantled and reconstructed 4.5 km downstream in Rümlang.

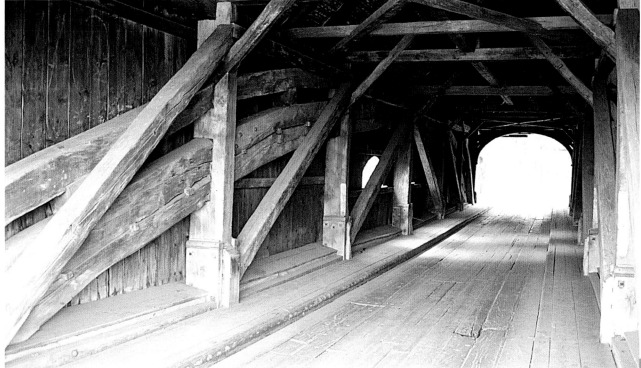

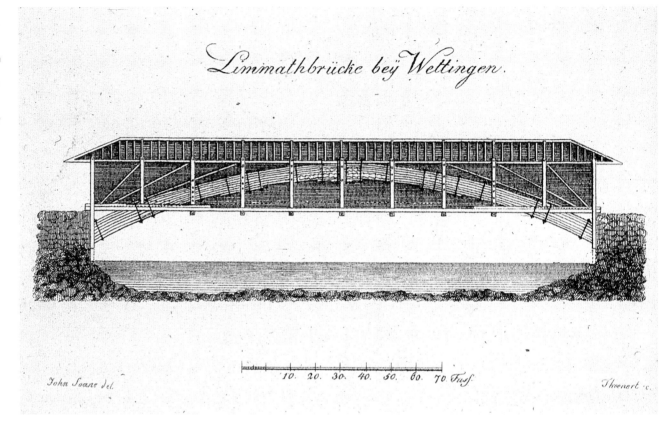

Limmathbrücke bey Wettingen.

John Soane del. 10. 20. 30. 40. 50. 60. 70. Fuß. Thvenort c.

The arch's moment-resisting quality is very important for the way it behaves. Moment resistance is used to overcome the problem of deflection caused by unequally distributed loads (i.e. live loads). The manner in which the individual arch elements are connected and the quality of the connections play a decisive role. In 1766, Grubenmann became the undisputed master of wooden arch construction with his 16-meter span Limmat Bridge near Wettingen (Aargau Canton). The arch itself was composed of six squared timbers with a cross section of approximately 300 x 300 mm, which were carefully connected and screwed together.

This road bridge has a span of 58 meters and was built in Hasle-Rüegsau (Bern Canton) by the two masters Rudolf and Jakob Schmid in 1838. It conveys a good impression of the character of Grubenmann's bridge in Wettingen. Like Grubenmann before them, the builders recognized the importance of interconnecting the arch elements. Their bridge has managed to accommodate increasing road traffic without any noticeable damage so far.

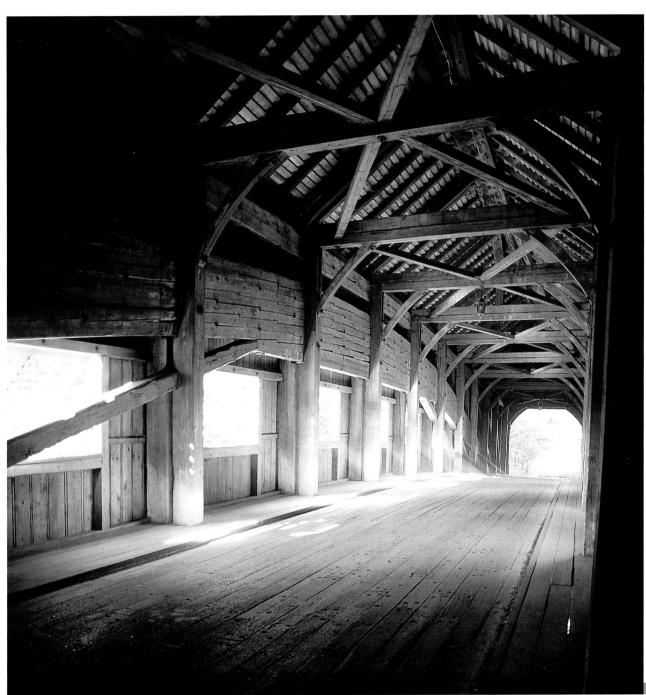

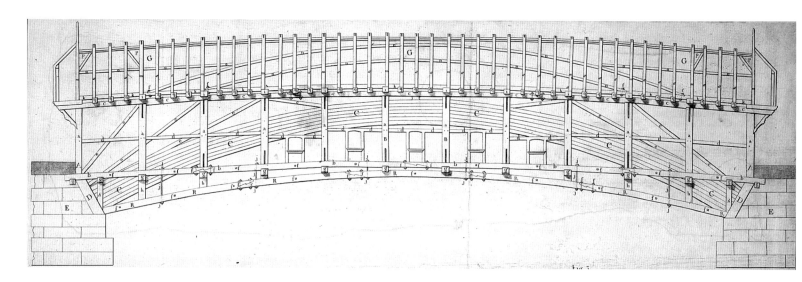

The construction plan of the bridge, which had a span of 46 meters and was built by Joseph Ritter over the Reuss River in Mellingen (Aargau Canton) in 1794.

Many of Grubenmann's successors evidently failed to appreciate the importance (for the bridge's load-bearing behavior) of using complex interconnections to form the individual beams into an arch – a method that placed great demands on the craftsmen's skills. When, for example, Joseph Ritter of Lucerne built the new arch bridge over the Reuss River near Mellingen in 1794 – some thirty years after Grubenmann had erected his bridge in Wettingen – he did without interconnecting elements. The arch beams, which created a span of approximately 46 meters, consisted of eight long curved hewn timbers (180 mm x 270 mm) that were connected solely by the hang posts. As there was a shortage of firewood at the time, the bridge soon had to bear a considerable amount of traffic transporting peat, which quickly revealed the structure's lack of rigidity. This, combined with a shift in the abutments at the left bank, resulted in an alarming deformation; as a consequence, a middle pier had to be constructed only twenty-two years after the bridge had first been opened.

The insufficient rigidity of the arch in the bridge near Mellingen caused deformation, which was still evident even after the erection of an additional pier in the middle.

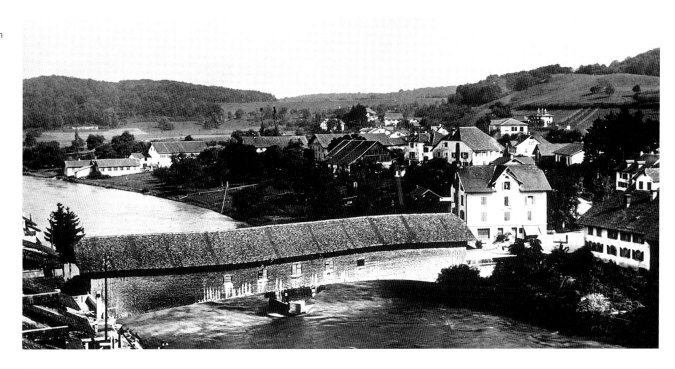

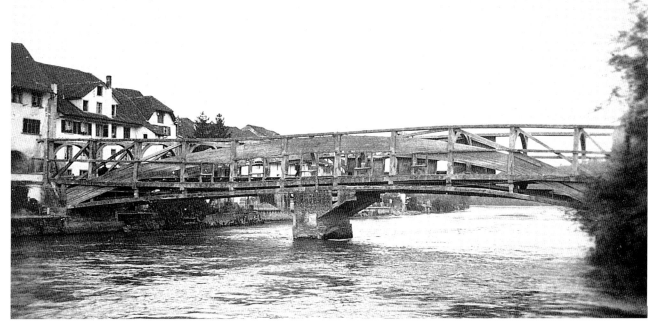

The structural problems caused by the belated addition of a middle pier manifested themselves for the last time when the bridge was demolished in 1927. Afterward, the wooden bridge was replaced by a steel structure designed as a simple plain-webbed girder with a riveted trough section.

The American Influence

As an alternative to the arch, engineers and builders came up with the idea of systematically filling in rod polygons to form a lattice structure or a truss. The only problem lay in the practice, then prevalent, of using purely wooden connections. The efficient and rational diagonal tie had not yet been invented.

In the early nineteenth century, American builders and engineers carved out new paths and created a new generation of trusses. Unencumbered by tradition and compelled to come up with quick, inexpensive solutions, they developed new building systems. Their trusses were composed of standardized wooden elements that were easy to produce and assemble. Taking these trusses as his starting point, Carl Culmann (1821–1881), professor at the ETH Zurich, established the foundations of structural engineering, which made it possible to calculate the forces acting on trusses and to solve the problems thus arising with the aid of the graphic method. These developments helped to popularize this structure among engineers.

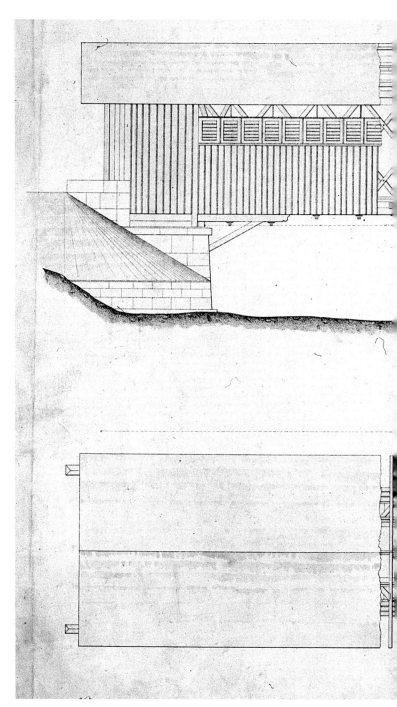

The construction technique patented by the American William Howe in 1840, in which the diagonally crossing filling bars are prestressed with perpendicular tie rods, was soon adopted in Switzerland, as the bridge built across the Sihl River near Adliswil (Zurich Canton) in 1852 shows.

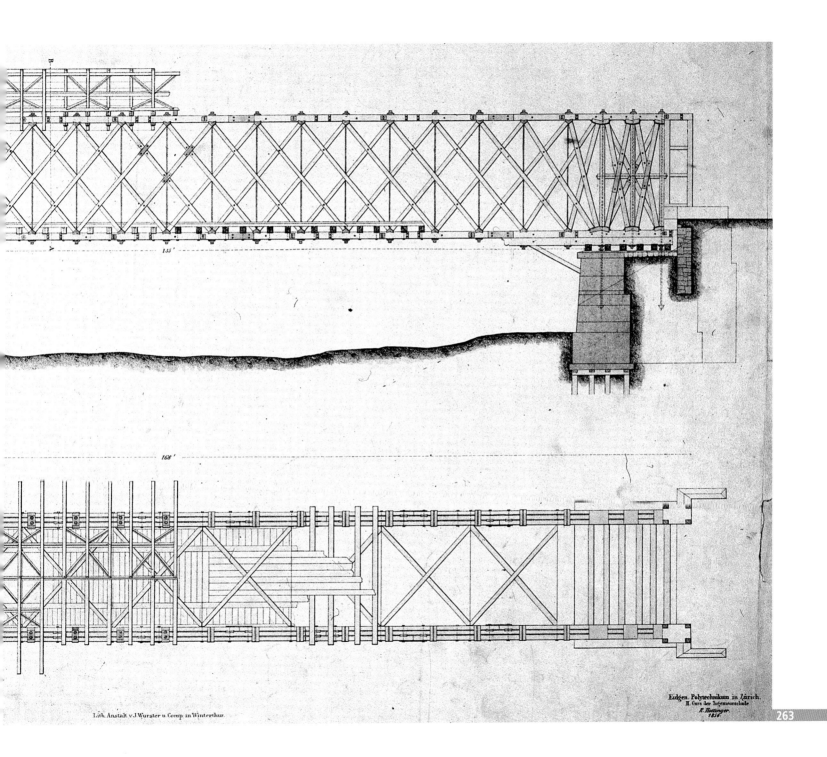

Eidgen. Polytechnikum in Zürich.
II. Curs der Ingenieurschule
E. Hottinger.
1856

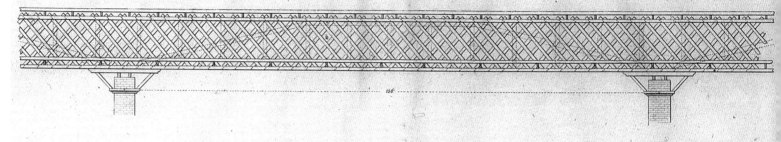

TOWN'SCHE LATTENBRÜCKEN.

Fig. 1 Brücke über den James bei Richmond.

150'

The American influence on the development of trusses is largely due to the work of two people: Town and Howe. Their new systems were applied in Switzerland to construct masterful and impressive bridges.

Ithiel Town (1784–1844) solved the problem arising from tension-struts with the aid of a closely meshed lattice. By placing the diagonals close to one another, he managed to reduce the tensile force that would arise when the components were connected.

"Town's largest bridge is probably the one that takes the long Southside railroad across the James River near Richmond, Virginia. It has twelve spans of 150 feet (46 meters) each." This is how Carl Culmann describes the impressive structure in his travel log in 1851. In his exposition, Culmann, later professor at the ETH in Zurich, uses the term truss for the very first time. He went on to develop his truss theory, which people still use today. The filigree connections used on the bridge near Richmond have, however, proved too weak to bear the two-track railroad traffic. Nor did the subsequently installed trussed frame, the additional supports or the one-way middle track help very much either. Consequently, the bridge was replaced not long after it had come into use.

Town's lattice truss was ideal for wooden structures, since it could be made from standardized, relatively small wooden sections and lengths that were connected with readily available bolts and rods. The Rotenbrücke Bridge built in 1862 near Teufen (Appenzell Ausserroden Canton) is a fine example of this type of structure.

The load-bearing structure used for the Fadenbrücke Bridge in Buochs (Nidwalden Canton) in 1852 is a lattice truss based on Town's design. It has a span of 24.6 meters.

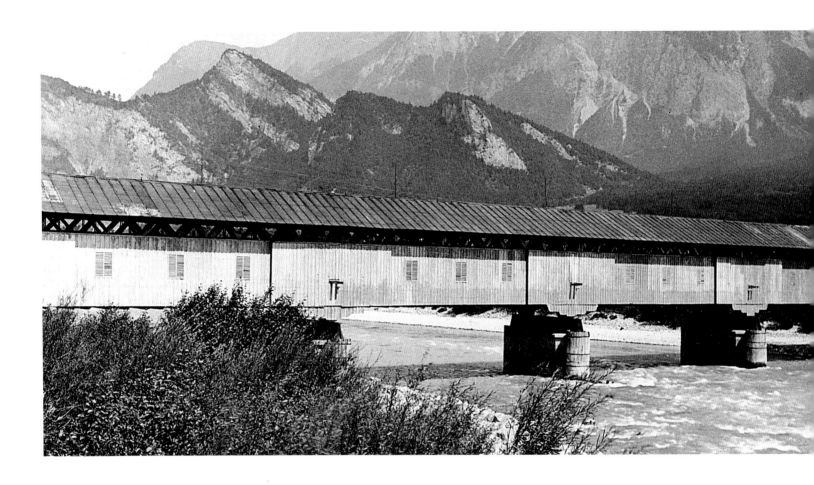

Unlike Town, William Howe (1803–1852) refrained completely from using tensile force in the diagonals. He prestressed the diagonally crossing struts with vertical iron rods and thus "overpressured" the existing tensile force. This way, each diagonal could be effortlessly connected using a compression splice.

In practice, further development of the trusses depended exclusively on improved connections. It was only after mechanical connections were standardized in the early twentieth century and made reliable by scientific testing methods that rapid progress was achieved. Recent improvements in development techniques are a sign of further progress. Optimized connections now make it possible to build trusses that are rational, competitive and of span great distances.

The single-track railroad bridge built between 1856 and 1857 over the Rhine River at Bad Ragaz (St. Gallen Canton) for the Sargans-Chur line was based on the principle developed by William Howe. The bridge remained in use for seventy years. Over 140 meters long, it is one of the most impressive structures of its type.

The bridge trusses designed in accordance with Howe's principle had double-braced spans and quadruple bracing above the piers. The bracing was continuous along the entire length of the spans to prevent the bridge from collapsing should one of the endangered piers fail when the river was in flood.

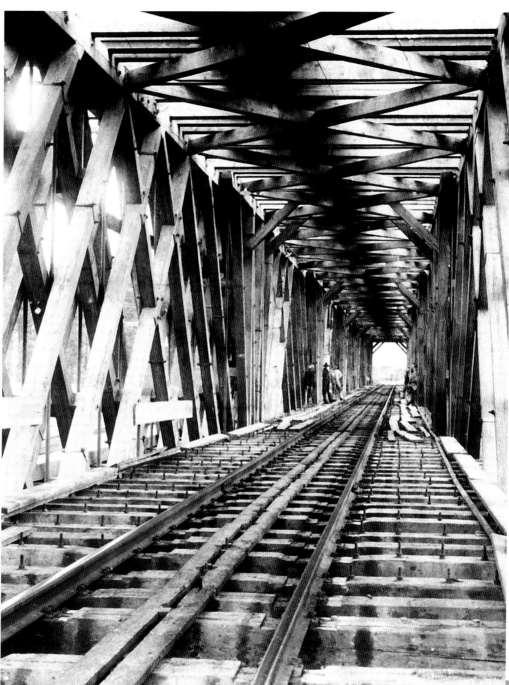

Temporary Bridges

At the end of the nineteenth century, the growing use of iron and concrete posed a serious challenge to wood as a bridge-building material. As these new materials apparently overcame all of wood's disadvantages, the latter declined in importance. Roles changed: wood now became an auxiliary material. Nevertheless, wooden bridge construction continued, albeit in a different way, in the form of huge falseworks, whose planning and execution was often more expensive and more impressive in scale than anything else built in the field of bridge construction. Their bold forms and structures made them unforgettable.

A combination of structural expertise, well-founded knowledge of materials and entrepreneurial experience is essential in the construction of falsework. There is a tension between the great loads that must be borne and the high degree of stiffness required on the one hand, and the economic viability, the engineer's powers of discretion and the skills of the carpenter on the other.

Nothing better symbolizes the change in bridge building during the early years of the twentieth century than the construction of the concrete arch bridge over the Hundwilertobel (Appenzell Ausserrhoden Canton) in 1924–1925. The fact that it replaced a wooden bridge built over a century before illustrates how much wood had declined in importance.

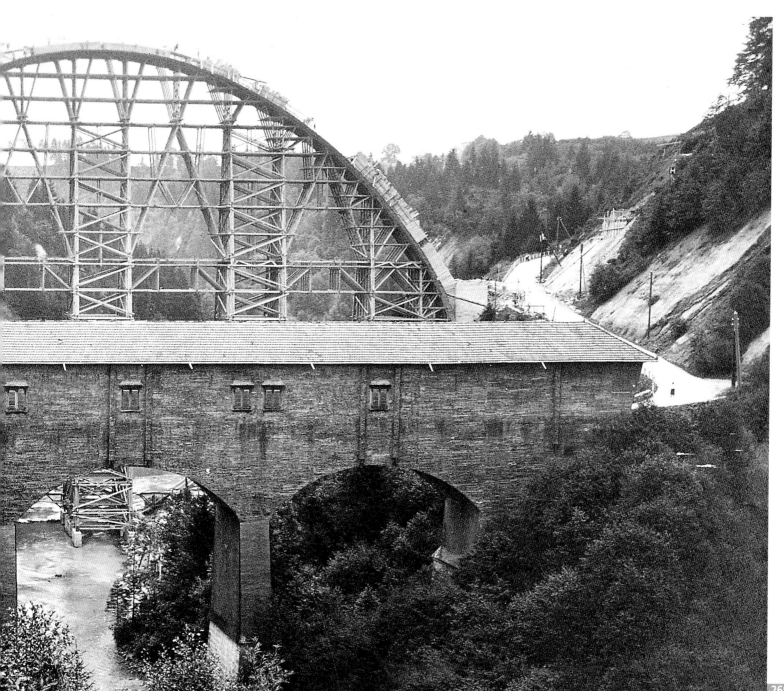

Swiss master carpenter Richard Coray (1869–1946) played a decisive role in the development of falsework. With his great daring and craftsmanship, he constructed unparalleled falseworks. In 1913, instead of simply using the standard tower construction, Coray proposed constructing a fan-like supporting structure for the falsework for the Langwieser Viaduct (a concrete arch bridge with a span of 100 meters, Graubünden Canton). This meant considerable savings in time, material and money. For the construction of the Soliser Viaduct in 1901, Coray insisted on building the stone vault in three layers. The first brick-built ring was intended to support the others, so that the frame would only have to bear half the weight of the final vault.

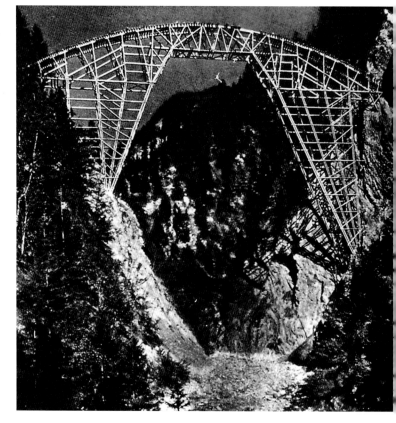

In 1929–1930, Richard Coray and his sons designed and built a falsework 80 meters above the ground for the masterful arch bridge designed by Robert Maillart, which had a span of 90 meters. Maillart's bridge links Schiers and Schuders on either side of the Salgina Gorge (Graubünden Canton).

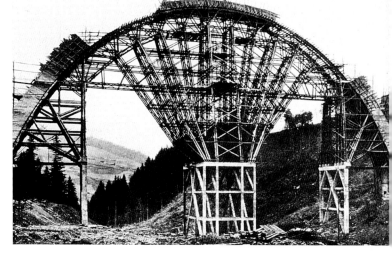

With this fan-like arch falsework erected for the 100-meter span of the Langwieser Viaduct (Graubünden Canton), Richard Coray found a solution that was not only far simpler than the tower, but also saved a considerable amount of wood.

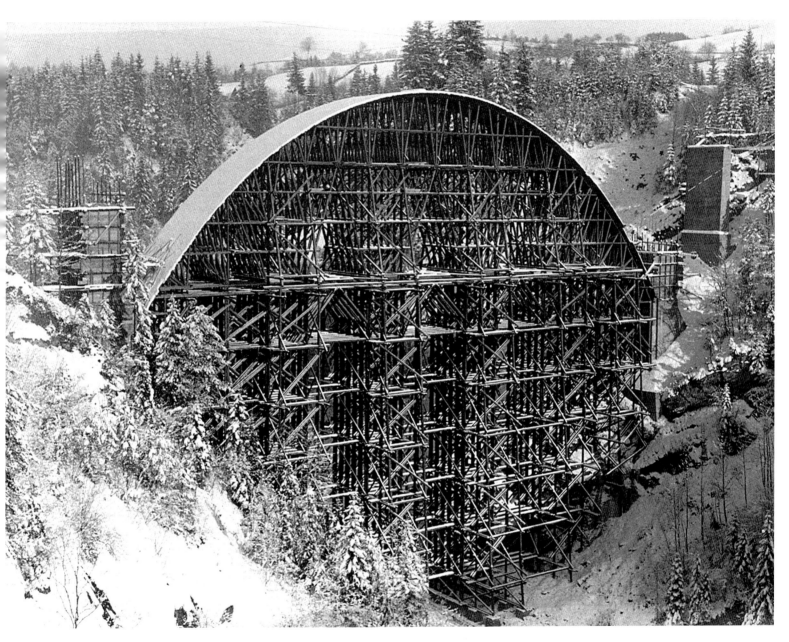

The falsework used for the 79-meter span of the concrete arch of the Gmündertobel Bridge at Teufen (Appenzell Ausserrhoden Canton) was erected as a so-called tower structure in 1907. The almost continuous row of supports across the valley floor necessitated a vast supply of wood.

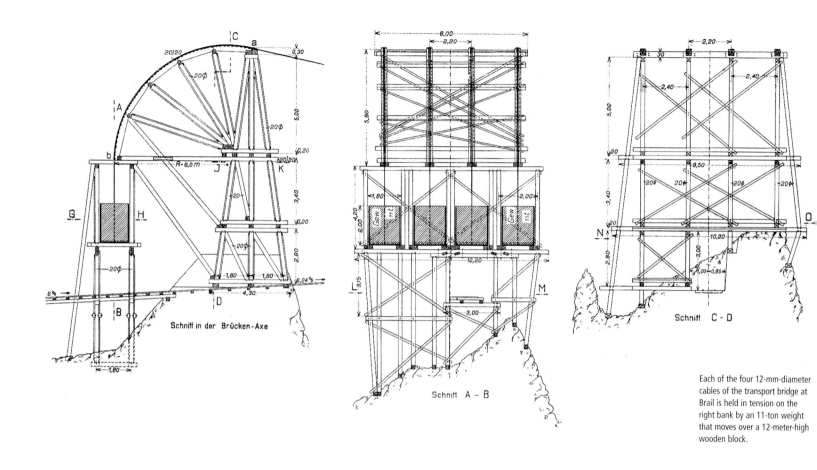

Schnitt in der Brücken-Axe

Schnitt A – B

Schnitt C – D

Each of the four 12-mm-diameter cables of the transport bridge at Brail is held in tension on the right bank by an 11-ton weight that moves over a 12-meter-high wooden block.

The suspension bridge designed by Richard Coray in 1910, which crossed the Inn River at Brail (Graubünden Canton), is a very impressive example of the use of temporary wooden structures. The bridge, which had an open span of 168 meters, was used for almost three years to transport materials required to construct the tunnel for the Unterengadine line of the Rhaetian railroad. The remarkable thing about the structure was the arrangement of the four suspension cables: two of them ran parallel; the other two extended outwards from the middle of the runway to the supports. This not only enhanced the lateral stability of this ex-

traordinarily slender structure but also minimized horizontal oscillation. The bridge itself had to support a runway track bearing a 1-ton live load as well as the workers passing back and forth. The construction method was both extremely simple and economical. A cross-beam was fixed to suspension cables that were arranged at intervals of 3 meters. Two 6-meter longitudinal beams were screwed together and laid on top of this. Boards were then fitted to provide a walkway.

The transport bridge built by Richard Coray across the Inn River at Brail (Canton Graubünden) had a span of 168 meters. The bridge had to support a runway track bearing a 1-ton live load as well as the workers passing back and forth. The construction was both extremely simple and economical. Boards were fitted to provide a walkway.

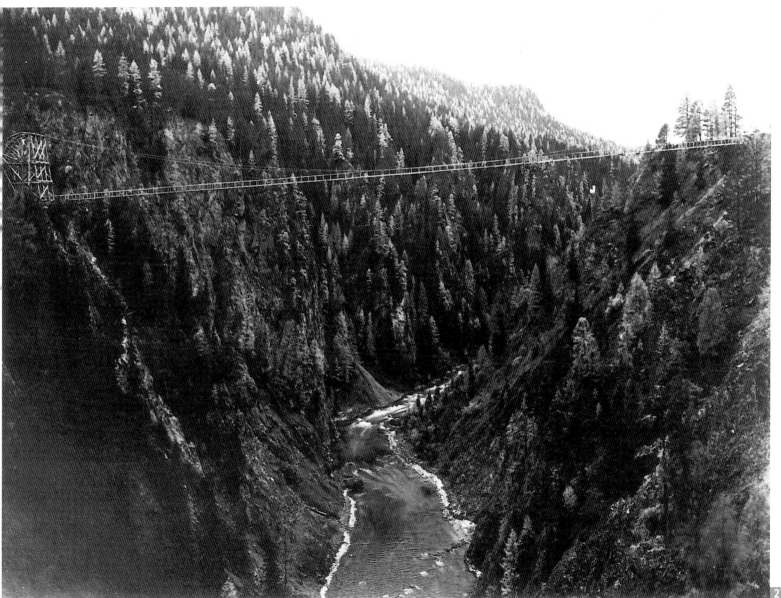

Wood's specific properties make it particularly suitable for a wide variety of temporary structures. The enormous dimensions of site installations, serviceways and formwork constructions present a great challenge to builders and engineers, inspiring them to design ever bolder structures.

The great advantage of wood is its favorable weight-strength ratio, lightness, easy processing, prefabrication and the reusability of individual elements. Being easy to process, it is also an ideal material for formwork.

The service bridge, which has a span of 165 meters, was built in 1957 for the construction of the Luzzone Val Blenia dam wall of the parish of Olivone (Tessin Canton). The basic structural system is a trussed frame fastened with additional diagonal cables.

Although they often look like artworks in their own right, formworks are merely temporary structures: they give concrete its form and then disappear. The sophisticated geometrical formwork made for the turbine discharge system at the underwater galleries of the pumped storage system in Vianden (Luxembourg) provides a good example of this. It was constructed in 1962 by specialists at the Zschokke corporation in Switzerland.

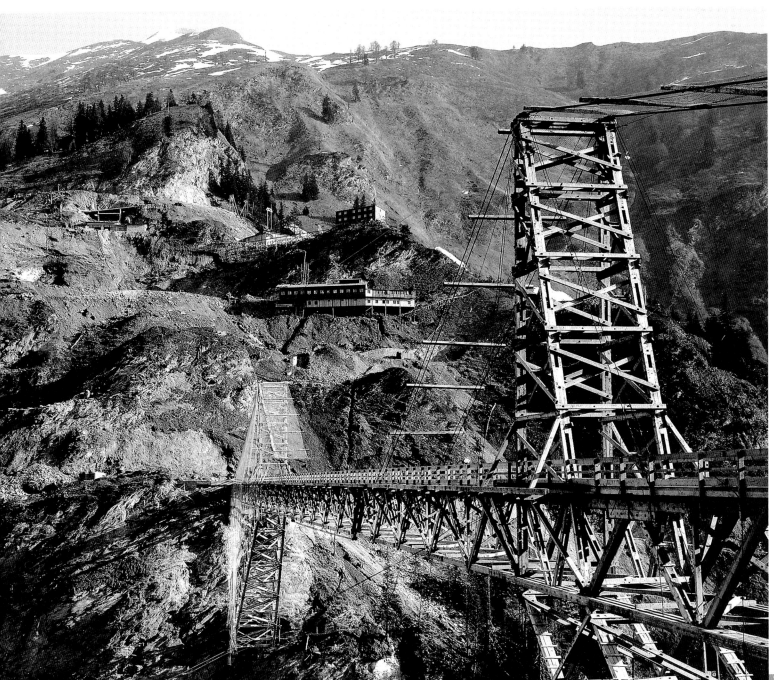

Progress: New Concepts

The transition from wooden constructions made by skilled carpenters to wooden structures erected by engineers had more or less been accomplished by the early twentieth century. At the same time, however, the new "technical" materials – steel and concrete – were quickly replacing wood in bridge construction. Nor could the use of glued laminated timber, with its enormous range of applications, halt this process. For a long period, wooden bridges were relegated to the sidelines.

It was only the construction of impressive halls in the early 1970s that visibly demonstrated wood's value for building robust structures and also encouraged – albeit belatedly – constructors to build footbridges and, here and there, road bridges in wood. The development of new wood-based building materials has been crucial for the renewed appreciation of wood as a useful and valuable material for constructing bridges.

Novel types of connections have also led to profound changes in manufacture and assembly. Whereas components once tended to be joined and staggered on site, entire bridge components are now prefabricated in the factory (as is the case with modern wooden housing construction) and assembled "in one go" on site to form a complete load-bearing structure. This not only results in great savings in time and money but also enhanced quality. The Swiss engineer Walter Bieler has decisively influenced the development of wooden bridge construction over the past twenty years.

Changes in manufacture and assembly: the triple-span, 93-meter-long truss of the Dominiloch Bridge over the Reuss River at Hermetschwil (Aargau Canton) was prefabricated in three parts in the factory and floated across the river to the construction site.

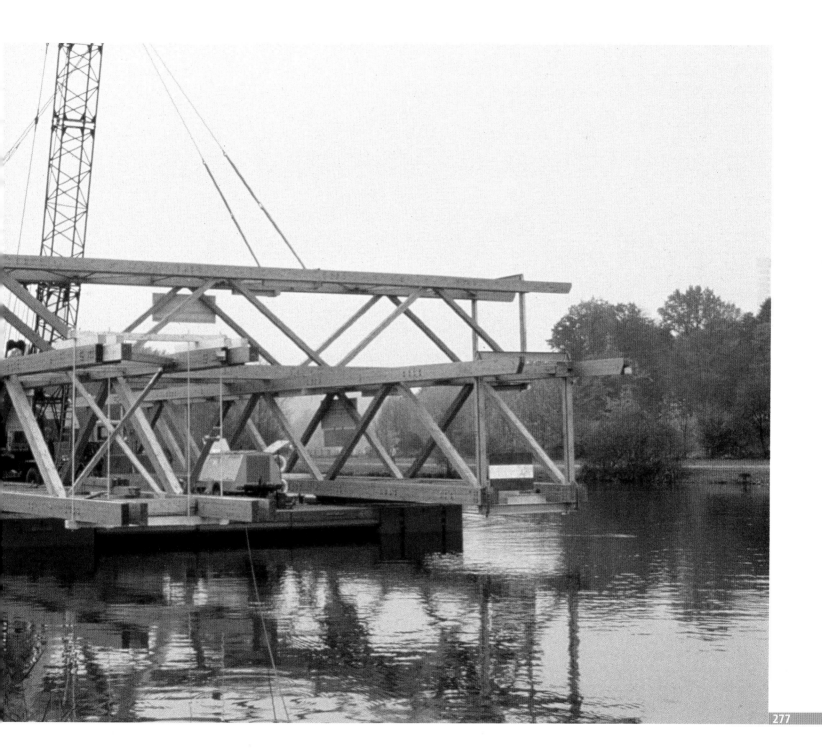

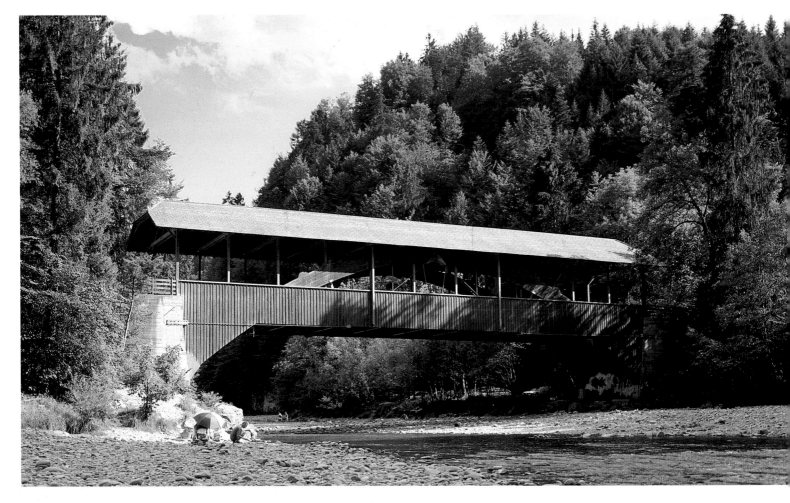

The sustained boom in wooden bridge construction during the past twenty years is due to technological improvements and, above all, to the methodological design and clear grasp of load-bearing structures on the part of engineers. The stricter demands placed on bridges by users, the greater forces acting on these structures, as well as the more stringent safety and maintenance requirements mean that designers can no longer rely on the old empirical approach to making static calculations.

Ruchmüli Bridge, which spans the Sense River with its 39-meter arch, was built near Albligen (Bern Canton) in 1977. It is the first of a new generation of wooden bridges. Instead of using the standard thick planks to bear loads, the builders deployed a continuous concrete slab with trapezoidal section sheeting as a carriageway slab.

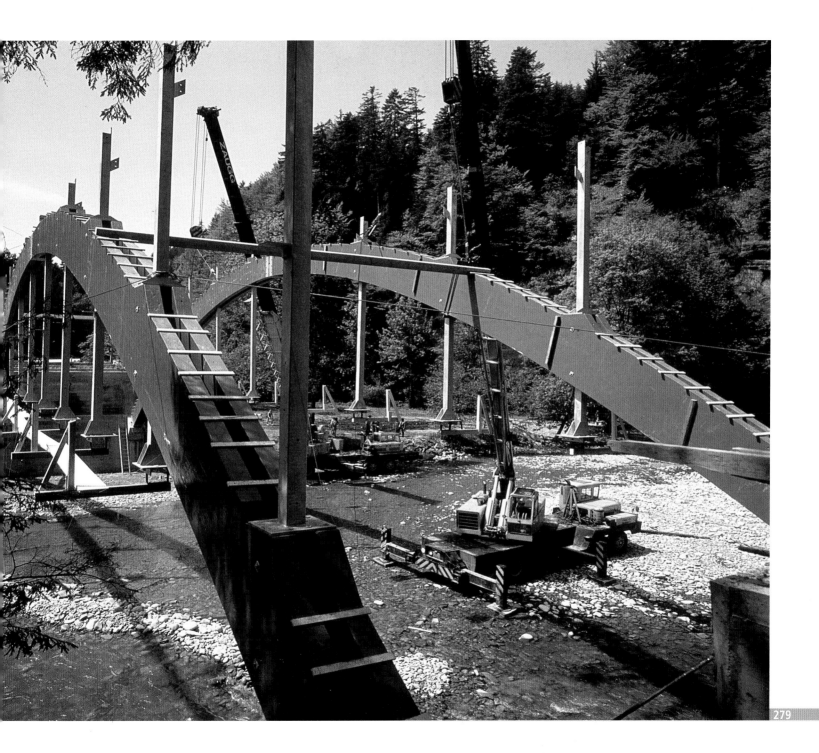

Stable load-bearing structures are a typical example of the changed approach to computing statics. In the past, designing and constructing in wood was a pragmatic and intuitive affair, and it was not possible to reliably establish the action of wooden structures. Nowadays, a carefully planned reinforcement concept based on struts, bents, and portal frames makes for clearly defined structures.

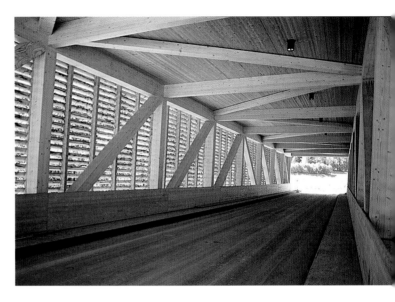

A clear and comprehensible stabilisation concept, as exemplified in the Selgis Road Bridge (Muotathal, Schwyz Canton), built in 2001, distinctly reveals the "new" quality of structural planning and the engineer's attitude to wooden bridges.

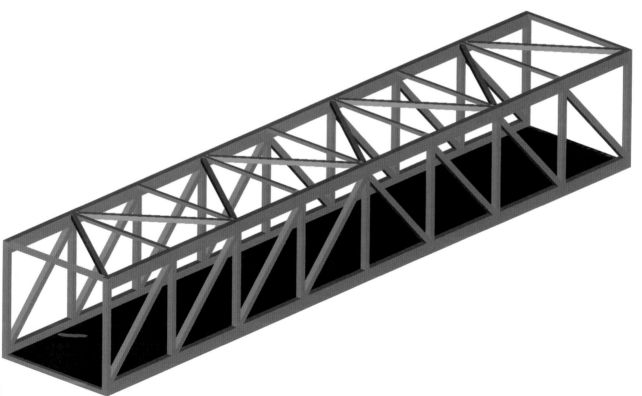

This illustration shows the structural function of horizontal parabolic compression arches which serve as upper trussed beams that absorb some of the wind loads and stabilise the main arched trusses against lateral forces. The present example shows how the arch was used in the construction of the Bubenei Road Bridge in Signau (Canton Bern).

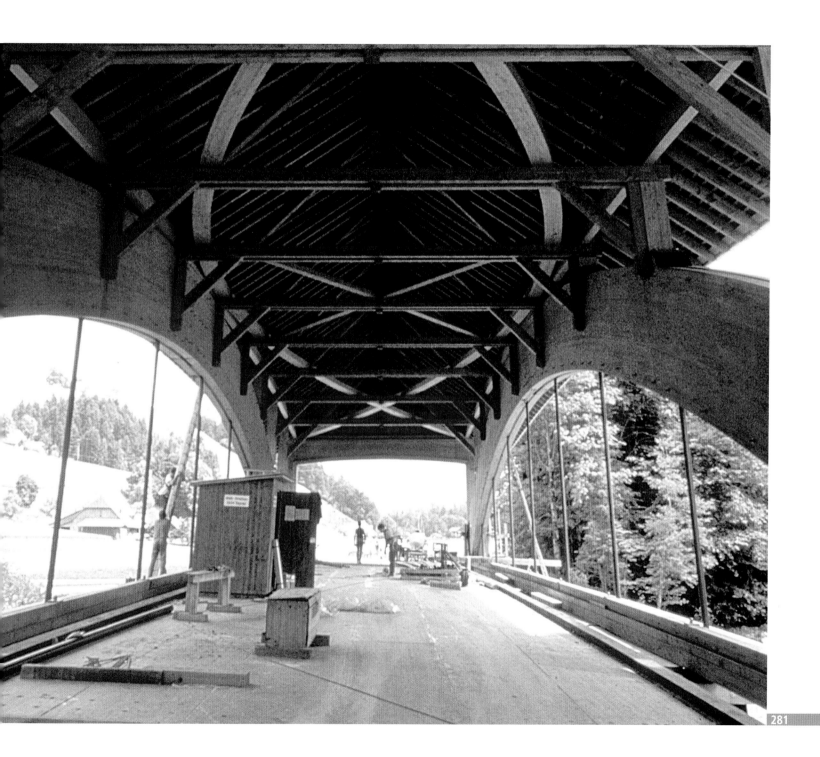

Modern connection systems are necessary for effective portal frames. Mathematical calculations allow engineers to make objective and comprehensible analyses of the projects they are planning. These developments have produced wooden bridges of an unprecedentedly high quality and novel design.

The horizontal forces acting on the upper truss of this road bridge, constructed in 1984 in Eggiwil (Bern Canton), are transferred through the portal frame into the foundation. Multiple shear bolted connections hold the structure firmly in the concrete base, thus increasing lateral stiffness.

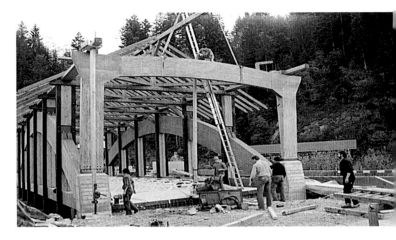

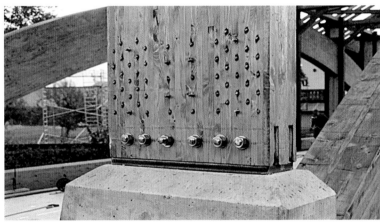

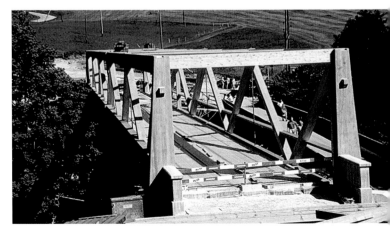

The roof truss of the twin-span Mühltobel Bridge in Libingen (St. Gallen Canton) was constructed in 1991; it is firmly held in place at both sides of the bridge ends by portal columns sunk in concrete.

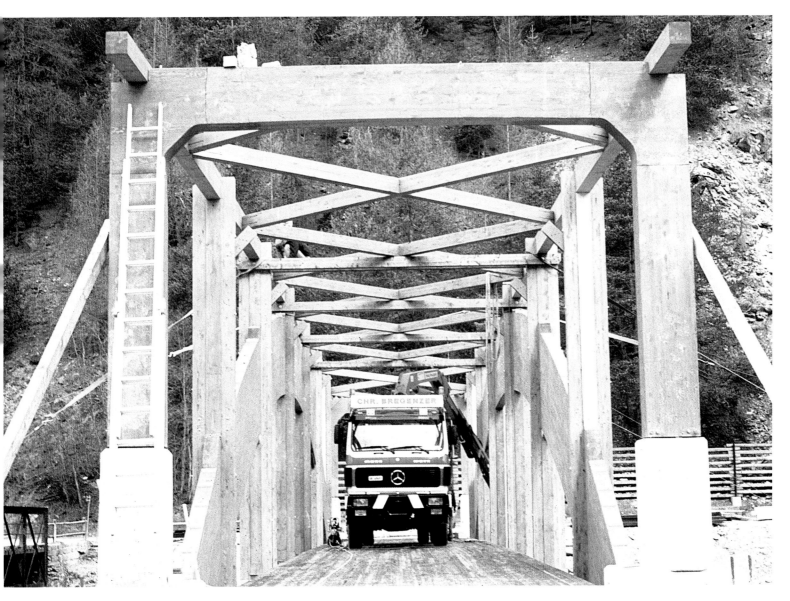

Sclamischot Road Bridge (Grau-
bünden Canton) was construct-
ed in 1990. Its portal frame is
made of custom-built 280-mm-
thick plywood boards. Despite
the high multiaxial local loads,
they allow full frame action,
thus ensuring sufficient lateral
stiffness. The frame corner is
connected to the cross beam
and the support by a finger
joint.

283

Progress: The Deck Slab

The traditional deck construction with transverse wooden planks does not fulfill today's requirements. Although the surfacing satisfies the conditions for a continuous deck, the substructure remains "unsettled", and cracks inexorably appear in the substructure when it becomes wet. Damage and high maintenance costs have given wooden bridges a bad name.

The development of the continuous, transverse pretensioned wooden deck slab represents an immense improvement in quality.

Pretensioned deck slabs are now state-of-the-art components in newly constructed bridges. Thanks to transverse pretensioning, the deck slab has a far more stable form for a continuous road pavement than the plank structure generally used until recently. This deck slab, 7 meters wide and 50 meters long, was designed for the two-lane Bubenei Road Bridge (Bern Canton), which was built in 1988. This type of structure was first used in the construction of the Dörfli Bridge in Eggiwil (Bern Canton) in 1984. The design is based on a concept developed by the ETH Zurich.

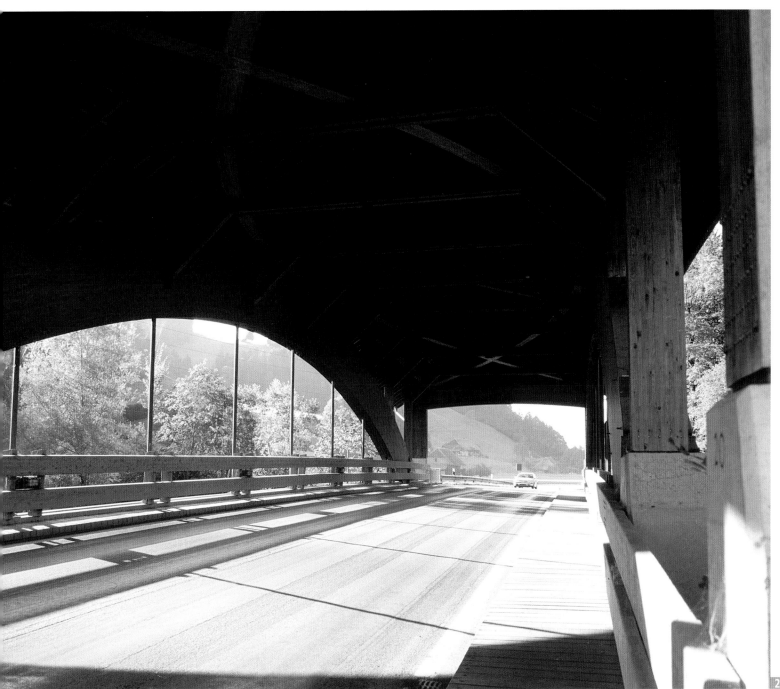

The pretensioned deck has two advantages over the old loose arrangement of boards and laminates: firstly, it significantly reduces problems caused by varying degrees of stiffness in longitudinal and transverse wooden planking, and secondly, it provides for greater dimensional stability when moisture varies.

The principle:
The QS Slab is made of glued laminated wood, single softwood boards bonded edgeways, or entire structural laminated timber beams. Steel rods, placed at regular short intervals, pass through them. After the system has been assembled and the beam joints glued together, the slab is pretensioned. A steel supporting plate and an edge element (generally of hardwood) distribute the high local compression; transverse compression is then increased to the highest permissible degree.

Encouraged by developments in the USA, technicians at the ETH adapted a new technical innovation – the continuous and pretensioned deck slab – to Swiss conditions at the ETH Zurich. They also added some essential new features.
The resulting QS slab solved the problems facing wooden decks. (QS originally stood for Qualité Suisse and later for transverse pretensioning.) Transverse pretensioning not only increases slab stiffness but also improves load distribution and dimensional stability, thus prolonging the deck's service life.

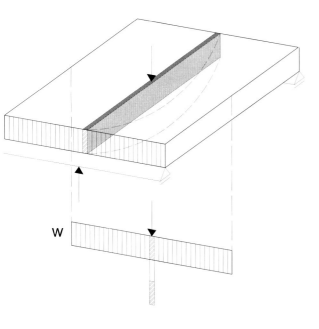

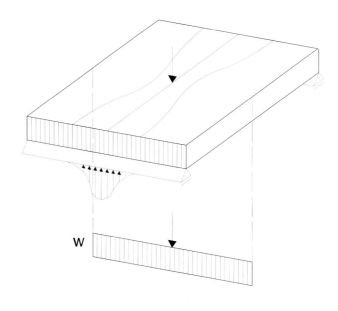

Structural Behavior:
The application of a concentrated load shows the structural behavior of the pretensioned slab. If the slab is not pretensioned, the force can only be transferred into the boards that directly bear the load. Pretensioning, in contrast, ensures transverse load distribution. Pretensioning generates slab action, considerably reducing deformation and, therefore, stresses and strains.

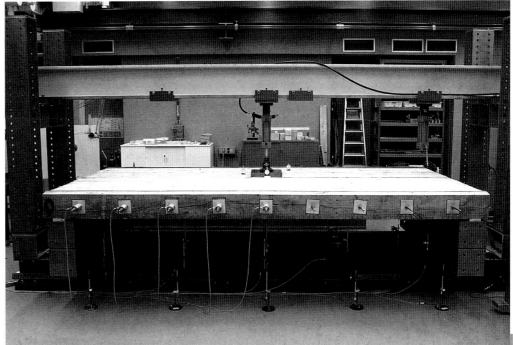

The load-bearing behavior of the transverse-pretensioned slab of wood under single loads was tested on 1:1 scale building elements at the ETH Zurich.

A new generation of wooden deck slabs have been developed as large elements. Nowadays, engineers can obtain suitable wood materials and pretensioned laminated cross sections to make these slabs. In contrast to traditional slabs, the new models are of great interest due to their more homogenous material properties. Apart from displaying greater stability of form, they also generate slab action. The latter helps distribute single loads transversely and thus greatly improves the transfer of wheel loads on road bridges. The slab can also act as wind bracing.

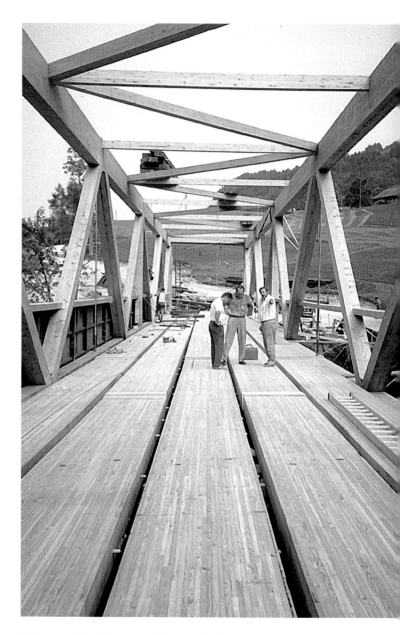

Over 5 meters wide and 61 meters long, the deck for the Mühltobel Road Bridge in Libingen (St. Gallen Canton) could not be transported in one piece. Five laminated wood beams (26 cm thick) were delivered to the construction site, placed alongside one another, glued and then pretensioned. The bridge was completed in 1991.

The 4-meter-wide and 35-meter-long deck for the List Road Bridge in Stein (Appenzell Ausserrhoden Canton) was prefabricated from a single laminated beam in the gluing shop. It was delivered in one piece to the site and fitted in the bridge-bearing structure.

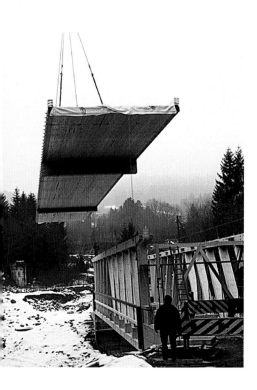

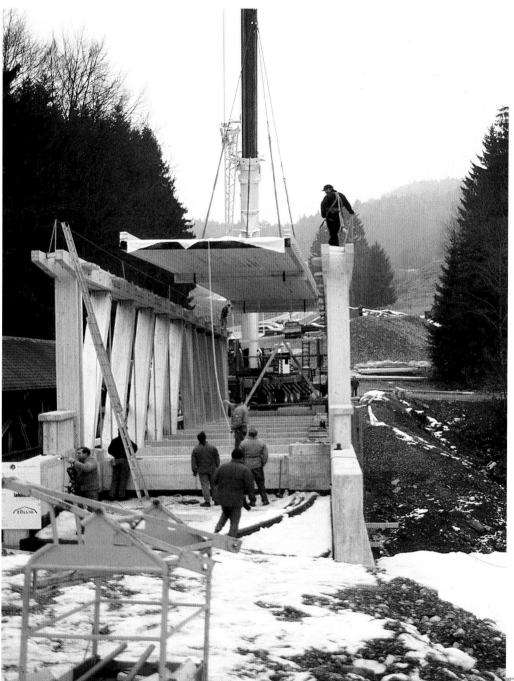

To create simple slabs, boards are placed edge-ways alongside one another and pretensioned transversely with tensioning reinforcement at regular intervals. Such structures are primarily used in rural and wooded areas to construct slab bridges. Road bridges with spans of up to 6 or 8 meters and footbridges of approximately 10 meters can be constructed with this method. Single transverse pretensioned glulam beams are used for the actual deck.

Slab bridges can also be built on site quickly and easily. The boards, which are supplied from the factory as prefabricated packages, are transferred directly from the truck to the abutment, which is completed first. The pretensioning rods are then placed in position and pretensioned. In less than twelve hours the bridge is ready for use.

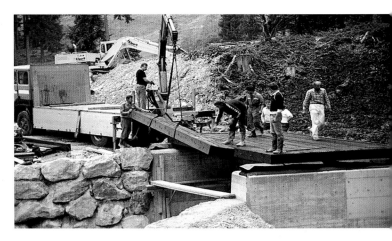

Curved bridges can also be constructed quite simply on site, as the example of this curved two-span bridge shows. It was built as part of a new forest road development project in Wila (Zurich Canton) in 1922. The 18-meter-long bridge has a radius of curvature of 22 meters.

Using transverse pretensioned boards placed edgeways, slab bridges capable of supporting heavy vehicles on forest roads can be built quickly, easily and at a favorable price.

As an alternative to existing deck slabs of transverse prestressed laminates, new wood materials are now available in the form of large laminated veneer lumber, veneer plywood and plywood slabs, all of which provide the desired transverse stability and material homogeneity.

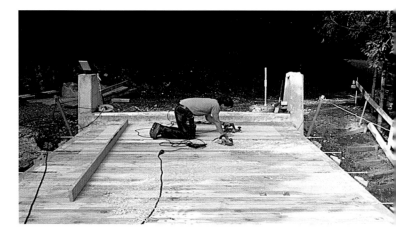

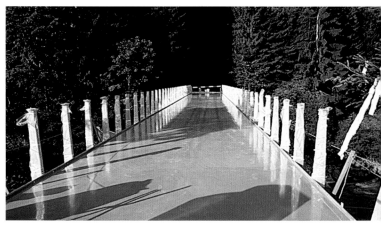

A 39-mm-thick laminated veneer lumber element (Kerto) formed the footpath slab of the 85-m-long cross-country skiing bridge across the River Inn at Pradella/Unterengadin (Graubünden Canton). It performs three functions: with the appropriate sealing, it protects the main load-bearing beams below and the substructure of the covering against the weather. The Kerto slab also distributes the individual loads quite effectively and transfers the wind loads and stabilizing forces.

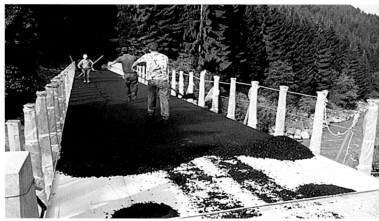

In four of the footbridges built in 1991 by the municipality of Samnaun (Graubünden Canton), the deck consists of a continuous beech veneer plywood slab; the three main beams below the deck form the load-bearing slab-and-beam structure. The main beam, which is longitudinally pretensioned as a "Kämpf bridge" gives this cross-sectional shape a high load-bearing capacity and great stiffness.

Progress: Composite Structures

The combination of timber and concrete may appear strange at first sight, but there is no reason why the specific properties of wood and concrete shouldn't be used and combined in one structure. Indeed, timber composite structures open up a vast range of possibilities for bridge construction.

This is especially true of uncovered bridges with load-bearing structures beneath the deck. Here, the principle of the so-called deck bridge offers a variety of ways to productively combine the two materials. The composite slab beam uses the indispensable concrete deck slab and its static properties to create a compression chord for the bearing structure. The sealed slab extensively protects the wooden bearing structure beneath it from the direct effects of weather, thus performing the function otherwise executed by the now superfluous roof. The greater stiffness achieved using a composite material not only improves the bridge's overall load-bearing capacity but, ultimately, the bridge's service life too.

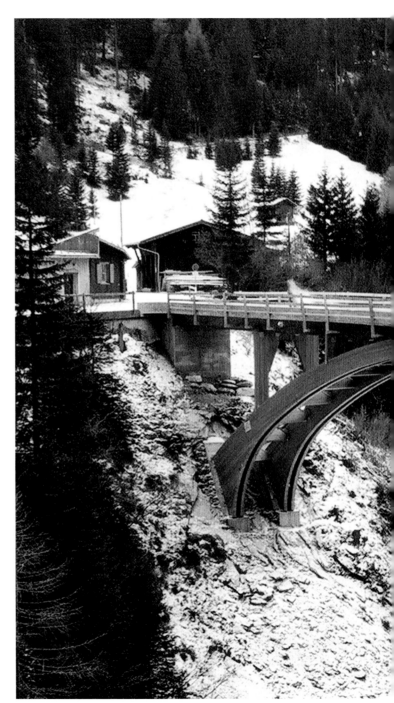

The elevated single-lane deck of the La Resgia arched road bridge at Innerferra (Graubünden Canton) is made of a composite timber-and-concrete structure. The bridge, which has a span of over 60 meters, was constructed in 1998. The four longitudinal load-bearing beams made of glued laminated timber are connected to the upper concrete deck slabs by glued reinforcing rods with a diameter of 14 mm. This not only effectively increases the stiffness of the bridge and provides for great longitudinal and lateral stability, but also protects the lower longitudinal beams from the vicissitudes of the weather.

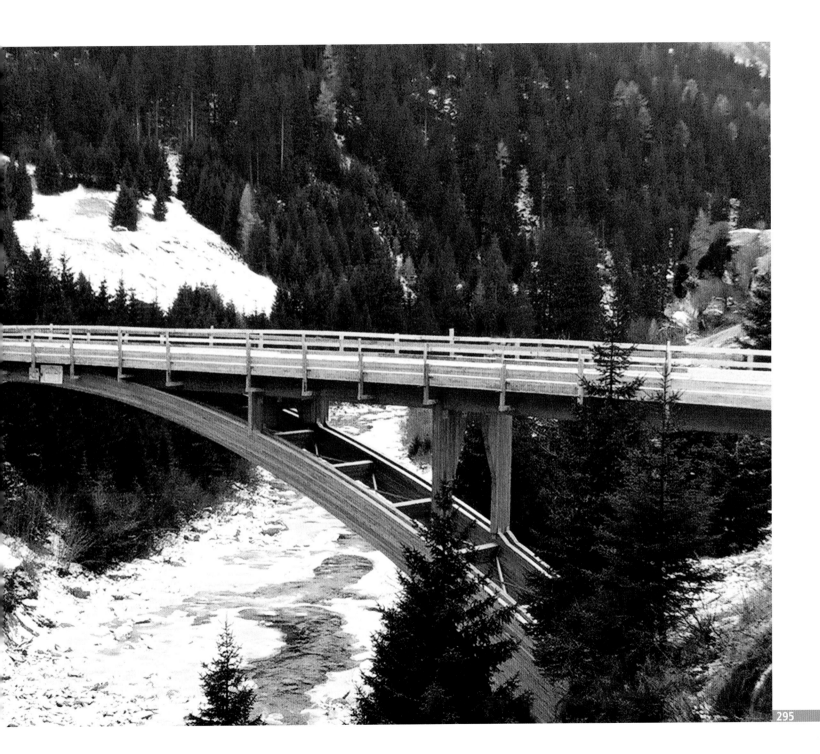

In the fall of 1991, the Ronatobel Bridge was completed in Furna (Graubünden Canton). It is the very first timber-and-concrete composite bridge built for road traffic in Switzerland. The design of the shear connection was inspired by the great diversity of existing timber-concrete composite structures in building construction. It should be remembered, however, that the action of forces in bridges is not only far greater and more concentrated than in buildings, but also mostly dynamic in nature. The shearing strength gained ultimately determines the increase in stiffness of the bearing structure as a whole.

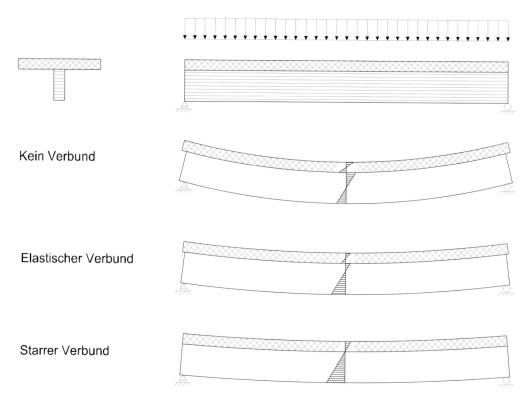

Kein Verbund

Elastischer Verbund

Starrer Verbund

The principle of composite construction as illustrated by the effect of varying composite action on the stress in midspan for simple beams with uniform action.

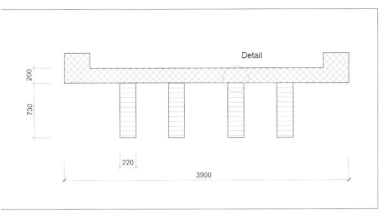

Detail

200

730

220

3900

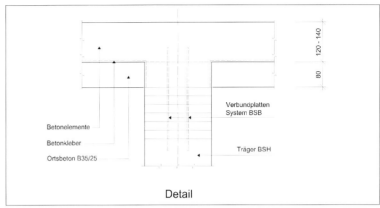

120 – 140

80

Betonelemente

Betonkleber

Ortsbeton B35/25

Verbundplatten
System BSB

Träger BSH

Detail

The load-bearing beam of the trussed frame structure of the Ronatobel Bridge in Furna (Graubünden Canton) is connected by means of conventional multiple shear bolts. The steel strips fitted into the longitudinal beams are connected with drift pins. The steel strip sections that project into the concrete slab contain holes for the round reinforcement bars that transfer the shearing forces. Thin prefabricated concrete elements serve as formwork for the deck slab. Reinforced site-placed concrete gives the slab its ultimate strength.

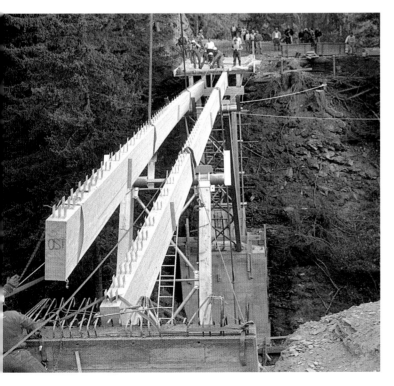

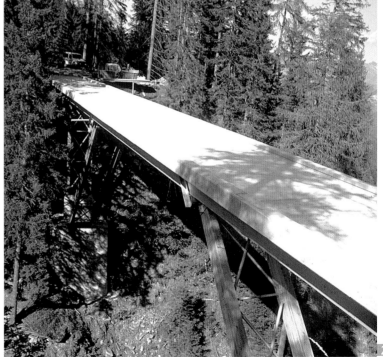

The stiffness of a connection determines whether a composite structure can be used or not. In other words, the connection between the two materials, concrete and timber (deck slab and main beams) ultimately determines the gain in structural strength achieved using this approach. As most composite materials used in construction do not meet the stricter requirements of bridge construction, the ETH Zurich developed a special concept for connecting materials. It is based on an incredibly simple principle, namely, that the transfer of forces in the concrete is effected through the shear studs normally used in composite structures. Fillets (basically nothing other than simple skew notches) are used to connect the materials. A different solution uses glued billet bars and notches to create a composite material of wood and concrete held together by a skew-notch.

In 1995, the ETH Zurich developed a composite material that was designed both to meet the greater demands on composite construction in road bridges and to exploit the advantages of this type of construction. Shear studs are very important in composite constructions. The basic idea behind the design was to limit the plastic load on the connection by purposefully causing the shear studs to fail. The goal was to determine and "tune" the material's ductility. Skewing the compressed area of the shear stud simultaneously pretensions the shearing joint and demonstrably increases its load-bearing capacity. So-called push-out tests confirm the high bearing capacity and ductile failure behavior. This new method of making composite materials was first applied in the construction of the Crestawald Bridge at Sufers (Graubünden Canton).

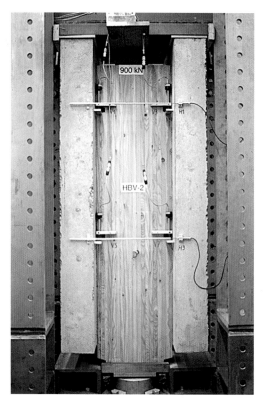

Crestawald Bridge at Sufers (Graubünden Canton) has a span of 33 meters and was built using a timber-concrete composite system. The four main beams in glued-laminated larch act in combination with the concrete deck slab to form a slab-and-beam section with structural properties (constructed in 1996).

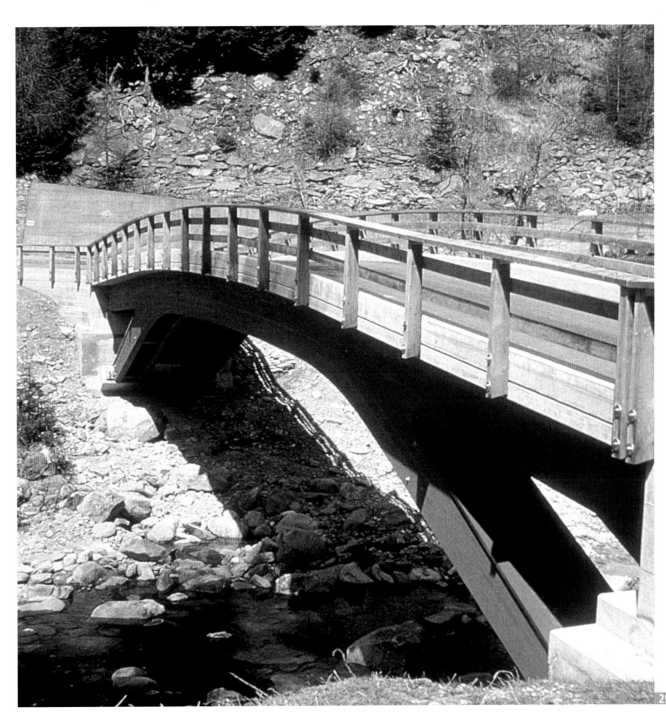

299

Durability

By nature, wood is a "composite" material which – like all other materials – decomposes into its original constituents. However, by applying foresighted construction methods builders can prevent this process almost completely, as confirmed by wooden structures that continue to fulfill their function more than four or five centuries after they were built. The Neubrügg Bridge, constructed in 1535 over the Aare River at Bremgarten (Bern Canton), is a fine example of wood's almost unlimited durability. The bridge continues to be used without restriction by road traffic, whose volume is quite considerable.

To ensure that a wooden structure lasts, certain steps must be taken. It is necessary to prevent moisture exchange. The wood must not be allowed to become wet or be directly exposed to moisture. It must also be well ventilated. Moisture causes dry rot and hence biological decomposition.

The Neubrügg Bridge, which is over 91 meters long, is an impressive example of wood's durability. More than 450 years old, the bridge provides impressive evidence of wood's unrivalled resilience as a building material. For wood to endure for such a long time, however, the appropriate protective measures must be taken to preserve its structural qualities.

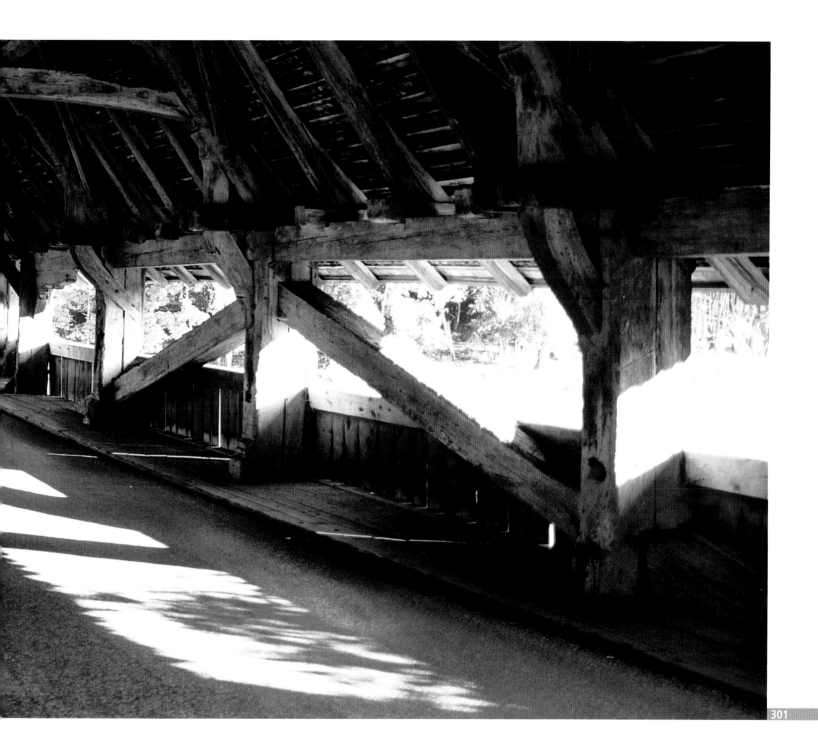

Damage to wooden structures is generally due to a failure to take adequate wood protection measures. If a structure is to last, its builders must apply a comprehensive wood protection concept, which means, above all, taking structural protection measures. These call for an appropriate overall design and the use of materials technology, as well as details designed to take into account the specific use and conditions.

What holds true for old bridges still applies today. Sustained structural protection can only really be achieved by providing adequate covering. The simplest form of protection is a roof built across the entire structure plus boarding on the sides. Chemical wood protection – such as pressure treatment – plays a secondary role, although biocide agents do prevent the growth of fungi. Chemical treatment alone cannot prevent fundamental problems in the long run.

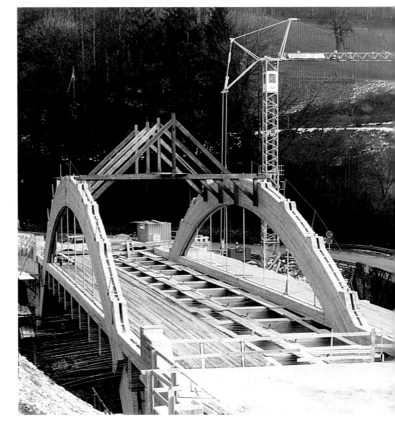

The Lochermoss Bridge, built in 1994 at Ganterschwil (St. Gallen Canton), is a covered structure. All of the building elements have been pressure-treated. The 42-meter arch of the two-lane road bridge is thus protected against the moisture transported by the traffic.

The footbridge built in 1989 over the Simme River at Reutigen-Wimmis (Bern Canton) illustrates that the covering need not appear heavy or cramped. A wide, gently sloping roof and prefabricated parapet elements with larch ribs in a shutter-like arrangement provide a protective sheath and create a sense of lightness.

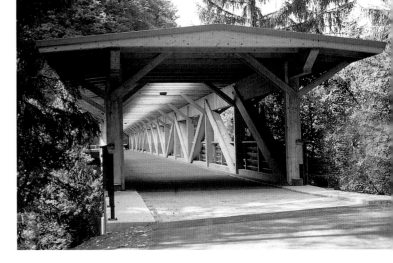

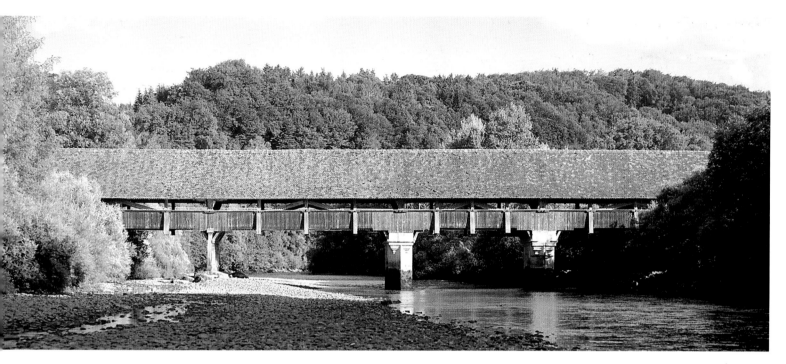

A bulky roof and high boarding on the sides have immortalized the Gümmenen Bridge, built in 1555 over the Saane River (Bern Canton). About 450 years old, it is one of the oldest surviving road bridges still open to traffic.

The protection concept for the 93-meter-long Dominiloch Foot-bridge, built in 1988 over the Reuss River at Hermetschwil (Aargau Canton), draws its in-spiration from traditional roofs and side boarding. It conveys a feeling of lightness.

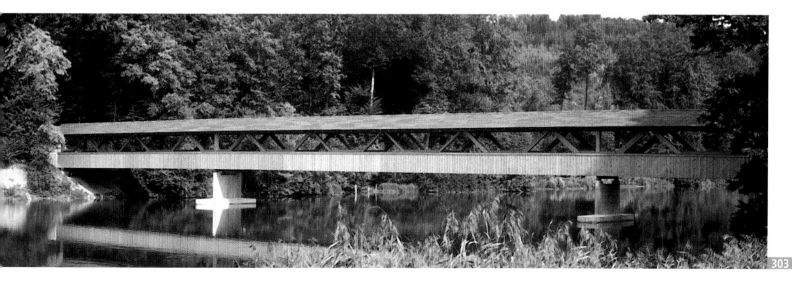

Although the prime aim in designing load-bearing structures is to create a sound structure that fulfils its intended purpose, the question of durability is vitally important too. Wood protection is an essential aspect of the design and planning process. A roof cannot always protect the load-bearing structure from the sun and rain. In the case of so-called deck bridges, the deck running across the load-bearing structure can be sealed so that the structure itself performs the roof's function. In other words, it protects itself. What would otherwise be a traditional form of structural wood protection with an expensive and elaborate roof is now reduced to both a watertight layer between the covering and the deck, on the one hand and an external water-protection layer for the load-bearing structure below, on the other.

At one time, railroad bridges were often only expected to last for ten to fifteen years. Building roofs on bridges was a problem, as there was often a danger of fire due to flying sparks. Not only that, the completely open structure, comprising many different sections, rotted at critical joints (sources of moisture) within a short space of time, which gradually lowered its bearing capacity. It was precisely this that caused the railroad bridge near Unghvár (then in Hungary) to collapse in 1877 while a train was passing over it.

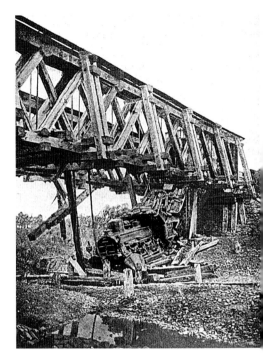

The tee-beam cross-sectional form of the Städtli Bridge, built in 1999 over the Reuss River in Mellingen (Aargau Canton), puts this structure in the category of deck bridges. The plywood carriageway slab fulfils diverse functions: in terms of statics, it is part of the slab-and-beam structure; it also serves as both a horizontal slab and as a roof with a sealing layer. Furthermore, having some overhang on each side, it protects the main beam against the direct effects of weather. The beams are also impregnated on all sides and have been given two coats of thick pigmented glazing. As the parapet supports beneath the slab are directly attached to the longitudinal beam, it was possible to seal the slab without leaving any perforations that might be susceptible to damage.

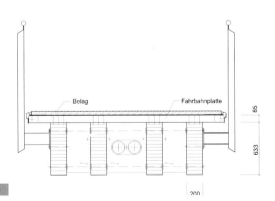

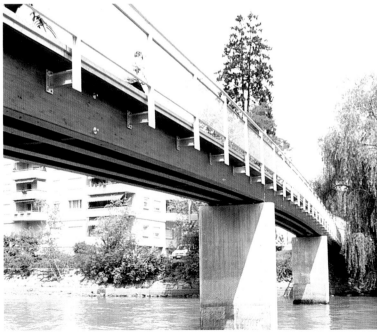

The veneer plywood deck of the Pradella Bridge, built in 1990 in Scuol (Graubünden Canton), provides a "roof" over the load-bearing structure and protects it and the larch panels against the direct effects of weather.

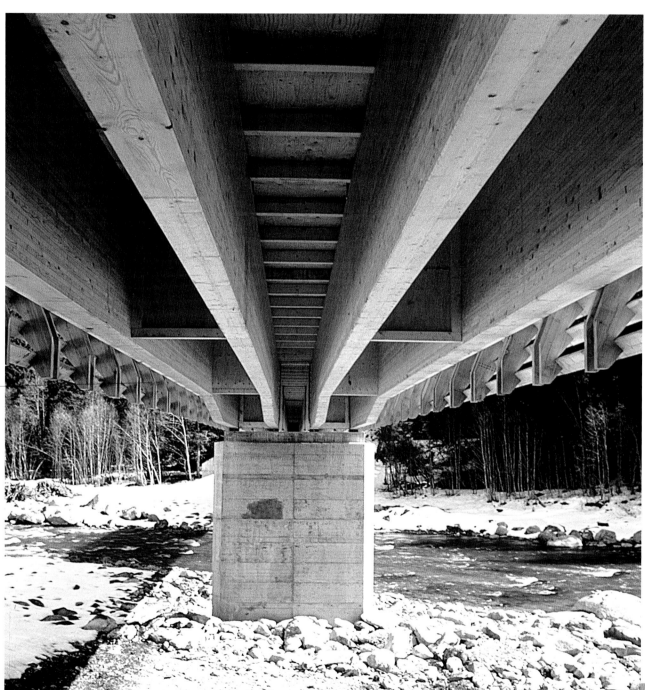

In the case of open bridge structures, durability can only be effectively ensured by covering and cladding the load-bearing structure. This insight led to the development of a monitoring program by the Eidgenössische Materialprüfanstalt Dübendorf (EMPA). Since 1982, 130 bridges have been continually monitored and given periodic checks. The results make it possible to examine and evaluate the effectiveness of the measures taken in each case. In additional research in the field of wood protection – especially in systematic studies on open weathering – the EMPA has made a major contribution to our understanding of the processes to which wood is exposed. The institute's research has ultimately resulted in more durable load-bearing structures.

Measures must be taken to protect the wood structurally in order to ensure that water runs off quickly and that good air circulation quickly dries the wood. Otherwise rot will set in after a very short time. This, in turn, can jeopardize the structure, as this illustration of a bridge support dramatically shows.

675

1155

The 20-meter-long Schlossmühlesteg Bridge, built in 2003 in Frauenfeld (Thurgau Canton), illustrates the necessity of protecting the load-bearing structure and of using easily replaceable components in an open bridge structure. Whereas the walkway covering and the larch parapets, both of which are well designed (rapid water run-off, large air gaps, etc.), are directly exposed to the vicissitudes of the weather, the beams, which are jointed by prestressing, are protected on all sides from the water.

The load-bearing structure of this road bridge, built in 1996, over the Thur near Nesslau (St. Gallen Canton), is protected by a thick deck and wooden side cladding.

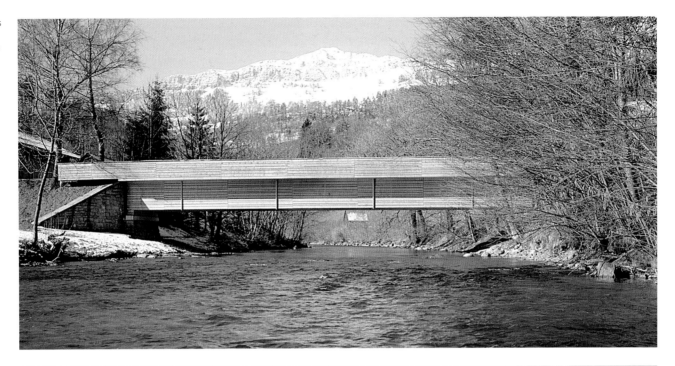

The Sagastäg Roadbridge was built in 1991 near Schiers (Graubünden Canton). The longitudinal beams and the cross members of the strutted frame load-bearing structure provide lasting protection from the vicissitudes of the weather: from above by the thick carriageway slab, and from the sides by the larch planking.

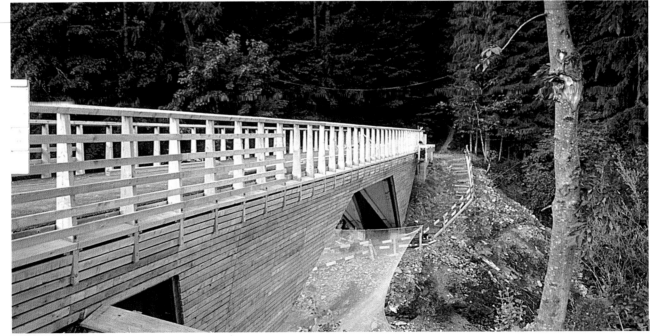

New Road Bridges

Wooden road bridges present a special challenge. The basic difference to other structures lies in the nature and magnitude of their live load. Nowadays traffic loads are quite considerable, very dynamic and concentrated. Together, they place high demands on the planning engineer.

The choice of the load-bearing structure is particularly important in the case of road bridges carrying heavy trucks. The connections peculiar to wooden structures play a particularly critical role in this context. In short: the structural concept is decisive, as many of the bridges successfully constructed in Switzerland over the past few years clearly show. The fact that the economic aspect is often decisive in a competitive environment may go some way to explaining the rather slow spread of wooden bridges.

The Selgis Bridge, which spans 30 meters and was built in 2001 high above the Muotha River (Schwyz Canton), is exemplary of modern wooden road bridges. Its distinguishing features are its confident design, the well thought-through structural concept with clearly arranged elements, its accurate connections, and a meticulously planned wood-protection concept.

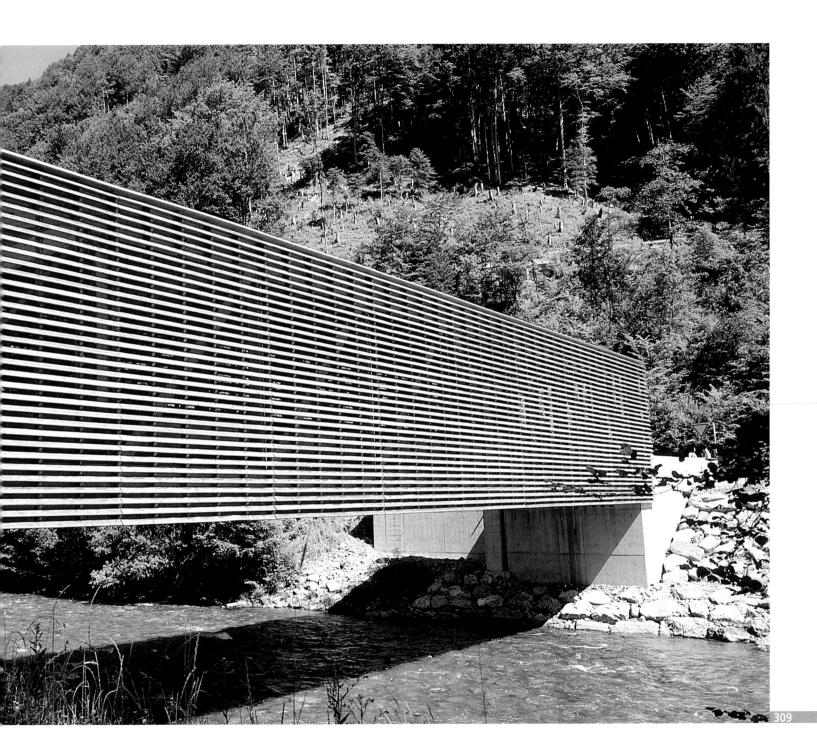

The position of the load-bearing structure is particularly important in the case of wooden bridges. Whether it is placed above or below the deck not only has economic consequences, but can also ultimately determine whether the bridge is constructed of wood or not. If the load-bearing structure is placed on top, it has to be positioned at the edge of the deck. In the case of two-lane bridges, solid cross-bracing must be used together with matching connections.

The main load-bearing element in the two-lane road bridge built in 1988 over the Emme River near Signau (Bern Canton) consists of 43-meter-long two-hinged twin arches. Its considerable cross-sectional dimensions of 2 mm x 200 mm x 1900 mm clearly show that there are limits to using wood in bridge construction.

The powerful twin cross braces used in the two-lane road bridge built in Eggiwil (Bern Canton) in 1984 illustrate the problem of placing the load-bearing structure above the deck. The relatively high road loads and the related new individual loads necessitated the use of strong sections which, in turn, had to be connected to the main load-bearing structure.

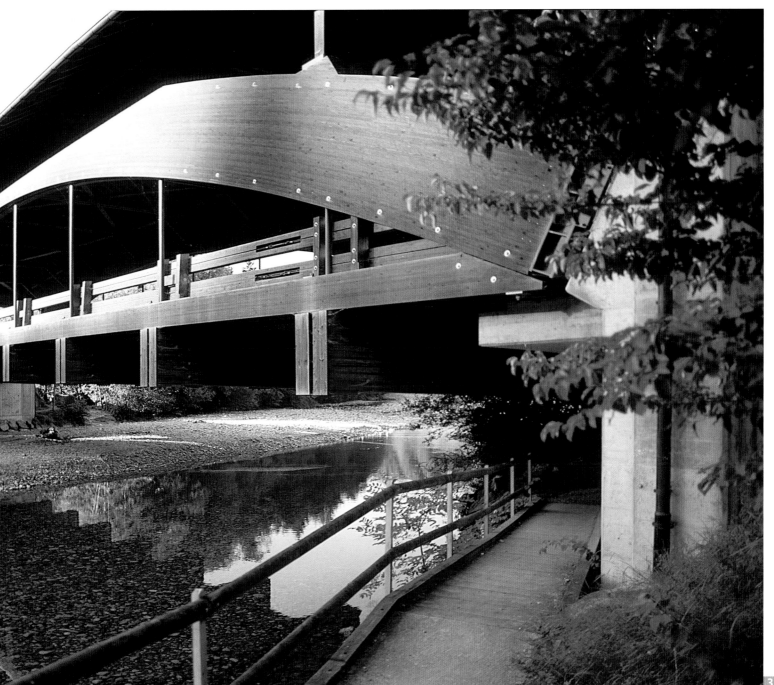

If the load-bearing structure directly supports the deck, a number of trusses can be placed above one another without any difficulty, thus increasing the load-bearing capacity of the entire structure and improving the deck's load-bearing behavior. Given the weight of transport along the main girder, however, this kind of structure is problematic for long bridges. Discontinuities in bridge rigidity impair the resilience of both the load-bearing structure and, in particular, the bridge flooring.

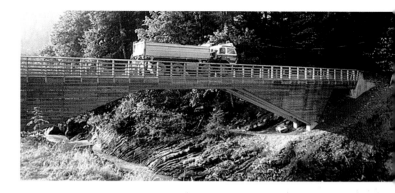

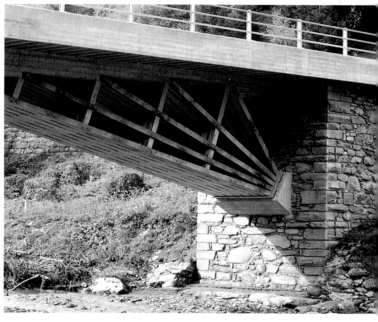

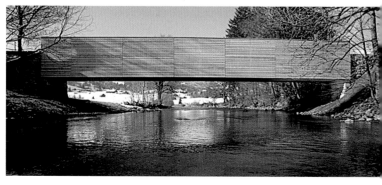

Where local topographical conditions permit sufficient clearance, a load-bearing structure below the deck offers distinct advantages. The heavy single loads typically borne by road bridges can be absorbed exactly where they occur. This has positive consequences for the economic efficiency of such bridges, as evidenced by the Sagastäg Bridge in Schiers (1991), the Glennerbrücke Bridge in Peiden Bad (2003) and the Laaderbrücke Bridge in Nesslau (1996).

A wide row of closely arranged main beams supports the deck on the Val Tgiplat Road bridge, built in 1999 near Domleschg (Graubünden Canton). This feature rendered secondary supports unnecessary.

Of the load-bearing systems most frequently chosen for road bridges, the arch is an obvious favorite. Although the arch is a classical "compression element," it is not necessarily the most expedient form for large, mobile loads as far as structural behavior is concerned. Nonetheless, it does offer advantages with respect to construction and economy. The connections are simple to make and the arch itself is both economical and easy to build.

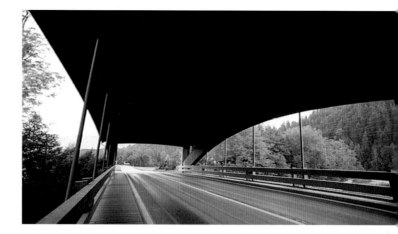

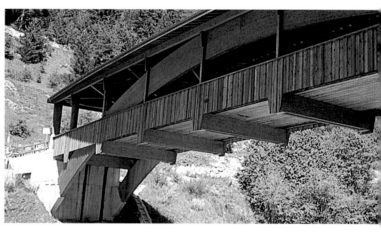

Depending on topographical conditions, the main load-bearing structure, the arch, is placed either above or below the deck. In the former case, the deck is supported by the arch. If the arch is beneath it, the deck is elevated where necessary. In cases where the arch is positioned above the deck, the transverse beam, the transition from the transverse beam to the hangers, and the local transfer of forces from the hangers to the arch are sensitive points whose construction demands great attention – especially when it comes to constructing road bridges.

From top to bottom:
Examples of arched road bridges are the Bubenei Bridge (1988), the Sclamischot Bridge (1990) and the single-lane road bridge over the A13 national highway near San Bernardino (1987).

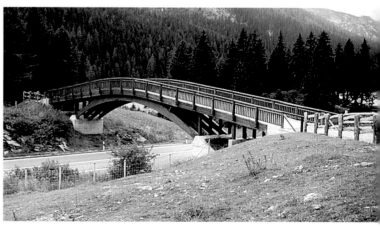

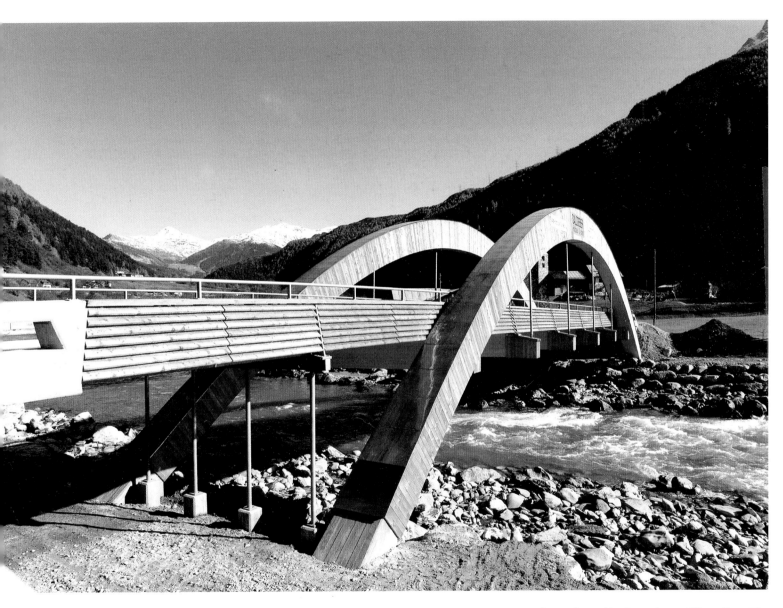

Two free-standing two-hinged arches – rising above the deck – with a span of 39 meters constitute the main bearing structure of the single-lane San Niclà Bridge over the Inn River (Graubünden Canton). Each arch varies in height and width from between 100 cm x 80 cm at the feet of the arches to 65 cm x 150 cm at the crown. The arches were constructed by bonding several glued laminated timbers together (built in 1993).

New Footbridges

Footbridges bear far lighter loads than road bridges and can therefore be built with very light and filigree structures. There is an almost endless range of solutions for every task. What planners and users find particularly exciting about footbridges is the fact that they are "close" to the users; that they are "tangible."

No wonder, then, that both engineers and architects welcome the challenge of designing a footbridge. Footbridges demand of the engineer considerable technical know-how, extensive knowledge of materials and a creative mind. A large number of footbridges have been built in Switzerland over the past few years. Their high level of technical development and aesthetic appeal have won them acclaim far beyond the country's borders.

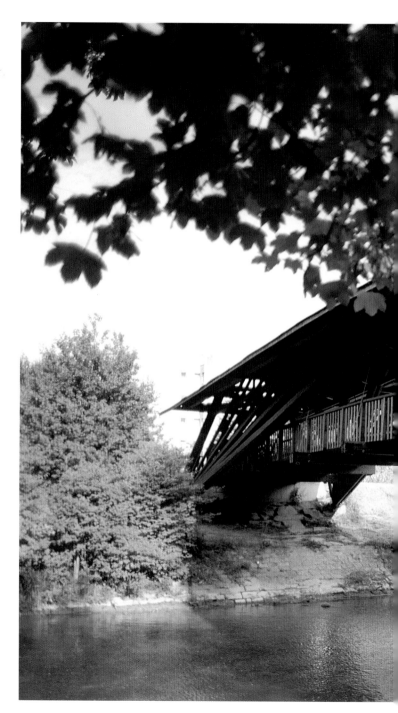

This seemingly weightless, inwardly inclined strutted framework spans 43 meters and links the two banks of the Töss River in Wülflingen (Zurich Canton, erected 1992).

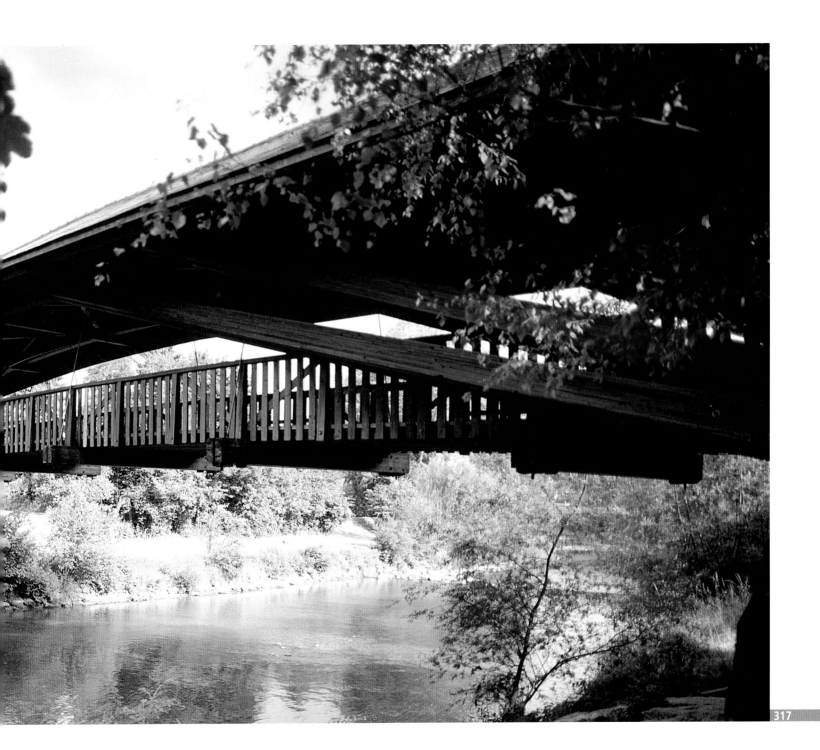

The appearance of a footbridge is primarily determined by both the static system selected for the load-bearing structure and the wood-protection concept chosen. In terms of its form, the traditional bridge covering harks back to the old Hüsli (house) bridge. The long spans and the light and transparent structures starkly distinguish present bridges from their bulky predecessors.

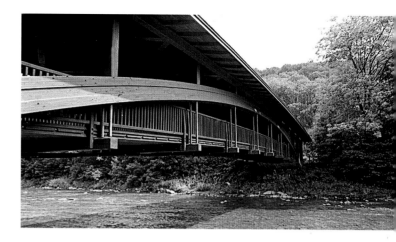

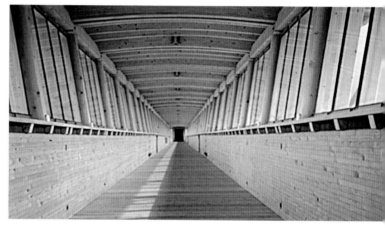

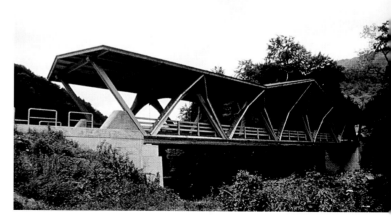

The new covered footbridge explores the interface between optimized, expedient construction and architectural intention. The semantics allude to the protective function of the "house bridge".

From top to bottom: the footbridge over the Sihl River near Leimbach, 1992; the footbridge crossing the A13 expressway near Sevelen, 1990; the footbridge over the Doubs River near St. Ursanne, 1991.

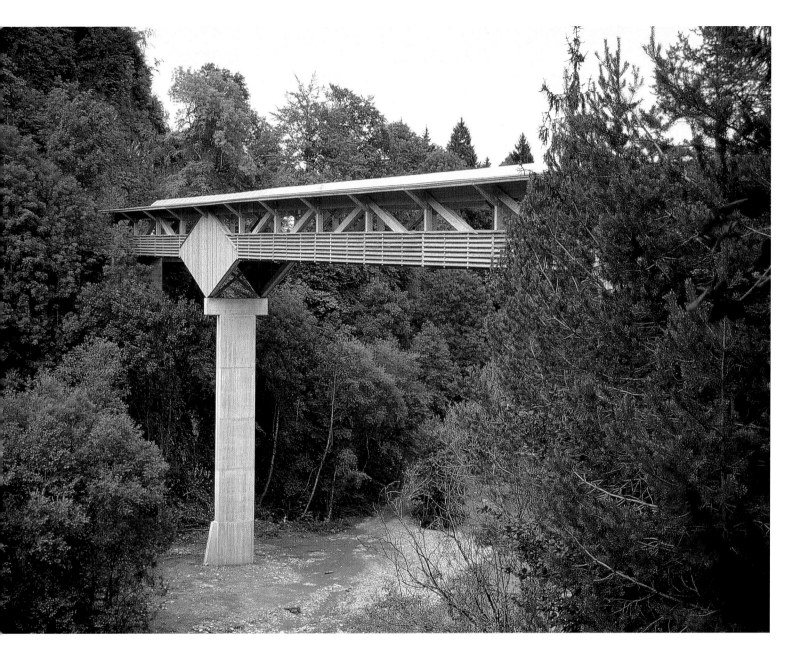

The design for the bridge over the Simme River near Wimmis (Bern Canton) was inspired by traditional structures. At the same time, however, its filigree and transparent in-terpretation embodies a new for-mal category. With a length of 108 meters, it is one of the longest new wooden bridges in Switzer-land (construction year 1989).

The uncovered deck bridge creates a very different vocabulary of forms to that embodied in the "house bridge." Although the deck bridge does without a roof, it still provides protection from the weather. The actual deck is located at the very top. As in the case of the road bridge, the expensive and complex footbridge roofing has been reduced to a watertight layer between the flooring and the deck and, where necessary, to an additional cladding layer that provides weather protection at the sides. This design is not only more economical than others but also far more competitive.

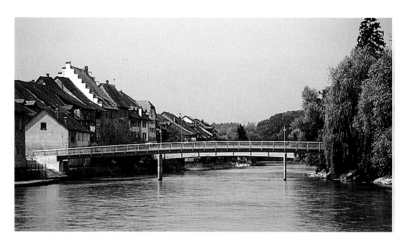

The deck bridge with a footpath appears to be lighter and more anonymous than the "house bridge" type, since its load-bearing structure is located beneath the footpath. As a consequence, the user does not experience any meaningful relationship to the load-bearing structure and the wooden building material. What makes the deck bridge so convincing as a structure is its simple, discreet elegance. From top to bottom: the Städli footbridge over the Reuss River near Mellingen, 1999; the Lenzhard Footbridge crossing the road near Rupperswil, 1982; the footbridge with bike path over the Bachtaltobel Gorge near Sins, 2002.

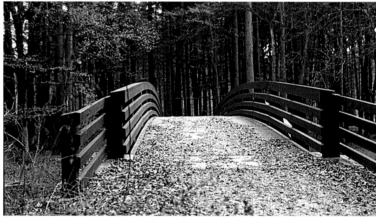

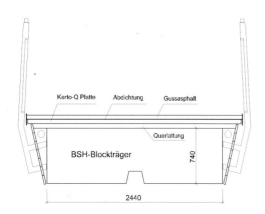

Kerto-Q Platte Abdichtung Gussasphalt

Querlattung

BSH-Blockträger 740

2440

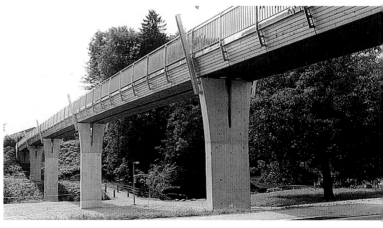

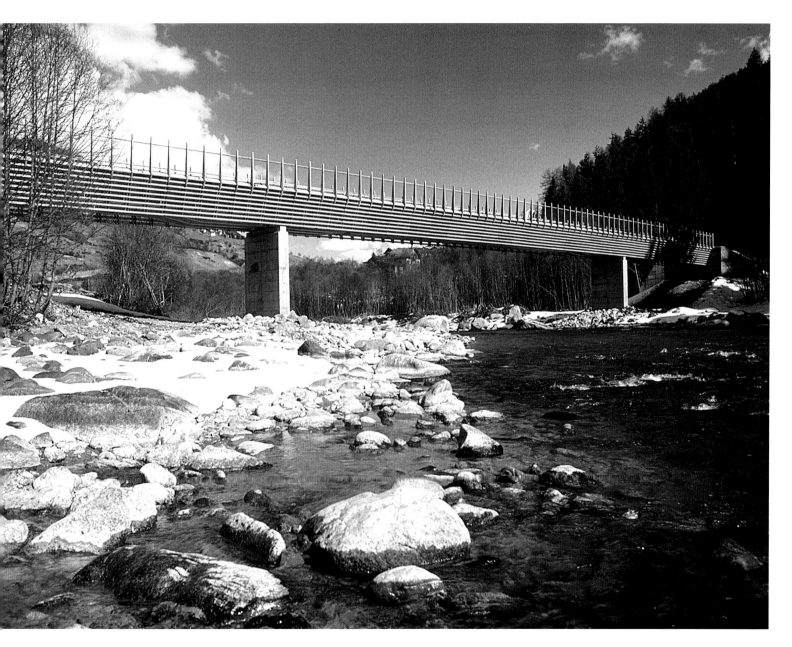

Four glued laminated timber beams create a Gerber system that forms a triple-span bridge over the 85-meter-wide Inn River near Scuol (Graubünden Canton). The covered deck and the wooden weather shields at the sides render the traditional roof superfluous (built in 1990).

Uncovered Footbridges

Footbridges often owe their aesthetic extravagance to the incredible freedoms they offer the engineers who construct them. As such bridges inevitably bear small loads, there is virtually no limit to the range of constructional solutions or the choice and combination of materials. Furthermore, footbridges, particularly those constructed in wood, provide a unique chance to experiment with technical innovations and ingenious forms.

Engineers have gradually freed themselves from traditional roles and formulae. Today's footbridges clearly show that extremely interesting and aesthetically satisfying load-bearing structures can be constructed in wood using the latest connection technology and manufacturing methods as well as modern building materials. Engineers need no longer fall back on nostalgic elements or expensive architectural structures. Furthermore, decorative forms that bear no relationship to a bridge's structure are superfluous. Considered in this light, many of Switzerland's new bridges are very exciting indeed.

Traversina Footbridge, an almost weightless structure, stretches 47 meters between two peaks as it crosses the rugged Via Mala Gorge (Graubünden Canton, erected 1996).

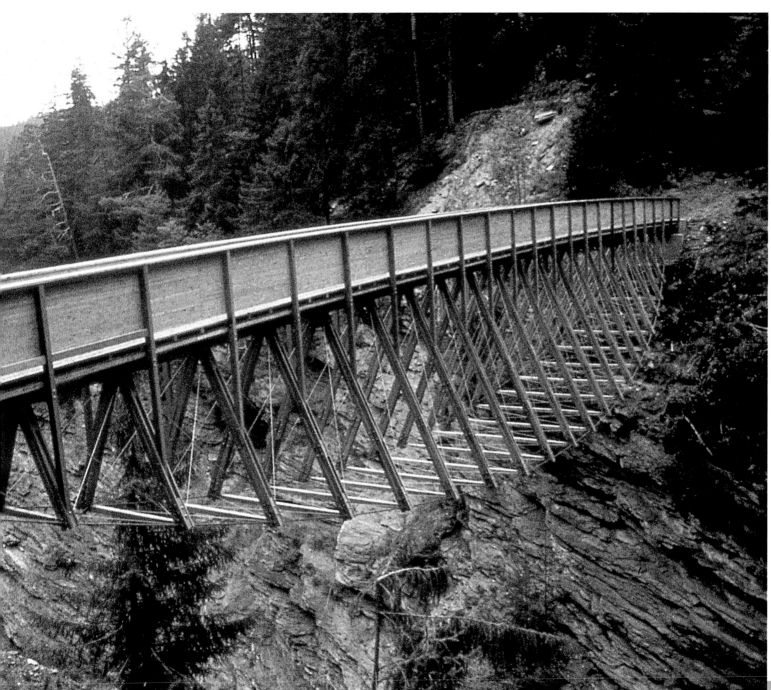

The Traversina Footbridge is a spectacular wooden structure. There was never any question of constructing a bridge on site using traditional methods in the impassable Via Mala region. The solution finally arrived at was a system comprising two elements: a parabolic truss and a reinforcing beam. Both elements were designed to be prefabricated and flown in by helicopter. In order to keep the transport weight down to 4,300 kilograms, the tensile elements of the truss were made of steel cables. These cables, which passed parabolically in and out of the truss, lent the bridge the form of a spherical prism. The verticals, which were directly exposed to the weather, consisted of four larch boards and could be simply dismantled and replaced if necessary. Three years after it was constructed, this daring bridge was destroyed by an avalanche during an unusually violent storm in 1999.

The transitional and connecting points reveal the intricate interplay of the wooden elements and steel cables. This simple and elegant connection is the product of intelligent structural concepts and consistent development.

The load-bearing concept is based on two structures: a very light filigree structure with a compression chord, larch posts trussed with steel cables, and a reinforcing superstructure of glued laminated larch beams.

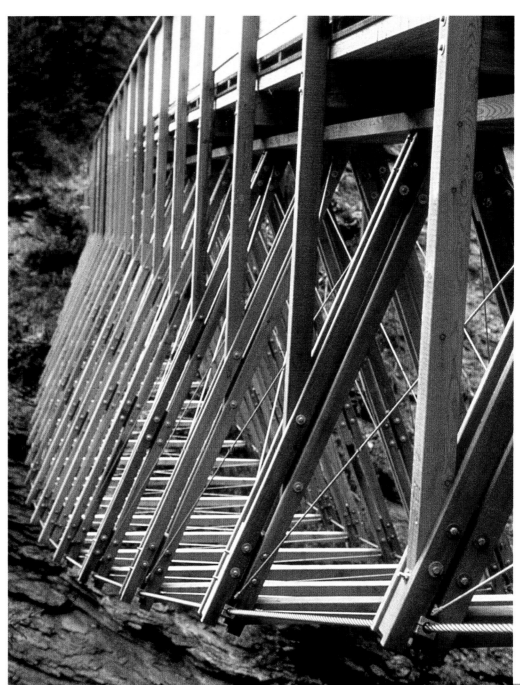

The freedom to develop and design footbridges that has been made possible by new technology has often resulted in solutions which, at first sight, do not seem to comply with traditional wood protection requirements. Uncovered load-bearing structures that are totally exposed to the weather present a great challenge to planners, entrepreneurs and the clients who have to maintain them.

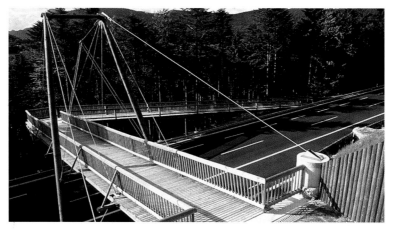

Uncovered footbridges have various forms:

This 24-meter footbridge, built in 1989, spans the expressway in Ballaigues (Waadt Canton). Its load-bearing structure is anchored with steel reinforcing rods. The actual bridge elements comprise pressure-impregnated lumber.

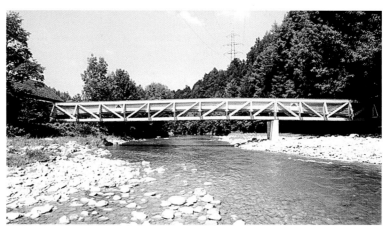

The bridge over the Sihl River in Sihlwald (Zurich Canton, constructed 1997) consists of two larch trusses bearing two spans of 15 and 33 meters respectively. Hinge-pin connections were used here. The curved pathway rising towards the middle of the bridge gives this structure its special character.

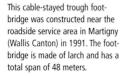

This cable-stayed trough footbridge was constructed near the roadside service area in Martigny (Wallis Canton) in 1991. The footbridge is made of larch and has a total span of 48 meters.

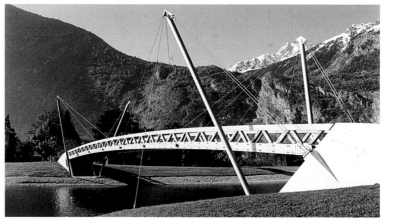

The Japanese artist Tadashi Kawamata made this wooden bridge t the Felsenbad Castell rock pool i Zuoz (Graubünden Canton) in 1997. He used simple boards and planks to create a unique ambience, modulating between landscape and architecture, the past and the present ... The emphasis is primarily on impact and less o durability.

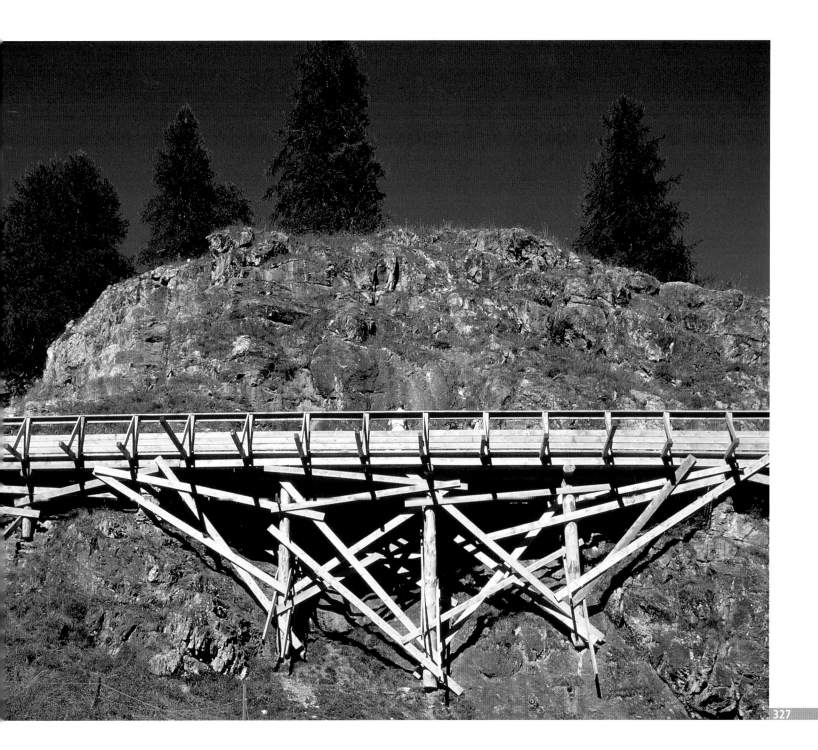

Planners can only partially remedy the failure to protect wood structurally by attending to details, selecting more resistant types of wood or providing additional protection with chemicals. A specially developed, rigorous monitoring and maintenance concept is essential if footbridges are to last. Creating a structure of captivating aesthetic lightness demands an intimate knowledge of the materials on the part of the planner.

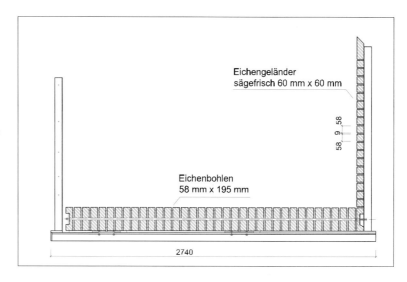

Eichengeländer
sägefrisch 60 mm x 60 mm

58 9 58

Eichenbohlen
58 mm x 195 mm

2740

An uncovered footbridge with an open-planked pathway offers no protection to the main beams underneath. Pressure-impregnated glued laminated timber does not necessarily guarantee the desired durability. Maintenance is absolutely essential.

With a length of 841 meters, the footbridge crossing Lake Zurich from Rapperswil to Hurden (St. Gallen Canton/Zurich Canton) is probably one of the longest bridges in the whole world. Closely spaced thick oak planks (58 x 195 mm) placed edgeways in rows form the load-bearing structure, which simultaneously serves as the pathway. They are butted like coupling purlins and span more than seven meters from trestle to trestle. (Construction year 2001).

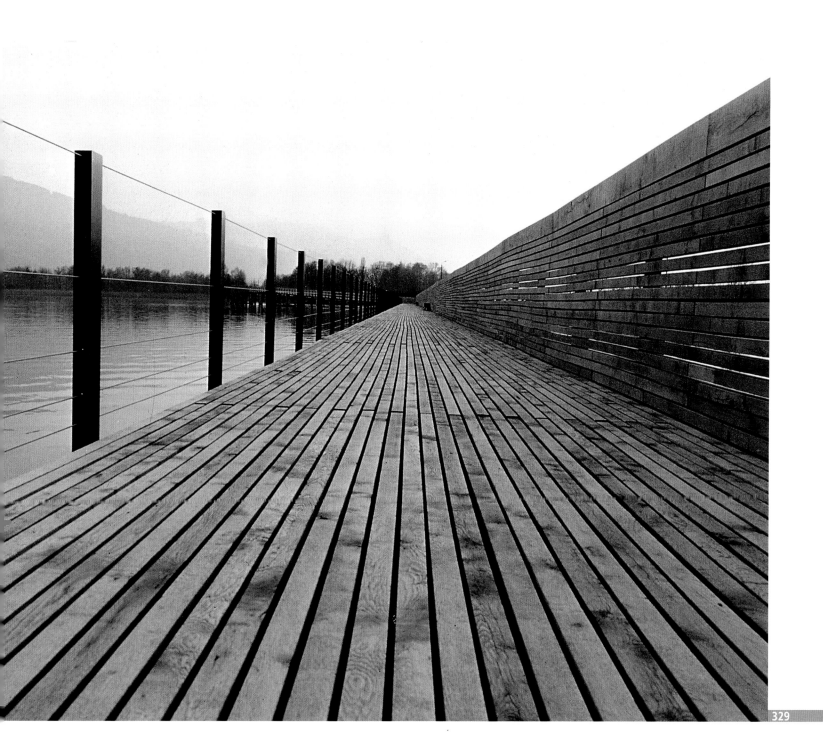

Picture credits

A

Architectural Archive of the City of Zurich
200/201; 202; 203; 204-t; 204-b
Altenmarkt Municipal Administration 98
Alvar Aalto Museum 156
Arm Hanspeter 16-t; 17; 21; 67-r; 92-t; 138/139; 176/177; 181-b

B

Banholzer Hans 160; 161; 320-br
Basler Christina 28; 29; 38; 39-l; 42-l; 112-b; 128-l; 140-b; 141; 142-b; 144-t; 183-lb; 224; 240-b; 280-b; 286; 287-t; 296; 297-t; 298-t; 304-bl; 306-bl; 320-bl; 325-l; 328-t
Bauernfeind Carl Maximilian 92/93
Bavier Simon 144-b
Bayerischer Rundfunk 81
Beaud Frédéric/LIGNUM 131
Bieler Walter 120; 121; 292; 305; 306-br; 307; 312-t; 312-b; 313; 318-m; 321
Bignia Bill 196/197
Blumer Hermann 166/167; 282-b; 297-b
Bogusch Walter 302-t; 315
Boss Pierre/LIGNUM 22; 23-r
Bossard Beda 242

C

City Archive, Mellingen 261
Construction technology 168
Conzett Jürg 128/129; 273; 322/323; 324; 325-r;
Culmann Carl 30/31; 31-t; 32; 33; 264

D

Dauner Hans 326-b
de l'Orme Philibert 94
Ducret Jean-Marc 182/183-t

E

Ege Hans Architekturfotografie Lucerne 124-b; 327
Ege Hans Luzern/LIGNUM 236/237
EMPA Timber Department 52-t; 53; 58; 106/107; 109; 150-t;
Emy Armand Rose 95
ERNE AG Holzbau 218; 219
Euler Leonhard 39-r

F

Farmhouse Research, Zug 186/187; 191-r
Fontana Mario 44/45
Fotoservice SBB 266; 267
Fromm Johannes 294/295
Fuhrmann Christoph 193; 304-br; 320-t

G

Gasser Hans-Heinrich 70-m

H

Historic preservation in Schwyz Canton 189
Häring & Co AG Pratteln 73; 122/123
Hefti Paul 64-t; 64-m; 65-t; 65-m; 66; 92-t; 105; 111-b; 138/139; 142-t; 143; 265-l
Henz Hannes/LIGNUM 133
Hermann Bruno 244; 245-rb
Honegger Emil 8/9; 12; 26/27; 90/91; 145; 246/247; 252; 253; 257; 259; 265-r; 278; 280-t; 284/285; 300/301; 303-t; 308/309; 310/311; 314-t; 316/317; 318-t
Institute of Structural Engineering, ETH Zurich 74/75; 92-b; 113; 130; 170; 171; 174; 184/185; 188; 190; 209-b; 212; 213-b; 215; 228/229; 230; 232; 233; 234; 235; 248/249; 256; 268/269; 270; 281; 282-t; 282-m; 287-b; 291; 310-b; 314-b; 328-lm

J

Jucker Heinz 136/137; 172/173; 180; 181; 210/211; 288
Jung Pirmin 241; 245-lm

K

Kämpf Hanspeter 276/277; 293; 303-b; 320-m
Kämpfen Beat 243
Kersten Carl 102-t; 150-b; 169
Krattiger Markus 299
Kuhn Mathias 56; 67-l
Kunstmuseum Bern 13
Künzli Holz AG Davos 126-l

L

LIGNUM Zürich 15; 59; 68/69; 72; 84/85; 99; 112-t; 134/135; 146/147; 195; 231; 238; 245-lb; 245rt; 245-rm

Index of Timber Structures

Page 327
Bridge to the Castell rock pool, CH-7524 Zuoz; 1997
Architect: Tadashi Kawamata
Artistic supervision: Ruedi Bechtler

Pages 328/329
Bridge over Zurich Lake, from Rapperswil to Hurden,
CH-8640 Rapperswil; 2001
Timber engineers: Walter Bieler, Bieler Ingenieurbüro für Holzbau,
Bonaduz; Huber & Partner AG, Rapperswil
Timber structure: W. Rüegg AG, timber construction and carpentry
business, Kaltbrunn; Holzbau G. Oberholzer GmbH, Eschenbach;
Walter Rüegg Holzbau, Ricken